THE PAINTINGS OF
JACOB OCHTERVELT

The Paintings of
JACOB OCHTERVELT
(1634-1682)

[With Catalogue Raisonné]

SUSAN DONAHUE KURETSKY

ALLANHELD & SCHRAM Montclair

ABNER SCHRAM LTD.
36 Park Street, Montclair, N.J. 07042

ALLANHELD, OSMUN AND CO. PUBLISHERS, INC.
19 Brunswick Road, Montclair, N.J. 07042

Published in the United States of America in 1979
by Abner Schram and by Allanheld, Osmun and Co.
under the imprint *Allanheld & Schram*

Library of Congress Cataloging in Publication Data

Kuretsky, Susan Donahue.
 The paintings of Jacob Ochtervelt, 1634–1682.

 Bibliography: p.
 Includes index.
 1. Ochtervelt, Jacob, 1634 or 5–ca. 1708. I. Title.
ND653.025K87 759.9492 79-63058
ISBN 0-8390-0240-8

Printed in the United States of America

To my parents

Preface

Ignorance and curiosity prompted the beginnings of this study. In 1967 the *Age of Rembrandt* exhibition opened at the Museum of Fine Arts in Boston. There, as a graduate student of Dutch art at Harvard, I first encountered Jacob Ochtervelt's *Music Lesson* (cat. nr. 63; Fig. 75; Art Institute of Chicago). The picture seemed to hold its own among a selection of extremely fine Dutch paintings. I wondered why the artist's name was not more familiar to me, and I began to seek out more of his works. In time, this investigation led to the writing of a doctoral dissertation on Ochtervelt (Department of Fine Arts, Harvard University, 1971). Special thanks are offered to Professor Seymour Slive for his meticulous, always constructive criticism of the original manuscript and for his encouragement and advice during the preparation of the book.

Much of the research and writing leading to the completion of this project was made possible by a year of freedom from other commitments (1974-75) provided by the Smith Fellowship, National Gallery of Art, Washington, D.C. I am extremely grateful to Robert H. and Clarice Smith for their generous support of scholarship in the field of Dutch art. In the course of my work, both museum personnel and private collectors have been most helpful in supplying data for the catalogue as well as access to the paintings themselves. Since many of Ochtervelt's works are still on the art market, a particular word of appreciation is due the numerous dealers who generously provided information and photographs and allowed me to examine their files.

Certainly no catalogue of a Dutch artist's *oeuvre* could be compiled without the seemingly infinite resources of the Rijksbureau voor Kunsthistorische Documentatie, The Hague, and the untiring assistance of its staff. I am greatly indebted to W. van de Watering and G. Kotting for their help at all stages of my research and to J. Nieuwstraten, Director of the RKD. The staffs of the Witt Library, Courtauld Institute of Art, London, The Frick Art Reference Library in New York, and the Fine Arts Library at Harvard also offered invaluable assistance, as did a number of colleagues working on Dutch genre painting who were extremely generous in sharing information and ideas: special thanks to Franklin Robinson, Otto Naumann, Albert Blankert, Lyckle de Vries, James Welu, and Peter Sutton, and to my husband, Robert, for his patient and helpful reading of these pages. The preparation of the manuscript for press was greatly facilitated by Sally Held's sensible editorial advice.

This book cannot pretend to be the conclusive treatment of its subject, for the present locations of many of Ochtervelt's paintings are still unknown. Furthermore, the fact that several works have only recently been added to this catalogue suggests that others await future discovery. Thus, in presenting this material I hope that more of the artist's paintings will subsequently be brought to light and that other scholars working on related problems will find stylistic and interpretive connections that have escaped my notice.

Contents

LIST OF ILLUSTRATIONS

LIST OF ABBREVIATIONS

HdG notes, RKD:

Unpublished notes on Ochtervelt's paintings prepared by Hofstede de Groot and his assistants, in the Rijksbureau voor Kunsthistorische Documentatie, The Hague.

Wurzbach:

A. von Wurzbach, *Niederländisches Künstlerlexikon*, 3 vols. (Vienna and Leipzig, 1906–11).

Valentiner (1924):

W. R. Valentiner, "Jacob Ochtervelt," *Art in America* 12 (1924): 264–84.

Gerson, *Thieme-Becker:*

H. Gerson, "Jacob Ochtervelt," vol. 25 (1931), pp. 556–57, in U. Thieme and H. Becker, *Allgemeines Lexikon der bildenden Künstler*, 37 vols. (Leipzig, 1907–50).

Plietzsch (1937):

E. Plietzsch, "Jacob Ochtervelt," *Pantheon* 20 (1937): 364–72.

Bénézit, *Dictionnaire:*

E. Bénézit, *Dictionnaire des Peintres, Sculpteurs, Dessinateurs et Graveurs*, 8 vols. (Paris, 1953).

Plietzsch (1960):

E. Plietzsch, *Holländische und flämische Maler des XVII. Jahrhunderts* (Leipzig, 1960).

Hollstein:

F. W. H. Hollstein, *Dutch and Flemish Etchings, Engravings and Woodcuts 1450–1700*, vol. 1—(Amsterdam, 1949—).

THE PAINTINGS OF
JACOB OCHTERVELT

Introduction

Considering the extraordinary artistic resources of the Netherlands in the 17th century, one is not surprised to find that the *oeuvres* of so many painters of the period remain uncatalogued. Indeed, of the numerous Dutch artists who specialized in domestic genre themes, only a few are widely known today. Despite the extensive body of literature on Vermeer and recent monographs on Gerard Ter Borch and Gabriel Metsu,[1] we still lack comprehensive, up-to-date accounts of Pieter de Hooch, Jan Steen, Gerard Dou, and Frans van Mieris, not to mention a host of less familiar figures whose contributions were substantial, but whose names evoke little recognition. It is the purpose of this study to attempt to raise one such Lazarus from the relative obscurity that has been his lot.

Jacob Ochtervelt was the leading Rotterdam specialist, during the 1660's and early 1670's, in aristocratic genre painting—a subject that had been developed during the previous generation in Rotterdam by Willem Buytewech and that was to be continued into the 18th century by Adriaen and Pieter van der Werff, also of Rotterdam. This large port city, second only to Amsterdam as a center of international trade, was not dominated by one major artist or school of painting in Ochtervelt's time. Indeed, despite its commercial importance, Rotterdam never became as vital or influential an artistic center as Amsterdam, Leiden, Delft, or Haarlem. Nonetheless, it was still the home of a substantial and varied group of painters. Ochtervelt's contemporaries numbered other genre specialists: Ludolf de Jongh, Joost van Geel, Eglon Hendrik van der Neer, Michiel van Musscher, and Heyman Dullaert. (Pieter de Hooch, although born in Rotterdam, worked primarily in Delft and Amsterdam.) Peasant and rural genre painting were represented by Cornelis Saftleven, Hendrik Martensz. Sorgh, Pieter de Bloot, and Abraham Diepram and architectural painting by Anthonie de Lorme. Rotterdam landscapists included Ludolf de Jongh, Abraham Hondius, and Herman Saftleven. Since the city was a major seaport, marine painting also flourished there, represented primarily by Simon de Vlieger, Jacob Bellevois, Julius Porcellis, and Lieve Verschuier.

Situated at the delta of the Maas and Rhine rivers, Rotterdam had evolved from a quiet fishing

village into a bustling city during the late 16th and early 17th centuries. Gerard van Spaan, the town historian, offers a vivid description of the extensive building activities undertaken during this period.[2] He reports that so many roads and houses were constructed—partly in response to the influx of immigrants from the southern provinces—that by 1609 Rotterdam boasted 1800 more houses than Delft. At the same time, the harbors were deepened and enlarged and new sea walls, dams, and bridges were built to accommodate the growing trade with Europe, England, and the East and West Indies. In 1597 the admiralty for the Maas region, the first in rank of the five Dutch admiralties, was established at Rotterdam, and in 1602 the city was assigned one of the six "chambers" of the Dutch East India Company. In 1630 the Rotterdam branch of the West India Company was built on the Haringvliet. A large English company, the Society of Merchant Adventurers, was moved from Delft to Rotterdam in 1635, indicating the growing importance of the Rotterdam harbors as a focus of international trade. Thus, although the herring fisheries and breweries remained major local industries, Rotterdam's economy in the 17th century was directed primarily toward traffic in foreign goods. By 1618 the French wine trade, which continued to be an important business until the end of the 18th century, was singled out by the town council as "de hoofdnering der stad."[3]

A Venetian envoy to The Hague, who had visited Rotterdam, sent the following impressions to his government in a dispatch of 1626—a description that evokes an atmosphere more commercial than cultural and suggests how much the life of the city was dependent upon the sea:

> . . . a large town, after Amsterdam the largest of these provinces, full of trade, crowded with ships, seamen and merchants. There is no court and no aristocracy so that, except for what happens in the immediate vicinity or is brought in now and then by the ships that moor there, little other news can be gleaned with any grounds of certainty.[4]

Like so many citizens of Rotterdam, the Ochtervelt family had close ties to seafaring. Jacob Ochtervelt's older brother, Pieter, became a gunner on the "Schiedam" and died in the East Indies in 1657.[5] A second brother, Jan, died during a return voyage from the East Indies in 1666. And Achtgen Ochtervelt, one of Jacob's three sisters, became the wife of a sailor. Lucas Hendricksz., the father of the six children, was a bridgeman whose annual wage, according to a salary list noting his appointment to the *Roode Brugge*, was only twelve pounds. Obviously the family was not a prosperous one; and it is noteworthy that the son who became an artist would make a specialty of the most luxurious scenes depicting the pleasures of patrician life and leisure.[6]

Jacob Ochtervelt was baptized in the Dutch Reformed Church of Rotterdam on February 1(?),[7] 1634, which indicates that his date of birth must have been in late January of that year. It is still uncertain where Ochtervelt received his artistic training and what the duration of his study was. The only known reference to his education is Arnold Houbraken's statement of 1719 that Ochtervelt and Pieter de Hooch had been students of Nicolaes Berchem at the same time.[8] This apprenticeship probably occurred in Haarlem within the period between 1646 and 1655, since Berchem returned from Italy in 1646 and was married in Haarlem in that year.

By 1655 Ochtervelt had returned to Rotterdam, for on November 28th of that year he and Dirkje Meesters posted their marriage banns. Their wedding took place in the Reformed Church of Rotterdam on December 14, 1655. Apparently the couple had no children, since none are recorded in the baptismal books of the church. Ochtervelt did, however, serve as guardian to the orphaned children of his brother Jan, according to an agreement drawn up in 1666.

Between 1661 and 1672 Ochtervelt's name appears in fourteen Rotterdam documents, several of which he witnessed for his brother-in-law, the notary Dirck Meesters. Aside from his functions as guardian, Ochtervelt also contributed to the support of an orphaned Meesters child in 1665 and served as a witness to christenings and the signing of wills and various property settlements. The documents suggest that he was a thoroughly responsible citizen who took an active and helpful part in family affairs.

On October 18, 1667, Ochtervelt was nominated for the mastership of the St. Luke Guild of Rotterdam, but he lost the election to Cornelis Saftleven. At this time the artist and his wife were living on the Hoogstraat in a house that had been leased (at a rent of 190 guilders per year) for a four-year period beginning on May 1, 1667. The Ochtervelts probably occupied this property until May of 1671. The latest documentary evidence of Ochtervelt's presence in Rotterdam dates from July 10, 1672, when he and Dirkje were witnesses at the baptism of an infant daughter of Jan Meesters.

By 1674 Ochtervelt and his wife had moved to Amsterdam, where the artist was to spend the remainder of his life. His residence there is documented by an entry in the taxation register of the City of Amsterdam for 1674, which notes that "Jacob Vechteveld (sic) fijnschilder" was taxed the sum of five guilders under the rates for the "200ste penning" (a municipal tax of one penny on every two hundred). This was a property tax rather than an income tax, and it indicates that Ochtervelt's house and holdings must have been worth about one thousand guilders. He was therefore living in comfortable, but certainly not wealthy, circumstances.[9] By 1679 the artist and his wife had rented a house at nr. 608 Keizersgracht. A bird's-eye-view map of this section of Amsterdam made in 1679 (Fig. 1), now in the collection of IJsbrand Kok, identifies this building as the house of the painter "Jacob Vechteveld." Ochtervelt and his wife probably continued to rent this property until January of 1681, when the house was sold by foreclosure. The fact that it fetched a sum of 4,100 guilders in the sale indicates that the property was a rather substantial one.[10] Indeed, Ochtervelt's career in Amsterdam must have brought him some degree of prosperity, for the artist was apparently able to lend money to others. Two Amsterdam documents of 1677 were drawn up in order that Ochtervelt might collect money owed to him by debtors.

An entry made five years later in the burial register of the Nieuwezijds Chapel in Amsterdam on May 1, 1682, establishes that the artist died at the age of forty-eight. According to the burial notice, Ochtervelt was living at the Schapenmarkt near the Amsterdam Mint at the time of his death. Dirkje Meesters remained in Amsterdam for at least six months after her husband's death, for she brought legal proceedings against another Amsterdam citizen on November 3, 1682.[11] She later moved back to Rotterdam; her burial was recorded there at the Dutch Reformed Church on February 11, 1710.[12] The sum of three guilders paid to the church wardens indicates that she did not leave a large estate.[13]

Despite the contemporary archival references and a surviving *oeuvre* of more than one hundred pictures—both of which suggest that the artist enjoyed a rather successful career—Ochtervelt was completely ignored by the writers and biographers of his own time. His name does not even appear in Gerard van Spaan's history of Rotterdam, published in 1698,[14] and the earliest mention of him in the literature is Houbraken's brief statement of 1719 noting that he studied with Berchem as a fellow apprentice of Pieter de Hooch.[15] During the second half of the 18th century, four sources on Ochtervelt can be cited. Van Gool's *De Nieuwe Schouburgh* of 1750-51, a continuation of Houbraken, includes a short but illuminating paragraph on Ochtervelt in which the author admires the fine technique and handling of light and shadow in the artist's "fraeje moderne gezelschapjes," which he feels are close to Metsu.[16] Hoet's collection of sale catalogues published in 1752 lists

twenty-two pictures by Ochtervelt,[17] but because of insufficient description only three of these can be identified with reasonable certainty today (cat. nrs. 14, 21, 72; Figs. 25, 29, 83). Terwesten's continuation of this work, published in 1770, mentions another eleven paintings, of which two can now be identified (cat. nrs. 20, 54; Figs. 27, 130).[18]

The earliest substantial evaluation of Ochtervelt's style was published in 1792 in Paris by the French connoisseur J. B. P. Lebrun in his *Galerie des Peintres Flamands, Hollandais et Allemands*. Praising Ochtervelt as "un des plus habiles artistes de son temps," Lebrun mentions the lack of written material on the artist and the fact that he is often confused with Van Mieris and Netscher. Indeed, the author states that Ochtervelt's paintings were often sold deliberately under these attributions in order to elevate the low prices (seven or eight florins) that they fetched under their rightful name. It is interesting that 18th-century collectors did not find Ochtervelt's works of greater value, especially as later critics were to admire the "rococo" qualities of his style. Even Lebrun, who wrote enthusiastically about Ochtervelt's colors, the beauty of his costumes, and the variety of his compositions, was anything but an expert on the artist's style. The "Ochtervelt" he chose to illustrate is actually by Pieter van Slingeland, while a genuine, signed Ochtervelt (cat. nr. 33; Fig. 61) is reproduced under a mistaken attribution to Eglon Hendrik van der Neer.[19]

During the first half of the 19th century, Ochtervelt was cited briefly by Brulliot,[20] Nagler,[21] and Immerzeel;[22] in 1857 Charles Blanc's *Le Trésor de la Curiosité* listed five paintings by Ochtervelt sold in France during the late 18th and early 19th centuries.[23] Not surprisingly, the most complete discussion of Ochtervelt by a 19th-century writer was the work of Etienne Thoré (writing under the pen name of W. Bürger). This perceptive French connoisseur, the first to recognize the importance of Vermeer, published his *Les Musées de la Hollande* in 1858 in which he described four paintings by Ochtervelt that he saw during his travels in the Netherlands (cat. nrs. 21, 36, 39, 41; Figs. 29, 40, 44-45, 123).[24] Thoré found Ochtervelt "un peu vulgaire dans ses types" and inferior to Metsu, whom he erroneously identified as Ochtervelt's teacher. He had great admiration, however, for the artist's fine technique and for his lively manner of treating faces. Perhaps because he saw only a few of Ochtervelt's paintings, his estimation is both enthusiastic and guarded: "Il est encore de ceux qui, parfois, touchent aux maîtres de premier rang."[25]

Kramm's dictionary of artists, published in Amsterdam in 1863, mentions Ochtervelt briefly,[26] while Woermann and Woltmann's general history of painting of 1877-88 includes Ochtervelt in a chapter on Rotterdam artists, citing eleven of his paintings and praising his color and handling of narrative.[27] In 1883-84 Obreen published six of the Ochtervelt documents, one of the most valuable additions to the literature on the artist.[28] On the whole, however, these 19th-century publications did little to increase or enhance Ochtervelt's reputation. It is significant that Hofstede de Groot did not devote a separate section to the artist in his mammoth catalogue of works by 17th-century Dutch painters (1907-28), but relegated him to paragraphs listing the followers of Metsu, De Hooch, and Ter Borch.[29]

In 1910 Wurzbach made the earliest attempt at a comprehensive list of Ochtervelt's paintings by compiling twenty-four works in European museums and private collections.[30] In the following year Mireur's *Dictionnaire des Ventes d'Art* listed eighteen sales in which paintings by Ochtervelt were auctioned.[31] By 1924, when Valentiner published his pioneering article on Ochtervelt in *Art in America*, he could list no more than thirty-five works by the artist.[32] Yet unlike his predecessors, Valentiner believed that Ochtervelt was one of the major Dutch painters of the late 17th century. His article was written in the hope of reviving interest in an artist who had been largely ignored in the

literature. Valentiner's sensitive analysis of Ochtervelt's color, composition, and treatment of figures makes his discussion one of the most useful publications on the artist to date. On the other hand, like subsequent writers, Valentiner believed that Ochtervelt lived into the 18th century, and he interpreted his style as one of direct "transition to the Rococo."[33] As stated previously, documentary evidence has now established that the artist's career ended in 1682.

By the time of Gerson's *Thieme-Becker* entry on Ochtervelt, written in 1931,[34] the artist's *oeuvre* had grown to thirty-seven paintings. Bénézit was able to list forty-five works in his *Dictionnaire des Peintres* of 1953.[35] Finally, the most extensive discussion of Ochtervelt's works is contained in Eduard Plietzsch's *Holländische and flämische Maler des XVII. Jahrhunderts* of 1960[36]—a slightly revised and expanded version of an earlier article that had appeared in *Pantheon* in 1937.[37] Originally Plietzsch had cited seventy-four paintings by Ochtervelt. His later publication includes specific references to eighty-two paintings and is invaluable for tracing dozens of works that had not been cited in earlier literature. Plietzsch expressed warm praise for many of Ochtervelt's paintings, but he tended to categorize the artist merely as an inferior follower of De Hooch, Metsu, and Ter Borch without attempting to define the originality of his style. Because he did not establish a chronology and because he included a number of faulty attributions in his study, he failed to give a clear view of the artist's development. As a result, Ochtervelt emerges in Plietzsch's discussion as an artist of extremely uneven quality: "Je besser seine Bilder sind, um so weniger sind sie für ihn typisch."[38] Plietzsch's careful research and compilation should not be underrated, but his estimation of Ochtervelt is contradicted by the large proportion of fine paintings that are, in fact, completely typical of the artist's style.

A fresh evaluation of Ochtervelt requires that all of the works attributed to him be examined carefully for both authenticity and dating. No drawings by the artist are presently known, so this study is necessarily restricted to paintings alone. But even in this case many problems arise, for like many painters who have not been thoroughly studied, Ochtervelt has had numerous pictures of uncertain authorship—and often of inferior quality—attributed to him. Paintings of questionable or rejected attribution are discussed in Part II of the Catalogue Raisonné, leaving an *oeuvre* of 106 works whose authenticity seems reasonably firm.

The primary objectives of this study are to provide as complete information as possible about individual paintings in the catalogue and, in the text, to establish a chronological framework for the artist's development and to explore the major influences on his style at each phase of his career. Ochtervelt's stylistic development and contributions as a genre painter are discussed in Chapter 1. In addition, two short chapters have been included in order to consider paintings whose specialized subjects can best be studied separately. Chapter 2 is devoted primarily to Ochtervelt's entrance hall scenes, a unique series of genre paintings in which figures appear in the foyers of their homes greeting street vendors or musicians at the door. Chapter 3 comprises Ochtervelt's twelve portraits, which follow a stylistic evolution independent of his genre paintings. Any method of organizing a body of material is somewhat arbitrary, but it is hoped that this arrangement will help to clarify Ochtervelt's development while illustrating the stylistic and thematic variety of his art.

Notes

1. S. J. Gudlaugsson, *Gerard Ter Borch*, 2 vols. (The Hague, 1959); and F. W. Robinson, *Gabriel Metsu (1629-1667): A Study of His Place in Dutch Genre Painting of the Golden Age* (New York, 1974). The most recent monograph on Vermeer is A. Blankert's *Johannes Vermeer* (Utrecht, 1975).

2. Gerard van Spaan, *Beschrijvinge der Stad Rotterdam* (Rotterdam, 1698); Donker edition (Antwerp, 1943), p. 116.

3. A. C. Kersbergen, *Zes Eeuwen Rotterdam* (Rotterdam, n.d.), p. 110.

4. A. J. Teychiné Stakenberg, *Rotterdam* (The Hague, 1958), p. 5.

5. The thirty-one Ochtervelt documents are reprinted in the Appendix in chronological order. For a complete discussion of the archival sources, see S. D. Kuretsky, "The Ochtervelt Documents," *Oud Holland* 87 (1973); 124-41. I am indebted to the editors of *Oud Holland* for permission to reprint the documents and to incorporate in the text portions of the information they contain. I would also like to express special thanks to Drs. R. A. D. Renting, J. C. Okkema, and Th. J. Poelstra of the Gemeentelijke Archiefdienst, Rotterdam, and to I. H. van Eeghen of the Gemeentelijke Archiefdienst, Amsterdam, for their great help in unearthing and interpreting the archival material in each city.

6. The distinction between Ochtervelt's family background and his professional milieu was certainly not unusual in the Netherlands in the 17th century (any more than it would be today). Yet it is interesting that the other major artists who painted similar "high life" genre themes were all the sons of skilled craftsmen or artists. De Hooch's father was a mason; Vermeer's father was a silk weaver who may also have been a picture dealer; the father of Frans van Mieris, the elder, was a goldsmith; both Ter Borch and Metsu were the sons of artists.

7. The date of the month of Ochtervelt's baptism is not clearly legible in the church records, but it has been interpreted by Drs. R. A. D. Renting of the Gemeentelijke Archiefdienst, Rotterdam, as a "1."

8. Arnold Houbraken, *De Groote Schouburgh der nederlantsche Konstschilders en Schilderessen* (Amsterdam), vol. 2 (1719), p. 35. On the question of Ochtervelt's and De Hooch's apprenticeships with Berchem, see R. E. Fleischer, "Ludolf de Jongh and the Early Work of Pieter de Hooch," *Oud Holland* 92 (1978); 49-67. Fleischer, noting stylistic similarities between the early works of Ochtervelt and De Hooch and the style of the older Rotterdam painter Ludolf de Jongh (1616-79), raises the possibility that Ochtervelt and De Hooch may have been apprenticed to De Jongh in their native city of Rotterdam rather than to Berchem in Haarlem. Alternatively, Fleischer suggests that the two younger painters came under De Jongh's influence shortly after their apprenticeship with Berchem.

9. For an idea of relative property values, it can be noted that Rembrandt's great house on the Joden Breestraat in Amsterdam had been sold in 1658 for a sum of 11,218 guilders (C. Hofstede de Groot, *Die Urkunden über Rembrandt* [The Hague, 1906], p. 236, nr. 187). This amount, according to Christopher White, was nearly 2,000 guilders less than Rembrandt had paid when he bought the property in 1639 (C. White, *Rembrandt and His World* [New York, 1966], p. 112.)

10. Information about Ochtervelt's house on the Keizersgracht was generously given to me by I. H. van Eeghen of the Gemeentelijke Archiefdienst, Amsterdam. Miss van Eeghen also brought to my attention the map of 1679 showing the location of Ochtervelt's house.

11. The reason for this lawsuit is not specified in the document, which simply authorizes a lawyer to act on behalf of the defendant. Possibly Dirkje was seeking funds to help her live without her husband's support. The importance of the document is that it identifies Dirkje, in 1682, as Ochtervelt's "widow." I am indebted to Lyckle de Vries for pointing out to me the summary of the document in the unpublished Bredius notes at the Rijksbureau voor Kunsthistorische Documentatie, The Hague. A search of the Amsterdam archives for that year brought to light the previously unknown date of Ochtervelt's death.

12. This document of 1710 citing the death of Ochtervelt's "widow" was first published by F. D. O. Obreen in 1883-84 (*Archief voor Kunstgeschiedenis* [Rotterdam], vol. 5, p. 321); since then it has served in the literature as a useful *terminus ante quem* for Ochtervelt's death date. Indeed, the artist was long thought to have lived at least until 1708, on the mistaken premise that his painting *The Toast* (cat. nr. 45; Fig. 51) is signed and dated 1708. MacLaren's revised reading of the date as 166(8?) accords perfectly with both the style of the costumes and of the painting itself (N. MacLaren, *National Gallery Catalogues: The Dutch School* [London, 1960], p. 277).

13. Drs. R. A. D. Renting has drawn this conclusion by comparison to sums paid at other burials during this period.

14. Van Spaan's *Beschrijvinge der Stad Rotterdam* was not published until 1698, sixteen years after Ochtervelt's death. Yet the author's list of Rotterdam artists (Donker edition [Antwerp, 1943], pp. 186-89) does include others who had died well before the book was published. Even though Ochtervelt had moved to Amsterdam by

1674, it is curious that Van Spaan did not note the fact that the artist had been active for nearly twenty years in Rotterdam.

15. See note 8.

16. J. van Gool, *De Nieuwe Schouburgh* (The Hague), vol. 2 (1751), p. 488.

17. G. Hoet, *Catalogus of Naamlyst van Schilderyen*, (The Hague, 1752); vol. 1, pp. 5-7, 9-10, 43, 45, 50, 246, 250, 285, 301, 333, 362, 417, 557; vol. 2, pp. 58, 161, 255, 306, 311.

18. P. Terwesten, *Catalogus of Naamlyst van Schilderyen* (The Hague, 1770), pp. 74, 79, 143, 146, 155, 332-33, 447, 532, 550, 577-78, 592.

19. J. B. P. Lebrun, *Galerie des Peintres Flamands, Hollandais, et Allemands*, vol. 2 (Paris, 1792). The print after Ochtervelt (attributed to Van der Neer) is on p. 90. Ochtervelt's biography and the print after Van Slingeland (attributed to Ochtervelt) appear on p. 87. This painting is now in the Henle Collection in Duisburg, West Germany. For illustration, see *Die Sammlung Henle aus dem grossen Jahrhundert der niederländischen Malerei* (Cologne; Wallraf-Richartz-Museum, 1964), nr. 37.

20. F. Brulliot, *Dictionnaire des Monogrammes, Marques figurées, Lettres initiales, Noms abrégées, etc.*, vol. 2 (Munich, 1834), pp. 75, 627.

21. G. K. Nagler, *Allgemeines Künstler-lexikon* (Leipzig), vol. 10 (1841), p. 301; vol. 19 (1849), p. 188.

22. J. Immerzeel, *De Levens en Werken der Hollandsche en Vlaamsche Kunstschilders, Beeldhouwers, Graveurs en Bouwmeesters*, vol. 2 (Amsterdam, 1842), p. 149.

23. C. Blanc, *Le Trésor de la Curiosité*, vol. 1 (Paris, 1857), p. 404; vol. 2 (1858), pp. 116, 135, 187, 404, 434.

24. E. J. T. Thoré (writing under the pen name of W. Bürger), *Les Musées de la Holland* (Paris, 1858); vol. 1, p. 251; vol. 2, pp. 249-50.

25. Ibid., vol. 2, p. 250.

26. C. Kramm, *De Levens en Werken der Hollandsche en Vlaamsche Kunstschilders, Beeldhouwers, Graveurs en Bouwmeesters* (Amsterdam), vol. 6 (1863), p. 1653.

27. K. Woermann and A. Woltmann, *Geschichte der Malerei* (Leipzig), vol. 3, pt. 2 (1888), p. 840.

28. F. D. O. Obreen, *Archief voor Kunstgeschiedenis* (Rotterdam), vol. 5 (1883-84), pp. 316-22.

29. C. Hofstede de Groot, *Beschreibendes und kritisches Verzeichnis der Werke der hervorragendsten holländischen Maler des XVII. Jahrhunderts* (Esslingen a N), vol. 1 (1907), pp. 336, 571; vol. 5 (1912), pp. 149, fn. 2, 151; vol. 9 (1926), p. 289.

30. A. von Wurzbach, *Niederländisches Künstler-lexikon* (Vienna and Leipzig, 1910), vol. 2, p. 249.

31. H. Mireur, *Dictionnaire des Ventes d'Art* (Paris), vol. 3 (1911), p. 482; vol. 5 (1912), pp. 413-14.

32. W. R. Valentiner, "Jacob Ochtervelt," *Art in America* vol. 12 (1924); 269-84.

33. See note 12.

34. H. Gerson, "Jacob Ochtervelt," in U. Thieme and F. Becker's *Allgemeines Lexikon der bildenden Künstler* (Leipzig) vol. 25 (1931), p. 556.

35. E. Bénézit, *Dictionnaire des Peintres, Sculpteurs, Dessinateurs et Graveurs* (Paris, 1953), vol. 6, pp. 404-05.

36. E. Plietzsch, *Holländische und flämische Maler des XVII. Jahrhunderts* (Leipzig, 1960), pp. 64-68.

37. E. Plietzsch, "Jacob Ochtervelt," *Pantheon* vol. 20 (1937); 364-72.

38. Plietzsch (1960), op. cit., p. 67.

Ochtervelt's Development as a Genre Painter

Italianate Influences: Circa 1648 to Circa 1660

As an apprentice of Nicolaes Berchem, Ochtervelt would have begun his artistic training in a tradition of Dutch Italianate painting that had been established during the second decade of the 17th century and that was to remain popular until well into the 18th century. Both Ochtervelt and his fellow student Pieter de Hooch must have received an up-to-date introduction to their master's specialty, since Berchem had traveled to Rome with Jan Baptiste Weenix in 1642 and had remained in Italy until 1645.[1] The paintings he created after his return to the Netherlands were still permeated with his direct experience of the Roman *campagna*.

Berchem's style, at the time Ochtervelt became his student, can be characterized by works such as his *Pastoral Landscape*, dated 1649 (Fig. 2), in the Toledo Museum of Art, which is a colorful, richly painted shepherd scene of figures and animals bathed in the clear Italian light against a dramatic background of mountains and sky. This approach to painting, however, with its emphasis on the idyllic and the picturesque, apparently suited neither of his young apprentices. Both went on to become specialists in a purely Dutch category of painting: the contemporary domestic interior.

Although none of De Hooch's paintings, not even his earliest works, reveal any noticeable debt to Nicolaes Berchem,[2] Ochtervelt's early style develops under strong Italianate influences. Berchem and Jan Baptiste Weenix seem to have been the principal sources for Ochtervelt's rare early landscapes with figures (cat. 1-4; Figs. 3, 5, 8, 10). His early garden scenes and interiors (cat. 5-11; Figs. 11, 14, 16, 18, 19, 22, 23) show stylistic connections to Weenix, Karel Dujardin, and, perhaps most of all, to the genre paintings of the Utrecht Caravaggisti. As a group, these Italianate scenes are quite different in style from Ochtervelt's later, more characteristic paintings of the 1660's and 1670's.[3] Indeed, the landscapes have so little in common with his *oeuvre* as a whole that if it were not for their signatures they might never have been attributed to him at all.

10

A precise chronology of Ochtervelt's early years is difficult to establish, for there is only one dated work of the 1650's: *Hunters and Shepherds in a Landscape* of 1652 (cat. 3; Fig. 8 in the Städtische Museen, Karl-Marx-Stadt, East Germany). This example may be taken as a documented point of departure for an analysis of the first decade of the artist's career. The subject of the painting, a common choice of Dutch Italianate artists, is that of a richly dressed hunting party pausing among a group of shepherds in a mountainous landscape. At the left is a hunter carrying a gun and trailed by two hounds; a mounted horseman at the right gestures into the distance as if indicating the direction of the chase. Meanwhile, an elegant young woman wearing a pale blue satin dress trimmed with gold has dismounted and reaches into her purse to offer coins to the ragged shepherd children. The younger child, wrapped in an animal skin, holds out his begging plate, while an older boy plays his pipe. A barefoot shepherdess is seated at the lower right.

Unlike Berchem, Ochtervelt does not evoke the idyllic pleasures of pastoral life. Instead, he makes the viewer aware of the contrast between the poverty of the shepherds and the careless ease of the aristocratic hunters who use the countryside for sport—rather than as a meager source of livelihood. Even in this early work, the figures act as the primary focus of the scene, while the setting functions only as a rather timidly defined backdrop. Indeed, the juxtaposition of these barren, undifferentiated cliffs and hills and the more solidly developed figures suggests that Ochtervelt had little inclination or aptitude for landscape painting.

Nonetheless, the overall composition of the painting owes much to Berchem (Fig. 2) in its diagonal arrangement of figures and animals in a foreground wedge, balanced by a panoramic vista at the left. A similar schema also appears frequently in the works of Jan Baptiste Weenix, such as his undated *Erminia with the Shepherds* (Fig. 9), in the Schloss Grünewald, Berlin. Although Weenix's subject has a literary source (Torquato Tasso's *Gerusalemme Liberata*), his representation of a young woman, dismounted and conversing with shepherds, is not unlike Ochtervelt's genre scene.[4] The comparison, however, demonstrates more explicitly Ochtervelt's divergence from the tenets of Italianate landscape painting. Weenix's fully developed setting contributes as much to the mood of his painting as his figures do, and, like Berchem, he captures the soft, pervasive effects of natural outdoor light. By contrast, Ochtervelt's landscape is extremely simplified and his lighting appears inconsistent with an outdoor setting. The arbitrary spotlighting of the standing woman, surrounded by partially shadowed figures, heightens the dramatic expression of the scene by isolating the figures rather than fusing them with their surroundings. The result is an almost theatrical tableau—an effect that will also be seen in Ochtervelt's later interior scenes.

Despite its early date, *Hunters and Shepherds* of 1652 is probably not Ochtervelt's earliest known work. The signed but undated *Granida and Daifilo* (cat. nr. 1; Fig. 3; present location unknown), seems far more rigidly composed and more tightly painted. These figures are stiffer and less physically substantial; trees and foliage have a literal, artificial quality suggesting the conscientious overelaboration of a beginner. This work was probably painted shortly before 1650, the time when Ochtervelt was beginning his study with Berchem. With its stiff, almost primitive style, it seems rather like a practice piece that a student might be asked to work up in order to familiarize himself with all the elements necessary to the creation of pastoral landscape painting. Certainly no subject could be a more appropriate assignment for a young apprentice. Pieter Cornelisz. Hooft's play, *Granida*, the first pastoral drama written in Dutch, was immensely popular both as a vehicle for the stage and as a thematic source for painters.[5]

Ochtervelt has depicted the pivotal scene from Act I, in which the lovers meet for the first time. Granida, daughter of the king of Persia, has lost her way while hunting and encounters the shepherd Daifilo, who offers her water in a shell. The shepherdess Dorilea appears in the right background guarding the flock. Gudlaugsson has rightly drawn attention to the striking similarity between Ochtervelt's composition and Ludolf de Jongh's *Granida and Daifilo*, dated 1654[6] (Fig. 4), in Osnabrück. The exact relationship between the two works is problematic, for the Ochtervelt would appear to be the earlier in date and yet would seem an unlikely source for a mature master like De Jongh. Perhaps both artists were inspired by another print or painting of the subject. Indeed, Ochtervelt may even have copied such a prototype for practice, which would account for the labored, unspontaneous style of the painting.

Ochtervelt's third early landscape with figures is the signed *Hunting Party at Rest* (cat. nr. 2; Fig. 5), formerly in the Van der Meulen Collection, which can also be dated about 1650. Although the artist's rather tight rendering of animals and figures is not far from the style of his *Granida and Daifilo*, the composition of this work seems looser and more complex, while the treatment of foliage is far more natural and convincing. Probably it was painted shortly after *Granida and Daifilo*, but before *Hunters and Shepherds* of 1652, in which the figures seem more fluidly painted. It is difficult, however, to set these earliest works in exact chronological order, for they do not have strong stylistic affinities to one another. As a group, they seem to reflect the inconsistencies of a young artist who has not yet found his most natural mode of expression.

Close parallels to Ochtervelt's treatment of the subject may be found, once again, in the works of Jan Baptiste Weenix and Ludolf de Jongh. Weenix's *Hunting Party at Rest* (Fig. 6), dated 1652, in the London art trade in 1947, includes a similar grouping with a mounted figure blowing a hunting horn and a pack of dogs at the edge of a deep forest. Ochtervelt must have known such early landscapes by Weenix, for aside from the obvious thematic and compositional similarities, he has apparently derived his treatment of foliage from the older artist. Instead of the thin, nonorganic trees of the earlier *Granida and Daifilo*, Ochtervelt now uses a more richly varied pattern of foliage— lighted in the foreground and silhouetted in spiky clumps against the sky. The same approach is found in hunting scenes by De Jongh, whose landscape style can be confusingly close to that of the early Weenix. Indeed, De Jongh's signed but undated *Hunting Party at Rest* (Fig. 7), in the New York art trade in 1920, is even closer in format and composition to Ochtervelt's painting. It would therefore appear that Ochtervelt was influenced by landscapes of both artists that he saw during the early 1650s.

If *Hunters and Shepherds* of 1652 (cat. nr. 3; Fig. 8) is indeed the latest of the three landscapes just discussed, one may conclude that Ochtervelt's early style developed rapidly toward a greater concentration on figures, with a diminishing emphasis upon their surroundings. A signed harbor scene, *The Embarkation* (cat. nr. 4; Fig. 10), formerly in the Matsvanszky Collection, Vienna, continues this trend. Here again, the artist has chosen one of the most common themes in Dutch Italianate landscape painting, but he has reinterpreted it by radically simplifying the setting. Instead of evoking the vivid, picturesque atmosphere of a foreign port with its crowds of travelers and ships, Ochtervelt selectively focuses upon the attitudes and actions of only a few figures: a seated woman and two men relaxing beside a fragment of a Roman building and watching a pair of workmen lifting bales of goods from the pier. As in *Hunters and Shepherds*, which probably dates a year or two earlier than this painting, the artist has set up a contrast between two types or classes of people: here,

the elegantly dressed trio of conversing onlookers and the half-naked workmen laboring over their heavy loads.

With *The Embarkation* one can begin to see the emergence of a coherent early Ochtervelt style. These sturdily proportioned figures, whose solidity is emphasized by the play of light and shadow, appear again in *Musical Trio in a Garden* (cat. nr. 5; Fig. 11), in Braunschweig, and also in a similar garden scene with musicians now in the Amsterdam art trade, *Musical Company in a Garden* (cat. nr. 6; Fig. 14). The Braunschweig painting (significantly, once attributed to Weenix) is actually a compositional variant, in reverse, of the left side of Ochtervelt's harbor scene. Italianate influences obviously continued to be an important factor in Ochtervelt's style of the mid-1650's, but it is now genre painting, rather than landscape, to which he turns for inspiration. The full-length Roman genre scenes of Dujardin (Fig. 12) and Weenix are similar to these garden paintings in their use of outdoor settings with antique architectural motifs and in their powerful, almost sculptural modeling of the figures. This dramatic contrast of light and shadow is handled so effectively in the Amsterdam garden scene that the maidservant, lifting a platter of food, seems almost like an animated sculpture herself. Ochtervelt may even have made a visual pun on this figure by placing a little marble putto, holding a shell above his head, immediately to the left of the maid.

Both the lighting and musical subject matter of these early works suggest that Ochtervelt must also have been strongly aware of the Utrecht followers of Caravaggio, who painted similar types of figures (usually in half-length) wearing rich, theatrical costumes. The musician in Dirck van Baburen's *Procuress* of 1622 (Fig. 13), in the Boston Museum of Fine Arts, is clearly a close relative of the lutenist in the *Musical Trio* in Braunschweig. It is interesting to note that Ochtervelt's development, in this respect, closely parallels that of his great contemporary, Vermeer. During the 1650's Vermeer, too, passed through an early Caravaggesque phase, as a prelude to his later concentration on patrician interior scenes.[7] Like Ochtervelt's *Musical Company in a Garden* in Amsterdam, Vermeer's *Diana and Her Nymphs* (about 1654), in the Mauritshuis, is also a full-length composition with statuesque figures grouped in an outdoor setting, but it is illuminated by an arbitrary spotlight that allows parts of the composition to submerge in soft, deep shadow. Both artists, at this early stage in their careers, apply the paint in a heavier and more pasty texture than either of them will use in their later works. Ochtervelt's palette, with its emphasis on yellow, brown, mustard, and red, is also very similar to Vermeer's coloring.[8] An earlier owner of the work must have been struck by these affinities, for there is a false Vermeer monogram on the base of the pilaster at the right.

Ochtervelt's two outdoor garden scenes seem to form a transition between the early landscapes and the genre interiors, which now become his major interest. His development as a specialist in interior subjects must have begun in Rotterdam, where his presence is documented by 1655.[9] A *Merry Company with Violinist* (cat. nr. 7; Fig. 16), in the Chrysler Collection, probably Ochtervelt's earliest interior, can be dated about 1655, for there is reason to believe that it is the pendant to the Amsterdam garden scene (cat. nr. 6; Fig. 14).[10] The same figure types and Caravaggesque lighting appear in both works. The violinist, indeed, is almost a replica of the standing musician in the Braunschweig garden painting (cat. nr. 5; Fig. 11). Like Ochtervelt's other early depictions of figures around a table (cat. nrs. 9–11; Figs. 19, 22, 23), the *Merry Company* is presented with a minimum of detail: a stool and cushion in the foreground, a table covered with a simple cloth, the back of a chair, and a completely bare floor and background wall. Despite its festive and lively atmosphere, the scene

in fact has little dramatic unity. The large central figure of the violinist both dominates and divides the composition, separating the lovers at the left from the servant offering oysters to an amorous couple at the right. Thus the painting gives the impression of having been constructed in parts—as a series of compatible but basically distinct incidents.

A far more unified and therefore perhaps slightly later work is the signed *Cardplayers* (cat. nr. 9; Fig. 19), in the collection of De Roij van Zuydewijn, Amsterdam, in which the simplicity of the setting is paralleled by that of the figures themselves, who wear plain, unadorned costumes in quiet shades of tan, gray, and lavender. The appealing immediacy of these broadly modeled faces, concentrating upon the game, and the spotlighting of the large hands holding the cards, gives the scene a narrative focus and intensity unlike any of Ochtervelt's earlier works.

The theme of women and soldiers or cavaliers gathered around a table in an interior, also seen in cat. nr. 10; Fig. 22, was first developed during the 1620's and 1630's by a group of Dutch specialists in barrack-room scenes such as Willem Duyster and Pieter Codde of Amsterdam and Anthonie Palamedesz. of Delft.[11] Ochtervelt may well have known paintings by members of this group, who also worked in subdued colors, presenting full-length figures in a muted half-light, often against plain background walls. Certainly the achievements of these painters of soldiers had a strong influence on the generation that followed them. Ochtervelt's fellow apprentice, Pieter de Hooch, left Berchem's studio to become, in the early 1650's, a painter of *corps du garde* scenes, such as his *Tric-trac Players* of about 1653[12] (Fig. 20), in the National Gallery of Ireland, Dublin. Ochtervelt must have known De Hooch's works of this period because of their personal acquaintance as students. Furthermore, De Hooch, who had also been born in Rotterdam, was in that city again in 1654 before his move to Delft.[13] And yet the artistic relationship between Ochtervelt and De Hooch during the 1650's seems to be one of parallel rather than specific influence. Although the two may have chosen similar themes, their styles have virtually nothing in common. De Hooch's chiaroscuro serves to merge his figures with their surrounding space; he seems more concerned with evoking a total milieu than with defining the individual participants. Ochtervelt, on the other hand, uses contrasts of light and shadow to silhouette his group against the plain wall behind them and to give each figure an individual sculptural weight and a separate presence. The strong Italianate bias of Ochtervelt's early style is never more obvious than when he is compared to De Hooch.

In its direct concentration upon the figures, Ochtervelt's *Card Players* has much in common with the early Ter Borch, another artist who began in the *corps du garde* tradition. Ter Borch's *Card Players* of about 1649[14] (Fig. 21), in the Reinhart Collection, Winterthur, employs a half-length format with more refined figure types than Ochtervelt's. Yet the interpretation of the scene, with a male onlooker helping the young lady choose her cards, is the same. Indeed, it is difficult to imagine that the female figure could have been painted without the inspiration of Ter Borch; the same tender image of a woman shown from the back so that the light emphasizes the graceful curves of her bared neck and shoulders is a characteristic motif in a number of Ter Borch's paintings.[15]

Probably the latest, and one of the finest, of Ochtervelt's early interiors is *The Feast* (cat. nr. 11; Fig. 23), in Prague, which can be dated shortly before 1660. Like *Card Players*, this work has narrative focus and coherence, but the figures now appear in a somewhat more specific environment, rather than in a bare set. One is reminded here of the full-length soldier scenes by Gerbrand van den Eeckhout painted in Amsterdam during the early 1650's in which figures, wearing similar costumes, appear in simply furnished tavern interiors.[16] In Ochtervelt's painting in Prague, a small map hangs

on the wall at the left, there is a doorway at the right, and the table is covered by a starched white cloth with a silver platter of meat. Light, falling in a diagonal stream from the upper left, is now used not only to model the figures but also to set up a subtle psychological contrast between the two soldiers. The lively drinker at the right, raising his glass to the maid, faces directly into the light. His companion at the left, who has fallen into a drunken stupor, is turned away from it so that his limp hands and unconscious face are cast into partial shadow. Reinforcing the contrast between these figures, the maid between them extends a glass toward the drinker while pointing an empty hand toward the victim of overindulgence. This concentrated interaction among the figures, largely a function of the artist's controlled and highly selective manipulation of light, emerges clearly for the first time at the end of the 1650's and becomes, in the following decade, one of the most distinctive features of Ochtervelt's style.

Ochtervelt's known early works, if few in number, suggest that from the very beginning the artist's natural inclination was toward the painting of figures. Even when working within the thematic framework of Italianate landscape, Ochtervelt, as we have seen, invariably makes the human incident count for more than the context in which it is set; not even his earliest figures can be classified as *staffage*. His early interiors, which evolve in a logical progression from these first outdoor scenes, already indicate the basic orientation of his mature work. During the 1660's Ochtervelt was to make a specialty of the same themes of gaming, music making, feasting, and drinking in a series of increasingly elegant interiors in which the Italianate influences diminish as the artist becomes part of the mainstream of Dutch "high life" genre painting.

Dutch Interiors: Circa 1660 to Circa 1670

If the Prague *Feast* (cat. nr. 11; Fig. 23) can indeed be dated about 1658-60, as was previously suggested, Ochtervelt's style of the early 1660's is represented by several tavern scenes (cat. nrs. 14, 15, 20; Figs. 25-27) that closely resemble *The Feast* in subject and style but seem slightly later in date. In these works the artist has reduced the size of the figures in relationship to the picture space while developing more complex and specific surroundings than the bare, stagelike backdrops seen in his early interiors. A close concentration on the figures, however, is maintained—and even intensified— by highlighting them strongly within the deeply shadowed space of the interior. As a group, these paintings also reveal that, by the beginning of the decade, Ochtervelt had begun to look closely at endemic Dutch developments in contemporary genre painting. No artist was more important to him during this period than Frans van Mieris, the elder, an almost exact contemporary (1635-81) who worked all his life in Leiden, where he had a large workshop. Indeed, the source for Ochtervelt's tavern interiors can clearly be traced to similar subjects by Van Mieris painted during the late 1650's, such as his *Soldier and Maid*, dated 1658 (Fig. 24), in the Mauritshuis.

Exactly the same figure types, similar costumes, and relationship of figures to space are found in two lively inn scenes by Ochtervelt (cat. nrs. 14, 15; Figs. 25, 26), probably painted as pendants, in the Assheton Bennett Collection, Manchester. In *The Embracing Cavalier* (cat. nr. 14; Fig. 25), a drunken sleeper in the background (as in Van Mieris's painting) serves as a foil to the vivacious merrymakers in the foreground. A grinning maid wearing a rakishly low bodice[17] offers a tankard to the seated soldier, who leans back to kiss the smiling girl behind him. A wicker cage of lovebirds hanging from the ceiling reinforces the erotic emphasis of the scene,[18] while a broken pipe on the

floor suggests yet another indulgence for the senses. Van Mieris, whose symbolism is always more overt than Ochtervelt's, makes the same point by placing a pair of copulating dogs behind the figures.

Ochtervelt's new interest in developing a specific milieu for his figures becomes even more obvious in *The Sleeping Soldier* (cat. nr. 15, Fig. 26), in which the darkened tavern interior opens, at the left background, into a flight of stairs leading up to a room filled with brilliant sunlight. It is difficult to point to a prototype for this extraordinary view. Pieter de Hooch himself never attempted such a daring juxtaposition of rooms on such different levels, although his interiors of the late 1650's showing successive, differently lighted spaces may have influenced Ochtervelt's conception. The fact that Ochtervelt's *Family Portrait* in the Fogg Art Museum, Cambridge, Massachusetts, (cat. nr. 18; Fig. 150), of approximately the same date (1663), also includes a view through an open door to a lighted room beyond suggests that De Hooch's style was of more than random significance to him during this period.[19]

In *The Sleeping Soldier* Ochtervelt depicts a silent moment just before a raucous and noisy reaction. The mischievous maid in the foreground tickles the nose of the unconscious soldier with a feather, while his comrade raises a bugle to his lips and prepares to blast him into wakefulness.[20] A maid on the stairs pauses to watch the results. The very atmosphere of this quiet room seems to quiver with expectation, for in the next instant the sleeper will leap to his feet with a shout of amazement, and the dozing spaniel at his feet will bound away howling. This humorously drawn contrast between the quiet moment actually seen and a violent conclusion left to the imagination reveals a marked development and enrichment of Ochtervelt's narrative powers, in comparison to his more simplified tableaux of the 1650's.

A third painting in Manchester (City Art Gallery), *Violinist and Two Maids* (cat. nr. 20; Fig. 27), reveals the continuing influence of Van Mieris—not only in the figure types but specifically in the treatment of the lighted strip of wall at the left. Although Ochtervelt shows slightly different objects hanging against the wall, this portion of his composition seems to have been directly inspired by Van Mieris's *Soldier and Maid* (Fig. 24). Despite the close affinities between the two artists, however, their styles are not identical. Van Mieris's scene appears in almost full daylight, in contrast to the delicate modulations of half-light and shadow that pervade Ochtervelt's interior. For Van Mieris, light serves to emphasize the crisp, finely painted details and sharp colors of material textures. For Ochtervelt—no less fine a painter—details seem less insistent and colors are slightly muted by an almost tangible veil of shadow. A more concentrated narrative is created by focusing light primarily on the figures' faces and hands and by allowing their postures to emerge from partial shadow.

In this context the word "posture," rather than "pose," seems more appropriate, for during the early 1660's Ochtervelt begins to use a notably original approach to composition based upon a pronounced angular positioning of the figures, individually and in relationship to one another. As a result, heads and faces are often seen in unusual, oblique views, and the design takes on a lightness and rhythm unlike the more stable, sculptural arrangements of the artist's early years. This manner of composing, which becomes perhaps the most recognizable characteristic of Ochtervelt's mature style, also distinguishes him from Van Mieris, whose more detailed, less angular designs are usually developed within a solid grid of perpendiculars.

As Ochtervelt continues to explore these new principles of composition, many of his paintings begin to center upon the theme of flirtation and love, emphasizing a more direct relationship

between individual male and female. In two paintings of oyster eaters (cat. nrs. 21 and 23; Figs. 29 and 33), dating shortly before 1665, the aphrodisiacal properties of the feast are discreetly implied by the sense of emotional interaction between the two figures.[21] Thus, in the *Oyster Meal* (cat. nr. 21; Fig. 29), in the Thyssen Collection, Lugano, the musician gazes longingly at his attractive companion, as the maid reaches between the couple to offer a platter of moist, shining oysters. A second Oyster Meal (cat. nr. 23; Fig. 33; private collection, England) depicts the man and woman alone within a deeply shadowed interior, in the background of which can be seen, significantly, a birdcage and a balcony with tumbled bedsheets. The relationship between the figures, however, is handled with great subtlety, largely because of the artist's masterful, indeed daring, use of chiaroscuro. Light falls directly upon the rich red velvet and blue satin of the woman's costume, highlighting her profile against the dark background, but her suitor is cast into deep shadow, which gradually decreases in intensity toward his lighted hand extending the tray of oysters. Like the Lugano *Oyster Meal*, this composition is constructed of slanting diagonals, which give the scene a lively immediacy, despite its quiet mood.

A more pungent comment on the vicissitudes of love can be found in two pendant paintings of about 1665: *The Gallant Drinker* (cat. nr. 26; Fig. 34), formerly in the collection of Sir Robert Bird, and *The Doctor's Visit* (cat. nr. 27; Fig. 35), in the Assheton Bennett Collection, Manchester. Ochtervelt's amorous themes rarely convey an obvious moral message. Yet the juxtaposition of these scenes was surely intended to suggest the idea of cause and effect. In the tavern scene a buxom, smiling girl with a suggestively loosened bodice offers a carafe of wine to a boisterous soldier. In the pendant the wine carafe is replaced by a flask of urine, held up by a doctor attending a languishing female patient. The slight smile on the sick girl's face indicates that the patient herself is aware of the futility of medical treatment, for she suffers from *febris amatoria*, a malady no physician can cure. Although Ochtervelt excludes the specific symbolic accoutrements often found in depictions of lovesickness,[22] his interpretation certainly relates to the many 17th-century examples of the subject, found both in painting and in emblem illustration (Fig. 36).

The related, but much rarer, theme of the fainting woman appears in *The Faint* (cat. nr. 28, Fig. 38), in Leipzig, in which the same costume seen in the Bennett interior is repeated. Although formerly attributed to Metsu, the Leipzig *Faint*, once again, is closest in style and subject to Van Mieris, whose painting of the same subject (Fig. 39), dated 1667, includes a reverse variant of the unconscious woman, as well as the same motif of the weeping child. Since the Ochtervelt was probably painted about 1665, it may have been based upon an earlier version of the theme by Van Mieris. Or perhaps, in this instance, Van Mieris was the borrower. In any case, the interpretations of the two artists are quite different, for Ochtervelt has depicted the situation before the doctor's arrival, thus emphasizing the psychological reactions of the immediate household, rather than the farcical humor commonly found in scenes of doctors' visits. Nor does his painting include any clear allusion to the idea of lovesickness. The Van Mieris interior, however, has a painted overmantle of a nocturnal mythological scene: Diana with the sleeping Endymion. Despite the reversal of sexual roles, the idea of unconsciousness and victimization through love obviously parallels the event in the foreground.[23]

The close relationship between Ochtervelt and Van Mieris continues into the latter half of the 1660's with equal force. Ochtervelt's dated *Oyster Meal* of 1667 (cat. nr. 36; Fig. 40), in the Boymans Museum, Rotterdam, may have been directly inspired by a Van Mieris of the same subject (Fig. 41),

dated 1661, formerly in the Alte Pinakothek, Munich. Both works employ the same three-quarter-length format, similar costumes and figure types, and include a tapestry covered table with a white ceramic pitcher. In the Ochtervelt the seated woman, seen from the back and in profile, raises her glass to her companion, who politely offers her an oyster from a silver tray. The playful interaction of this couple, joined by the diagonal of their extended arms, is quite different in spirit from the more lecherous relationship implied in Van Mieris's painting. Here the woman's breasts are exposed by her low décolletage, and she offers an oyster to an openly leering suitor: a large curtained bed appears in the background.

As a dated work, the Rotterdam *Oyster Meal* forms an important point of reference for establishing Ochtervelt's chronology of the late 1660's.[24] Around it may be grouped a series of five undated interior scenes (cat. nrs. 37–40, 42; Figs. 42–46, 48) in which variations of the same female figure have been repeated. Ochtervelt's approach to composition, as already indicated in several paintings of the 1650's (cat. nrs. 4, 5, 7; Figs. 10, 11, 16), often allows for close variations upon a single figure or motif, for he seems to work like a stage director, using a common set of *dramatis personae* at each phase of his career. Even when he repeats the same motif, however, he avoids the monotony of literal copying by making changes in its placement and narrative context. Thus, it is not possible to state with certainty which work was the first in this series of about 1667, especially as the artist has used a variety of compositional formats. Probably the latest in the group is Ochtervelt's fine, full-length *Tric-trac Players* (cat. nr. 42; Fig. 48), in the Bührle Collection, Zurich, for the figures are strikingly similar to the couple depicted in *The Gallant Man* dated 1669 (cat. nr. 53; Fig. 53), in Dresden.

Aside from the Rotterdam *Oyster Meal* of 1667, a number of dated interior scenes help to clarify Ochtervelt's development at the end of the decade. Two works dated 1668 (cat. nrs. 45, 46; Figs. 51, 52), as well as two dated in the following year (cat. nrs. 53, 57; Figs. 53, 55), indicate that the paintings of this period constitute the most elegantly refined expression of Ochtervelt's style. In comparison to the artist's works of the early and mid-1660's, these figure types have become more slender and elongated (like the shapes of the canvases themselves), diagonal figure groupings are accentuated, and there is an increasing emphasis upon the material opulence of shimmering satins embroidered with gold and silver.

In *The Toast* (cat. nr. 45; Fig. 51), in Capetown, for example, which is signed and dated 166(8?),[25] the composition is a tall triangle in which the repeating diagonals of the seated man and woman are lightly balanced by the counterdirection of the floor tiles, the dog, and the man's raised arm with its tall glass. The graceful structure of this lively composition, combined with the rich textures of the costumes, gives the scene an almost rococo elegance. It is not difficult to understand, on the basis of this work alone, why Ochtervelt's career was long thought to extend into the 18th century. The same qualities are found in two music scenes of the period: *Musician with Tric-trac Players* (cat. nr. 44; Fig. 50), in Cologne, which includes the same costume seen in *The Toast*, and *Violin Practice*, dated 1668 (cat. nr. 46; Fig. 52), in Copenhagen. In both works light is selectively focused upon the seated woman in the foreground, whose pink satin skirt forms a brilliant splash of color against the shadowed background. The subject of the Copenhagen painting is new, for instead of the concert or music lesson, we see a woman practicing privately in her boudoir, while her maid works unobtrusively in the background and her young daughter quietly plays with a book at the left. Here, for the first time, Ochtervelt presents a scene exclusively devoted to the activities of women, without the participation of men—a theme to which he will return frequently in the 1670's (cat. nrs. 73–80; Figs. 84, 86–91, 93).

The Gallant Man dated 1669 (cat. nr. 53; Fig. 53), in Dresden, incorporates basically the same lighting and figure types used in other works of the late 1660's, but a second dated work from the same year displays a different type of illumination and treatment of space, suggesting direct influences of the Delft School, which become perceptible in a number of Ochtervelt's later paintings. In *The Dancing Dog* (cat. nr. 57; Fig. 55), in Hartford, Ochtervelt's usual method of lighting is reversed, so that the foreground is cast into deep shadow and the background is strongly illuminated, a device commonly used in Vermeer's interiors (Fig. 56), in combination with similar, diagonally tiled floors. In the Hartford painting, a male violinist is seated in the shadowed foreground, while a standing woman appears behind him against the brightly lighted wall, as if on a spotlighted stage. As the lady encourages a spaniel to dance on his hind legs, the musician humorously accompanies the "performance" with a tune on his violin. Since the violinist is placed exactly at the transition between the shadow and the light, only the silhouettes of his head and the instrument are projected against the pale wall beyond; a few subtle highlights define the inner contours of his face, the position of his limbs, and the active fingers manipulating the violin and bow. This dark area at the left is balanced at the right by a De Hooch-like open doorway leading to a shadowed back room with a maid at work—an arrangement that not only helps to frame the lighted dance in the center but also reinforces the diagonal orientation of the composition from the near left to the far right.

Another version of *The Dancing Dog* of the same period (cat. nr. 56; Fig. 54; private collection, England), includes the same tiled floor and a narrower view through an open door at the left. But in this scene Ochtervelt returns to his usual foreground lighting. The energetic poses of the figures and the overturned chair create an almost boisterous mood (unusual for a work of this period), in comparison to the more restrained interpretation in Hartford. The subject, in both cases, may have been intended to convey a moral message. In emblem literature the theme of a young lady who lures her pet to dance on his hind legs illustrates the idea of easy amorous conquest: the enticements of sinful woman.[26] Indeed, in the Hartford painting, one of the few works by Ochtervelt with a clearly moralizing intent, this message is made explicit by the inclusion of a painted frieze on the map behind the figures. Three scenes from Genesis, in which man's loss of innocence and downfall are brought about by the moral weakness and powerful allure of woman, illustrate the biblical counterparts to the modern Adam and Eve in the foreground.[27] In addition, De Jongh has suggested that the placement of the map behind the woman's head relates to the traditional "Lady World" image of a female figure with a globe on her head, symbolizing lust and vice.[28] Despite these allegorical allusions, however, the mood of the scene is not overtly didactic. Since the figures are refined in both appearance and behavior, the painting should be read primarily as a genre piece, but with a reticent comment on contemporary morals.

Two music scenes that can be dated at the very end of the decade (cat. nrs. 58 and 59; Figs. 57 and 58) suggest that Ter Borch's style was also of interest to Ochtervelt during this period. The delicate, minute handling of fine satins—almost a hallmark of Ter Borch's style—had appeared in earlier works by Ochtervelt, but in these paintings the erect, slender forms of the standing women seem specifically reminiscent of similar Ter Borchian motifs (Fig. 59). In *The Singing Practice* (cat. nr. 58; Fig. 57), in Kassel, light shimmers over the brilliant satin dresses of the two musicians; the woman in white standing at the virginals accompanies the seated singer beside her, who wears a red satin skirt and a blue satin jacket. The implication of specific psychological communication between the figures also recalls Ter Borch. As the two women turn toward each other, totally absorbed in their duet, the viewer can sense the warmth of an emotional contact that unites them in the harmony of

their music and removes them, psychologically as well as physically, from the two lovers in the background. A similar sensitivity is evident in *The Serenade* (cat. nr. 59; Fig. 58; present location unknown), in which the standing woman, seen from the back, glances down toward the left, entranced with the nimble fingers of a musician, who gazes into her face with an expression of wistful admiration. In both works the balance in emphasis between the internal mood of the figures and the splendor of their external appearance, while closely paralleling Ter Borch, must also reflect Ochtervelt's independent development. Visual sources may be borrowed easily by anyone; psychological resources are acquired only through personal growth.

Half-Length Figures and Niche Scenes: 1665 to Circa 1675

Apart from the numerous interior scenes that form the bulk of Ochtervelt's production, there exists another group of paintings, composed in a special format, that can be considered in a category of their own. These half-length representations of single figures or pairs of figures, some of which include niche enframements, are smaller in scale than Ochtervelt's interiors and demonstrate, once again, his connections to painting in Leiden.

The earliest of these works is a small panel, *The Flag Bearer*, dated 1665 (cat. nr. 25; Fig. 60) in the Zurich art trade. Single portraits of officers are certainly not uncommon in Dutch art,[29] and indeed Ochtervelt himself, in 1660, had painted a full-length portrait of an ensign holding a flag (cat. nr. 13; Fig. 148). Yet the tiny size of this painting (19 x 16 cm.), the genrelike representation of a battle in the background, and the fact that the flag has no identifying coat of arms or markings make it unlikely that the work was intended as a specific, commissioned portrait. Interestingly enough, Ochtervelt may have used himself as the model for this figure, for the same face with its heavy-lidded dark eyes, slightly cleft nose, and thin moustache reappears in his *Self-Portrait* as an artist (cat. nr. 30; Fig. 160); again, in three paintings of singing violinists (cat. nrs. 33–35; Figs. 61, 63, 64); and yet again in his *Peasant Smoking* (cat. nr. 31; Fig. 65). Although not identical in size, these works are all small-scale representations (on panel), using similar half-length or bust-length formats. Since all appear to date from the same period (cat. nr. 33; Fig. 61 is signed and dated 1666), it is possible that the artist was experimenting with a new approach to genre painting—a departure from his customary group compositions—and used himself as a basis for working up studies of various types or professions.[30] In *The Flag Bearer* the close framing of the figure and the powerful diagonal of the flag, which bisects the picture space, focus attention directly upon the man's face.[31]

The same compositional clarity and focus are found in Ochtervelt's *Singing Violinist*, dated 1666 (cat. nr. 33; Fig. 61), in Glasgow. Here again, the figure wears a metal cuirass, but the costume as a whole is far more elaborate: a violet jacket with slashed sleeves of pale lavender satin and, on the table, a soft red velvet beret with blue and white plumes. Surrounded by deep shadow, out of which his highlighted hands and face emerge, the musician is convincingly represented at a specific moment, blending the sounds of his voice and instrument into a harmony the viewer can almost hear. Both the subject matter of this work and the meticulous attention to material textures reveal the influence of painting in Leiden—notably of Dou and Van Mieris. Indeed, the exact prototype for Ochtervelt's figure may have been an undated *Singing Violinist* by Pieter van Noort of Leiden (Fig. 62). Van Noort, better known for his fish still lifes, was born in 1602 and was recorded as a guild member in Leiden until 1648.[32] Nearly a generation older than Ochtervelt, he may easily have served

as the source for the *Singing Violinist* in Glasgow. His violinist is almost identical to Ochtervelt's figure in activity, pose, and costume, although he is shown wearing the plumed beret. Since Van Noort's painting belongs to a series depicting the Five Senses (Landesmuseum, Münster), it is possible that the Ochtervelt painting, too, was intended to represent "Hearing."

But if Ochtervelt did derive his subject and composition from the older artist, his interpretation of the theme is totally his own. Van Noort's figure is a far less individual one, clearly a type, who displays his instrument like a decorative prop. Ochtervelt's musician holds the violin with far more ease and familiarity, as if he were actually playing it. The same convincing sense of a performance in progress is conveyed by Ochtervelt's *Singing Violinist in a Niche* (cat. nr. 34; Fig. 63; present location unknown), in which the musician (again recognizable as the artist himself) leans out of an arched window to serenade the viewer directly. In a close variant of this figure, shown without the niche (cat. nr. 35; Fig. 64; present location unknown), the physical proximity and direct glance of the violinist create an equally intense confrontation between performer and audience.

Interestingly enough, all of Ochtervelt's music scenes are characterized by a precise representation of the instruments used and by an equally knowledgeable interpretation of how each is handled and played. The fact that the artist devoted more than one-third of his total *oeuvre* to musical subjects (thirty-nine paintings altogether)[33] suggests that, like so many of his contemporaries, he may have found music an absorbing avocation, quite apart from his artistic use of musical motifs. If so, it is easy to understand why he would have chosen to portray himself three times in the guise of a singing violinist.

Why Ochtervelt would represent himself as an unshaven peasant, as in his signed *Peasant Smoking* (cat. nr. 31; Fig. 65), in Hamburg, is an intriguing question, considering the fact that the artist generally minimized or totally avoided low-life subjects.[34] Like his paintings of violinists, however, this work may also have been intended as one of the Five Senses: "Taste." Such figures were often painted by Dutch specialists in peasant genre; for example, Adriaen van Ostade, whose *Peasant Smoking*, dated 1640 (Fig. 66), also in Hamburg, is similar to the Ochtervelt in both costume and format. Nonetheless, Ochtervelt's peasant is a much younger and more individualized personality than Ostade's and he is shown in a more momentary attitude—displaying the glowing bowl of his lighted pipe to the viewer while exhaling a wisp of smoke through compressed lips.

In addition to the works just discussed, an extraordinary, miniature-sized *Woman Nursing a Child* (cat. nr. 29; Fig. 67), in Zurich, depicts a similarly close view (again on panel) of a figure in half-length format. Because of its unusual subject, the painting is difficult to date. Probably it can also be assigned to the mid-1660's. Since there are no documents mentioning children of the artist, and it is unlikely that such an intimate scene would have been commissioned as a record of a specific mother and child, Ochtervelt may again have intended an allusion to one of the Five Senses: possibly "Taste" or "Touch." The composition may also be viewed as a secular descendant, in contemporary dress, of the popular 15th-century Flemish schema of the half-length Virgin nursing Christ. This tradition was certainly familiar to 17th-century Dutch artists, as indicated by Gerbrand van den Eeckhout's tender *Virgin and Nursing Child*, dated 1659 (Fig. 68), in Braunschweig. Ochtervelt may even have been influenced by Eeckhout's composition, which is also painted on a small panel (19 x 15 cm.).

Ochtervelt's few niche paintings constitute a small but significant aspect of his *oeuvre*, for his use of architectural enframements relates these works directly to the Leiden School, the center of niche painting.[35] Two pendant paintings, of a woman singing (cat. nr. 47; Fig. 69) and a man listening

(cat. nr. 48; Fig. 70; dated 1668), display the same *feinmalerei* technique and rich theatrical costumes seen in Ochtervelt's paintings of singing violinists (cat. nrs. 33–35; Figs. 61, 63, 64). As a pair, these works function as subtle counterparts in action and mood. In the painting of the female singer (present location unknown), which would have hung on the left (a reversal of the heraldic placement used for matrimonial pendants), the figure wears her beret at a jaunty angle, holds a music book, and leans out of the niche facing toward the right. The listener (Städelsches Kunstinstitut, Frankfurt am Main) appears in a more dreamy, passive mood, leaning an elbow upon the sill of the niche and dangling his velvet cap from a relaxed hand.

A larger and more elaborate niche scene (cat. nr. 88; Fig. 72), formerly in the Hermitage, Leningrad, can probably be dated in the mid-1670's on the basis of the costumes and figure types. The smaller, more squared windows used in earlier scenes of this type have been replaced by an arched stone enframement, within which a maid offers a glass of wine to a cavalier holding a pipe. Here the niche is used not only to frame the figures but also to display a rich medley of objects. A dead game bird hangs at the left, compositionally balanced by a pulled curtain at the right, while the windowsill is completely covered by a tapestry, the man's cape and sword, and a silver tray with a cut melon. The diffusion of emphasis in this composition, resulting from the artist's tendency to fill up the picture space, becomes characteristic of Ochtervelt's style around 1675.

A similar couple appears in Ochtervelt's extensively restored *Cavalier and Maid on a Balcony* (cat. nr. 89; Fig. 73), now in the Zurich art trade, which probably dates from the same period. In this work, however, the architecture does not enclose the figures, who stand on an open balcony against a background of landscape and sky. As the maid leans over the parapet to empty a metal basin, the man behind her touches her shoulder and playfully offers a glass of wine. Ochtervelt may well have been aware of similar subjects painted by artists of the Leiden School that show maidservants leaning out of niches to empty metal jugs.[36] Interestingly enough, an undated mezzotint (Fig. 74), after Ochtervelt's painting, by Pieter Schenk (1660–1718/19) records the same couple, framed by an arched stone niche. Since recent restoration of the painting has not revealed a niche, Ochtervelt may have painted another variant of the scene that has since been lost. At any rate, it is significant that both depictions of pairs of figures (cat. nrs. 88, 89; Figs. 72, 73) can be dated in the 1670's, while Ochtervelt's single figures were all painted during the 1660's, or a period of greater compositional economy and focus. The artist's later years are marked by the increasing elaboration of imagery that characterizes most Dutch genre painting during the last decades of the century.

Stylistic Diffusion: 1671 to 1682

Probably the most complex and the least understood phase of 17th-century Dutch painting is the last quarter of the century, a time that Plietzsch has aptly termed "die Zeit der Nachblüte."[37] Although the major part of Ochtervelt's development had occurred during the 1650's and '60's—the "Golden Age" of Dutch painting—more than one-third of his works can be dated in the '70's and early '80's. A number of fine paintings were produced during the last decade of the artist's career. On the whole, however, this body of works constitutes the most uneven portion of his *oeuvre*, revealing the growing uncertainties of an artist who attempted to combine familiar traditions with a new taste. If Ochtervelt's late works are often his least impressive in quality, they are nonetheless extremely

interesting for what they reflect of the overall artistic and cultural situation that developed in the Netherlands during those years—a situation that also profoundly affected the later styles of many of his contemporaries.

Direct relationships between art and historical trends can rarely be calculated with any accuracy. Yet it is undeniable that the artistic flowering of the Netherlands during the first half of the 17th century had developed hand in hand with the burgeoning political and economic power of the nation as a whole. Likewise, it seems significant that the political upheavals and economic difficulties that beset the Dutch nation during the 1670's were paralleled by the beginnings of a noticeable artistic decline. The declaration of war by England and the invasion of the French armies in the Spring of 1672 caught the nation unprepared and led to six years of struggle, culminating in the Peace of Nijmegen, which left the country exhausted and embittered. A decade later, in 1688, the crowning of William III as king of England assured the peace of the Netherlands, but it also diminished its influence in world affairs.

In a sense, these events can be viewed as surface manifestations of the underlying attitudes of a period in which personal security was often valued before national well-being. Having accumulated their fortunes, many Dutch citizens turned from active commercial enterprise and involvement in patriotic issues to the enjoyment of personal leisure. And as Rosenberg and Slive have pointed out: "Artists seem to have acquired something of the spirit of the Dutch patricians of the period who were mainly *rentiers,* not *entrepreneurs.* They preferred to live on the dividends of their substantial capital rather than risk new ventures."[38]

Most Dutch artists did indeed continue to work within established tradition during these years—or, more accurately, to elaborate upon tradition, partly in response to the increasingly luxurious taste and refined manners of their patrons. In contrast to the selective simplicity of earlier Dutch art, genre painting after 1670 is often characterized by an obvious emphasis upon outward show. At the same time, the artistic situation was complicated by the new vogue for academic French art, which, paradoxically, became increasingly popular during the years of struggle with France and which continued to dominate Dutch taste throughout the 18th century. Huizinga has scathingly referred to this phenomenon as "French classicism, the sickness that sapped our culture of its national strength."[39] Aside from the admiration for French architecture, furniture and costume, *le gout français* required an entirely new esthetic for painting: one in total opposition to traditional Dutch realism.[40] If artists of the later generation such as Adriaen van der Werff and Gerard de Lairesse could accept and work fairly comfortably within the theoretical tenets of academic French art, the same was not true of those who had reached maturity before 1670. It is not surprising that the late works of painters such as Ochtervelt, De Hooch, Van Mieris, and even Vermeer often seem to lack conviction and a sense of firm direction.

Ochtervelt's style at the beginning of the 1670's can be documented by two fine dated paintings of 1671 that indicate, respectively, the continuing influences of both Vermeer and Ter Borch. *The Music Lesson* (cat. nr. 63; Fig. 75), in Chicago, is, in fact, remarkably close in lighting, format, and setting to Vermeer's *Soldier and a Laughing Girl* (Fig. 76), in the Frick Collection, although Ochtervelt avoids contrasting the scale of the two figures and omits the actual source of light. As in *The Dancing Dog* of 1669 (cat. nr. 57; Fig. 55), in Hartford, the seated musician in the left foreground is placed between the shadow and the light so that he becomes a dark silhouette—the negative counterpart of the standing woman, whose yellow costume shines in the light against the pale gray

wall. The oblique placement of the figures is further accentuated by the diagonals of the musical instruments they hold, the slanting lines of a foreshortened viola on the table, and the diagonally placed chair in the right foreground.

The Leipzig *Tric-trac Players* (cat. nr. 64; Fig. 77), also dated 1671, is a work more characteristic of the early 1670's, a period in which the influence of Ter Borch predominated and in which Ochtervelt began to use a calmer and more balanced approach to composition. Interestingly enough, this composition is a variant of Ochtervelt's *Musician with Tric-trac Players* of about 1668 (cat. nr. 44; Fig. 50), in Cologne. A comparison of the two works is instructive. The asymmetrical design of the earlier painting with its light, open structure of sharp diagonals has been transformed in the later work into a denser and more balanced grouping, composed of somewhat weightier figures arranged in less eccentric poses. Similar conclusions may be drawn in comparing other works of this period to their earlier compositional or thematic counterparts. For example, *The Soldier's Offer* (cat. nr. 69; Fig. 80), one of a pair of paintings whose present location is unknown, is completely different from inn scenes Ochtervelt had painted during the mid 1660's, such as *The Gallant Drinker* (cat. nr. 26; Fig. 34). Despite general similarities in subject and placement of the figures, the later work is much quieter and more decorous in composition and mood. Furthermore, Ochtervelt now uses a blander and more even foreground lighting, replacing the complex, dynamic interactions of light and shadow that heightened the active interplay between the figures in the earlier scene. The easy camaraderie expressed in Ochtervelt's genre paintings of the 1660's evolves, in the following decade, into an atmosphere of more restrained *politesse*, with a growing emphasis on elegance and social refinement that follows the overall development of 17th-century Dutch genre painting as a whole.

Although this new artistic and emotional formality may make Ochtervelt's late works seem less immediately appealing than his more ebullient scenes of the 1660's, these paintings can hardly be criticized for attempting to fulfill different aims. On the other hand, signs of weakening technical quality do begin to appear in many works of this period. In *The Dancing Dog* (cat. nr. 70; Fig. 81), in Stockholm, the standing woman—a reverse variant of the female figure in *The Soldier's Offer*—seems frozen in both gesture and facial expression. Her satin skirt falls in brittle folds that lack the convincing fluidity of the previous work, and the figures are poorly integrated in both composition and mood. Furthermore, the lighting has become much harsher, losing the clarity and subtlety Ochtervelt had achieved in earlier versions of the same theme (cat. nrs. 56, 57; Figs. 54, 55). In *The Betrothal* (cat. nr. 72; Fig. 83; private collection, Germany), one finds passages of impressive technical virtuosity in the finely painted satins and velvets of the woman's costume and in the beautifully rendered texture of the Turkey carpet at the right. But here, again, the gestures are rather wooden, and the spatial relationships among the figures remain unclear. The uncertain handling of half-shadow, which Ochtervelt had used with such authority only a few years earlier, is particularly noticeable in the male figure, whose awkward stance is accentuated by abrupt, harsh contrasts of light and shadow.

This unevenness of quality, which is difficult to reconcile with the artist's earlier accomplishments, becomes increasingly evident in many, although certainly not all, of Ochtervelt's late paintings. At the same time, one finds a gradual breakdown of stylistic homogeneity. Thus, instead of painting in a single style during the 1670's, Ochtervelt begins to work more erratically, producing several groups of paintings that are no longer consistent in style or in quality. Moreover, the few

works dated after 1670 are quite diverse in subject and in style, further complicating the problem of understanding Ochtervelt's late chronology.[41]

A series of eight interior scenes showing women with their maidservants (cat. nrs. 73–80; Figs. 84, 86-91, 93) gives a strong indication of Ochtervelt's growing stylistic diffusion. Each of these undated works seems to belong to the first half of the 1670's, yet as a group they demonstrate numerous approaches to the same general thème. In *The Nursery* (cat. nr. 73; Fig. 84), in Capetown, in which the seated woman bears a striking resemblance to the young lady in *The Betrothal* (cat. nr. 72; Fig. 83), the artist's treatment of the interior recalls the late styles of both Vermeer and De Hooch. The strong diagonals of the highly polished, tiled floor, reinforced by the receding shapes of the table, cradle, and cushion, are combined with the rectangular forms of the picture frame and fireplace in the background. The result is an almost geometric definition of space, seen also in two other works of this period: *Lady and Maid Feeding a Parrot* (cat. nr. 74; Fig. 86; present location unknown) and *Lady with Servant and Dog* (cat. nr. 75; Fig. 87), in the New York Historical Society. The subtle differentiation of contrasting textures in *The Nursery* extends even to the artist's treatment of light, for the atmosphere of the room with its moving, transparent veils of shadow seems to have a specific density of its own. Despite these extraordinary visual refinements, Ochtervelt's figures retain the same static self-consciousness seen in *The Betrothal* (cat. nr. 72; Fig. 83) and in the Stockholm *Dancing Dog* (cat. nr. 70; Fig. 81). This type of mannerism, also found in late works by Vermeer and De Hooch, betrays the loss of spontaneity that often results from a long-term continuation and elaboration of the same style. The traditional, even conservative, style of Ochtervelt's *Nursery* becomes obvious when it is compared to a depiction of the same subject, of similar date, by an artist of the next generation. *Nursery Scene*, by Jan Verkolje (1650-93), dated 1675 (Fig. 85), in the Louvre, was probably influenced by Ochtervelt in its subject and choice of figure types. But the sinuous gestures of Verkolje's figures and his rather ornate, twisted ropes of drapery have a noticeably French flavor—more reminiscent of Simon Vouet than of Vermeer.

Other works in this series, relating more closely to Ter Borch, lack the tight perspectival rendering of space seen in *The Nursery*. Indeed, in *Lady Trimming Her Fingernails with Maid* (cat. nr. 76; Fig. 88), in the National Gallery, London, similar in composition to *The Betrothal* (cat. nr. 72; Fig. 83), the artist's cursory definition of the interior and imprecise handling of spatial intervals makes the figures seem rather isolated and dwarfed by their surroundings. The intimacy of the boudoir and the relationship between mistress and servant are more convincingly evoked in *The Letter Reader* (cat. nr. 77; Fig. 89), in a private collection in Cologne, for here the two women are more coherently related to each other and to their setting. As the seated lady reads aloud from a letter (probably a love letter, as implied by the background painting of a reclining Venus), her maid pauses to listen, setting the silver pitcher and basin on the table. These utensils, which are repeated in five of the works in this series (cat. nrs. 75-79; Figs. 87-91), were commonly used in 17th-century emblems as symbols of cleanliness and purity.[42] Thus, in this context they may have been intended as references to the chastity of the woman receiving the love letter.

The same motif reappears in a somewhat more ironic context in Ochtervelt's *Lady with Servant and Dog* (cat. nr. 78; Fig. 90), in the Carnegie Institute, Pittsburgh. In this work, however, it is the worldliness of the woman that is emphasized—not only by her fashionable dress and coiffeur but also by the large wall map of the world, with one of the hemispheres placed directly above her head.

As in the Hartford *Dancing Dog* of 1669 (cat. nr. 57; Fig. 55), this composition may be related to "Lady World" allegories, in which a female figure with a globe on her head symbolizes lust and vice.[43] Although Ochtervelt does not comment directly upon the moral behavior of his figure, her frivolous attitude and elaborate costume proclaim that her concerns are hardly those of the spiritual realm.

Both the lighting and treatment of space in the painting in Pittsburgh are quite different from Ochtervelt's other boudoir scenes of this period. The strong, even illumination gives the interior itself as much emphasis as the figures, and the setting has been developed in unusual detail. Wide wooden floorboards define the recession of the richly furnished foreground room, which opens at the left into a De Hooch-like view of an inner chamber with tall windows and a tiled floor. These successive spaces are linked both architecturally and psychologically, for a man and woman in the background room watch and actively respond to the scene in the foreground. Focus on the foreground is intensified by a painting above the door of a young soldier glancing over his shoulder toward the playful women.

Certainly the most intimate of Ochtervelt's boudoir themes is *The Footwashing* (cat. nr. 79; Fig. 91), formerly in Moscow, in which the standing woman closely resembles the figure in the Pittsburgh interior. Here, however, the artist returns to his usual foreground lighting, casting the setting into deep shadow. Ochtervelt's interpretation of this rarely depicted subject is surprisingly frank, for the woman, still wearing the satin skirt of her formal attire, has bared her breasts as well as her extended foot. By contrast, an undated version of the theme (Fig. 92) by the Amsterdam artist Jan Voorhout (1647-1723) offers a more decorous treatment in which the grave formality of the figures in their richly appointed setting gives the scene the solemnity of a ritual. Unlike Ochtervelt's purely domestic grouping, Voorhout's women could almost be viewed as characters in an historical or biblical drama, were it not for their contemporary setting. Indeed, the Voorhout painting, which can probably be dated near the end of the century, clearly displays the diverse, contradictory stylistic trends prevalent in Amsterdam during the later 17th century: a meticulous realism in the depiction of objects and material textures, combined with a rather abstract, classicizing treatment of the figures themselves. The same uneasy alliance of Dutch and imported French traditions reoccurs in a number of works by Ochtervelt painted in Amsterdam during the last phase of his career.

Ochtervelt's move from Rotterdam to Amsterdam, which was to have a significant impact upon the final development of his style, must have occurred by 1674, as documented by his group portrait of *The Regents of the Amsterdam Leper House* (cat. nr. 82; Fig. 163), signed and dated in that year.[44] At the time of his arrival, one of the most popular artists working in Amsterdam was Gerard de Lairesse (1640-1711), the "Dutch Poussin," whose emulation of the French Academy had helped to create a new fashion for classical painting. Lairesse's *Antony and Cleopatra* of about 1670 (Fig. 95), in the Rijksmuseum, exemplifies his fully developed style. This grandiose scene from Roman history with its sculptural figures, friezelike design, and Roman architectural setting could easily serve as a textbook illustration for the classicizing precepts advocated by the major art theorists writing throughout the later 17th century.[45]

Ochtervelt responded immediately to his new artistic milieu. *Concert in a Garden*, dated 1674 (cat. nr. 83; Fig. 94), in the Hermitage, Leningrad, perhaps the very first of his Amsterdam genre paintings, shows a radical departure from the scenes of everyday Dutch life painted during the previous decade in Rotterdam. Yet its decorative subject and outdoor setting with classical architec-

tural motifs are by no means new to Ochtervelt's *oeuvre*. Some twenty years earlier he had painted garden scenes with musicians (cat. nrs. 5, 6; Figs. 11, 14) that incorporated similar settings and the same heavy, broadly modeled figure types. In the Hermitage painting, however, the artist's technique is looser and more fluid; the sharp Caravaggesque lighting of the 1650's has become softer, creating a calmer and more unified design.

That Ochtervelt was impelled to rework his own early style is surprising but understandable, considering the loss of freshness and decline in quality of his late Rotterdam paintings. In moving to Amsterdam, the artist must have been seeking not only a new circle of patrons but also a change that might revitalize his own attitudes. Reaching back to his own early Italianate style allowed Ochtervelt to explore an alternate but familiar mode of painting that he must have felt would appeal to his Amsterdam patrons. If *Concert in a Garden* displays neither Lairesse's elaborate academic rhetoric nor his historical subject matter, its modest use of Italianate figures and classical architecture does relate it to the requirements of "Roman taste." During his Amsterdam period, Ochtervelt responded erratically to academic classicism while continuing to work within his own Dutch tradition. His vacillation between two incompatible styles and his intermittent attempts to reconcile them results in a body of rather disparate works whose precise chronology is difficult to reconstruct.

Musical Company in a Rotunda (cat. nr. 84; Fig. 96), in the collection of Baroness Bentinck, can also be dated around 1674, for it is very similar in style to the Leningrad music scene. The same weighty, muscular types of figures are compactly grouped around a table in an outdoor setting. Nearly all of the background is filled by a massive Roman rotunda, whose carved architrave and engaged stone columns form an appropriate backdrop for the strongly modeled figures in the foreground. As in the Hermitage painting, the figures wear Dutch rather than Roman costume, although their surroundings tend to abstract the scene from the contemporary present. Unlike Lairesse, Ochtervelt was not concerned with archeological accuracy or consistency. He responded to classical painting as a fashion from which motifs could be borrowed, but he never totally absorbed or embraced the theories behind it.

Indeed, the paintings that seem to follow in date return to purely Dutch settings and subjects. Three genre interiors (cat. nrs. 85–87; Figs. 99–101), closely related in style, display the same broader figure types, soft lighting and rather loose technique seen in the late garden paintings. In all three compositions the quiet gestures of the figures and the artist's emphasis on stable horizontals and verticals create a mood of restrained calm. Even in *The Tease* (cat. nr. 86; Fig. 100; private collection, Switzerland), the liveliest subject in the group, interaction among the figures remains quite controlled. Ochtervelt has conveyed something of the refinement of late 17th-century Dutch society in *The Visit* (cat. nr. 85; Fig. 99; private collection, England), a Ter Borch-like scene, in which a bowing suitor, hat in hand, approaches an elegantly attired girl with shyly downcast eyes.

These three interiors, however, demonstrate only one aspect of Ochtervelt's development of the mid 1670's. At the same time, he continued to seek even closer alliances with the new classical taste. *Lucretia*, dated 1676 (cat. nr. 91; Fig. 102; present location unknown) represents not only a new experiment with historical subject matter but also a new way of depicting the nude. Lucretia, dramatically spotlighted against a backdrop of satin draperies, is shown preparing to plunge the dagger into her breast. The curving rhythm of her gracefully extended arms, repeated in linked twists of drapery at her elbows and waist, and the smoothly modeled flesh of her bared torso seem closer in style to the refinements of Lairesse or Adriaen van der Werff than to anything Ochtervelt had painted

earlier. One has only to compare this figure to the similarly attired woman in *The Footwashing* of about 1671-73 (cat. nr. 79; Fig. 91; present whereabouts unknown); to realize how far the artist has departed from his usual manner of treating female anatomy. Only one other example can be cited which probably dates from the same period: *Woman Combing Her Hair Before a Mirror* (cat. nr. 92; Fig. 103), now in the Dutch art trade. Here again, the same female type is represented, partially nude, in a boudoir setting from which all contemporary references have been excluded. Surrounded by cool satins of yellow, pink, and white, the figure gazes into a mirror at the right, at the base of which is a string of pearls. Certainly the scene has little in common with Ochtervelt's boudoir paintings of the early 1670's (cat. nrs. 73-80; Figs. 84, 86-91, 93), and it is possible that he intended it as a Vanitas allegory or as a representation of Venus or Bathsheba. Despite its delicacy of coloring and refined surface textures, this composition is hardly one of Ochtervelt's most appealing, for the figure's body is awkwardly segmented by the position of the arms and the placement of drapery. In the remainder of his works, the artist avoided the depiction of such idealized historical or allegorical figures, but several of his late genre scenes suggest that he continued to be very much aware of the theatrical rhetoric of academic classicism.

The *Faint* in Venice (cat. nr. 98; Fig. 110), which is dated 1677—only a year after Ochtervelt's *Lucretia*—offers a revealing variation on the theme the artist had painted more than a decade earlier (cat. nr. 28; Fig. 38). But instead of the spare simplicity of the earlier work, which included only three figures, this painting shows numerous attendants responding to the plight of a finely dressed woman, who reclines gracefully against a luxurious heap of soft pillows and satin quilts. At first glance this dramatic tableau might seem to depict the death of some historical heroine, rather than a fainting Dutch *huisvrouw* in a domestic interior.

A group of music scenes, which can be dated in the late 1670's (cat. nr. 93-97; Figs. 104, 105, 107-109), are less dramatic in theme and expression, but they show a similar interest in visual ornateness and compositional elaboration. Perhaps the finest in this series is Ochtervelt's signed *Music Party* (cat. nr. 94; Fig. 105), in the National Gallery, London, in which a woman standing at the virginals accompanies a singer and violinist.[46] Both the subject of this painting and the artist's emphasis on compositional geometry immediately recall Vermeer's style of the late 1660's, notably his *Lady and Gentleman at the Virginals* (Fig. 56), in Buckingham Palace. Furthermore, the London interior displays the same Vermeer-like pattern of contrasting light and shadow found in earlier works by Ochtervelt dated 1669 (cat. nr. 57; Fig. 55; Hartford) and 1671 (cat. nr. 63; Fig. 75; Chicago). Characteristic of the late 1670's, however, is the fact that light is no longer used to define a single focus, but to add to the complexity of a design in which the sweeping curves of the figures' elaborate costumes are combined with the multiple squared patterns of the interior and its furnishings.

It has been noted earlier that Ochtervelt's paintings of the 1670's are often less consistent in quality than those of the 1660's. By the end of the decade a more pervasive stylistic decline emerges in works marked by obvious technical disintegration and weak self-quotation. In *The Sleeping Soldier* (cat. nr. 99; Fig. 111), in Stockholm, for example, a kneeling woman, whose crudely painted head is sharply silhouetted against the lighted wall behind her, holds up a mirror to the face of a sleeping soldier as a man behind him prepares to blow a trumpet into his unsuspecting ear. Unlike Ochtervelt's earlier interpretation of the subject (cat. nr. 15; Fig. 26; Manchester), this painting lacks both compositional and thematic concentration. Harsh contrasts of light and shadow at the left and right detract attention from the central figures, as do the lovers in the background, whose awkward

placement emphasizes the lack of spatial clarity in the interior. Furthermore, Ochtervelt's technique has lost its crispness and delicacy; the roughly applied paint no longer captures the fine details of faces or costumes. The same crude technique and uncertain compositional structure appear in *Musical Company Around a Table* (cat. nr. 102; Fig. 115), in Dayton, Ohio, a crowded, rather pastichelike design upon which a completely arbitrary pattern of light and shadow has been imposed.

Ochtervelt's two latest interiors, which seem to have been painted during the early 1680's, are equally unimpressive in quality but are nonetheless extremely revealing as stylistic documents of their time. In none of the artist's other works is the conflict between French classicism and Dutch realism more explicitly stated. *The Doctor's Visit* (cat. nr. 105; Fig. 116), in the German State Collection, Munich, depicts two women reviving a fainting patient, as a physician records a diagnosis at the left. Similar subjects had appeared on several occasions in Ochtervelt's *oeuvre* (cat. nrs. 27, 28, 32, 98; Figs. 35, 38, 37, 110), but not even his late interpretation of the theme of 1677 (cat. nr. 98; Fig. 110), in Venice, incorporated such an opulent and blatantly artificial setting. Now, instead of a Dutch interior, we find a Roman backdrop with Corinthian pilasters and a niche displaying a Roman sculpture. One has only to refer to the academic style of Lairesse (Fig. 95) to realize that Ochtervelt must have included these classical trappings in an attempt at partially emulating his younger contemporary. But while Lairesse's choice of narrative, figure types, and costumes all match his setting, Ochtervelt's scene remains a mélange of two different traditions.

Ochtervelt was certainly well aware of the inconsistencies that inevitably resulted from the combination of two such disparate styles. His *Last Testament* (cat. nr. 106; Fig. 117), in the Schloss Grünewald, Berlin, reveals his final attempt at resolving the artistic conflict with which he was confronted. The unusual subject of this work—which clearly relates to the artist's depictions of fainting or ailing women—is that of a dying lady, surrounded by mourners as she signs her last testament. Ochtervelt himself was certainly familiar with such legal procedures, for his name appears in contemporary documents as a witness to the signing of wills.[47] Yet it is immediately obvious that the artist has not attempted to evoke a contemporary scene in this painting. Instead, he seems to have selected the subject for its theatrical possibilities, transforming it into a staged tableau that not only includes classical motifs but also employs, for the first time, a composition in the style of Lairesse. In the background sweeping draperies part to reveal a Roman sculpture; the dying woman reclines on a French *chaise* rather than on a Dutch bed. Most significantly, the figures are grouped in a calculated, friezelike design parallel to the picture plane—a design in which light isolates the individual gestures and attitudes of the mourners.

Unlike Lairesse, however, Ochtervelt was not willing to depart completely from the realm of genre painting. Although the subject is presented as if it were an historical drama, the familiar Dutch spaniel and the chamberpot in the foreground, as well as the costumes, still proclaim the artist's ties to his own tradition. The unheroic figure types also remain the same as those in Ochtervelt's genre scenes. As a result, their emotive attitudes seem artificial and tend to generate more artistic than dramatic tension. In a sense, this painting might be considered a statement of Ochtervelt's own last testament. While it illustrates his attempt to absorb a radically different approach to painting, it also reveals his discomfort in expressing what was essentially foreign to his own development and taste. The fact that Ochtervelt could never totally assimilate the elements of the classical style points up the quandary faced by many artists who develop successfully within an established tradition, only to be confronted by the beginnings of a new era.

Notes

1. By 1645 Berchem must have returned to the Netherlands, because he painted a view of Heemstede Castle near Haarlem that is dated that year (E. Schaar, *Studien zu Nicolaes Berchem* [Inaug. diss., University of Cologne, 1958], p. 12).

2. One possible exception to this statement is *Mounted Pair in a Landscape*, in the Dienst Verspreide Rijkscollecties, The Hague, which Valentiner has assigned to the early De Hooch (Valentiner, *Pieter de Hooch* [Stuttgart, 1929], p. 6, with ill.). The mountainous setting with shepherds in this scene may have been influenced by Berchem. The attribution to De Hooch is problematic, however, and the Dienst now lists the painting as a questioned work by De Hooch or by Ludolf de Jongh. (For further reference to this painting, see notes to cat. nr. 2; Fig. 5.) In a recent article on De Hooch's early style ("Ludolf de Jongh and the Early Work of Pieter de Hooch," *Oud Holland* 92 [1978], 49–67), R. E. Fleischer accepts a De Hooch attribution for the Dienst painting, but notes that the work was strongly influenced by De Jongh's style.

3. Interestingly enough, Ochtervelt returned to his early Italianate style in several paintings of the 1670's, such as his *Concert in a Garden*, signed and dated 1674 (cat. nr. 83; Fig. 94), in the Hermitage, Leningrad, and his *Musical Company in a Rotunda* (cat. nr. 84; Fig. 96), in the collection of Baroness Bentinck, which appears to date from the same period.

4. Ochtervelt's painting does not appear to be derived from any literary source. The subject is clearly not *Granida*, which it superficially resembles, since his young woman is neither alone with the shepherds nor wearing battle armor.

5. P. C. Hooft, *Granida*; modern spelling by C. A. Zaalberg (Zutphen, 1958). The play was originally written about 1605. Ochtervelt's painting is based upon Act I, scene 3, transcribed on p. 40 of the Zaalberg edition.

6. S. J. Gudlaugsson, "Representations of Granida in Dutch Seventeenth-Century Painting III," *Burlington Magazine* 91 (February 1949); 40.

7. On the relationship between Vermeer and the Utrecht Caravaggisti, see H. Voss, "Vermeer von Delft und die Utrechter Schule," *Monatshefte für Kunstwissenschaft* 5 (1912); 79–83.

8. More complete color notations on Ochtervelt's *Musical Company*, in Amsterdam, appear in the notes to cat. nr. 6; Fig. 14.

9. The archival reference to Ochtervelt's marriage in Rotterdam on December 14, 1655, is listed in Appendix to Documents.

10. See notes to cat. nr. 6; Fig. 14.

11. For discussion of this aspect of Dutch genre painting, see C. B. Playter, *Willem Duyster and Pieter Codde: The "Duystere Werelt" of Dutch Genre Painting, c. 1625–35*, (Inaug. diss., Harvard University, 1972).

12. Date assigned by W. R. Valentiner, *Pieter de Hooch* (Stuttgart, 1929), p. 17.

13. N. MacLaren, *London National Gallery, The Dutch School* (London, 1960), p. 183.

14. Date assigned by S. J. Gudlaugsson, *Gerard Ter Borch*, 2 vols. (The Hague, 1959), 1; 232.

15. Works by Ter Borch that include the same motif are illustrated in Gudlaugsson, *Ter Borch*, vol. 1, p. 243, nr. 83; p. 267, nr. 110; p. 268, nr. 111; p. 304, nr. 148; and p. 395, nr. 272.

16. See notes to cat. nr. 11; Fig. 23.

17. The fact that the lusty maidservant in this scene wears a crucifix at her throat is probably not without iconographic significance. The same motif is worn by a similar figure in Van Mieris's *Soldier and Maid* (Fig. 24), in the Mauritshuis, and it appears again in Ochtervelt's *Oyster Meal* (cat. nr. 23; Fig. 33), in an English private collection, and in *The Dancing Dog* (cat. nr. 57; Fig. 55), Wadsworth Atheneum, Hartford, Connecticut. Since all four scenes have strongly erotic implications, the crucifix should perhaps be read as a moralizing counterpart to the life of the senses or as a reminder of spiritual virtue.

18. The caged bird, an image frequently employed by Dutch genre painters, derives from emblem literature and refers to the sweet imprisonment imposed by love. Thus, an emblem of a caged bird from Jacob Cats' *Silenus Alcibiades, sive Proteus*, published in Amsterdam in 1622, bears the motto "Amissa Libertate Laetior," or "Joyful Bondage" (cf. fig. 21, p. 34, E. de Jongh, *Zinne -en Minnebeelden in de Schilderkunst van de*

Zeventiende Eeuw [Amsterdam, 1967]. Ochtervelt's image seems to be a variation on this emblem, for his cage holds two lovebirds and has an open door, indicating that imprisonment with the beloved is preferable to freedom.

19. Similar views from a foreground interior into a lighted background space were incorporated into two of Ochtervelt's late portraits: the dated *Family Portrait* of 1670 (cat. nr. 61; Fig. 156), in Budapest, and the undated *Portrait of a Couple Making Music* of about 1671-75 (cat. nr. 81; Fig. 158), in Augsburg.

20. For discussion of other depictions of sleeping soldiers in Dutch art and their iconographic associations, see the notes to cat. nr. 15, Fig. 26.

21. The source of the notion that oysters possess aphrodisiacal powers may have been the belief that Aphrodite, goddess of love, was conceived in an oyster shell and sailed upon it to Cyprus, where she rose from the sea. C. Stephanus's unpaged *Dictionarium Historicum, Geographicum, Poeticum* (London, 1586) includes the following passage under "Venus:" "Fertur in conchâ margaritarum feraci fuiffe concepta in quâ etiam navigavit in Cyprum, quare cum de formosâ muliere loqueretur Venus apud Papinium, illam dignam effe inquit, quae fua effet foror, in eâdem conchâ navigaret." (For further references to oysters, see notes to cat. nr. 21; Fig. 29.)

22. The relationship between love and illness is defined most clearly in Jan Steen's *Lovesick Girl*, in the Alte Pinakothek, Munich, nr. 158 (ill., *Alte Pinakothek, Katalog III, Holländische Malerei des 17. Jahrhunderts* [Munich, 1967], pl. 75). In this scene, one of Steen's many depictions of the theme, a doctor takes the pulse of a patient, who holds a sheet of paper bearing the inscription: "Daar baat geen / medesyn / want het is / minepyn" ("No medicine will help when it is the pain of love"). A statue of Cupid over the doorway and a painting of Venus and Amor above the canopied bed at the right background serve to reinforce the message (cf. R. Keyszelitz, *Der "clavis interpretandi" in der holländischen Malerei des 17. Jahrhunderts* [Inaug. diss., Ludwig-Maximilians-Universität, Munich, 1956], p. 50). For full discussion of this theme, see J. B. Bedaux, "Minnekoorts-, zwangerschaps-en Doodsverschijnselen op 17de Eeuwse Schilderijen," *Antiek*, vol. 10, nr. 1 (1975-76), pp. 17-42.

23. The juxtaposition of the candle and chamberpot beside the fainting woman in Van Mieris's painting may also have erotic meaning, aside from their obviously practical functions. De Jongh has discussed a number of Dutch genre paintings in which the combination of jug and candle are interpreted as symbols of the male and female sexual organs (E. de Jongh, "Erotica in Vogelsperspectief: De Dubbelzinnigheid van een Reeks 17de eeuwse Genrevorstellingen," *Simiolus* 3 [1968-69]: 43-47).

24. In addition to the other dated genre interiors of the late 1660's (cat. nr. 45; Fig. 51; 166[8?]; cat. nr. 46; Fig. 52; 1668; cat. nr. 53; Fig. 53; 1669; and cat. nr. 57; Fig. 55; 1669), there is also one dated entrance hall scene of 1669 (cat. nr. 54; Fig. 130) discussed in Chapter 2. Two dated depictions of single figures (cat. nr. 33; Fig. 61; 1666; cat. nr. 48; Fig. 70; 1668) are discussed in the section Half-Length Figures and Niche Scenes in Chapter 1.

25. For discussion of the date of *The Toast*, see notes to cat. nr. 45; Fig. 51.

26. E. de Jongh, *Zinne -en Minnebeelden in de Schilderkunst van de 17de Eeuw* (Amsterdam, 1967), pp. 38-42. See notes to cat. nr. 56; Fig. 54.

27. The scene at the left is obscured by shadow, but it probably represents the Creation of Eve. The Temptation is depicted in the center and the Expulsion at the right.

28. E. de Jongh, "Vermommingen van Vrouw Wereld in de 17de Eeuw," in *Album Amicorum J. G. van Gelder* (The Hague, 1973), p. 203.

29. In the early part of the century, Jan van Ravesteyn frequently filled commissions for such single military portraits, often in half-length, such as his *Portrait of an Officer*, in the Mauritshuis, nr. 438 (ill., E. Plietzsch, *Holländische und flämische Maler des XVII. Jahrhunderts* [Leipzig, 1960], pl. 292). Frans Hals also contributed to this tradition in his *Portrait of a Man Wearing a Cuirass*, about 1638-40, in the National Gallery, Washington, (ill., S. Slive, *Frans Hals* [New York and London, 1970], vol. 2, pl. 202), as did Pieter de Hooch in *Portrait of an Officer*, about 1650, formerly in the Amsterdam art trade (ill., W. Valentiner, *Pieter de Hooch* [Stuttgart, 1929], p. 8). A market for such paintings continued into the late years of the century, as illustrated by Ter Borch's *Portrait of a General*, about 1680, in the Hermitage, Leningrad (ill., S. J. Gudlaugsson, *Gerard Ter Borch* [The Hague, 1959], vol. 1, pl. 287). None of these portraits, however, has the same miniature scale of Ochtervelt's painting.

30. The motif of a soldier wearing a metal cuirass had been included in a number of Ochtervelt's genre scenes from the late 1650's to the mid-1660's (cat. nrs. 6, 7, 9-11, 14, 15, 26; Figs. 14, 16, 19, 22, 23, 25, 26, 34) and in a

number of his later works (cat. nrs. 64, 69, 70, 83, 84, 86, 87, 99, 100, 102; Figs. 77, 80, 81, 94, 96, 100, 101, 111, 112, 115).

31. Despite compositional focus on the face, the Ochtervelt remains more a study of the profession than of the individual personality of the model. This distinction becomes obvious when his painting is compared to Rembrandt's depictions of himself in military trappings (ills., A. Bredius, revised by H. Gerson, *Complete Paintings of Rembrandt* [London, 1969], nrs. 4, 6, 20, 22-24). For Rembrandt, who shows himself in a variety of specific moods, costume was selected primarily to set up a dramatic frame for the face, in order to heighten the concentration upon the inner life of the figure.

32. U. Thieme and F. Becker, *Allgemeines Lexikon der bildenden Künste* (Leipzig, 1907-50), vol. 25 (1931), p. 512.

33. The number of musical subjects increases in each decade of Ochtervelt's career. Five were painted during the 1650's, sixteen during the 1660's, and eighteen during the 1670's.

34. Only one other peasant painting by Ochtervelt is known: *Peasant Spinners in an Interior* (cat. nr. 17; Fig. 142), formerly in Leipzig. The artist did, however, include peasant types in his entrance hall paintings (see Chapter 2) and in his painting *Fish Market* (cat. nr. 52; Fig. 145), in Vienna.

35. For a discussion of niche scenes painted in Leiden by Gerard Dou and his followers, see F. W. Robinson, *Gabriel Metsu* (New York, 1974), pp. 89-100.

36. An especially fine example of this type is Gerard Dou's *Maid Emptying a Jug of Milk*, about 1640, in the Van der Vorm Collection, Museum Boymans-van Beuningen, Rotterdam (ill., D. Hannema, *Beschrijvende Catalogus . . . Stichting Willem van der Vorm* [Rotterdam, 1962], cat. nr. 21, pl. 28). Here a maid with a large dustcloth empties her container over a stone sill decorated with a Duquesnoy relief of tumbling putti; a putto at the left also empties an amphora upon the ground. Within the immaculate interior beyond the niche, a boy and his mother are saying grace, suggesting a parallel between cleanliness and godliness. Such paintings may well have been intended as illustrations, not only of daily life, but of the moral virtues of the good household—a counterpart to Jan Steen's domestic parodies of the Untidy Household (cf. *Topsy-turvy World*, Kunsthistorisches Museum, Vienna). Domenicus van Tol, a follower of Dou, painted a similar subject in his *Woman Pouring out a Jug* (formerly Walter Weber Collection, New York; photograph: Rijksbureau voor Kunsthistorische Documentatie, The Hague). In this context the large spiderweb at the left of the niche probably alludes to diligence or industry.

37. E. Plietzsch, *Holländische und flämische Maler des 17. Jahrhunderts* (Leipzig, 1960), p. 185.

38. J. Rosenberg, S. Slive, and E. H. ter Kuile, *Dutch Art and Architecture 1600-1800* (London: Pelican Series, 1966), p. 207.

39. J. H. Huizinga, *Dutch Civilization in the Seventeenth Century* (London, 1968), p. 97.

40. The basis of academic theory and painting is the notion that nature must be "ennobled" rather than imitated; that artists should follow the example of the ancients to arrive at proper harmony and proportion; and that the most worthy subjects are historical themes, not scenes of daily life. These precepts are all obviously contrary to the aims of traditional Dutch genre painting and demand an entirely different concept of the function of art. As early as 1671, Jan de Bisschop published his *Paradigmata Graphices variorum Artificum* with etchings after classical sculpture for Dutch artists to study. Sandrart's *Teutsche Academie*, published at Nuremberg between 1675 and 1679, advised artists to study classical art in Italy and to conform to the rules and canons of the ancients. Samuel van Hoogstraten published his *Inleyding tot de Hooge Schoole der Schilder-Konst* in 1678, a handbook of artists arranged in nine books, corresponding to the nine muses, which also advocated painting "by the rules." Throughout the remainder of the 17th century, other theorists—Baldinucci, Félébien, and De Piles, among others—continued to promote a classicizing approach to art. Lairesse himself became a lecturer on art theory in the 1690's, after blindness had terminated his career as a painter. These lectures were published at the beginning of the 18th century in two popular volumes: *Grondlegginge ter Teekenkonst* (1701) and *Het Groot Schilderboek* (1707).

With the exception of several Rembrandt studies, little attention has been given in the literature to the impact of academic classicism, or classicistic criticism, upon Dutch artists whose styles had been formulated earlier in the century (S. Slive, *Rembrandt and His Critics 1630-1730* [The Hague, 1953]; J. Emmens, *Rembrandt en de*

Regels van de Kunst [Utrecht, 1968]; A. Blankert, "Rembrandt, Zeuxis and Ideal Beauty," in *Album Amicorum J. G. van Gelder* [The Hague, 1973], pp. 32–39).

41. Aside from a family portrait dated 1670 (cat. nr. 61; Fig. 156), Ochtervelt's late dated works include two genre interiors of 1671 (cat. nrs. 63 and 64; Figs. 75 and 77); an Italianate garden scene and a regent portrait dated 1674 (cat. nrs. 82 and 83; Figs. 163 and 94); an historical subject of 1676 (cat. nr. 91; Fig. 102); and a final dated interior of 1677 (cat. nr. 98; Fig. 110).

42. E. Snoep-Rietsma, "De Waterzuchtige Vrouw van Gerard Dou en de Betekenis van de Lampetkan," in *Album Amicorum J. G. van Gelder* (The Hague, 1973), pp. 285–92. This author also points out (pp. 288, 291, fn. 28) the significance of the string of pearls as a symbol of purity in Dutch toilette scenes. (A broken strand symbolizes lost chastity.) In Ochtervelt's painting a pearl necklace appears on the table next to the pitcher and basin.

43. E. de Jongh, "Vermommingen van Vrouw Wereld in de 17de Eeuw," in *Album Amicorum J. G. van Gelder* (The Hague, 1973), p. 202. See also, E. de Jongh, "Realisme en Schijnrealisme in de hollandse Schilderkunst van de 17de Eeuw," in *Rembrandt en zijn Tijd* (Brussels, 1971), p. 180. The Pittsburgh painting is the only one of Ochtervelt's interiors to include a full world map.

44. Ochtervelt's name also appears in the taxation register of the City of Amsterdam in 1674, which is further evidence of his residence there. See Appendix to Documents.

45. See note 40.

46. Variants of this figure, wearing the same costume, appear in cat. nrs. 95–97; Figs. 107–109.

47. Ochtervelt witnessed two wills in Rotterdam: on December 23, 1661, and on September 8, 1664. See Appendix.

The Entrance Hall Paintings and Related Genre Themes

As a genre painter, Ochtervelt concentrated primarily upon the activities of the patrician class of Dutch society. Depictions of peasants are rare in his *oeuvre*.[1] He did give them a significant role, however, in an important series of "entrance hall" paintings, which show the foyer of a Dutch house with an open doorway at which street musicians or food vendors appear. In developing the entrance hall theme, Ochtervelt was able to expand his subject matter to include low-life types while retaining his major emphasis on the bourgeois interior and its inhabitants. The fact that he painted at least nine entrance hall scenes at various stages of his career reveals his interest not only in exploring the relationship between different levels of society but also in defining the contrast between the secluded inner world of the Dutch household and the life of the city beyond its doors.

The Dutch entrance hall (*voorhuis*) served, as its name implies, as the foyer or vestibule for the entire house and was the site of both communication and commercial exchange with the outside world.[2] From the entrance hall, which received natural illumination through the tall façade windows, doors and stairways led to the interior of the household—as illustrated by an architectural study in pen and wash attributed to the Rembrandt School and now in the British Museum (Fig. 118). This area, however, functioned as far more than a passageway. Often richly decorated as a formal living room, it was also an important center of family life and activity. For example, a signed but undated painting by Ludolf de Jongh (Fig. 119; present location unknown) shows an elegant tiled *voorhuis* with a woman sewing and a maid descending the staircase with fresh linen, as the lady of the house receives a letter from a liveried messenger. A large, gold-framed painting above the figures presents a witty mythological counterpart to the visitor's intrusion into this peaceful sphere of feminine activity: Acteon stumbling upon Diana and her maidens. The presence of a world just outside the entrance hall is further implied by the confrontation of the courier's hound with the domestic spaniel in the foreground and by the light streaming through the large windows at the left.

The entrance hall setting could also be used as a device to set up an explicit contrast between outside and indoor space and light, as in Pieter de Hooch's *The Letter,* dated 1670 (Fig. 120), in the Rijksmuseum. Here, only members of the immediate household appear within the muted half-light of the interior, while an arched doorway and open window frame sunlit views of a canal bordered by trees and buildings.

Oddly enough, entrance hall scenes are relatively rare in Dutch genre painting. Indeed, Ochtervelt seems to have depicted them more frequently than any of his contemporaries. Like De Hooch, he usually chose this setting as a means of combining interior and cityscape, but Ochtervelt was clearly more interested in focusing upon the interaction of human beings at the threshold of the house than in De Hooch's abstract pictorial interplay of light and architecture. In comparing his treatments of the theme to those by other artists, one is struck by his selectivity and by his manipulation of the setting for special expressive ends. Details of the interior are reduced to a minimum. Most significantly, Ochtervelt omits or masks the large façade windows of the entrance hall, so that the open doorway becomes his compositional and narrative center of interest.

The advantages of this schema are already apparent in the artist's earliest entrance hall painting: the Berlin *Street Musicians at the Door* (cat. nr. 16; Fig. 121) which seems to date from the same period as his inn scenes of the early 1660's (cat. nrs. 14, 15; Figs. 25, 26). The open door, framing the young violinist and old hurdy-gurdy player, allows them to communicate with the inhabitants of the household, but it also establishes the separation of their different worlds. Ochtervelt subtly underlines this distinction through his handling of color and light, for the wet nurse and her two young charges within the interior are dressed in brighter colors and are more strongly illuminated, while the peasants in their simple brown costumes have their backs to the light. Despite these careful adjustments, the attention of the figures seems rather dispersed, and the cityscape beyond the open doorway is only tentatively defined, suggesting that the Berlin painting was Ochtervelt's first experiment with an entrance hall theme.

Ochtervelt treated the same subject with greater concentration and a more complex interaction of interior and exterior in his *Street Musicians at the Door,* dated 1665 (cat. nr. 24; Fig. 122), in St. Louis. In this scene the musicians are far more vivacious and individualized, and although the artist still makes the contrast between itinerant peasants and comfortable householders, he stresses their uninhibited delight in their own performance more than he emphasizes their poverty. The lively attitudes of the maidservant and child at the threshold, contrasting to the stiff decorum of the seated lady at the left, create a center of reciprocal action and reaction at the transition between household and street. Even the cityscape, now fully defined by a row of sharply foreshortened buildings, contributes to the focus of the scene: at a tiny upper window in the background appears a woman who, like the people in the foreground, has been drawn from her shuttered interior by the sound of the music.

When Ochtervelt returned to this theme once again in the early 1670's (Rijksmuseum; cat. nr. 62; Fig. 134), he no longer used it to establish the same relationship between interior and exterior. In the later work the musicians perform, not at the threshold, but within the richly decorated hallway itself, so that the figures are all compressed within the same space. The foreshortened doorway at the left allows only a narrow view of the outdoors, although the large landscape painting behind the figures offers an artificial vista to the outside world. As in many of the artist's later works, compositional elaboration tends to diminish the narrative subtleties captured in earlier versions of the same theme.

Like his frequent depictions of music lessons and concerts, Ochtervelt's street musicians illustrate the pervasive, and varied, presence of music as an accompaniment to Dutch life. In most of his entrance hall scenes, however, the artist depicted peasants hawking produce, rather than entertainment. The representation of such traveling vendors is not uncommon in Dutch art. Nicolaes Maes, for example, often depicted the confrontation of buyer and seller at the doorway of the house.[3] Even Rembrandt created a memorable version of the theme in his famous etching *Rat Catcher* of 1632 (Bartsch 121), in which a bizarre peddler with a basket of dead rodents stands at the entrance to a cottage, offering rat poison to the inhabitant, who reaches reluctantly for it while recoiling in disgust from the exterminator's touch.

Most artists who treated such subjects, like Maes and Rembrandt, chose an outdoor setting, at the exterior threshold of the house. In shifting to the entrance hall itself, Ochtervelt not only shifted the main emphasis from exterior to interior but from seller to buyer as well. As in his music scenes, however, he continued to employ the open doorway as a means of framing the visitor and relating him to the outside world from which he has come. In Ochtervelt's *Fish Seller at the Door* (cat. nr. 41; Fig. 123), in the Mauritshuis, which can be dated about 1667-68,[4] a bearded, roughly clad peasant with a basket of fish under his arm pauses at the threshold as he politely tips his hat to the woman and child in the foyer. Transition to the view of the canal and buildings behind him is effected by the presence of two children seated in the sunlight on the front steps, weighing pebbles in a toy scale made of walnut shells. Like the fish seller, the woman and child seem to have just arrived at the entrance hall from the shadowed doorway behind them. The progression of the figures—from outside and from inside the house—toward their confrontation is further implied by the converging lines of the floor tiles at their feet.

Only one of Ochtervelt's contemporaries, Quiringh van Brekelenkam of Leiden (c. 1620-68), painted the entrance hall as a site of commercial transaction. Which of the two artists should be credited with the invention of the subject is uncertain; both employ the same close, full-length view of the figures with an open doorway leading to the outside. But Van Brekelenkam's entrance hall scenes, of which his *Fish Sellers*, dated 1666 (Fig. 126), in Leipzig, is a typical example, invariably place more emphasis on the interior and its furnishings, and less on the outdoor view. In his painting the barefoot fisherwoman and her son stand well within the entrance hall, as the buyer kneels to examine the fish in the basket on the floor. Ochtervelt, by contrast, seems less interested in the actual process of buying food than in the moment of meeting between two types of people at the transition between their different worlds.

Furthermore, unlike Van Brekelenkam, who always depicted fish sellers, Ochtervelt expanded the content of his entrance hall scenes to include a variety of produce. *The Poultry Seller* (cat. nr. 50; Fig. 127; present location unknown) and its companion piece *The Cherry Seller* (cat. nr. 51; Fig. 128), in the Museum Mayer van den Bergh, Antwerp, seem to be slightly later in style than Ochtervelt's *Fish Seller* in Berlin, for both have a new intensity of focus, with the attention of every figure directed toward the doorway. In these beautifully painted pendants, perhaps the finest of Ochtervelt's entrance hall scenes, the interiors are cast into deep shadow, and a lively irregular pattern of highlighting accents the figures gathered around the open door. This selective manipulation of light in *The Poultry Seller* not only draws the usual distinction between members of the household and the jovial visiting peasants but also sets up a clever contrast between the women within the interior: the delicate, refined profile of the lady making payment at the left versus the endearingly

pudgy profile of her servant receiving the plump bird at the right. In the Antwerp *Cherry Seller* a brilliant pool of sunlight, cast through an arched doorway onto the floor of the entrance hall, frames the young girl selecting the crimson fruit. Here an especially close relationship between indoors and outdoors is established, since the peasant woman at the threshold is also fully lighted, as is the couple strolling along the street below, who turn to watch the transaction in progress. The transition between the lighted center of this composition and the surrounding darkness of the interior is accomplished with remarkable subtlety through the placement of mistress and maid, who stand within the shadows but lean partially into the sunlight, at either side of the doorway. Ochtervelt's handling of light equals the sureness of a Vermeer or a De Hooch in details such as the head of the servant at the left, whose white coif becomes gradually saturated with sunlight, revealing the contours of her veiled neck and profile.

Two entrance hall scenes in the Hermitage, Leningrad, one dated 1669, were probably also painted as pendants. The dated *Grape Seller* (cat. nr. 54; Fig. 130), with its diagonally tiled floor, large wall map,[5] and Vermeer-like clarity of light, relates closely in style to Ochtervelt's *Dancing Dog* in Hartford (cat. nr. 57; Fig. 55), also dated 1669. Although the doorway is shifted here to the left as in the Amsterdam *Street Musicians* (cat. nr. 62; Fig. 134), which was discussed earlier, the strongly geometric design and ample display of open space, both inside and outside the entrance hall, prevent the crowded compression found in the later work. Women of diverse types and ages gather at the threshold, as the child playfully feeds grapes from the fruit vendor's scales to the kneeling maid. The masculine counterpart to this scene is the Leningrad *Fish Seller* (cat. nr. 55; Fig. 132), in which the open doorway is again centered in the scene and the same old woman now appears with a basket of fish. But in this work, it is the master of the household who greets her. The relaxed cameraderie of the figures shows that Dutch street vendors must have called regularly at the same houses, where they were personally greeted and welcomed as familiar visitors. Like its companion piece, this firmly structured composition is built up of repeated diagonals and counterdiagonals, characteristic of Ochtervelt's style at the end of the 1660's,[6] that reinforce the animated mood of the scene.

Ochtervelt's last entrance hall scene, another depiction of fish sellers at the door, in the Pushkin Museum, Moscow (cat. nr. 103; Fig. 135), reveals the same uneasy elaboration of design, dispersion of focus, and technical deterioration found in other works of about 1680 (cat. nrs. 101, 102; Figs. 114, 115). Typical of this period is the fact that the artist has expanded his cast of characters to include both husband and wife and two maids—even two dogs—in order to make the subject more imposing.

Even though Ochtervelt's entrance hall paintings decline in quality at the end of his career, his inventive and varied use of the theme should be considered one of his finest and most original contributions to 17th-century Dutch art. Indeed, his unique definition of the communication of Dutch householders with the world of the street has no parallel in the works of any of his contemporaries. At least one 19th-century Dutch artist must have been deeply impressed by his development of the subject. Hendrik Bergen's *The Welcome* (Fig. 136),[7] formerly in the Morrissey Collection, Cork, Ireland, employs Ochtervelt's special compositional schema, along with historicizing 17th-century costume, for a scene of familial reunion at the threshold of an entrance hall.

With the exception of his entrance hall paintings, few of Ochtervelt's domestic interiors depict activities relating in any way to the practical side of running a household. He almost always preferred to represent women—his major subject—amusing themselves at the feast or game table,

adorning themselves in the boudoir, or enjoying the pleasures of making or listening to music. His range of subject matter, in other words, is considerably narrower than that of most of his contemporaries who painted similar themes. The *oeuvres* of De Hooch, Ter Borch, Metsu, and even Vermeer also encompass such subjects as kitchen maids, lacemakers, and women sewing, spinning, or actively caring for children.[8]

There are, in fact, only two interiors that depict women engaged in specific household duties. It is perhaps significant that one of these (cat. nr. 17; Fig. 142) is also Ochtervelt's only known peasant interior: the signed *Peasant Spinners*, formerly in Leipzig, in which an old woman working at a spinning wheel and an old man winding thread on a bobbin appear in a simple interior with a dirt floor. This unusual work, destroyed in World War II and now known only through photographs, is difficult to date, especially as the peasants are rather different in type from those in Ochtervelt's entrance hall scenes. Perhaps it should be placed in the early to mid-1660's, a time when Ochtervelt was under strong influence of the Leiden School. The sharp light/dark contrasts and laborious definition of faces and textural surfaces suggest connections to Leiden painters such as Jacob Toorenvliet and Domenicus van Tol.[9] The subject of this work may also relate to an emblem (Fig. 143) from Johan de Brune's *Emblemata of zinne-werck*, published in Amsterdam in 1624. In the emblem a similar elderly pair works together in an interior, illustrating the virtue of joint labor that is not done for worldly profit. Indeed, the motif of the woman spinning, also seen in the emblem, was a common symbol of domestic virtue in Dutch genre painting.[10]

More typical of Ochtervelt's style and choice of subject matter is his *Lady and Maid Choosing Fish* (cat. nr. 67; Fig. 137; private collection, England), datable by costume to the early 1670's, in which a lady seated beside a sewing basket makes a selection from a platter held by her maidservant. This scene, which certainly relates to the artist's entrance halls with fish sellers, may even take place in the corner of a *voorhuis*, as suggested by the large windows and arrangement of narrow benches against the walls (cf. Fig. 118). Again, Van Brekelenkam may have been Ochtervelt's source. His *Interior with a Lady Choosing Fish*, dated 1664 (Fig. 141), in the Assheton Bennett Collection, Manchester, shows exactly the same subject, although the room is more elaborately furnished and a fish seller appears at the right background.[11] The exceptional quality of Ochtervelt's version, with its selective, concentrated design and sense of warm communication between mistress and servant, must have been recognized, for at least three copies after the painting exist (cat. nrs. 67A-C; Figs. 138-140).

In seaport cities such as Rotterdam, the selection of fish could also, of course, be made at the source—the harbor fishmarket. Indeed, one Rotterdam artist, Hendrik Martensz. Sorgh, made something of a specialty of these open-air market scenes in paintings such as his dated *Fish Market* of 1655 (Fig. 144), also in the Assheton Bennett Collection. Ochtervelt, too, treated this theme in his signed *Fish Market* (cat. nr. 52; Fig. 145), in Vienna, his only outdoor genre painting of this type.[12] Similar in style to the Antwerp *Cherry Seller* of about 1668-69 (cat. nr. 51; Fig. 128), the painting in Vienna shows a maidservant doing the family shopping beneath the canopy of a fishwife's stall. Beyond this shaded foreground, a varied crowd of buyers and sellers mingle in the bright sunlight at the harbor's edge. Sorgh's market scenes, by contrast, are monochromatic, more evenly lighted, and place the primary emphasis on peasant types. Closer parallels to Ochtervelt's conception can be found outside Rotterdam, in the market scenes of the Amsterdam architectural painter Emmanuel de Witte. For example, De Witte's *Fish Market* of about 1661-63[13] (Fig. 146), in the London National Gallery, uses the same device of isolating principal figures of different types under a foreground canopy and contrasting them with a crowded background scene in strong sunlight. Unlike Sorgh and De Witte, however, Ochtervelt departs from the usual interpretation of such scenes by totally

omitting the elaborate fish still life. As in his entrance hall paintings, his real interest is clearly not the produce offered for sale, but the varied human confrontations that evolve in the process of selling it.

Notes

1. Only two pure peasant paintings by Ochtervelt are known: the signed *Peasant Smoking* (cat. nr. 31; Fig. 65), in the Kunsthalle, Hamburg, and the signed *Peasant Spinners in an Interior* (cat. nr. 17; Fig. 142), formerly in the Leipzig Museum der bildenden Künste.

2. For discussion of the Dutch entrance hall and how it was used, see P. Zumthor, *La Vie Quotidienne en Hollande au Temps de Rembrandt* (Paris, 1959), p. 55 ff; and N. de Roever and G. Dozy, *Het Leven van onze Voorouders*, 6 vols. (Amsterdam, 1892-1906), 4: 42 ff. Ir. R. Meischke and H. J. Zantkuijl, *Het Nederlandse Woonhuis van 1300-1800* (Haarlem, 1969), traces the development of floor plan and elevation in Dutch domestic architecture from the medieval period to the end of the 18th century.

3. Ill., W. R. Valentiner, *Nicolaes Maes*, Klassiker der Kunst (Stuttgart, 1924), pp. 45-47; and F. W. Robinson, *Gabriel Metsu* (New York, 1974), pp. 125-27.

4. On the dating of Ochtervelt's painting in the Mauritshuis, see notes to cat. nr. 41; Fig. 123.

5. The identification of this map, which appears in other paintings by both Ochtervelt and his contemporaries, is discussed in the notes to cat. nr. 40; Fig. 46.

6. Similar diagonal compositions appear in cat. nrs. 45, 56, and 57; Figs. 51, 54, and 55.

7. I am indebted to Willem van de Watering of the Rijksbureau voor Kunsthistorische Documentatie, The Hague, for pointing out Bergen's painting and its relationship to Ochtervelt's entrance hall scenes. Peter Sutton has also brought to my attention similar scenes by Abraham van Strij (1753-1826). Van Strij's *Entrance Hall with Food Seller* (Rijksmuseum, nr. 2274.A1) is especially close to prototypes by Ochtervelt.

8. In two of his small, half-length compositions, however, Ochtervelt did depict women involved in active maternal or household tasks: *Woman Nursing a Child* (cat. nr. 29; Fig. 67), in the Kunsthaus, Zurich, and *Cavalier and Maid on a Balcony* (cat. nr. 89; Fig. 73), now in the Zurich art trade. His full-length *Nursery* (cat. nr. 73; Fig. 84), in the Count Labia Collection, Capetown, also shows a mother and child, but the infant is clearly in the charge of the wet nurse.

9. The peasant types of Jacob Toorenvliet, with their sunken faces, thin mouths, and ridged foreheads, seem especially close to these Ochtervelt figures. See, for example, Toorenvliet's *Old Peasant Woman with a Distaff*, signed and dated 1667, in the Kunsthalle, Karlsruhe (ill., W. Bernt, *The Netherlandish Painters of the Seventeenth Century* [London and New York, 1970], vol. 3, nr. 1188).

10. The symbolism of the spinner and De Brune's emblem are discussed in E. de Jongh, *Tot Lering en Vermaak* (Amsterdam: Rijksmuseum, 1976), p. 49. Further discussion of the spinner is found in the same catalogue, pp. 41-43.

11. According to F. G. Grossmann, *Catalogue of Paintings and Drawings from the Assheton Bennett Collection* (Manchester, 1965), p. 10, nr. 11, a close variant of the same scene, also signed by Van Brekelenkam and dated 1664, was sold in Dusseldorf, March 23, 1939, nr. 4.

12. Ochtervelt did paint outdoor genre scenes in his early period during the late 1650's (cat. nrs. 2-6; Figs. 5, 8, 10, 11, 14), and he returned to an outdoor setting for two of his late genre paintings of the mid-1670's (cat. nrs. 83 and 84; Figs. 94 and 96). All of these works, however, employ imaginary, usually Italianate settings rather than the specific contemporary milieu depicted in *Fish Market*.

13. The date of De Witte's *Fish Market* has been convincingly established by documentary evidence that also indicates this work may be a portrait of the wife and daughter of De Witte's Amsterdam patron Joris de Wijs. A discussion of the documents and literature relating to this painting is given in Neil MacLaren, *National Gallery Catalogues: The Dutch School* (London, 1960), pp. 458-62.

3

The Development of Ochtervelt's Portrait Style

Twelve portraits by Jacob Ochtervelt are known, seven of which are signed and dated. This small group of paintings, however, encompasses a considerable range of portrait types. In the majority of his portraits, the artist depicted families or couples in domestic interiors—a natural preference for a specialist in genre subjects. Yet Ochtervelt also experimented with various other types: a pastoral portrait in a landscape, a militia portrait, a self-portrait, a single portrait, and even a regent group portrait. Diverse in style as well as in type, Ochtervelt's portraits seem to follow an evolution quite independent of his genre paintings.

This distinction is most obvious in the artist's early portraits, two of which are dated 1660 (cat. nrs. 12, 13; Figs. 147, 148); the style of these works is totally different from that of his genre paintings of the same period (cat. nrs. 11, 14, 15; Figs. 23, 25, 26). Indeed, the closest parallels to the pastoral setting of Ochtervelt's *Children and Frisian Nursemaid in a Landscape* (cat. nr. 12; Fig. 147; Private collection, England) can be found, a decade earlier, in his landscapes with figures (cat. nrs. 1, 2; Figs. 3, 5) painted under the influence of Berchem and other Dutch Italianate artists. Nonetheless, the hilly, wooded setting for this portrait group, which includes the ruin of a classical building at the center background, is by no means identical in style to the more simplified landscape backdrops found in Ochtervelt's early genre scenes. This finely detailed setting may even have been contributed by another artist, for the figures are not, in fact, strongly integrated with their surroundings. In the foreground three elaborately dressed children appear with their nursemaid, who wears the provincial costume of West Friesland. Their relationship to the outdoors is suggested primarily by their gestures and by the objects they hold, which seem to function as "attributes" of the world of nature. One child points to a bird's nest,[1] and another caresses a tame sheep, while the youngest girl prepares to crown her dog with a little flower garland.

In this early portrait the figures have an almost primitive stiffness, accentuated by their rather

40

frozen gestures and facial expressions, and also by the doll-like proportions of the children's slender bodies with their large heads and tiny hands. The closest comparison to these figure types that can be made within Ochtervelt's *oeuvre* is his *Granida and Daifilo* (cat. nr. 1; Fig. 3), painted at least a decade earlier. By 1660 Ochtervelt had developed a completely different style in genre painting, as seen, for example, in *The Feast*, of about 1658–60 (cat. nr. 11; Fig. 23), in Prague, in which the large, freely painted forms of the figures are solidly modeled by light and shadow.[2]

Although completely different in subject, Ochtervelt's *Portrait of an Ensign*, also dated 1660[3] (cat. nr. 13; Fig. 148), in the Dienst Verspreide Rijkscollecties, The Hague, incorporates similarly slender, rather limpid figure types with delicate hands and minutely observed, finely painted costumes. Ochtervelt must have derived this composition from an Amsterdam tradition for such small-scale, full-length likenesses of sitters in occupational surroundings, popularized earlier in the century by Thomas de Keyser (c. 1596–1667). As in De Keyser's *Portrait of Constantijn Huygens and His Clerk*, dated 1627 (Fig. 149), in the National Gallery in London, Ochtervelt's ensign is seated and turns toward a secondary figure, who approaches him, hat in hand. This format may well have been selected because the sitter belonged to an Amsterdam militia group. Neither the identity of the man himself nor that of his company has been established, but a portion of the Amsterdam coat of arms is visible at the top of the orange flag he holds.[4] Aside from his meticulous definition of the ensign's costume and accoutrements,[5] Ochtervelt has also evoked the context in which the man performed his ceremonial duties. Through the open portico at the left, uniformed men with plumed helmets muster for parade, while other members of the company linger in discussion around a table at the far right.

More typical of Ochtervelt's approach to portraiture are his depictions of Dutch families in household interiors, the earliest of which is a dated portrait of 1663 (cat. nr. 18; Fig. 150), in the Fogg Art Museum, Cambridge, Massachusetts. The three figures in this scene are much plainer and more simply dressed than Ochtervelt's elegant *Ensign*, but they retain the rather shortened proportions, large heads, and small hands found in both portraits of 1660. A similar interest in the juxtaposition of differently lighted spaces is also evident, for beyond this simple interior with its scrubbed wooden floor is a more elaborate, brightly lighted room with a marble fireplace and tiled floor.

Both the large bookcase behind the figures and the open volume on the table suggest that Ochtervelt has represented the family of a scholar or clergyman. A formal connection between parents and child is established by the mother's gesture, but the figures remain quite isolated from one another. Indeed, this portrait seems to set up a specific contrast between the sobriety of adulthood and the more lighthearted pursuits of youth. Unlike the plainly dressed couple with their solemn facial expressions, the smiling child, whose toys are scattered at the left, is engaged in playfully coaxing her spaniel to sit up on its hind legs. In teaching her pet, she forms a childish parallel and counterpart to her father's more serious instruction of the family from the open book before him. Interestingly enough, the same appealing motif of a child instructing a dog is the subject of a slightly earlier portrait, dated 1661, by Ochtervelt's Rotterdam colleague Ludolf de Jongh (Fig. 151), in the Virginia Museum of Fine Arts, Richmond. As mentioned earlier, De Jongh seems to have influenced the artist's early landscape style (see cat. nr. 2; Fig. 5 and Fig. 7), so it is likely that Ochtervelt was familiar with his portraits as well.[6]

As Ochtervelt's portrait style develops, he continues to place his sitters in specific, homelike surroundings, but he begins to create less static groupings that suggest a closer and more natural

relationship among family members. Such "conversation pieces,"[7] which became popular with Dutch patrons after midcentury, have much in common with genre painting and were intended to evoke the intimacy of family life, while often suggesting the material wealth and social refinement of the sitters. Thus, Ochtervelt's *Family Portrait* (cat. nr. 19; Fig. 152), in the Wadsworth Atheneum, Hartford, Connecticut, which is dated 166(4?),[8] presents a seemingly casual arrangement of seven figures in the corner of an interior with a richly decorated fireplace, gold-framed paintings, and a large Italianate tapestry of a seated women surrounded by putti.[9] As in Metsu's similar *Family Portrait* (Fig. 153), dated about 1657,[10] in Berlin-Dahlem, the figures are shown in a variety of poses, and all members of the family have been represented, including the nursemaid and the children's pet spaniel. Ochtervelt has even revealed that the woman holding the baby is its wet nurse, for her breast is exposed and the child's hand rests upon it. The dominant focus of this composition, however, is the standing mother at the left, who displays an orange in her left hand—perhaps an allusion, hardly necessary here, to the fruitfulness of her marriage.[11]

In its muted coloring, treatment of faces, and placement of the figures on a plain wooden floor, the Hartford portrait remains close in style to Ochtervelt's painting in Cambridge, dated only a year earlier, although the figures now have slightly taller proportions and are more varied in pose and gesture. The artist's portrait style, however, still remains quite distinct from that of his genre paintings of the same period, for the dated *Street Musicians* of 1665 (cat. nr. 24; Fig. 122), in St. Louis, is not only more colorful and more luminously painted but also displays a far more rhythmic, angular design, accented by strong contrasts of light and shadow.

By about 1670 Ochtervelt's family portraits begin to display something of the stylistic refinement and coloristic opulence found in his later genre paintings, as figure types become more slender and both costumes and settings take on a new richness and formality. *A Family Portrait* of this period (cat. nr. 60; Fig. 154; Dienst Verspreide Rijkscollecties, The Hague), which can be dated about 1670 on the basis of costume, presents the subjects in an unusual, almost stagelike setting. Seated within a raised alcove, the head of the family is flanked on either side by his wife and children, who stand or sit on the steps of the platform and upon the tiled marble floor in the foreground. The large mural behind him is a variant of the Italianate tapestry seen in the Hartford portrait.

In this painting the artist creates an air of distance between sitters and viewer, which is very different from the intimacy of a conversation piece. The motionless poses of the figures, their rather expressionless faces, and their formal placement in a semicircular grouping preclude direct inter-action among members of the family. A comparison of this work to the earlier portraits in Cambridge and Hartford (cat. nrs. 18, 19; Figs. 150, 152) reveals that, although Ochtervelt does not strongly evoke the individual character of any of these sitters, he seems to become progressively more concerned with defining the family in terms of its social refinement. In the Dienst portrait, the songbooks held by the two daughters, along with the books and recorder scattered at the right, serve as further allusions to the cultivated taste and manners of the sitters. Other Dutch portraitists active at the same period also use musical motifs to suggest the elegance of the sitters, but they often show the figures actually performing together, as an expression of the harmony and unity of family life.[12] For example, Jan Verkolje's *Family Portrait*, dated 1671 (Fig. 155), in the Kunsthaus, Zurich, depicts the sitters performing a full-scale concert within an elaborate loggia with pulled curtains; additional

motifs such as the bowl of fruit and the floral bouquet held by the children at the left suggest the cultivation and refinement of all the senses.

Similar to the Dienst portrait in figure types and costume, Ochtervelt's *Family Portrait*, dated 1670 (cat. nr. 61; Fig. 156), in Budapest, shows a return to a more informal grouping of figures within a fully defined household interior. This imposing room with its white marble floor and carved fireplace even opens at the left background into a De Hooch-like view of a secluded outdoor courtyard. Concentrated in the right foreground, the figures appear in the focus of the light, set off against the shadowed interior behind them. Thus, the carefully selective foreground illumination that Ochtervelt had developed earlier in his genre scenes now begins to appear in his portraits. The increasingly animated poses of the figures also reveal closer connections with genre painting; as the older daughter approaches her parents from the left, bearing a silver tray of fruit, her younger sister turns away from her mother to encourage the spaniel to dance on its hind legs. The same motif of the dancing dog appeared in two of Ochtervelt's genre interiors of 1669 (cat. nrs. 56, 57; Figs. 54, 55).

The gradual convergence of Ochtervelt's genre and portrait styles seems to culminate in his portrait of a couple with their young daughter (cat. nr. 66; Fig. 157), in the Norton Simon Museum, Pasadena. This work can be dated about 1671, since the costumes, figure types, and lighting are strikingly similar to the artist's *Tric-trac Players* in Leipzig (cat. nr. 64; Fig. 77), which is dated in that year. In the Pasadena portrait, the figures, placed in the immediate foreground, completely dominate the picture space and are arranged in a graceful, pyramidal composition whose lightness and rhythm strongly recall Ochtervelt's genre interiors of the late 1660's and early '70's, as does the brightly patterned Turkey carpet on the table at the left. A new concentration of focus is created, as the gestures and poses of both mother and daughter are directed toward the central male figure, who stands slightly beyond the lighted foreground in muted, transparent half-shadow. Ochtervelt seems to have derived the pose of the child at the right from a similar figure in his portrait in Budapest, but in the later work the girl is far more active and runs impetuously toward her parents with her spaniel prancing joyously beside her.

In earlier portraits Ochtervelt had repeatedly employed the same general facial types, regardless of the age or sex of the figures, and had made little effort to distinguish the moods or personalities of individual sitters. Interestingly enough, the merging of the artist's portrait and genre styles seems to have given him a new freedom and assurance to explore finer variations in human appearance and expression. Indeed, the faces of the couple in the Pasadena portrait are captured with a sympathetic directness and individuality almost worthy of Ter Borch.

Even closer affinities with genre painting are evident in Ochtervelt's latest family portraits (cat. nrs. 81, 90; Figs. 158, 159), both of which depict couples engaged in music making. In each work the representation of a duet, which serves to unite the figures in a specific activity, may also be understood as an allusion to the harmony of marital love.[13] Similar in style to the Pasadena painting, the portrait in Augsburg (cat. nr. 81; Fig. 158) shows a seated man tuning his cello as his wife sounds a key on the virginals. Both figures appear in the focus of the light before a shadowed interior with an elaborate fireplace at the right and an open door leading to the outside at the left background: a close variation of the setting used in the Budapest portrait of 1670 (cat. nr. 61; Fig. 156). In the later work, however, Ochtervelt has created a far more complex physical and expressive milieu for the sitters. The floor tiles at the left serve as a perspective grid to draw the viewer's attention directly into a long

corridor, through varying intensities of light and shadow, to the open doorway, where a man and woman pause at the threshold. Further in the distance a woman looks out the half-door of her house. One has the impression that these people, like the attentive spaniel in the foreground, have stopped to listen to the performers, whose music reverberates through both the interior and outdoor spaces.

In a later compositional variant of the Augsburg portrait (cat. nr. 90; Fig. 159), now in a private collection, in Milan, Ochtervelt presents a similar couple within a shallower, less fully defined interior. Yet the ornate satin and velvet costumes of these figures, which date the painting in the mid to late 1670's, add such richness to the scene that no further attributes of wealth are needed. Both the standing singer and the seated cellist, shown during a pause in their concert, gaze directly at the viewer with slight smiles, as if responding to our presence. While these musicians are less active than the couple in the Augsburg portrait, they are just as individualized, and the composition seems equally fluid and balanced. The rectangle of the fireplace behind the pair frames their heads, while the diagonally tiled floor, seen earlier only in Ochtervelt's genre scenes, disperses attention equally from figure to figure, reinforcing their diagonal placement within the design as a whole.

Only two single portraits by Ochtervelt are known (cat. nrs. 30, 104; Figs. 160, 162), both very small in scale. As noted previously, Ochtervelt's *Self-Portrait* as an artist, signed and dated 166(?),[14] (cat. nr. 30; Fig. 160; Bundesdenkmalamtes, Vienna) can be related to a series of small-scale genre figures, dating from the mid-1660's, for which the artist seems to have used himself as model (cat. nrs. 25, 31, 33–35; Figs. 60, 65, 61, 63, 64). Just as Ochtervelt had represented himself in the varied activities and accoutrements of soldier, musician, and peasant, here he appears in yet another guise: that of his own profession. Indeed, although this portrait probably records the artist's features quite faithfully, it seems to function more as a generic definition of the sitter's occupation than as an exploration of individual character or mood. Leaning on the back of a chair behind a wooden sill that displays his palette and brushes, the artist gazes at the viewer with an expression of cool, aloof detachment. Eyes, hand, and painting implements (significantly juxtaposed to a burnt match stick that acts as a subtle *Vanitas* allusion) become the main points of focus in this highly selective composition. Paradoxically, Ochtervelt's costumed depictions of himself in the guise of other professions or ways of life seem far more intimate and approachable than his self-portrait, in which the penetrating but remote gaze of the artist and the foreground sill set up barriers that discourage close communication between viewer and sitter. The self-contained mood of this painting becomes even more striking when it is compared to an undated self-portrait by Frans van Mieris (Fig. 161; Lakenhal, Leiden). Van Mieris, whose genre paintings strongly influenced Ochtervelt during the 1660's, chooses a similar costume, composition, and format but shows himself, in the process of painting, as a jovial extrovert who makes direct emotional contact with the viewer. Moreover, in the Van Mieris portrait, the artist's costume overlaps the foreground sill so that it acts not as a barrier, but as a pictorial intermediary between viewer and sitter.

Ochtervelt's signed *Portrait of a Boy with Bird's Nest* (cat. nr. 104; Fig. 162; present location unknown), which can be dated more than a decade later, depicts a three-quarter-length view of a young man wearing the costume of the late 1670's or early '80's, leaning on a stone parapet before a background of trees and sky. Since this work is unique in Ochtervelt's *oeuvre* in subject, composition and format, it is difficult at first glance to see its stylistic connections with the artist's other portraits. However, comparison of this youth to the young son in the Dienst *Family Portrait* (cat. nr. 60; Fig. 154) reveals strong similarities; the oval faces of both children with their large, grave eyes and

faintly smiling mouths have an almost familial resemblance. The motif of the bird's nest with four fledglings, which the boy holds in his left hand and points to with his right, may have been intended as a play on the name of the unknown sitter, as an emblematic reference, or perhaps, like the nest in Ochtervelt's children's portrait of 1660 (cat. nr. 12; Fig. 147), it was added to relate the sitter to his outdoor surroundings.[15]

Ochtervelt dealt with still another portrait type in his *Regents of the Amsterdam Leper House* (cat. nr. 82; Fig. 163), in the Rijksmuseum, Amsterdam, which was painted in 1674, immediately after his move from Rotterdam to Amsterdam. Ochtervelt's largest painting, this group portrait is, nonetheless, only about three-quarter life size, rather than the full-size scale traditionally used for Amsterdam regent pieces. Since Ochtervelt was not a specialist in portraiture of this type, he may have felt more confident working on a smaller scale, or perhaps the dimensions of the room for which the work was commissioned required a smaller size. At any rate, the composition and setting of this portrait clearly derive from Amsterdam regent pieces that show the men at work around a table before a pilastered wall with relief sculptures relating to the institution the sitters serve.

A possible prototype for Ochtervelt's portrait is Karel Dujardin's *Regents of the Amsterdam Correction House* (Spinhuis), dated 1669 (Fig. 164) in the Rijksmuseum, Amsterdam, which includes a similar, although slightly larger, figural grouping, similar wall decorations, and, as in Ochtervelt's portrait, an open door at the far right with waiting or listening figures. In Dujardin's painting the symbolism of the wall reliefs acts as a straightforward play on the word "Spinhuis," since one relief figure holds a bundle of flax, another a thread, and the third the distaff or spindle. Accordingly, Ochtervelt's reliefs seem to refer to the disease of leprosy. The large panel behind the regents depicts a standing male figure with a lyre (Apollo, god of healing), while the small panel above the doorway at the right shows a reclining man with two dogs licking his legs—a reference to the parable of Lazarus, the beggar, who was covered with sores and lay at the gate of the rich man, hoping for crumbs from his table, while the dogs came and licked his sores.[16] Thus in Ochtervelt's portrait a clear relationship is suggested between the beneficent activities of the regents of the asylum and the exigencies of those who appeal to it for help—a relationship that is emphasized by the placement of the woman and children, who listen hopefully to the men's deliberations, directly beneath the Lazarus relief. At the same time, the varied treatment of the physiognomies, facial expressions, and poses of the regents themselves, convincingly unified around the boardroom table, evokes the atmosphere of an actual meeting in progress, in which each member contributes and responds individually to the common concerns of the group.

In examining Ochtervelt's portraits as a group, one is impressed not only by the wide variety of portrait types with which the artist experimented but also by the manner in which his portraiture develops in terms of quality as well as style. As mentioned earlier, the 1670's was a decade of uneven and gradually declining artistic quality for Ochtervelt's genre painting. Yet the same period saw him creating a series of consistently fine portraits that can be ranked among the most impressive works of the artist's career.

Notes

1. Ochtervelt also included this motif in his late *Portrait of a Boy with Bird's Nest* (cat. nr. 104; Fig. 162). For discussion of its meaning, see notes to cat. nr. 104.

2. Such stylistic discrepancy between portraiture and genre painting of the same period also occurs in the

works of other artists. For example, the early portrait style of Nicolaes Maes, as seen in his signed and dated *Portrait of a Dordrecht Merchant with His Wife and Children* of 1659 (North Carolina Museum of Art, Raleigh, nr. 52.9.47), is equally difficult to reconcile with the artist's genre paintings of the 1650's, such as his *Old Woman at Prayer* (Rijksmuseum, Amsterdam, nr. C 535), of about 1655. Like Ochtervelt, Maes is capable of creating such a portrait with its truncated figure types, brittle gestures, and rather masklike faces at the same time—or even after—he has painted genre scenes that seem more stylistically advanced in every way. The necessity of pleasing a patron, which can contribute to this duality, is even noticeable in one of the greatest Dutch portraitists, Frans Hals, whose early commissioned portraits (until about 1640) are tighter and more conventional in composition and technique than the genre pieces he was painting at the same period (J. Rosenberg, S. Slive, and E. H. ter Kuile, *Dutch Art and Archtecture 1600-1800* [Pelican, 1966], pp. 31-32).

3. The date of this portrait, no longer clearly legible, is discussed in the notes to cat. nr. 13; Fig. 148.

4. Ochtervelt may well have visited Amsterdam and painted this portrait there in 1660. There is no evidence that the artist became a resident of Amsterdam until 1674, but his name is not cited in any Rotterdam documents during the period between 1657 and 1661.

5. In commenting upon the elaborate dress worn by ensigns, Slive points out that only bachelors were allowed to hold this rank, since it was believed that only an unmarried man would be able and willing to bear the costs of the uniform (*Frans Hals* [London and New York, 1970], vol. 1, p. 43).

6. It may be significant that both Ochtervelt and De Jongh place the child in the presence of an object that seems to relate to the idea of transience (of youth?). In Ochtervelt's portrait a top lies motionless on the floor at the left, as in Roemer Visscher's emblem "Elck zijn Tijd" (*Sinnepoppen*, Amsterdam, 1614; ill., E. de Jongh, *Zinne -en Minnebeelden in de Schilderkunst van de 17de Eeuw* [Amsterdam, 1967], p. 79, pl. 66). A fallen rose appears at the feet of De Jongh's child.

7. For discussion of the conversation piece and its development, see S. Sitwell, *Conversation Pieces: A Study of English Domestic Portraits and Their Painters* [New York, 1937]; R. Edwards, *Early Conversation Pieces from the Middle Ages to about 1730: A Study in Origins* [London, 1954]; A. Staring, *De Hollanders Thuis. Gezelschapstukken uit drie Eeuwen* [The Hague, 1956]; M. Praz, *Conversation Pieces: A Survey of the Informal Group Portrait in Europe and America* [Pennsylvania State University Press, 1971].

8. The partially illegible date of this portrait is discussed in the notes to cat. nr. 19.

9. For speculations on the possible meanings of this scene, variants of which appear in two later portraits by Ochtervelt (cat. nrs. 60 and 61; Figs. 154 and 156), see the notes to cat. nr. 19; Fig. 152.

10. The date of Metsu's portrait is suggested in the recent catalogue of the Berlin-Dahlem Museum, which states that the painting probably represents the family of the Amsterdam Burgomaster Dr. Gillis Valckenier (*Gemäldegalerie Berlin-Dahlem, Katalog der ausgestellten Gemälde des 13. bis 18. Jahrhunderts* [Berlin, 1975], p. 279, nr. 792).

11. Interestingly enough, Kirchenbaum has given the same interpretation of the motif of oranges as references to the fruits of marriage in his discussion of Jan Steen's *The Marriage of Tobias and Sarah*, in the M. H. de Young Museum, San Francisco, in which a boy at the right foreground displays oranges to the viewer. Kirchenbaum also points out that an orange appears on the emblem page of Jacob Cats's long poem on marriage, *Houwelick* (*The Religious and Historical Paintings of Jan Steen* [New York, 1977], p. 93 and fig. 86).

12. On the association of the group portrait and the concert (as an expression of familial harmony), see P. Fischer, *Music in Paintings of the Low Countries in the 16th and 17th Centuries* [Amsterdam, 1975], pp. 76-87; and E. de Jongh, *Tot Lering en Vermaak* [Amsterdam: Rijksmuseum, 1976], pp. 183-185. De Jongh points out that this tradition can be traced back to the 16th century in paintings such as Frans Floris's *Family Portrait* in the Wuyts-Van Campen and Baron Caroly Museum in Lier (p. 183, fig. 45a). Fischer has demonstrated that the actual music being performed in certain 17th-century portraits of this kind can be identified (by reading the song books) and that it often relates specifically to the type of family represented. Thus, Abraham van den Temple's *Portrait of the Family of David Leeuw*, dated 1671 (Rijksmuseum, Amsterdam, nr. A 1972), depicts a Mennonite merchant and his family performing Gastoldi's "Lo Spensierato" (originally published in Venice in 1594 and reissued in a new Dutch edition with sacred text in 1650). The author convincingly argues that this music not only expresses the idea of familial harmony but also conveys the hope that the children may be spared

from premature death in order to have the opportunity to strive for Eternal Life ("te stre-ven Nae't eeu-wigh le-ven") (Fischer, p. 79, ill., p. 78).

13. See note 12. The use of musical motifs in genre painting and emblem illustration as allusions to the harmony of love was well established by the 17th century. The representation of music-making as a symbol specifically of marital accord already appears in 16th-century portraits such as *The Wedding Feast of Joris Hoefnagel* by Frans Pourbus, the elder (Musée Royale des Beaux Arts, Brussels, nr. 944), in which the couple dances to the music of virginals and lutes (ill., R. Edwards, *Early Conversation Pieces* [London, 1954], fig. 8). P. J. J. van Thiel has also shown that stringed instruments were common attributes of Temperance; in representations of married couples they are frequently used to symbolize the harmonious virtue of moderation, the key to a happy married life ("Marriage Symbolism in a Musical Party by Jan Miense Molenaer," *Simiolus* 2 [1967–68]: 91–99).

14. The date of this portrait (partially illegible) is discussed in the notes to cat. nr. 30; Fig. 160.

15. Further discussion of the bird's nest in Dutch portraiture and genre painting appears in the notes to cat. nr. 104; Fig. 162.

16. I am indebted to the late David van Fossen for pointing out to me the subject of this relief.

4

Conclusion

Reconstructing an artist's *oeuvre* and development is always an exciting task, and especially so when one confronts an unfamiliar figure working within a familiar context. Ochtervelt emerges as a surprisingly gifted and varied painter who was open to many influences, yet who cannot be readily classified as a direct follower of any of his contemporaries. The diversity of Ochtervelt's sources may well relate to the fact that Rotterdam, unlike other major cities in the Netherlands, did not have a strongly defined local school or style of painting. Thus, at various phases of his career, the artist responded to a number of the leading trends in Dutch genre painting outside his native city, absorbing them into his own development. Ochtervelt based his early works of the 1650's primarily upon the Italianate landscapes of Berchem and his circle and upon the figure paintings of the Utrecht School. During much of the following decade, the Leiden School—notably Frans van Mieris, the elder—provided the strongest impetus for his development of the domestic interior, as well as niche scenes and single figure studies. The closest counterparts to Ochtervelt's entrance hall scenes of this period are also found in Leiden: in the works of Quiringh van Brekelenkam. By the late 1660's, however, Vermeer and Ter Borch had become the dominant influences on Ochtervelt's style. Their impact continues throughout the 1670's, even after the artist's move to Amsterdam, which brought him into contact with Gerard de Lairesse's form of academic classicism. His latest works illustrate his attempts to reconcile these very diverse stylistic influences.

Examination of Ochtervelt's total production reveals not only varied sources of inspiration but also striking variations in quality. Both factors may have inhibited earlier understanding and appreciation of his art, especially because no chronology of his paintings had been established. It is now possible to see that most of the works of mediocre quality belong to the same late phase of Ochtervelt's style and were created during a time of general artistic decline. As a result, the bulk of his *oeuvre* becomes far more consistent, and far more impressive, in quality.

Incomplete knowledge of the archival sources has also led to a misunderstanding of Ochtervelt's position within the evolution of 17th-century Dutch genre painting as a whole. The assumption that the artist lived on into the 18th century became the basis for categorizing him as a later imitator of such artists as Vermeer, Ter Borch, Metsu, and De Hooch. Instead, he must be viewed as their close contemporary. Valentiner's comments about the "rococo" qualities of Ochtervelt's style may not have been historically correct, but they still seem valid in purely visual terms. That the artist developed this manner of painting as early as he did not only illustrates the uniquely personal quality of his style but also underlines the richness and diversity of the period in which he was active.

With the exception of his entrance hall paintings, Ochtervelt was not an especially innovative artist in terms of his choice of subject matter. His way of handling familiar themes does, however, set him noticeably apart from his contemporaries. Moreover, his basic attitudes and intentions seem to remain quite constant throughout all phases of his career. Like other Dutch genre painters, Ochtervelt usually selected subjects that reflect a contemporary Dutch milieu. Yet few of his paintings attempt to offer a fully developed illusion of the daily life of his time. Indeed, Ochtervelt's scenes are almost always handled as *tableaux vivants*. The same *dramatis personae* frequently appear repeatedly in various contexts, like pantomimists taking their places in a series of different stage sets or situations. It is interesting that Ochtervelt's earliest known painting, *Granida and Daifilo* (cat. nr. 1; Fig. 3), was based directly upon a scene from a Dutch play. His genre paintings, although certainly not derived from the theater, also convey a sense of having been carefully staged for an audience. One reacts to his protagonists as to a troupe of actors presented in the guise of everyday life.

Often, Ochtervelt's figures seem to pose more than they perform, for the artist prefers incidents of restricted narrative scope that are intended primarily to create a striking *mise-en-scène:* the offer of an oyster or a glass of wine, musical and gaming ensembles, views of the boudoir. Correspondingly, Ochtervelt's interiors seldom function as more than frameworks for his presentation of graceful figural groupings. It is significant that the artist usually casts all or most of his figures' surroundings into deep shadow, using light as a calculated and purely arbitrary device to heighten compositional rhythm and to draw the viewer's attention to subtle images of extreme visual refinement: the angular extension of a limb, the elusive gleam of gold braid or satin emerging from the shadows, the definition of a tilted profile, or a hand. Ochtervelt was certainly able to capture the effects of natural daylight, as he demonstrated in his entrance hall scenes, but in most of his works he chose to manipulate light and shadow for expressive, rather than naturalistic, purposes. His chiaroscuro reinforces the decorative, theatrical quality of his paintings more than it fosters an illusion of reality.

That the artist was primarily a painter of women and of activities in which women partake is another revealing aspect of his temperament. Even in group scenes that also include male figures, Ochtervelt invariably focuses his illumination, and attention, upon their female companions, whose graceful attitudes and elegant costumes receive more emphasis than the activity in which the group as a whole is engaged. In the boudoir or receiving company, Ochtervelt's women become, themselves, attributes of a certain style of living and leisure. Such scenes must have appealed to the kind of patrons who wished to see themselves as members of a refined, privileged society whose major concern was light divertissement. In another time or place, one might expect to find an artist of Ochtervelt's sensibility working in close proximity to a court. Instead, he created his distinctive pictorial realm within the practical, mercantile world of 17th-century Holland.

CATALOGUE RAISONNÉ

Part I: Authentic Paintings

A chronological list of dated works precedes the catalogue of authentic works. Copies and variants after known originals are listed by letter after the catalogue number to which they relate. Copies of lost originals and paintings of disputed attribution are discussed in Part II of the catalogue. Measurements throughout are given in centimeters, height followed by width.

DATED PAINTINGS BY OCHTERVELT

1652	*Hunters and Shepherds in a Landscape,* Städtische Museen, Karl-Marx-Stadt (cat. nr. 3; Fig. 8).
1660	*Children and Frisian Nursemaid in a Landscape,* private collection, England (cat. nr. 12; Fig. 147).
166(0?)	*The Ensign,* Dienst Verspreide Rijkscollecties, The Hague (cat. nr. 13; Fig. 148).
1663	*Family Portrait,* Fogg Art Museum, Cambridge, Massachusetts (cat. nr. 18; Fig. 150).
166(4?)	*Family Portrait,* The Wadsworth Atheneum, Hartford, Connecticut (cat. nr. 19; Fig. 152).
1665	*Street Musicians at the Door,* City Art Museum, St. Louis, Missouri (cat. nr. 24; Fig. 122).
1665	*The Flag Bearer,* Galerie Bruno Meissner, Zollikon/Zurich (cat. nr. 25; Fig. 60).
166(?)	*Self-Portrait,* Bundesdenkmalamtes, Vienna (cat. nr. 30; Fig. 160).
1666	*The Singing Violinist,* Glasgow Art Gallery and Museum (cat. nr. 33; Fig. 61).
1667	*The Oyster Meal,* Museum Boymans-van Beuningen, Rotterdam (cat. nr. 36; Fig. 40).
166(8?)	*The Toast,* private collection, Capetown (cat. nr. 45; Fig. 51).
1668	*Violin Practice,* Statens Museum for Kunst, Copenhagen (cat. nr. 46; Fig. 52).
1668	*Man in a Niche,* Städelsches Kunstinstitut, Frankfurt am Main (cat. nr. 48; Fig. 70).
1669	*The Gallant Man,* Staatliche Kunstsammlungen, Dresden (cat. nr. 53; Fig. 53).
1669	*The Grape Seller,* The Hermitage, Leningrad (cat. nr. 54; Fig. 130).
1669	*The Dancing Dog,* The Wadsworth Atheneum, Hartford, Connecticut (cat. nr. 57; Fig. 55).
1670	*Family Portrait,* Országos Szépmüveszéti, Budapest (cat. nr. 61; Fig. 156).
1671	*The Music Lesson,* Chicago Art Institute, Chicago (cat. nr. 63; Fig. 75).
1671	*The Tric-trac Players,* Museum der Bildenden Künste, Leipzig (cat. nr. 64; Fig. 77).
1674	*The Regents of the Amsterdam Leper House,* Rijksmuseum, Amsterdam (cat. nr. 82; Fig. 163).
1674	*Concert in a Garden,* The Hermitage, Leningrad (cat. nr. 83; Fig. 94).
1676	*Lucretia,* present location unknown (cat. nr. 91; Fig. 102).
1677	*The Faint,* Galleria Giorgio Franchetti alla Ca' d'Oro, Venice (cat. nr. 98; Fig. 110).

1. Granida and Daifilo (Fig. 3)

Signed, lower right, c. 1648–50.
Material of support unknown, 80 × 99 cm.
Present location unknown.

Provenance: Galerie van Diemen, Amsterdam, 1934; Private Collection, Paris.

Notes: Stylistically the earliest of Ochtervelt's paintings, this work should be dated about 1648–50, the period when Ochtervelt was beginning his study with Nicolaes Berchem. As Gudlaugsson has pointed out, the costumes are close to fashionable dress of the period and the faces are "portrait-like." The subject is drawn from Act I, Scene 3, of P. C. Hooft's pastoral play *Granida,* written about 1605. Gudlaugsson has suggested that the painting is a variant of Ludolf de Jongh's strikingly similar *Granida and Daifilo,* signed and dated 1654 (Fig. 4), in the Osnabrück Museum. It is unlikely, however, that the Ochtervelt was painted as late as 1654, since it is clearly earlier in style than his dated *Hunters and Shepherds* of 1652 (cat. nr. 3; Fig. 8). Nor does it seem possible that the thirty-eight-year-old De Jongh would have borrowed from a young apprentice. Probably a third print or painting of the same subject served as the source for both artists; the similarities between the two works are too strong for coincidence.

Literature:
Plietzsch (1937), pp. 364 (ill.), 368; I. Kunze, "Depotbilder einer grossen Galerie," *Pantheon* 27 (January 1941); 8; S. J. Gudlaugsson, "Representations of Granida in Dutch Seventeenth-Century Painting: III," *Burlington Magazine* 91 (February 1949); 40, fig. 12; Plietzsch (1960), p. 64; R. E. Fleischer, "Ludolf de Jongh and the Early Work of Pieter de Hooch," *Oud Holland* 92 (1978); 53, fig. 9.

2. Hunting Party at Rest (Fig. 5)

Signed, lower right, c. 1650.
Panel, 91 × 124 cm.
Present location unknown.

Provenance: J. v. Bergen van der Gryp Sale, Soeterwoude (Delfos), June 25, 1784, nr. 97; Van Embden Collection; Van Embden Sale, Amsterdam (Muller), November 10, 1896, nr. 32; Van der Meulen Collection; Van der Meulen Sale, Amsterdam (Roos), April 3, 1900, nr. 68; Sale, Berlin (L. Spik), February 11–12, 1943, nr. 296; H. W. Lange, Berlin; Munich Collecting Point, nr. 3666.

Notes: The painting shows stylistic affinities with *Granida and Daifilo* (cat. nr. 1; Fig. 3) in the treatment of both figures and animals and can be related to similar hunting scenes by Jan Baptiste Weenix and Ludolf de Jongh (Figs. 6 and 7). Brière-Misme suggested that it may have been the pendant to *Mounted Pair in a Landscape* of about 1650, attributed to De Hooch (canvas, 98×131 cm., Dienst Verspreide Rijks-collecties, The Hague, inv. nr. NK 2428; (ill., Valentiner, *Pieter de Hooch,* p. 6).

Fleischer (pp. 51–52, figs. 6–8) has noted the striking similarity between the white horse and the dog at the lower left in Ochtervelt's painting and corresponding motifs in *Landscape with Riders* (location unknown) by Ludolf de Jongh and Joris van der Hagen. This author also points out that the dog licking himself at the lower right of Ochtervelt's composition is identical to one in De Jongh's *The Wounded Man* in Geneva.

It is not possible to see a signature on old photographs of Ochtervelt's *Hunting Party,* but when Hofstede de Groot viewed the painting at the Van der Meulen Sale in 1900, he noted that it was "voluit gemerkt. De handteekening ziet er zeer goed uit" (HdG notes, RKD). According to the records of the Bayerischen Staatsgemäldesammlungen, Munich, the painting was stolen from the Munich depot in 1945.

Literature:
C. Brière-Misme, "Tableaux inédits ou peu connus de Pieter de Hooch," *Gazette des Beaux Arts* (1927/I), pp. 364–65; W. R. Valentiner, *Pieter de Hooch,* Klassiker der Kunst (Stuttgart, 1929), p. 289; Plietzsch (1937), p. 368; Plietzsch (1960), p. 64; R. E. Fleischer, "Ludolf de Jongh and the Early Work of Pieter de Hooch," *Oud Holland* 92 (1978); 49–53, fig. 6.

3. Hunters and Shepherds in a Landscape (Fig. 8)

Signed and dated 1652, center foreground.
Canvas, 77.5 × 88 cm.
Städtische Museen, Karl-Marx-Stadt, East Germany, nr. 576.

Provenance: Austrian Royal Collection, Vienna (Stallburg-Galerie); National Museum, Vienna, 1920, nr. 269; Galerie Sanct Lucas, Vienna, 1928; P. Larsen, London, 1929; Lässig Collection, Chemnitz; Bundesdenkmalamt, Vienna.

Exhibitions: Galerie Neumann and Saltzer, Vienna, "Das holländische Sittenbild im XVII. Jahrhundert," May-June, 1930, nr. 41.

Notes: Ochtervelt's only dated painting of the 1650's, this work is similar in composition and format to his *Hunting Party at Rest* of c. 1650 (cat. nr. 2; Fig. 5). Von Frimmel (*Blätter,* 6:38; *Studien und Skizzen,* 5:175) believed that it was painted as the pendant to his *Embarkation* (cat. nr. 4; Fig. 10). The two works are not of identical size, however, and the proportion of figures to picture space is considerably smaller in this painting.

The condition of the picture is poor. The surface has been rubbed, colors are obscured by darkened varnish, the face of the standing woman has been overpainted, and there is an area of severe damage below the hand of the mounted cavalier at the right. The predominant gray-brown-tan tonality of the painting is accented with three areas of brighter color: an orange-yellow sunset in the left background; the dress of the standing woman of very pale blue-gray satin trimmed with gold; and the costume of the seated woman at the right, with yellow bodice, red sleeves, and bright blue skirt.

Literature:
F. Stampart and A. Prenner, *Prodromus* (Vienna, 1728–35), pl. 20; T. von Frimmel, *Geschichte der Wiener Gemäldesammlungen* (Leipzig, 1899), vol. 1, pl. 89 and fn. 2; T. von Frimmel, "Neuerwerbungen der Sammlung Matsvanszky," *Blätter für Gemäldekunde* 6 (1910): 38; 7 (1911): 50; T. von Frimmel, "Der wiedergefundene Ochtervelt im Weiner Nationalmuseum," *Studien und Skizzen zur Gemäldekunde* 5 (1920–21): 173–76; W. R. Valentiner, *Pieter de Hooch*, Klassiker der Kunst (Stuttgart, 1929), pp. 190 (ill.), 289; Gerson, *Thieme-Becker*, vol. 25 (1931), p. 556; Plietzsch (1960), p. 64.

4. The Embarkation (Fig. 10)

Signed, lower left, c. 1653.
Canvas, 78.5 × 75 cm.
Present location unknown.

Provenance: Sale, Aachen (Creutzer-Lempertz), April 28, 1910, nr. 40; Matsvanszky Collection, Vienna.

Notes: Von Frimmel suggested that this work is the pendant to Ochtervelt's *Hunters and Shepherds* of 1652 (cat. nr. 3; Fig. 8), in Karl-Marx-Stadt. The stronger concentration on the figures and the more coherent composition, however, point to a slightly later date. The subject of the painting, although restricted in scope, relates to the Italianate harbor scenes of Nicolaes Berchem, Jan Baptiste Weenix, and Johannes Lingelbach. The brown and white spaniel, a motif that becomes almost a signature in Ochtervelt's later works, appears here for the first time: at the right foreground.

Literature:
T. von Frimmel, "Neuerwerbungen der Sammlung Matsvanszky," *Blätter für Gemäldekunde* 6 (1910): 38–39, 94–95; 7 (1911): 50–51; T. von Frimmel, "Der wiedergefundene Ochtervelt im Wiener Nationalmuseum," *Studien und Skizzen zur Gemäldekunde* 5 (1920–21): 174–76; T. Von Frimmel, *Verzeichnis der Gemälde in der Sammlung Matsvanszky, Wien* (Vienna, 1922), p. 18, nr. 42; Plietzsch (1937), p. 368; Plietzsch (1960), p. 65, fn.

5. Musical Trio in a Garden (Fig. 11)

Canvas, 82 × 73 cm., c. 1654–55.
Herzog-Anton-Ulrich Museum, Braunschweig, nr. 365.

Provenance: Ducal Gallery, Salsthalen.

Notes: Until Valentiner's pioneering article on Ochtervelt of 1924, this painting was attributed to Jan Baptiste Weenix. Ledermann's statement that it was painted as the pendant to Karel Dujardin's *The Sick Goat* (Alte Pinakothek, Munich, nr. 291) is rightly rejected in the Munich catalogue of 1967. Brochhagen, indeed, dates the Dujardin a decade later, about 1665 (*Karel Dujardin* [Cologne, 1958], p. 92).

The standing violinist at the left is a reversed variant of the central figure in Ochtervelt's *Embarkation* (cat. nr. 4; Fig. 10). A similar Italianate cornice also appears in both works. The face and neck of the seated singer in *Musical Trio* have been retouched, although the contour of the profile appears to be unchanged. The jacket of this figure (heavily painted in orange over pale brown) may also have been repainted. The muted but rich colors of the scene are typical of Ochtervelt's early style: the figure at the right wears a white satin skirt, the lutenist has a gray satin bodice and dark green apron, and the violinist wears mustard-colored trousers and stockings and a violet-gray jacket.

Literature:
C. N. Eberlein, *Catalogue des Tableaux de la Galerie Ducale à Salsthalen* (Brunswick, 1776), p. 266, nr. 8 (as J. B. Weenix); L. Pape, *Verzeichnis der Gemälde-Sammlungen des herzoglichen Museums zu Braunschweig* (Braunschweig, 1844), p. 108, nr. 295 (as J. B. Weenix); *Herzogliches Museum, Führer durch die Sammlungen* (Braunschweig, 1891), p. 99, nr. 365 (as J. B. Weenix); I. Ledermann, *Beiträge zur Geschichte des romantischen Landschaftsbildes im Holland und seines Einflusses auf die nationale Schule um die Mitte des 17. Jahrhunderts*, Inaug. diss., Berlin, 1920, pp. 106–7, p. 195, fn. 6 (as J. B. Weenix); E. Flechsig, *Verzeichnis der Gemäldesammlungen im Landesmuseum zu Braunschweig* (Braunschweig, 1922), p. 48, nr. 365 (as J. B. Weenix); Valentiner (1924), p. 273, fig. 8 (as Ochtervelt); Gerson, *Thieme-Becker*, vol. 25 (1931), p. 556; *Kurzes Verzeichnis der Gemäldesammlungen im Herzog-Anton-Ulrich Museum* (Braunschweig, 1932), p. 34, nr. 365; Pleitzsch (1937), p. 368, fn. 2; Bénézit, *Dictionnaire*, vol. 6 (1953), p. 404; Plietzsch (1960), p. 65, fn. 1; *Katalog III, Holländische Malerei des 17. Jahrhunderts*, Alte Pinakothek (Munich, 1967), p. 23.

6. Musical Company in a Garden (Fig. 14)

Canvas, 110 × 97 cm., c. 1655.
Kunsthandel Gebr. Douwes, Amsterdam.

Provenance: Ver Meer Gallery, London, 1925; A. Reyre, London, 1928, 1935; Collection Sven Boström, Stockholm.

Exhibitions: Galerie Schäffer, Berlin, "Die Meister des holländischen Interieurs," April-May, 1929, nr. 67, pl. 27; Museum Boymans-van Beuningen, Rotterdam, "Vermeer: Oorsprong en Invloed," 1935, nr. 75, pl. 113; Gebr. Douwes, Amsterdam, "Tentoonstelling van Schilderijen en Tekeningen," April 28–May 28, 1964,

nr. 1 (color ill., cover); The Metropolitan Museum of Art, New York, "International Exhibition under the Auspices of La Confédération Internationale des Negotiants en Oeuvres d'Art," October 19, 1974–January 5, 1975, nr. 13.

Notes: Close in style, subject, and setting to *Musical Trio in a Garden* (cat. nr. 5, Fig. 11), this painting is probably the companion piece to the interior in the Chrysler Collection, *Merry Company with Violinist* (cat. nr. 7; Fig. 16). Although this and the Chrysler painting have different provenances, they are of similar size, and copies of both (cat. nrs. 6-A and 7-A; Figs. 15 and 17) have been sold and exhibited as a pair. A complete provenance of this garden scene is difficult to establish because of confusion with its copy. A painting whose catalogue description corresponds to both the original and the copy was nr. 33 in the Odon Sale, Amsterdam, September 6, 1785, but its dimensions (115 × 102.5 cm.) do not match either exactly. Similarly, nr. 498 in the Thun Sale, Lucerne (Fischer), August 31–September 2, 1933, was listed at 119 × 108 cm. The catalogue reproduction (pl. 31) is too indistinct for exact identification. (Neither sale included a pendant.)

This painting has a false Vermeer monogram (above which are illegible traces of an effaced signature) at the base of the pilaster at the right. The setting is painted in typically neutral tones of gray, brown, and tan. The violinist has a bright red cape, silvery brown sleeves, and mustard trousers; mustard is repeated in the skirt of the maid at the left. The seated singer wears a yellow and white satin dress, while the standing lutenist has a violet-brown skirt and a black bodice.

Literature:
H. Wichmann, "Die Meisters des holländischen Interieurs—Ausstelling April–Mai 1929 in der Galerie Dr. Schäffer Berlin," *Kunstchronik* 63 (May 1929): 11; W. R. Valentiner, *Pieter de Hooch,* Klassiker der Kunst (Stuttgart, 1929), pp. xxix, 191 (ill.), 289; Plietzsch (1937), p. 368; Plietzsch (1960), p. 64, pl. 98; *Die Weltkunst,* vol. 34, nr. 10 (May 15, 1964).

6-A. Musical Company in a Garden (copy) (Fig. 15)

Canvas, 119.5 × 106.3 cm.
Present location unknown.

Provenance: Dessau Castle, Julius Böhler, Munich, 1954; Berliner Handelsgesellschaft, Frankfurt am Main, 1954–67.

Notes: See notes to *Musical Company in a Garden* (cat. nrs. 6; Fig. 14) and *Merry Company with Violinist* (cat. nr. 7-A; Fig. 17). Although the composition of this painting matches that of the Douwes original (cat. nr. 6; Fig. 14) almost exactly, it is of much cruder quality; the skirt of the seated singer is yellow in the original and

pink in the copy. The pendant to this work is listed as cat. nr. 7-A; Fig. 17. When Hofstede de Groot saw the pair at Böhler in 1928, he noted that the garden scene was signed at the lower left "na Ochtervelt" (HdG notes, RKD), an inscription that has since been removed.

7. Merry Company with Violinist (Fig. 16)

Canvas, 115 × 102 cm., c. 1655.
Collection Walter P. Chrysler, Jr. (on loan to Chrysler Museum, Norfolk, Virginia).

Provenance: Collection M. Ernest F. O. de Weerth, Paris; Collection Ernest W. A. de Weerth, Baltimore, 1932–49; Acquavella Galleries, New York, 1949.

Exhibitions: On permanent loan to the Baltimore Museum of Art (with E. W. A. de Weerth Collection), 1932–49; Baltimore Museum, "A Century of Baltimore Collecting 1840–1940," 1941, p. 51; Baltimore Museum, "Musical Instruments and Their Portrayal in Art," 1946, nr. 33; Baltimore Museum, "Themes and Variations," 1948, nr. 84; Wichita Art Association Galleries, Wichita, Kansas, "Dutch Painting and Its Influence on the British School," 1949; University of Miami Art Gallery, Coral Gables, Florida, "Dutch Old Masters, Part II, from the Collection of Walter P. Chrysler, Jr.," February–March, 1951, nr. 33; Portland Art Museum, Portland, Oregon, "Paintings from the Collection of Walter P. Chrysler, Jr.," 1956, nr. 14.

Notes: Probably the pendant to *Musical Company in a Garden* (cat. nr. 6; Fig. 14). The violinist is a variant of the standing musician in the Braunschweig *Musical Trio* (cat. nr. 5; Fig. 11). An old (undated) photograph of the painting in the Rijksbureau voor Kunsthistorische Documentatie, The Hague (neg. nr. L 35307), reveals that the corner of a framed landscape painting was once added at the upper right. This overpaint is no longer present and does not appear in the copy of the Chrysler painting (cat. nr. 7-A; Fig. 17). Both the old photograph and the copy include a full view of the servant at the right and two hunting dogs at the left, suggesting that the Chrysler painting has been cropped by several centimeters at either side.

The figures appear against a dark gray wall. The violinist has yellow sleeves, a dark gray cuirass, orange-red trousers, and dark mustard stockings. The woman at the left wears a tan hat and a brown tunic with violet sleeves. Next to her is a man dressed in dark blue. The seated woman has a white satin dress, and the serving boy wears dark blue livery.

Literature:
Art Digest, vol. 26, nr. 2 (October 15, 1951), p. 9; *Pictures on Exhibit,* New York, November, 1951, p. 12.

7-A. Merry Company with Violinist (Fig. 17)
(copy)

Canvas, 117 × 106 cm.
Present location unknown.

Provenance: Dessau Castle, Julius Bohler, Munich, 1954; Berliner Handelsgesellschaft, Frankfurt am Main, 1954–67.

Notes: An excellent copy of the painting in the Chrysler Collection (cat. nr. 7; Fig. 16), but with small variations from the original: the chairback behind the table has been omitted, and the page at the right wears a slightly different costume. Although this work appears to be the companion piece of the copy of *Musical Company in a Garden* (cat. nr. 6-A; Fig. 15), it is of higher quality than its pendant and seems to have been painted by a different, more able hand.

8. The Concert (Fig. 18)

Material of support and dimensions unknown, c. 1655–58 (?)
Present location unknown.

Provenance: Jules Porges, Paris, 1921.

Notes: Presently known only through an old photograph in the Frick Art Reference Library, New York (nr. 320-23a), this painting appears to be genuine and can be related to other early works by Ochtervelt (cat. nrs. 5–7, 9, 10; Figs. 11, 14, 16, 19, 22), especially in the choice of figure types. The composition is reminiscent of *Musical Company in a Garden* (cat. nr. 6; Fig. 14), in which a similar serving maid appears. The man standing behind the musicians is strikingly like the background onlooker in Ochtervelt's *Card Players* (cat. nr. 9; Fig. 19).

9. The Card Players (Fig. 19)

Signed, lower right, c. 1655–58.
Canvas, 76.5 × 73 cm.
Collection Drs. Ch. De Roij van Zuydewijn, Amsterdam.

Provenance: Kunsthandel P. de Boer, Amsterdam.

Exhibitions: P. de Boer, Amsterdam, "Wintertentoonstelling," 1965–66, nr. 23.

Notes: Despite close similarities to Ochtervelt's other early genre scenes in technique, lighting, figure and facial types, these figures are somewhat plainer and less opulently dressed, similar to the types seen in Karel Dujardin's Roman genre paintings (cf. Fig. 12; *Soldiers at a Roman Tomb,* Yale University Art Gallery). The

interpretation of the scene, particularly the treatment of the woman, may derive from Ter Borch (Fig. 21). As in the interior in *Merry Company with Violinist* (cat. nr. 7; Fig. 16), the group appears against a plain gray wall. The male figures are all dressed in closely related hues of gray, brown, mustard, and tan; the seated woman wears a tan jacket with a violet stripe at the neck and a beige satin skirt.

10. Musical Company at a Table (Fig. 22)

Signed, lower left, c. 1655–58.
Canvas, 81 × 73 cm.
Collection Marie Andrén, Sollebrunn, Sweden.

Provenance: Collection R. H. du Mosch; Du Mosch Sale, Amsterdam (Muller), June 1, 1932, nr. 491; Professor Julius Singer, Prague, 1938; Collection Sven Boström, Stockholm, 1949; Sale, Stockholm (Bukowski), April 22, 1972, nr. 174.

Notes: This scene is similar in composition and setting to *The Card Players* (cat. nr. 9; Fig. 19). Judging from photographs, the upper left portion (around the head and shoulders of the standing woman) may have been damaged or retouched. According to a color description in the Du Mosch sale catalogue, 1932, the wall is gray and the major colors of the costumes are yellow, olive green, brick red, brown, and black.

Literature:
Plietzsch (1937), p. 368, fn. 2; Plietzsch (1960), p. 65, fn. 1.

11. The Feast (Fig. 23)

Canvas, 75 × 74 cm., c. 1658–60.
Národní Galerie, Prague, nr. DO 274.

Provenance: A. Grill Sale, Amsterdam (Posthumus de Bosch JZ.), April 10, 1776, nr. 6 (to B.d. Bont); J. W. v. Arp Sale, Amsterdam (v. d. Schley . . . Pruyssenaar), June 19, 1800, nr. 128 (to J. Yver); A. Meynts Sale, Amsterdam (Roos), July 15, 1823, nr. 129 (to Eymer); Sale, Amsterdam (De Vries, Roos & Brondgeest), October 26, 1852, nr. 121 (to Wolf); Dealer A. G., Lucerne, July 1923; F. Rothmann, Berlin, March 1926; Collection A. Reyre, London, 1928; Sale, Stockholm (Bukowski), September 25, 1929, nr. 53; Collection R. Morawetz, Prague.

Exhibitions: Museum Boymans-van Beuningen, Rotterdam, "Vermeer: Oorsprong en Invloed," 1935, nr. 74.

Notes: Probably slightly later in date than *Card Players* (cat. nr. 9; Fig. 19) and *Musical Company at a Table* (cat. nr. 10; Fig. 22), since the setting has become somewhat more fully defined. The three-cornered cush-

ioned stool at the right also appears in the foreground of cat. nr. 10. Indeed, Ochtervelt frequently repeats the same studio props in paintings of similar date. The red, green, and blue flowered cushion on the chair at the left is seen again in cat. nrs. 14, 15, 20, 23, and 26; Figs. 25, 26, 27, 33, and 34.

The Prague *Feast* may have been influenced by Gerbrand van den Eeckhout's full-length genre interiors painted in Amsterdam during the early 1650s. Eeckhout's soldier scenes also include simple inn interiors with similarly costumed figures in partial shadow against a gray wall (cf. W. Bernt, *The Netherlandish Painters of the Seventeenth Century* [London and New York, 1969], vol. 1, nr. 356). The colors of *The Feast* are quite monochromatic. The soldier at the left wears a rich brown jacket touched with lavender, a metal cuirass, and tan trousers, while his companion, also in armor, has tan sleeves striped with silver and dark yellow trousers. A red cloak is thrown over the table at the right. The maidservant wears a pale gray satin bodice and a dark gray skirt.

Literature:
W. R. Valentiner, *Pieter de Hooch*, Klassiker der Kunst (Stuttgart, 1929), pp. xxix, 191 (ill.), 289; Plietzsch (1937), p. 368; J. Sip, *Mistri Hollandské* (Prague, 1949), nr. 30; *Sbírka Starého Umění Národní Galerie v Praze* (Prague, 1955), p. 68, nr. 434; L. Kesner (trans. R. F. Samsour), *The National Gallery in Prague* (Prague, 1964), p. 59; W. Bernt, *The Netherlandish Painters of the 17th Century* (London, 1970), vol. 2, nr. 874.

12. Children and Frisian Nursemaid in a Landscape (Fig. 147)

Signed and dated 1660, lower right.
Canvas, 92 × 80 cm.
Private collection, England.

Provenance: E. Goldschmidt Sale, Berlin (Lepke), April 27, 1909, nr. 43; Collection Alan P. Good, Glympton Park; Good Sale, London (Sotheby), July 15, 1953, nr. 37 (to Mawston); Collection W. A. T. Crawles; Sale, London (Sotheby), July 8, 1964, lot 170.

Exhibitions: Marlborough Fine Arts Ltd., London, "Paintings of Importance," March 7–April 2, 1949, nr. 8.

Notes: The outdoor setting of this early portrait recalls Ochtervelt's Italianate landscapes with figures painted a decade earlier, about 1650 (cat. nrs. 1–3; Figs. 3, 5, 8). Here, however, the landscape is articulated into a complete panorama that functions as more than a generalized backdrop. It is possible that Ochtervelt, who never developed a strong or consistent landscape style of his own, painted only the figures and left the

setting to another artist. In any case, the same stiff, rather primitive figure types and tight, highly detailed painting technique are seen in other portraits by Ochtervelt painted before 1665 (cat. nrs. 13, 18, 19; Figs. 148, 150, 152)—an approach that is reminiscent of the early portrait style of Nicolaes Maes (cf. A. Staring, "Vier familiegroepen van Nicolaes Maes," *Oud Holland* 80, [1965] 171–72).

13. The Ensign (Fig. 148)

Signed and dated 166(0?), on table edge at right.
Canvas, 65 × 57 cm.
Dienst Verspreide Rijkscollecties, The Hague, nr. NK 2374.

Provenance: The Buttery, London, 1911; Collection August Janssen, Amsterdam; Goudstikker, Amsterdam, 1919; Munich Collecting Point, nr. 2060.

Exhibitions: 'Pulchri Studio,' The Hague, "La Collection Goudstikker d'Amsterdam," November 1919, nr. 83.

Notes: Although the last digit of the date is no longer legible, Hofstede de Groot noted that the painting was "voluit gemerkt en 1660 gedateerd" when he saw it in London in June of 1911 (HdG notes, RKD). This observation accords with the style of the painting, which, despite differences in subject, is similar in the treatment of figures to Ochtervelt's *Children and Frisian Nursemaid*, also dated 1660 (cat. nr. 12; Fig. 147). The format of the painting derives from an Amsterdam type of portraiture, seen for example in Thomas de Keyser's *Constantijn Huygens and His Clerk*, dated 1627 (Fig. 149), in the National Gallery, London. Indeed, the unidentified ensign in Ochtervelt's painting carries an orange flag, at the top of which can be seen part of the Amsterdam coat of arms (three saltires in fess). In the background at the upper right is a marble bust of Diana (wearing a crescent-moon headdress and quiver) in an oval niche, below which is an illegible shield emblazoned with stars (?) and arrows (?). These motifs may relate to the name of the sitter or may suggest that he belonged to an Amsterdam company of cross-bowmen. The ensign, dressed in brownish-purple, trimmed with lavender and white ribbons and a bright blue sash, holds out a metal disc (possibly a mirror, a small portrait, or a company emblem) to his companion, who wears a tan and gray costume with blue stockings. For another depiction of a flag bearer, dated 1665 (probably a genre painting for which the artist used himself as model), see cat. nr. 25; Fig. 60.

14. The Embracing Cavalier (Fig. 25)

Panel, 44.6 × 35.6 cm., c. 1660–63
The Assheton Bennett Collection, Manchester, England. On loan to Manchester City Art Gallery.

Provenance: Jacob van der Dussen Sale, Amsterdam (De Leth, v.d. Bergh), April 12, 1752, nr. 21; Collection Count Adam Gottlob Moltke, Copenhagen, 1758; Moltke Sale, Copenhagen (Winkel and Magnussen), June 1, 1931, nr. 98.

Exhibitions: Manchester City Art Gallery, "Paintings and Drawings from the Assheton Bennett Collection," 1965, nr. 44; The Royal Academy, London, "The Assheton Bennett Collection," 1965, nr. 50.

Notes: Related in subject to the Prague inn scene with soldiers (cat. nr. 11; Fig. 23), this interior is further expanded and elaborated and the colors are brighter. The standing maid has a red blouse and gray satin skirt, the amorous woman is dressed in orange with a black headdress, and the soldier wears a light brown satin costume with gray armor and pale blue stockings. The wicker cage with lovebirds is an emblematic reference to the sweet imprisonment of love (cf. J. Cats's emblem, "Amissa Libertate Laetior," *Silenus Alcibiades, sive Proteus* [Middelburg, 1618], p. 27, nr. XII).

This is probably the pendant to *The Sleeping Soldier* (cat. nr. 15; Fig. 26), also in the Bennett Collection, in which the same models were used for the soldier and maid. According to Grossmann's catalogue (p. 16), the painting is "recorded as signed and dated 1665." The source of this observation is not specified, nor is a signature or date visible today. In my opinion, the style of the painting suggests a slightly earlier date. It is understandable that the work was once attributed to Frans van Mieris, the elder, since it shows strong influences of his tavern scenes of the late 1650s (Fig. 24).

Literature:
G. Hoet, *Catalogus of Naamlyst van Schilderyen* (The Hague, 1752), vol. 2, p. 311, nr. 21; H. Høyen, *Catalogue of the Moltke Collection* (Copenhagen, 1841), nr. 98 (as Frans van Mieris); *Fortegnelse over den Moltkeske Malerisamling* (Copenhagen), p. 28, nr. 43 (as Van Mieris); *Catalogue des Tableaux de la Collection du Comte de Moltke* (Copenhagen, 1885), p. 25. nr. 43 (as Van Mieris); Plietzsch (1937), p. 368; Plietzsch (1960), p. 68; F. G. Grossmann, *Catalogue of Paintings and Drawings from the Assheton Bennett Collection* (Manchester City Art Gallery, 1965), p. 16, nr. 44.

15. The Sleeping Soldier (Fig. 26)

Panel, 46 × 37.7 cm., c. 1660–63.
The Assheton Bennett Collection, Manchester, England. On loan to Manchester City Art Gallery.

Provenance: Collection J. Walter, Bearwood, by 1857; Arthur Walter Sale, London (Christie), June 18, 1937, nr. 83; Collection A. de Casseres.

Exhibitions: Manchester City Art Gallery, "Art Treasures," 1857, nr. 1064; British Institution, London, 1863, nr. 12; D. Katz, Amsterdam, "Arti et Amicitiae," May 7–June 4, 1938, nr. 55; The Royal Academy, London, "Dutch Pictures: 1450–1750," 1952–53, nr. 440; Manchester City Art Gallery, "Art Treasures Centenary: European Old Masters," 1957, nr. 123; The Royal Academy, London "The Assheton Bennett Collection," 1965, nr. 48; Manchester City Art Gallery, "Paintings and Drawings from the Assheton Bennett Collection," 1965, nr. 45.

Notes: Probably the pendant to *The Embracing Cavalier* in the Bennett Collection (see notes to cat. nr. 14; Fig. 25). Ochtervelt returned to the theme of a sleeping soldier being awakened by a mischievous trumpeter in two late works of about 1678–80 (cat. nrs. 99 and 100; Figs. 111 and 112). Sleeping soldiers also appear in cat. nrs. 11 and 14; Figs. 23 and 25. The painting is similar in style to Van Mieris's *Sleeping Officer* in the Alte Pinakothek, Munich (nr. 241) of about 1660 (ill., *Katalog III, Holländische Malerei des 17. Jahrhunderts* [Munich, 1967], pl. 88). In the Van Mieris, however, the soldier's companion displays money to the maid and admonishes her not to awaken him. A closer thematic prototype of Ochtervelt's composition is Ter Borch's *Sleeping Soldier* of about 1656–57, in Cincinnati, in which (as in the Ochtervelt) a woman tickles the face of the sleeper; behind her stands a smiling officer holding a trumpet (ill., Gudlaugsson, *Ter Borch*, vol. 1, p. 280, nr. 121). Gudlaugsson (vol. 2, p. 134) cites an even earlier example of this subject: an inn scene by Nicolaes Regnier of about 1625 (Collection M. H. Baderou, Paris) in which a masked man tickles the face of a sleeping cardplayer (ill., catalogue, *Mostra del Caravaggio e dei Caravaggeschi* [Milan: Palazzo Reale, April–June, 1951], p. 81, nr. 141, pl. 102).

The motif of a trumpeter blowing his horn in an inn interior also appears in Ter Borch's *Carousing Soldiers* of about 1655, in the Rothschild Collection, Paris (ill., Gudlaugsson, vol. 1, p. 282, nr. 123). In this context the trumpet blast has been interpreted as an allusion to the Last Judgment: a moralizing warning against such activities as cardplaying, smoking, and drinking (catalogue, *Ter Borch Exhibition* [Münster: Landesmuseum, 1974], p. 140, nr. 37). Ochtervelt's herald "awakens" the soldier in a more literal sense, and he does so in collaboration with a voluptuous maid. Thus, although the wine pitcher on the table and the broken pipe on the floor indicate that the artist is illustrating the effects of overindulgence, this humorous interpretation does not have a strongly moralizing tone.

Dutch genre scenes that feature a sleeping soldier may have some iconographic association with the theme of Sleeping Mars, which was well known to 17th-century artists. An etching of a sleeping soldier by Jacques de Gheyn III is identified as the god of war by its caption: "Mars rests after crowning himself with glory; may he rest more gloriously from now onwards for the good of the people" (Hollstein, vol. 8, De Gheyn III, nr. 22). Possibly the same meaning was intended in Hendrik Terbrugghen's *Sleeping Mars* of about 1623–25, Centraal Museum, Utrecht, which B. Nicolson has interpreted as "a kind of pacifist picture," painted at the height of war (*Hendrik Terbrugghen* [London, 1958], pp. 102–3, pl. 40). Genre scenes with sleeping soldiers painted later in the century (after the Treaty of Münster of 1648) may, in turn, reflect something of the tenor of a period of peace; they illustrate a more direct concern with individual behavior than with patriotic or political issues.

Literature:
Wurzbach, vol. 2 (1910), p. 249; A. Graves, *A Century of Loan Exhibitions* (London, 1913-15), vol. 2, p. 874; Valentiner (1924), p. 283; Plietzsch (1937), p. 364; Plietzsch (1960), p. 67; F. G. Grossmann, *Catalogue of the Paintings and Drawings from the Assheton Bennett Collection* (Manchester City Art Gallery, 1965), p. 16, nr. 45.

16. Street Musicians at the Door (Fig. 121)

Panel, 56 × 46.5 cm., c. 1660-63.
Berlin-Dahlem Museum, nr. 1972.

Provenance: Wallraf-Richartz-Museum, Cologne, 1905, nr. 699; Cologne art trade, 1926; Kaiser-Friedrich Museum, Berlin.

Notes: The Berlin *Street Musicians*, which appears to be the earliest in style of Ochtervelt's entrance hall paintings, should probably be dated in the early 1660s, for the wet nurse at the left is almost a twin, in costume and figure type, to the sturdy, buxom maidservants in Ochtervelt's tavern scenes assigned to this period (cat. nrs. 14 and 15; Figs. 25 and 26). The sketchy definition of the cityscape (possibly a simplified depiction of the St. Laurenskerk of Rotterdam) also implies that this was the artist's first attempt at the subject. Two later paintings of the same subject by Ochtervelt are known (cat. nrs. 24 and 62; Figs. 122 and 134). Street musicians also appear in the works of other Dutch artists such as Adriaen van Ostade (*Violinist at the Doorway of an Inn*, signed and dated 1673, Mauritshuis, The Hague) and Jan Steen, who, like Ochtervelt, contrasted peasant performers to more refined, richly dressed listeners (*Beggar Musicians*, signed and dated 1659, The National Trust, Ascott; photograph: Courtauld Institute,

London, neg. C55/23). Ochtervelt seems to have been the only artist, however, to use an interior setting for such scenes.

In this painting the violinist and hurdy-gurdy player are dressed in shades of brown. The nurse has a blue-green velvet jacket and a dark green or black apron; and the child at the left (whose face is abraded on the left side) wears a yellow satin dress, trimmed with red, blue, and yellow ribbons. The child at the right wears a dark pink satin dress and holds a gray hobbyhorse with a white mane. There is a brown rug on the gray and brown marble floor.

Literature:
K. Woermann and A. Woltmann, *Geschichte der Malerei*, vol. 3, pt. 2 (Leipzig, 1888), p. 840; *Verzeichnis der Gemälde des Wallraf-Richartz-Museum der Stadt Cöln* (Cologne, 1905), p. 251, nr. 699; *Berliner Museen* 47 (1926): 72; *Beschreibendes Verzeichnis der Gemälde im Kaiser Friedrich Museum und Deutschen Museum* (Berlin, 1931), p. 342, nr. 1972; Gerson, *Thieme-Becker*, vol. 25 (1931), p. 556; Plietzsch (1937), p. 370; Bénézit, *Dictionnaire*, vol. 6 (1953), p. 404; Plietzsch (1960), p. 65; *Verzeichnis der Ausgestellten Gemälde des 13. bis 18. Jahrhunderts im Museum Dahlem* (Berlin, 1961), p. 61, nr. 1972; *Verzeichnis der Ausgestellten Gemälde des 13. bis 18. Jahrhunderts im Museum Dahlem* (Berlin, 1964), p. 77, nr. 1972; *Katalog der ausgestellten Gemälde des 13. bis 18. Jahrhunderts* (Berlin, 1975), p. 299, nr. 1972.

17. Peasant Spinners in an Interior (Fig. 142)

Signed, on windowsill, c. 1660-65 (?)
Canvas, 60 × 50 cm.
Formerly, Leipzig Museum der bildenden Künste (destroyed, World War II).

Provenance: J. Pekstok Sale, Amsterdam (v.d. Schley . . . Yver), December 17, 1792, nr. 100; Clauss'che Bequest to museum, 1860.

Notes: The meaning of this scene may relate to an emblem (Fig. 143) from De Brune's *Emblemata of Zinne-werck*, Amsterdam, 1624, nr. 318, which praises men and women who work together without thought of worldly gain (cf. E. de Jongh, *Tot Lering en Vermaak* [Amsterdam: Rijksmuseum, 1976], p. 49). Stylistically, the painting is reminiscent of the Leiden artists Domenicus van Tol and Jacob Toorenvliet, who painted similar peasant interiors with vivid contrasts of light and shadow. Van Brekelenkam's scenes of elderly peasant couples, sometimes shown with spinning wheels, may also have been known to Ochtervelt (cf. *Peasants in an Interior*, signed and dated 1657, Sale, London [Slatter], April 1951, nr. 4). Only one other peasant painting by Ochtervelt is known: a small-scale single figure in Hamburg of about 1665-66 (cat. nr. 31; Fig. 65). Since the Leipzig *Spinners* is the artist's only known peasant

interior, it is difficult to assign it a firm date. Plietzsch (1960, p. 67, fn. 1) suggested that it is a late work. The closest parallels to it, however, can be found in Ochtervelt's inn scenes of the early to mid-1660s (cat. nrs. 14, 15, 20; Figs. 25–27), which depict similarly plain interiors with simple household objects hanging against the walls. The fact that Ochtervelt's style evolves toward an increasing emphasis on elegance and refinement of both figures and their surroundings makes a late date for this peasant scene unlikely.

Literature:
Verzeichnis der Kunstwerke im Städtischen Museum zu Leipzig (Leipzig, 1888), p. 88, nr. 342; catalogue (1891), p. 117, nr. 342; catalogue (1897), p. 175, nr. 342; catalogue (1909), p. 115, nr. 342; catalogue (1914), p. 119, nr. 342; catalogue (1924), p. 139, nr. 342; catalogue (1929), p. 53, nr. 342; Gerson, *Thieme-Becker*, vol 25 (1931), p. 556; Plietzsch (1937), p. 372, fn. 1b; Bénézit, *Dictionnaire*, vol. 6 (1953), p. 404; Plietzsch (1960), p. 67, fn. 1.

18. Family Portrait (Fig. 150)

Signed and dated 1663, lower left.
Canvas, 97.5 × 85 cm.
Fogg Art Museum, Cambridge, Massachusetts, nr. 1922.135.

Provenance: Laffan Collection; gift to museum of Frederic Sherman in memory of his brother Frank D. Sherman.

Notes: This painting is the earliest of Ochtervelt's seven family portraits set in domestic interiors. Both parents are dressed in sober black-and-white costumes. The child wears a gray dress patterned with tiny red dots, trimmed with red at the shoulders, and with red, yellow, and gray waist ribbons. This figure is strikingly similar to Ludolf de Jongh's *Portrait of a Child*, signed and dated 1661 (Fig. 151), in the Virginia Museum of Fine Arts, Richmond. The subdued grays and blacks of the interior are accented by two bright red chairs, the muted orange and green of the table carpet, and the red hat and child's top on the wooden floor at the left. A view into a lighted inner room shows a more opulent interior with a gray tiled floor, blue chair and ceiling, and an elaborate marble fireplace with a classical landscape in a gold frame. Similar De Hooch-like vistas are found in two later portraits of the 1670s (cat. nrs. 61 and 81; Figs. 156 and 158).

Literature:
Valentiner (1924), pp. 269, 273–74, fig. 1; Gerson, *Thieme-Becker*, vol. 25 (1931), p. 556; Plietzsch (1937), p. 370; Bénézit, *Dictionnaire*, vol. 6 (1953), p. 404; Plietzsch (1960), p. 65; S. Donahue, "Two Paintings by Ochtervelt in the Wadsworth Atheneum," *Bulletin of the Wadsworth Atheneum* 5 (Fall 1969): 47, fig. 2.

19. Family Portrait (Fig. 152)

Signed and dated 166(4?), below mantle at left.
Canvas, 75 × 58.5 cm.
The Wadsworth Atheneum, Hartford, Connecticut, nr. 1960.261.

Provenance: Collection E. Higginson, Saltmarshe, England; Collection John Walter, Bearwood, by 1912; John Walter Sale, London (Sotheby), February 13, 1946, nr. 101; Collection Paul Hatvany; Hatvany Sale, London (Sotheby), July 4, 1956, nr. 33 (to Curzon); Collection Robert Lehman, New York; gift of Robert Lehman to museum, 1960.

Notes: Although the date of this portrait was listed as 166(7?) in the catalogue of the Walter Sale in 1946, a reading of 166(4?) is also possible and is more consistent with the strong stylistic affinities of the painting with cat. nr. 18; Fig. 150, which is firmly dated 1663. According to the Higginson catalogue, published in 1842, the painting depicts the family of Daniel Elsievier (1626–80), the Dutch printer, and was commissioned to commemorate his receipt of a decoration from the government for his skill in typography: a medal worn by the child at his knee. This anecdotal interpretation is certainly dubious at best, for similar "decorations"— christening medals presented to infants after baptism— appear quite frequently in Dutch portraits of young children (cf. Nicolaes Maes, *The Happy Child*, Toledo Museum of Art, Toledo, Ohio).

The condition of the painting is good except for losses and retouching at the lower right and along the right side of the tapestry at the upper right. The standing lady wears a gray velvet jacket, a pale blue apron, and a brocade skirt of gold on gray-blue; the child at her side, a black and white cap trimmed with blue ribbons and a pale lavender-gray dress; the kneeling girl, a white apron and mauve print dress; the young boy, a dark gray costume with blue-white sleeves and blue and yellow waist ribbons; the wet nurse at the right, a gray apron, dark orange skirt, and black jacket; the baby in her arms, a light blue dress with red, yellow, and blue ribbons at the elbows. The father of the family is dressed in black. The table carpet is red, the chair at the left is green, and the marble fireplace is trimmed with gold and has a landscape overmantle in the style of Jan Both. On the gray wall in the center are two bust-length pendant portraits in gold frames in which the sitters (probably the parents of the husband or wife in the foreground) wear costumes of the late 1640s.

The large tapestry at the right, framed by green curtains, depicts a Titianesque scene of a female figure surrounded by putti, several of which are in flight. Variants of this scene appear in two later portraits by Ochtervelt (cat. nrs. 60 and 61; Figs. 154 and 156). Its meaning in this context (like the orange held by the

young mother) may relate to the idea of marital fruitfulness or fertility. In addition, Julius Held has pointed out that putti in flight, included in family portraits by Jacob Jordaens (cf. *The Jordaens Family*, The Hermitage, Leningrad), refer to the souls of deceased children in the family. (J. Held, "Jordaens' Portraits of His Family," *Art Bulletin* [1940]: 72, fig. 1).

Literature:

Catalogue, Collection of E. Higginson of Saltmarshe (London, 1842), p. 78, nr. 3; E. W. Moes, *Iconographia Batava* (Amsterdam), vol. 1 (1897), p. 270, nr. 2336; T. P. Grieg, "In the Auction Rooms," *Connoisseur* 117 (June 1946): 133, 136 (ill.); F. van Braam, *World Collectors' Annuary 1946-67* (Delft), vol. 1 (1946), p. 470, nr. 5984 (ill. opposite p. 601); *Burlington Magazine* (June 1956): vii; S. Donahue, "Two Paintings by Ochtervelt in the Wadsworth Atheneum," *Bulletin of the Wadsworth Atheneum* 5 (Fall 1969): 46-49, fig. 1.

20. Violinist and Two Maids (Fig. 27)

Canvas, 51.7 × 41.2 cm., c. 1663-65.
Manchester City Art Gallery, Manchester, England, nr. 1926/II.

Provenance: De la Court-Backer Sale, Leiden (Luchtmans), September 8, 1766, nr. 61; Collection Lord Francis Pelham Clinton Hope; Hope Sale, London (Christie), July 20, 1917, nr. 40; purchased by the Manchester City Art Gallery from Agnew and Sons, February, 1926.

Exhibitions: British Institution, 1855, nr. 3; The Royal Academy London, "Dutch Pictures: 1450-1750," 1952-53, nr. 441; Graves Art Gallery, Sheffield, "Dutch Masterpieces," Fall 1956, nr. 36.

Notes: Close in style and setting to *The Embracing Cavalier* (cat. nr. 14; Fig. 25) and *The Sleeping Soldier* (cat. nr. 15; Fig. 26), but perhaps slightly later, since the figures are comparable to the more slender types seen in Ochtervelt's interiors of the mid- to late 1660s. The two figures at the right and the treatment of the wall at the left seem to have been derived from Van Mieris's inn scene, dated 1658 (Fig. 24), in the Mauritshuis. The standing maid at the left wears a black velvet blouse, a pale gray satin skirt, and a dark blue apron; the central woman wears a pale blue blouse and dark green skirt; and the violinist has a bright red cape, a light brown satin jacket, and dark yellow stockings.

Literature:

P. Terwesten, *Catalogus of Naamlyst van Schilderyen* (The Hague, 1770), p. 550, nr. 61; C. Kramm, *De Levens en Werken der Hollandsche en Vlamsche Kunstschilders* (Amsterdam, 1851-64), p. 1653; A. Graves, *A Century of Loan Exhibitions* (London, 1913-15), vol. 3, p. 1361; Valentiner (1924), p. 270, fig. 7; Plietzsch (1937), p. 364; L. Haward, *Illustrated Guide to the Art Collections in the Manchester Corporation Galleries*

(Manchester, 1938), pp. 11, 41 (ill.); *International Studio* 134 (July 1947): 5 (color ill.); *International Studio* 145 (March 1953): 68 (color ill.); Plietzsch (1960), p. 67.

21. The Oyster Meal (Fig. 29)

Panel, 47 × 37.5 cm., c. 1663-65.
The Thyssen-Bornemisza Collection, Lugano/Castagnola.

Provenance: Sale, Amsterdam (Jolles, de Winter), May 23, 1764, nr. 102 (to Bogaard); A. de Lange Sale, Amsterdam (v.d. Schley . . . Vinkeles), December 12, 1803, nr. 97; Van Winter Collection; Six Collection, Amsterdam; Six Sale, Amsterdam (Muller), October 16, 1928, nr. 32 (to Goldschmidt); Schloss Rohoncz.

Exhibitions: Stedelijk Museum, Amsterdam, "Verzameling Schilderijen en Familie-Portretten van de Herren . . . Six," 1900, nr. 93; Neuen Pinakothek, Munich, "Sammlung Schloss Rohoncz," 1930, nr. 243; Alte Pinakothek, Munich, 1931; Villa Favorita, Castagnola/Lugano, "Aus dem Besitz der Stiftung Sammlung Schloss Rohoncz," 1949, nr. 190; National Gallery, London, "From van Eyck to Tiepolo: an Exhibition of Pictures from the Thyssen-Bornemisza Collection," March 2-April 20, 1961, nr. 81.

Notes: Similar to the Manchester *Violinist and Two Maids* (cat. nr. 20; Fig. 27) in the choice of figure types and costumes. In this painting, however, the male musician wears a pale lavender jacket, violet-brown trousers, and dark green stockings. The maid has a dark blue-green blouse, and the seated woman wears an orange velvet blouse and a tan satin skirt bordered in black.

The offering of oysters, a subsidiary motif in Ochtervelt's early interior *Merry Company with Violinist* (cat. nr. 7; Fig. 16), becomes the focus of a number of later works (see also cat. nrs. 23, 36, 71; Figs. 33, 40, 82) in which an amorous relationship between a man and woman is clearly implied. Belief in the aphrodisiacal properties of oysters, which can be traced back to antiquity, may derive from the notion that Aphrodite was conceived in an oyster shell (S. Bernan and R. Bernan, *A Guide to Myth and Religion in European Painting, 1270-1700* [New York, 1973], p. 43). Dutch writers in the 17th century also commented upon the efficacy of oysters as inducements to the libido and as aids to fertility and sexual potency (cf. De Jongh, *Tot Lering en Vermaak*, pp. 202-5).

Three copies of the Thyssen *Oyster Meal* are known (cat. nrs. 21-A, 21-B, 21-C; Figs. 30-32). Since all three copies include a tapestry covered table, it is possible that the tablecloth in the original (now dark blue-green flecked with white) has been overpainted.

Literature:
G. Hoet, *Catalogus of Naamlyst van Schilderyen* (The Hague, 1752), vol. 1, p. 417, nr. 128; W. Bürger, *Les Musées de la Hollande* (Paris, 1858), vol. 1, p. 250; *Catalogus der Verzameling Schilderijen en Familie-Portretten van de Herren . . . Six* (Amsterdam, 1900), p. 21, nr. 93; Valentiner (1924), p. 270, fig. 3; *Pantheon* 2 (September 1928): 54 (ill.); A. L. Mayer, "Die Austellung der Sammlung Schloss Rohoncz in München," *Pantheon* 6 (July 1930): 314; *Art News* 28 (August 16, 1930): 19; Plietzsch (1937): 364; R. Heinemann, *Stiftung Sammlung Schloss Rohoncz* (Lugano-Castagnola, 1937), vol. 1, p. 114, nr. 310; vol 2, pl. 142; E. Gordon Spencer, "The Thyssen-Bornemisza Gallery at Castagnola," *Connoisseur* 127 (May, 1951): 120 (ill.); Plietzsch (1960), p. 67; *Collection Thyssen-Bornemisza* (Lugano, 1967), p. 59, nr. 310; E. de Jongh, *Tot Lering en Vermaak* (Amsterdam: Rijksmuseum, 1976), nr. 51, pp. 202-5.

21-A. The Oyster Meal (copy) (Fig. 30)

Material of support unknown, 50 × 42 cm.
Present location unknown.

Notes: Known only through an old photograph in the Rijksbureau voor Kunsthistorische Documentatie, The Hague (neg. L 35303), with the notation: "Bukarest, Museum." The painting is not listed, however, in catalogues of the Simu Museum, Bucharest.

21-B. The Oyster Meal (copy) (Fig. 31)

Canvas, 52 × 40 cm.
Present location unknown.

Provenance: Sale, Frankfurt am Main (Hahn), March 6, 1941, nr. 59; Sale, Amsterdam (Muller), November 20-23, 1951, nr. 99.

Notes: Judging from the reproduction in the sale catalogue of 1941, this copy is somewhat cruder than cat. nr. 21-A; Fig. 30, especially in the treatment of faces.

21-C. The Oyster Meal (copy) (Fig. 32)

Material of support and dimensions unknown.
Present location unknown.

Notes: Known only through a photograph in the Rijksbureau voor Kunsthistorische Documentatie, The Hague (neg. L35220), with the notation: "Private Collection, The Netherlands." The background at the left has been changed to show an open door with a view to the outside. A segment of a gold picture frame has been added at the upper left.

22. The Offer (Fig. 28)

Signed (?), c. 1663-68 (?)
Material of support and dimensions unknown.
Present location unknown.

Provenance: Rosenbaum, Berlin, c. 1933; Mellaert, The Hague, May 1938; Amsterdam art trade, n.d.

Notes: This is probably the painting that Plietzsch has referred to as "die galante Szene mit einem stehenden Herrn, der einer Frau die Hand reieht und zwei Nebenfiguren am Tisch im Hintergrunde (ehemals Amsterdamer Kunsthandel)." According to a notation in the Rijksbureau voor Kunsthistorische Documentatie, The Hague, the painting is signed (location of signature unknown). The date of the picture is problematic, although its subject and setting obviously relate to Ochtervelt's tavern scenes of the early 1660s (cat. nrs. 14, 15, 20; Figs. 25-27). The lighted wall with hanging objects at the left is similar to the corresponding portion of the *Violinist and Two Maids* in Manchester (cat. nr. 20; Fig. 27). The balconylike structure, over which a striped pillow and tumbled bed sheets have been tossed, seems to be a variation of the upper part of Van Mieris's *Soldier and Maid* (Fig. 24), in the Mauritshuis—a work that also influenced the Manchester painting. On the other hand, the dress worn by the seated woman is very close to costumes found in later works dating from about 1668 (cat. nrs. 44 and 45; Figs. 50 and 51). In the absence of the original itself, or of a recent photograph, a precise date cannot be assigned. The theme of a man offering money to a woman—a rare subject in Ochtervelt's *oeuvre*—is known in only one other painting: a more refined, less overtly sensual interpretation of the early 1670s (cat. nr. 69; Fig. 80).

Literature:
Plietzsch (1937), p. 368, fn. 3; Plietzsch (1960), p. 65, fn. 1.

23. The Oyster Meal (Fig. 33)

Canvas, 54 × 44.5 cm. c. 1664-65.
Private Collection, England.

Provenance: Collection Le Comte de Morny; Sale, Paris (Hotel Drouot), April 27-28, 1874, nr. 73; Bischoffsheim Collection, London; Bischoffsheim Sale, London (Christie), May 7, 1926, nr. 75 (to Wallis); A. Preyer Collection; Preyer Sale, Amsterdam (Muller), November 8, 1927, nr. 23; Collection Teixeira de Mattos; D. Katz, Dieren, 1936; Galerie Meissner, Zurich, 1965; Collection J. William Middendorf II; Edward Speelman Ltd., London.

Exhibitions: Guildhall, London, 1903; D. Katz, Dieren, "Oud Hollandsche en Vlaamsche Meesters," November 16–December 15, 1935, nr. 49; The Metropolitan Museum of Art, New York, 1967–69 (loan, nr. 67.45).

Notes: See notes to cat. nr. 21; Fig. 29. Many of the accoutrements of the interior are repeated in other Ochtervelts of about 1660–65 (cat. nrs. 11, 14, 15, 20–22; Figs. 23, 25–27, 29, 28). The bedclothes thrown over the balcony and the birdcage (cf. cat. nrs. 14 and 22; Figs. 25 and 28) discreetly reinforce the erotic implications of the scene. The male figure wears a dark brown costume tinged with lavender, and with silver embroidery at the elbows. His companion has a red velvet jacket bordered with white fur and a pale blue satin skirt trimmed with silver embroidery. The carpet on the table is painted in dark tones of green and yellow.

Literature:
Plietzsch (1937), p. 364; Plietzsch (1960), p. 67.

24. Street Musicians at the Door (Fig. 122)

Signed and dated 1665, lower right.
Panel, 68.6 × 55.9 cm.
City Art Museum of St. Louis, Missouri, nr. 162.28.

Provenance: Lambert-du Porail Sale, Paris (Lebrun), March 27, 1787, nr. 126 (to Drouillet); Coclers Sale, Paris (Lebrun), February 9, 1789, nr. 74 (to Dufour); Lebrun Sale, Paris (Lebrun), April 11–30, 1791, nr. 145; Collection J. B. Puthon, Vienna, 1840; Collection Josef Winter, Vienna; Collection Baroness Stummer von Tavarnok, Vienna, 1895; gift to St. Louis Museum by Mrs. Eugene A. Perry in memory of her mother Mrs. Claude Kilpatrick.

Exhibitions: K. K. Österreichischen Museum, "Gemälde Alter Meister aus dem Wiener Privatbesitze," August–September, 1873, nr. 16; The Metropolitan Museum of Art, New York, "Dutch Painting: The Golden Age," 1954–55, nr. 56; Museum of Fine Arts, St. Petersburg, Florida, and High Museum of Art, Atlanta, Georgia, "Dutch Life in the Golden Century," January 21–May 4, 1975, nr. 33.

Notes: See cat. nrs. 16 and 62; Figs. 121 and 134. The signature and date (on the brown floor tile at the bottom right) have been abraded, but they are still legible. The woman at the left is seated on a green silk chair and wears a pale blue satin jacket trimmed with yellow ribbons and a salmon pink satin skirt with gold embroidery. The child wears a darker blue satin dress with yellow cuffs and a blue and yellow cape; the maid wears a dark green blouse, white apron, and orange skirt. The musicians (similar in type to those in cat. nr. 16; Fig. 121) wear costumes in muted tones of gray, brown, and

lavender. The cityscape is predominantly tan and gray, except for a bright red shutter in the center of the row of buildings at the right, which draws attention to a woman who leans out to listen to the music.

In the files of Kunsthandel P. de Boer, Amsterdam, is an engraving after this painting by W. French (c. 1815–98), inscribed: "Jan Uchtervelt pt., W. French sc."

Literature:
C. Blanc, *Le Trésor de la Curiosité* (Paris, 1857), vol. 2, pp. 116, 135; *Zeitschrift für bildenden Künste*, vol. 9 (1874), p. 60; *Katalog einer Sammlung von Ölgemälden alter Meister aus der Italienischen, Niederländischen, Spanischen und Altdeutschen Schule des Herrn Josef Winter* (Vienna, 1875), p. 28, nr. 128; T. von Frimmel, *Verzeichnis der Gemälde im Besitz der Frau Baronin Auguste Stummer von Tavarnok (Galerie Winter)* (Vienna, 1895), p. 56, nr. 133; H. Mireur, *Dictionnaire des Ventes d'Art* (Paris, 1911), vol. 5, pp. 413–14, nr. 1789; T. von Frimmel, "Zur Geschichte der Puthon'schen Gemäldesammlungen," *Blätter für Gemäldekunde*, vol. 7, nr. 2 (July–August 1911), pp. 24–25; T. von Frimmel, "Der wiedergefundene Ochtervelt im Wiener Nationalmuseum," *Studien und Skizzen zur Gemäldekunde* 5 (1920–21): 173; Gerson, *Thieme-Becker*, vol. 25 (1931), p. 556; Plietzsch (1937), p. 370; Plietzsch (1960), p. 65.

25. The Flag Bearer (Fig. 60)

Signed and dated 1665, upper right.
Panel, 19 × 16 cm.
Galerie Bruno Meissner, Zollikon/Zurich.

Provenance: Collection E. A. Leatham, 1868.

Exhibitions: Leeds, "National Loan Exhibition," 1868, nr. 632.

Notes: Similar in costume to the soldiers depicted in Ochtervelt's pendant genre scenes in the Assheton Bennett Collection (cat. nrs. 14 and 15; Figs. 25 and 26), which can be dated about 1660–63. Significantly, the artist's portrait of an ensign, dated 1660 (cat. nr. 13; Fig. 148), in The Hague, includes a completely different costume. Probably the Zurich *Flag Bearer* should be interpreted as a genre painting for which the artist himself may have modeled. The same likeness is seen in his *Self-Portrait* in Vienna (cat. nr. 30; Fig. 160), and again in several studies of other single genre types (cat. nrs. 31, 33–35; Figs. 65, 61, 63, 64). These works are clearly related in concept, for all are painted on small panels, use similar formats, and can be dated in the mid-1660s. They seem to represent a series of experiments in which the artist portrayed himself in the guise of various professions.

The Flag Bearer is painted in rather monochromatic colors. The background scene is gray and the flag is white (or pale gray). The figure wears a black hat with

dark blue and white plumes and a dark gray metal cuirass with a red, blue, and yellow scarf at the neck. His sleeves are mustard and white.

26. The Gallant Drinker (Fig. 34)

Signed, upper right, c. 1665.
Canvas, 63.5 × 51.4 cm.
Present location unknown.

Provenance: Collection Lord Athlumney; Collection William Cremin, Dublin; Collection Sir Robert Bland Bird; Sir Robert Bird Sale, Paris (Palais Galliéra), April 1, 1965, nr. 16.

Exhibitions: Slatter Gallery, London, "Dutch and Flemish Masters," May 27–July 9, 1949, nr. 1; Birmingham City Museum, "Some Dutch Cabinet Pictures of the 17th Century," August 26–October 8, 1950, nr. 46; The Royal Academy, London, "Dutch Pictures: 1450–1750," 1952–53, nr. 437.

Notes: Probably the companion piece to *The Doctor's Visit* (cat. nr. 27; Fig. 35), which has similar dimensions and has been in two of the same private collections. The subjects of the two works can also be viewed as moralizing counterparts. The wine carafe, which the flirtatious maid offers the soldier in the tavern scene, is transformed, in the pendant, into a flask of urine held up by a doctor attending a lovesick girl. According to a color reproduction in the Slatter catalogue of 1949, the maid holds a carafe of red wine and wears a pale yellow and white headdress, a tan satin blouse, and a pale gray or white satin skirt. The soldier is dressed in a dark yellow coat with brown sleeves, orange stockings, and dark brown boots.

Literature:
Illustrated London News, vol. 214, pt. 2 (June 11, 1949), p. 819; *Apollo* 81 (June 1965): 516.

27. The Doctor's Visit (Fig. 35)

Canvas, 62.5 × 50 cm., c. 1665.
The Assheton Bennett Collection, Manchester, England. On loan to Manchester City Art Gallery.

Provenance: Collection Lord Athlumney; Collection William Cremin, Dublin; Collection A. D. Rofe, Majorca; Wildenstein and Co., London, 1968; Thos. Agnew and Sons, London, 1969.

Exhibitions: Thos. Agnew and Sons, London, "Summer Exhibition of Fine Old Masters," May–June, 1949, nr. 43; The Arts Council, London, August–October, 1958, nr. 39.

Notes: Probably the pendant to *The Gallant Drinker* (see notes to cat. nr. 26; Fig. 34). Three other interpretations of the doctor's visit by Ochtervelt are known (cat. nrs. 32, 98, 105; Figs. 37, 110, 116). The depiction of the urine scan is also common in medical scenes by Teniers, Dou, Van Mieris, and Metsu, among others. (For illustrations, see E. Holländer, *Die Medizin in der Klassischen Malerei* [Stuttgart, 1950], pp. 284–328. The combination of this motif with a lovesick patient is also found in several emblems by Otto van Veen (*Amorum Emblemata* [Antwerp, 1608], pp. 121, 169, 277), which show a sympathetic attendant holding a urine vial beside a stricken putto, whose illness can only be cured by the medicine of love (see Fig. 36). J. B. Bedaux points out that such scenes of lovesick women may also allude to erotic melancholy and/or pregnancy ("Minnekoorts-Zwangerschaps-en Doodsverschijnselen op 17de eeuwse schilderijen," *Antiek,* vol. 10, nr. 1 [1975–76], pp. 17–42).

The ailing woman in Ochtervelt's painting is dressed in brilliant colors: a deep plum velvet jacket and a bright pink satin skirt trimmed with silver embroidery. The woman behind her has a dark purple dress, while the doctor wears black with touches of white at the neck and wrists.

28. The Faint (Fig. 38)

Canvas, 66 × 57 cm., c. 1665.
Museum der bildenden Künste, Leipzig, East Germany, nr. 1559.

Provenance: Collection B. de Bosch, Amsterdam; Collection De Burtin, Brussels, 1819; Galerie Speck von Sternberg, Lützschena.

Exhibitions: Museum der bildenden Künste, Leipzig, "Alte Meister aus Mitteldeutschem Besitz," May 13–August 15, 1937, nr. 55.

Notes: Formerly attributed to Gabriel Metsu, this work was correctly assigned to Ochtervelt by Plietzsch in 1960. For a later version of the same theme, see Ochtervelt's painting in Venice dated 1677 (cat. nr. 98; Fig. 110). The unconscious woman in the Leipzig *Faint* is strikingly similar to the foreground figure (only in reverse) in Frans van Mieris's *The Faint* of 1667 (Fig. 39; private collection, Paris). In Ochtervelt's version the fainting woman wears the same costume as the patient in *The Doctor's Visit* (cat. nr. 27; Fig. 35), except that her jacket is red and her skirt is a darker shade of pink. The weeping child has a white cap trimmed with blue ribbons, a pale gray satin dress with white apron, and carries a doll dressed in dark brown. The servant wears a brown dress trimmed with red and white at the neck and elbows.

Literature:

Description du Cabinet . . . de Burtin (Brussels, 1819), nr. 99 (as Metsu); *Verzeichnis der von Speck'schen Gemälde-Sammlung* (Leipzig, 1826), p. 4, nr. 11 (as Metsu); *Catalogue Galerie Speck von Sternberg* (1889), nr. 102 (as Metsu); F. Becker, *Gemälde-Galerie Speck von Sternberg in Lützschena* (Leipzig, 1904), nr. 23 (as Metsu, Ochtervelt or Van Geel); *Kunsthistorische Gesellschaft für Photographische Publikationen Leipzig*, vol. 11 (1905), nr. 23 (as Metsu); C. Hofstede de Groot, *Beschreibendes und kritisches Verzeichnis der Werke der hervorragendsten holländischen Maler des XVII. Jahrhunderts* (Esslingen a N.), vol. 1 (1907), nr. 117 (as Metsu); Plietzsch (1960), p. 67, fn. 1.

29. Woman Nursing a Child (Fig. 67)

Signed, upper left, c. 1665.
Panel, 14.3 × 11.1 cm.
Kunsthaus, Zurich, nr. R. 22.

Provenance: Galerie Sanct Lucas, Vienna; Collection W. Duschnitz, Vienna; Art trade, Lucerne, 1943; Collection L. Ruzicka, Zurich (Ruzicka Bequest to museum, 1949).

Exhibitions: Museum Boymans-van Beuningen, Rotterdam, "Vermeer: Oorsprong en Invloed," 1935, nr. 71; Kunsthaus Zurich, "Gemälde der Ruzicka Stiftung," December 1949–March 1950, nr. 22.

Notes: Related in size and format (and probably in date) to cat. nrs. 25, 31, 33–35; Figs. 60, 65, 61, 63, 64. Similar headdresses and facial types appear in interiors of the early to mid-1660s (cat. nrs. 14 and 15; Figs. 25 and 26). Ochtervelt included depictions of wet nurses in two of his paintings (cat. nrs. 19 and 73; Figs. 152 and 84), but the fine costume worn by this woman indicates that she must be the mother of the child. Her pale orange silk jacket is trimmed with white fur; the infant has a white cap and is wrapped in a light tan blanket with red stripes. Although nursing mothers appear in a number of De Hooch's interiors (ills., Valentiner, *Pieter de Hooch* [Stuttgart, 1929], pp. 71, 113, 118–19, 157), Ochtervelt's intimate, half-length interpretation seems unique. The closest parallel known to this writer is Gerbrand van den Eeckhout's *Virgin and Nursing Child* of 1659 (Fig. 68), in Braunschweig. Both works can be related to the traditional half-length Virgin and Nursing Child popular in 15th-century Flemish painting (cf. Dirck Bouts, *Virgin and Child in a Niche*, about 1465, National Gallery, London, nr. 2595). Dutch genre painters of the 17th century must have been aware of the religious derivation of secular depictions of this theme, as indicated by Jan Verkolje's full-length *Mother Nursing Her Child* of 1675 (Fig. 85), in the Louvre; at the right background is a large painting of the Virgin and Child.

30. Self-Portrait (Fig. 160)

Signed and dated 166(?), lower left.
Panel, 20.5 × 14.5 cm.
Present location unknown.

Provenance: W. Paech, Amsterdam, 1935; L. D. van Hengel Sale, Geneva (Moos), May 25, 1935, nr. 112; Munich Collecting Point, nr. 2866, Bundesdenkmalamtes, Vienna, nr. 345.

Notes: Van Hall's identification of this painting as a self-portrait is supported by the tiny size of the work and by the close juxtaposition of the signature to the palette and brushes. The painting should probably be dated near the mid-1660's, for it is similar in style and format to two dated genre figures, also on small panels, for which the artist apparently posed: *The Flag Bearer*, dated 1665 (cat. nr. 25; Fig. 60) and *The Singing Violinist*, dated 1666 (cat. nr. 33; Fig. 61). The same face reappears in several undated, small-scale genre figures of the same period (cat. nrs. 31, 34, 35; Figs. 65, 63, 64).

The general condition of the painting seems good (judging from a photograph), but the rather awkward contours of the artist's beret suggest that it has been retouched.

Literature:

H. van Hall, *Portretten van Nederlandse beeldende Kunstenaars* (Amsterdam, 1963), p. 235, nr. 2; S. D. Kuretsky, "The Ochtervelt Documents," *Oud Holland* 87 (1973): 131, pl. 6; "The Ochtervelt Documents (aanvulling)," *Oud Holland* 89 (1975): 65–66.

31. Peasant Smoking (Fig. 65)

Signed, upper left and right edges of archway; Ochter . . . velt, c. 1665–66.
Panel, 16 × 13 cm.
Kunsthalle, Hamburg, nr. 235.

Provenance: Hoogeveen Sale, Amsterdam (v.d. Linden, De Winter), June 5, 1765, nr. 85; Speth Collection, Munich; Collection Hudtwalcker-Wesselhoeft, until 1888.

Notes: Related in size and format to cat. nrs. 25, 30, and 33–35; Figs. 60, 160, 61, 63, and 64, for which the artist apparently used himself as model (see notes to cat. nrs. 25 and 33). Jan van Mieris also seems to have portrayed himself in the guise of a smoker in a dated painting of 1688 in the Kunsthalle, Hamburg, which depicts the artist smoking a pipe in the context of his studio (ill., *Katalog . . .Hamburger Kunsthalle* [1966], p. 114, nr. 625). Representations of single smokers, which also appear in contemporary emblem books, commonly refer to the transience of human life, a parallel to the evanescence of smoke (cf. E. de Jongh, *Tot Lering en*

Vermaak, [Amsterdam: Rijksmuseum, 1976], pp. 54–57). They were also frequently used as symbols of "Taste" in Five Senses series (cf. S. Slive, *Frans Hals* [London and New York, 1970], vol. 1, pp. 77–79). Indeed, there is reason to believe that Ochtervelt's painting had at least one pendant. The description under nr. 85 in the Hoogeveen Sale of 1765 reads: "Twee Stuks, het eene verbeeldende een Rookend Mannetje, en het andere speelende met een Hondje, Beide zeer uitvoerig op Paneel geschildert, en jeder hoog 6, breed 5 duim." A print after the painting was made by Wilhelm Hecht (1843–1920), inscribed "W. Hecht sct., Jac. Ochtervelt pxt." (Hollstein, vol. 14, p. 187, nr. 2; reproduction: Witt Library, Courtauld Institute, London). The colors of the painting are all variations of gray and tan. The figure has a medium gray cap, darker gray torso, and grayish-tan sleeve; the table is gray; the background is dark brown; and the pipe is white with glowing red embers. Only one other peasant painting by Ochtervelt is known: *Peasant Spinners in an Interior* (cat. nr. 17; Fig. 142), formerly in the Leipzig Museum der bildenden Künste.

Literature:
W. von Bode, *Die Sammlung Wesselhoeft* (1886), p. 28; Wurzbach, vol. 2 (1910), p. 249; *Kunsthalle zu Hamburg, Katalog der Alten Meister* (Hamburg, 1918), p. 119, nr. 235; *Kunsthalle zu Hamburg, Katalog der Alten Meister* (Hamburg, 1921), pp. 123–24, nr. 235; Valentiner (1924), p. 274; G. Pauli, *Führer durch die Galerie Alterer Meister der Kunsthalle Hamburg* (Hamburg, 1928), p. 126; *Kunsthalle zu Hamburg, Katalog der Alten Meister* (Hamburg, 1930), pp. 115–16, nr. 235; Gerson, *Thieme-Becker*, vol. 25 (1931), p. 556; Plietzsch (1937), p. 372, fn. 1b; Bénézit, *Dictionnaire*, vol. 6 (1953), p. 404; *Katalog der Alten Meister der Hamburger Kunsthalle* (Hamburg, 1956), p. 123, nr. 235; Plietzsch (1960), p. 67, fn. 1; *Katalog der Alten Meister der Hamburger Kunsthalle* (Hamburg, 1966), p. 121, nr. 235; S. D. Kuretsky, "The Ochtervelt Documents," *Oud Holland* 87 (1973): 133–34, fig. 8.

32. The Lovesick Girl (Fig. 37)

Canvas, 48 × 42 cm., c. 1665–68.
Dienst Verspreide Rijkscollecties, The Hague, nr. NK 1984.

Provenance: S. T. Smith and Son, 1920; Wallraf-Richartz Museum, Cologne, 1925, nr. 2678 (?); Anderson Gallery, New York, 1931; P. Cassirer & Co., Amsterdam, 1936; P. de Boer, Amsterdam, 1937–39; Collection P. Eschauzier, The Hague, 1940; Wallraf-Richartz Museum, Cologne (depot), 1942–50.

Exhibitions: P. de Boer, Rotterdam, "Kersttentoonstelling van oude Schilderijen," 1937–38, nr. 4; P. de Boer, The Hague, 1939, nr. 69; Ferens Art Gallery, Kingston-on-Hull, "Dutch Painting of the Seventeenth Centu-

ry," June 6–July 2, 1961, nr. 76; Apeldoorn, Sittard, Venlo, July 10–October 15, 1965, nr. 25; Burgerweeshuis, Zierikzee, "Grote en kleine Meesters der 17de Eeuw," July 1–September 18, 1963.

Notes: According to the files of the Dienst Verspreide Rijkscollecties, the painting was at the Wallraf-Richartz Museum, Cologne, in 1925 (nr. 2678). The museum, however, has no record of the work before 1942. Although the lighting, painting technique, and colors are all characteristic of Ochtervelt, the painting is difficult to date because of its uneven condition. The left side appears to have been badly damaged and extensively retouched. Photographs of the painting taken between 1939 and 1976 show a copper pan, rather than a chamberpot, on the footstool in the foreground. Recent cleaning removed the overpaint in this area.

The patient wears a red velvet jacket and white satin skirt. The bed curtains are dark green, the stool is blue, and a yellow basket (containing the urine flask) stands on a red Turkey carpet at the right. (For other interpretations of the same subject, see cat. nrs. 27, 98, and 105; Figs. 35, 110, and 116).

Literature:
Valentiner (1924), p. 283; Plietzsch (1937), p. 370, fn. 1; *Maandblad voor beeldende Kunsten*, vol. 14 (1937), p. 353; F. H. Fischer, *Het Leven van onze Voorouders* (De Roever-Dozy) (Amsterdam, 1938), vol. 3, ill. opposite p. 344; Plietzsch (1960), p. 66, fn. 1; F. Robinson, *Gabriel Metsu: A Study of His Place in Dutch Genre Painting of the Golden Age* (New York, 1974), pp. 81, 212, fig. 192.

33. The Singing Violinist (Fig. 61)

Signed and dated 1666, upper right.
Panel, 25.7 × 20.6 cm.
Glasgow Art Gallery and Museum, nr. 590.

Provenance: Collection J. B. P. Lebrun; Collection John Slater, by 1833; Slater Sale, London (Christie), April 22, 1837, nr. 104; E. W. Lake Sale, London (Christie), July 11, 1845, nr. 14 (to R. Artis, Ramsgate); R. Artis Sale, London (Christie), May 17, 1851, nr. 22 (to Evans); Scarisbrick Sale, London (Christie), May 13, 1861, nr. 174 (to Graham-Gilbert); Graham-Gilbert bequest to Glasgow Museum, 1877.

Notes: Variants of the same musician appear in cat. nrs. 34 and 35; Figs. 63 and 64. This painting belongs to a series of small-scale paintings of single figures (cat. nrs. 25, 30, 31, 33–35; Figs. 60, 160, 65, 61, 63, 64), for which the artist seems to have used himself as model. (See notes to cat. nr. 25; Fig. 60.) Despite its signature, the painting was long thought to be by Eglon Hendrik van der Neer on the basis of an engraving after the composition by C. L. Lingée, dated 1778, and inscribed "Eglon

van der Neer pinx." This print was published in Lebrun's volume of 1792, p. 90. The *feinmalerei* technique, costume, and theme of the painting are strongly reminiscent of Frans van Mieris, the elder (cf. *Woman Tuning a Lute*, Rijksmuseum, Amsterdam, nr. A 262). The exact source for Ochtervelt's conception, however, was probably the undated *Singing Violinist* by Pieter van Noort (Fig. 62; Landesmuseum, Münster), which is strikingly similar in composition. Since Van Noort's painting is one in a series of Five Senses, it is possible that the Ochtervelt can also be interpreted as a representation of "Hearing." Perhaps the painting once belonged to a series such as the *Five Senses* by Gonzales Coques (Musée Royale des Beaux Arts, Antwerp, nrs. 759-63), based upon portraits of contemporary painters (possibly including the artist himself). For illustrations, see S. Slive, *Frans Hals* (London and New York, 1970), vol. 1, p. 79, fig. 58.

The coloring of the Glasgow *Violinist* is both rich and delicate. The beret on the table is red velvet with blue and white plumes; the musician wears a metal cuirass over a violet jacket with red and white ribbons at the throat and slashed sleeves of pale lavender satin.

Literature:
J. B. P. Lebrun, *Galerie des Peintres Flamands* (Paris, 1792), p. 90 (as Eglon Hendrik van der Neer); A. Smith, *A Catalogue Raisonné of the Works of the Most Eminent Dutch, Flemish and French Painters* (London), vol. 4 (1833), nr. 14 (as E. H. van der Neer); C. Hofstede de Groot, "Holländsche Kunst in Schotland," *Oud Holland* 11 (1893): 141, nr. 316 (as E. H. van der Neer); C. Hofstede de Groot, *Beschreibendes und kritisches Verzeichnis der Werke der hervorragensten Maler des XVII. Jahrhunderts* (Esslingen a N, 1907-28), vol. 5, nr. 66 (as E. H. van der Neer); Gerson, *Thieme-Becker*, vol. 25 (1931), p. 556 (as Ochtervelt); *Dutch and Flemish, Netherlandish and German Paintings, Glasgow Art Gallery and Museum* (Glasgow, 1961), vol. 1, p. 101, nr. 590; vol. 2, p. 67, nr. 590 (ill.); S. D. Kuretsky "The Ochtervelt Documents," *Oud Holland* 87 (1973): 133-34, fig. 7; "The Ochtervelt Documents (aanvulling)," *Oud Holland* 89 (1975): 65-66.

34. Singing Violinist in a Niche (Fig. 63)

Panel, 26.7 × 19 cm., c. 1666-68.
Present location unknown.

Provenance: Collection Rev. J. M. Heath, 1880; Collection David Martin Currie, Campden Hill Court, Kensington; Currie Sale, London (Christie), February 18, 1921, nr. 18.

Exhibitions: Leeds, 1868.

Notes: Presently known only through a photograph in the Frick Art Reference Library, New York (neg. C10431), in which the painting is catalogued under the name of Ary de Vois. I am indebted to Otto Naumann for bringing the photograph to my attention.

A close variant of this musician (without the niche) appears in cat. nr. 35; Fig. 64. The figure has a similar costume and the same face as Ochtervelt's signed and dated *Singing Violinist* of 1666 in Glasgow, for which the artist apparently used himself as model. (See notes to cat. nr. 33; Fig. 61.) A similar format and setting appear in Ochtervelt's signed and dated *Man in a Niche* of 1668 (cat. nr. 48; Fig. 70), in Frankfurt.

35. Singing Violinist (Fig. 64)

Panel, 28.5 × 15 cm. (?), c. 1666-68.
Present location unknown.

Provenance: A. G. H. Ward, London, 1920; Empress Eugénie Sale, London (Christie), January 27, 1922, nr. 138; D. A. Hoogendijk, Amsterdam, 1932; R. H. Ward, London, 1936.

Notes: Hofstede de Groot, who catalogued this painting with the *oeuvre* of Frans van Mieris, the elder, noted that its original dimensions were 15.5 × 12 cm., with "Anstückung vom Maler selbst." The exact size of the work is uncertain; a notation on a photograph in the Witt Library, Courtauld Institute, London, gives dimensions of 18 × 14.7 cm. Hofstede de Groot's description of the painting includes full color notes: "Violinspieler in Halbfigur von vorn gesehen, in Braun, einen roten Mantel über linker Schulter und rechtem Knie. Weisse Armel. Schwarze Mütze mit roter Unterseite und weiss- und grüner Feder. Vor dem Hals eine rote Schleife."

The correct attribution of the painting to Ochtervelt (credited to Albert Blankert) was published in a note in *Oud Holland* 89 (1975): 65-66, which points out the close relationship of the work to Ochtervelt's *Singing Violinist* of 1666 (cat. nr. 33; Fig. 61), in Glasgow. Except for small changes in costume and facial expression and the omission of an architectural enframement, this figure is almost identical to Ochtervelt's *Singing Violinist in a Niche* (cat. nr. 34; Fig. 63; present location unknown).

Literature:
C. Hofstede de Groot, *Beschreibendes und kritisches Verzeichnis der Werke der hervorragensten Maler des XVII. Jahrhunderts* (Esslingen a N., 1907-28), vol. 10, p. 51, nr. 202 (as Frans van Mieris, the elder); "The Ochtervelt Documents (aanvulling)," *Oud Holland* 89 (1975): 65-66 (ill. p. 65).

36. The Oyster Meal (Fig. 40)

Signed and dated 1667, lower left.
Panel, 43 × 33.5 cm.
Museum Boymans-van Beuningen, Rotterdam, nr. 1618.

Provenance: M. van Noort Sale, Leiden (Lamme), April 29, 1845, nr. 15; H. de Kat Sale, Paris (Lamme, Petit), May 2, 1866, nr. 59 (to the Boymans Museum).

Exhibitions: Institut Néerlandais, Paris, "Le Décor de la Vie privée en Hollande au XVIIᵉ Siècle," February 1–July 3, 1965, nr. 40.

Notes: Possibly viewed by Thoré-Bürger during his travels in the Netherlands, since he mentions in his section on Ochtervelt "un tableau de la collection Kat à Dordrecht" (W. Bürger, *Les Musées de la Hollande* [Paris, 1858], vol. 2, p. 250). The Rotterdam *Oyster Meal* forms the dated core of a group of works in which variations of the same female figure, seen in three-quarter view from the back, are repeated (cat. nrs. 37–40, 42; Figs. 42–48). Wurzbach has correctly related the painting to *Oyster Meal* by Frans van Mieris (Fig. 41; dated 1661, formerly Alte Pinakothek, Munich, nr. 613), which may have served as Ochtervelt's source. The young woman, seated on a dark green stool, wears a yellow satin skirt and a red velvet jacket trimmed with white fur and silver embroidery; her companion has a dark blue coat with light brown trimming and a brown belt. The carpet on the table is painted in muted tones of black, white, pale orange, and dark red. Within the deep shadow of the background is a large tapestry showing what appears to be hunters in a forest—possibly a thematic parallel to the mutual amorous "pursuit" in the foreground. (For other depictions of oyster eaters, see cat. nrs. 7, 21, 23, and 71; Figs. 16, 29, 33, and 82. For the meaning of the theme, see notes to cat. nr. 21.)

Literature:
K. Woermann and A. Woltmann, *Geschichte der Malerei* (Leipzig, 1888), vol. 3, pt. 2, p. 840; P. H. van Rijsewijk, *Notice descriptive des Tableaux et Sculptures du Musée de Rotterdam* (Rotterdam, 1892), pp. 185–86, nr. 214; *Bryan's Dictionary of Painters and Engravers*, ed. G. C. Williamson (London, 1904), vol. 4, p. 32; Wurzbach, vol. 2 (1910), p. 249; *Museum Boymans Rotterdam, Geïllustreerd Catalogus* (1927), p. 67, nr. 337; *Museum Boymans, Beknopte Catalogus* (Rotterdam, 1928), p. 28, nr. 337; Gerson, *Thieme-Becker*, vol. 25 (1931), p. 556; Plietzsch (1937), p. 370, fn. 1; *Museum Boymans, Beknopte Catalogus Schilderijen en Beeldhouwwerken* (Rotterdam, 1937), p. 36, nr. 337; W. Martin, *De Schilderkunst in de 2de Helft van de 17de Eeuw* (Amsterdam, 1950), p. 103, pl. 261; *Bénézit, Dictionnaire*, vol. 6 (1953), p. 404; Plietzsch (1960), p. 66, fn. 1; *Catalogus Schilderijen tot 1800, Museum Boymans-van Beuningen* (Rotterdam, 1962), p. 99, nr. 1618; F. A. van Braam, *Art Treasures of the Benelux Countries* (1958), vol. 1, p. 344, nr. 3984; *Old Paintings 1400–1900, Illustrations, Museum Boymans-van Beuningen* (Rotterdam, 1972), p. 86, nr. 1618; S. D. Kuretsky, "The Ochtervelt Documents," *Oud Holland* 87 (1973): pl. 1; E. de Jongh, *Tot Lering en Vermaak* (Amsterdam: Rijksmuseum, 1976), p. 203, fig. 51a.

37. The Lemon Slice (Fig. 42)

Panel, 48.5 × 37.5 cm., c. 1667.
Present location unknown.

Provenance: A. Bout van Lieshout and Willem van Hogendorp Sale, The Hague (Bosboom), May 3, 1797, nr. 6 (to Valette); Jos. Valette Sale, Amsterdam (v.d. Schley. . . De Vries), August 26, 1807, nr. 218; Engelberts Sale, Amsterdam (v.d. Schley, Roos, De Vries), August 25, 1817, nr. 97 (to De Boer); Collection Carl Thürling, Amsterdam; Galerie van Diemen & Co., Amsterdam, 1929; private collection, Germany (?).

Exhibitions: Rijksmuseum, Amsterdam, "Tentoonstelling van oude Kunst door de Vereeniging van Handelaren in oude Kunst in Nederland," 1929, nr. 106.

Notes: Plietzsch, who incorrectly refers to this painting as an "Austernmahlzeit," stated in 1937 that it was in an Amsterdam private collection and in 1960 in a German private collection. The composition is a close variant of Ochtervelt's *Oyster Meal* in Rotterdam (cat. nr. 36; Fig. 40). According to an old color reproduction made by Galerie van Diemen and Co. (in the Rijksbureau voor Kunsthistorische Documentatie, The Hague), the colors are almost identical to the scene in Rotterdam. In this painting, however, the pitcher is blue and white (rather than plain white), the table carpet is red, yellow, and dark blue, and a lavender jacket with blue ribbons appears at the lower right. (For other variants of the same female figure, see cat. nrs. 38–40, 42; Figs. 43–46, 49.) Albert Blankert has suggested (in conversation) that the combination of lemons and wine may allude to the "sour and sweet" aspects of love. (See also cat. nrs. 53, 86; 88; Figs. 53, 100, 72). Two antique marble busts and an illegible painting over the mantelpiece (possibly a visionary subject or a scene of Hell) may have been intended as further clues to the meaning of the scene.

Literature:
Gerson, *Thieme-Becker*, vol. 25 (1931), p. 556; Plietzsch (1937), p. 370, fn. 1; Plietzsch (1960), p. 66, fn. 1.

38. The Concert (Fig. 43)

Panel, 41.2 × 39.3 cm., c. 1667.
Private collection, London.

Provenance: Fleischmann Collection.

Exhibitions: British Fine Arts Council, 1926; Birmingham City Art Gallery, "Some Dutch Cabinet Pictures of the 17th Century," August 25–October 8, 1950, nr. 45.

Notes: Variants of the female figure in the foreground appear in cat. nrs. 36, 37, 39, 40, 42; Figs. 40, 42, 46–48. Here she is seated on a purple silk stool and wears a red

velvet jacket and white satin skirt. The carpet on the table is light brown and black with small touches of green. The male figure is dressed in dark brown, and the singer has a black dress with white collar and cuffs. The face and breast of this figure have been extensively repainted.

Literature:
Plietzsch (1937), p. 370, fn. 1; Plietzsch (1960), p. 66, fn. 1.

39. The Card Players (destroyed)

Canvas, 51 × 42 cm., c. 1667.
Formerly Boymans Museum, Rotterdam (destroyed in the fire of 1864).

Provenance: J. Odon Sale, Amsterdam (v.d. Schley . . . Yver), September 6, 1784, nr. 33; Collection F. J. O. Boymans; Boymans Museum, Rotterdam.

Notes: The original painting was recorded in two copies now in the Museum Boymans-van Beuningen, Rotterdam (cat. nrs. 39-A and 39-B; Figs. 44 and 45). These indicate that the colors in the original were as follows: the standing woman wears a red velvet jacket and yellow satin skirt, the seated woman is dressed in dark blue, and the soldier has a metal cuirass, white sleeves embroidered with gold, violet trousers with yellow ribbons, and yellow boots. The chairs are bright green. On the mantelpiece in the background are two marble putti playing pipes and cymbals. The standing woman is a reverse variant of the figure in *The Music Lesson* (cat. nr. 40; Fig. 46): the same female type seen again in cat. nrs. 36-38, 40, 42; Figs. 40, 42, 43, 46-48.

Literature:
Catalogue d'un magnifique Cabinet de Tableaux . . . par Monsieur F. J. O. Boymans (Utrecht, 1811), pt. A, nr. 50 (as Metsu; the sale was planned for August 31, 1811, and was catalogued but did not take place); *Beschrijving der Schilderijen Enz. in het Museum te Rotterdam* (1849), nr. 282; W. Bürger, *Les Musées de la Hollande* (Paris, 1858), vol. 2, pp. 249-50; *Beschrijving der Schilderijen Enz. in het Museum te Rotterdam* (1859), p. 50, nr. 337; *Beschrijving der Schilderijen Enz. in het Museum te Rotterdam* (1862), p. 53, nr. 350; F. D. O. Obreen, *Archief voor Kunstgeschiedenis* (Rotterdam), vol. 5 (1883-84), p. 322; P. Haverkorn van Rijsewijk, *Het Museum Boijmans te Rotterdam* (The Hague and Amsterdam, 1909), p. 89; Wurzbach, vol. 2 (1910), p. 249; Plietzsch (1937), p. 370, fn. 1; Plietzsch (1960), p. 66, fn. 1.

39-A. The Card Players (copy) (Fig. 44)

Canvas, 36 × 30 cm.
Museum Boymans-van Beuningen, Rotterdam, nr. 2272.

Provenance: Collection J. D. Voorn Boers; Collection D. Seldenthuis (bequest to museum, 1943).

Notes: According to Haverkorn van Rijsewijk, this copy after the destroyed *Card Players* (cat. nr. 39) is by the Rotterdam painter and lithographer Sebastian Theodorus Voorn Boers (1828-93). The painting was cleaned and restored in 1976.

Literature:
P. Haverkorn van Rijsewijk, *Het Museum Boijmans te Rotterdam* (The Hague and Amsterdam, 1909), ill. opposite p. 89.

39-B. The Card Players (copy) (Fig. 45)

Signed, upper left: Voorn Boers Ft. naar J. Ochterveld.
Gouache on paper, 34 × 28 cm.
Museum Boymans-Van Beuningen, Rotterdam, nr. MVS 380.

Provenance: Collection Hubertus Michiel Montauban van Swijndregt (bequest to museum, 1929).

Notes: A second copy by S. Th. Voorn Boers (see notes to cat. nr. 39-A) after Ochtervelt's lost *Card Players* (cat. nr. 39).

Literature:
Aquarellen en Tekeningen uit het Legaat Montauban van Swijndregt, Museum Boymans-van Beuningen (Rotterdam, 1944), nr. 380.

40. The Music Lesson (Fig. 46)

Canvas, 66 × 56 cm., c. 1667.
Reiss Museum im Zeughaus, Mannheim, West Germany, nr. 127.

Provenance: Mannheimer Schloss.

Notes: The standing woman is a reverse variant of the figure in *The Card Players* (cat. nr. 39; Figs. 44 and 45) and similar to the female types in cat. nrs. 36-38, 42; Figs. 40, 42, 43, 48. The map of the Seventeen Provinces on the background wall, which also appears in cat. nrs. 54, 63, and 75; Figs. 130, 75, and 87, has been identified as C. J. Visscher's "Germania Inferior," of which the only known copy is in the Bibliothèque Nationale, Paris, nr. Ge.DD. 5732 (Welu, p. 539, fn. 49). The same map was used by both Vermeer (*The Art of Painting*, Kunsthistorisches Museum, Vienna) and Nicolaes Maes (*Listening Housewife*, Queen's Collection, London; *The Listener*, Apsley House, London).

Because of substantial areas of damage, the 1969 restoration of this painting involved considerable repainting: the face, hair, bodice, and right arm of the

seated woman; both arms and hands of the standing woman, whose profile has also been retouched; and the door jamb at the right. The dark-haired woman at the left, seated on a dark green chair, has a black bodice, dark mustard brown skirt, and white apron; the male figure wears dark brown or black; the standing woman has a light red velvet jacket, yellow satin skirt, and white apron; and the chair behind her is dark lime green with yellow green highlights.

Literature:
Verzeichnis der Gemälde in der Grossherzoglichen Galerie zu Mannheim (1900), p. 21, nr. 127; Gerson, *Thieme-Becker*, vol. 25 (1931), p. 556; G. Jacob, *Das Mannheimer Schloss und seine Sammlungen* (Mannheim, 1939), ill. opposite p. 3; Bénézit, *Dictionnaire*, vol. 6 (1953), p. 404; J. A. Welu, "Vermeer: His Cartographic Sources," *Art Bulletin* 57 (1975): 539, fn. 49.

40-A. The Music Lesson (copy) (Fig. 47)

Watercolor, material of support unknown, 47 × 37 cm. Present location unknown.

Notes: This 18th-century copy after the Mannheim *Music Lesson* (cat. nr. 40; Fig. 46) is known only through photographs in the Rijksbureau voor Kunsthistorische Documentatie, The Hague (neg. L 20909), and the Witt Library, Courtauld Institute, London. The name of the copyist is unknown.

41. Fish Seller at the Door (Fig. 123)

Signed, upper right corner of door frame, c. 1667-68. Canvas, 55.5 × 44 cm.
The Mauritshuis, The Hague, nr. 195.

Provenance: S. Stinstra Sale, Amsterdam (v.d. Schley . . . Yver), March 26, 1783, nr. 191 (to Fouquet); G. van der Pals Collection, Rotterdam; Van der Pals Sale, Rotterdam (Lamme, v. Leen), August 30, 1824, nr. 39 (to Van den Berg); Van Roothaan Sale, Amsterdam (De Vries . . . Roos), March 29, 1826, nr. 109.

Notes: Other entrance halls with fish sellers appear in cat. nrs. 55 and 103; Figs. 132 and 135. Similar subjects were also painted by Quiringh van Brekelenkam of Leiden (Fig. 126). The hairstyle and costume of the young woman (a red velvet jacket trimmed with white fur and silver embroidery, a white apron, and a yellow satin skirt) are the same as in Ochtervelt's *Oyster Meal* in Rotterdam, dated 1667 (cat. nr. 36; Fig. 40). The child wears a pale blue smock and dark blue sleeves with narrow orange cuffs. The fisherman is dressed in brown, and the two children on the steps are painted in

tones of tan and yellow. The floor tiles are gray and black.

Although the existence and location of a signature were noted in the catalogue of 1895 and by Hofstede de Groot (HdG notes, RKD: "met zeer dunne letters voluit gem."), this inscription is not visible today. An engraving was made after the painting by A. L. Zeelander (1789-1856) for the Steengracht catalogue of 1827 and a lithograph by G. Craeijvanger (1810-98) for the print catalogue published by Desguerrois in 1833. Three copies after the Mauritshuis *Fish Seller* are known (cat. nrs. 41-A, 41-B, 41-C; Figs. 124 and 125).

Literature:
J. Steengracht, *De Voornaamste Schilderijen van het Koninklijk Kabinet te 's Gravenhage* (The Hague, 1827), vol. 2, p. 37, nr. 48; *Het Koninklijk Museum van 's Gravenhage op steen gebragt* (Amsterdam: Desguerrois, 1833), p. 10-2; J. Immerzeel, *De Levens en Werken der Hollandsche en Vlaamsche Kunstschilders, Beeldhouwers, Graveurs en Bouwmeesters* (Amsterdam), vol. 3 (1843), p. 149; *Koninklijk Kabinet van Schilderijen te 's Gravenhage* (The Hague, 1844), p. 19, nr. 173; W. Bürger, *Les Musées de la Hollande* (Paris, 1858), vol. 1, p. 251; *Notice Historique et Descriptive des Tableaux et des Sculptures exposés dans le Musée Royal de La Haye* (The Hague, 1874), pp. 168-69, nr. 162; K. Woermann and A. Woltmann, *Geschichte der Malerei* (Leipzig), vol. 3, pt. 2 (1888), p. 840; *Catalogue Raisonné du Musée Royal de La Haye* (The Hague, 1895), p. 274, nr. 195; *Bryan's Dictionary of Painters and Engravers*, ed. G. C. Williamson (London, 1904), vol. 4, p. 32; Wurzbach, vol. 2 (1910), p. 249; *Catalogue Raisonné des Tableaux et des Sculptures, Musée Royal de La Haye, Mauritshuis* (The Hague, 1914), pp. 254-55, nr. 195; Valentiner (1924), pp. 270, 274, fig. 2; Gerson, *Thieme-Becker*, vol. 25 (1931), p. 556; *Catalogue Raisonné des Tableaux·et des Sculptures, Musée Royal de Tableaux, Mauritshuis* (The Hague, 1935), pp. 236-37, nr. 195; W. Martin, *De Hollandsche Schilderkunst in de 17de Eeuw* (Amsterdam, 1936), vol. 2, p. 211; Plietzsch (1937), p. 370; W. Martin, *De Hollandsche Schilderkunst in de tweede Helft van de 17de Eeuw* (Amsterdam, 1950), p. 103, pl. 261; Bénézit, *Dictionnaire*, vol. 6 (1953), p. 404; Plietzsch (1960), p. 65; F. van Braam, *Art Treasures of the Benelux Countries* (n.p., 1958), vol. 1, p. 344, nr. 3983; *Beknopte Catalogus van de Schilderijen . . . Mauritshuis* (The Hague, 1968), p. 107, nr. 195.

41-A. Fish Seller at the Door (copy) (Fig. 124)

Panel, 36 × 30 cm.
Present location unknown.

Provenance: Sale, Van Marle and Bignell, The Hague, March 24, 1964, nr. 150.

Notes: A literal but crude copy of the Ochtervelt in the Mauritshuis (cat. nr. 41; Fig. 123). According to the reproduction in the sale catalogue (pl. 1), the composition has been cropped by several centimeters at the top, the bottom, and the left side.

41-B. Fish Seller at the Door (copy) (Fig. 125)

Panel, 28.5 × 20.5 cm.
Present location unknown.

Provenance: Sale, Rudolf Bangel, Frankfurt am Main, October 12, 1926, nr. 154.

Notes: A copy of the Mauritshuis *Fish Seller* (cat. nr. 41; Fig. 123), in which the cityscape beyond the open door is replaced with a seascape. The copy is signed at the lower right: "J. van Uchtervelt f."

41-C. The Fish Seller (copy)

Canvas, 52 × 44 cm.
Present location unknown.

Provenance: Gotha Museum, 1890.

Notes: No reproduction of the painting is known, but it is listed in the Gotha catalogue of 1890 (as a copy) with the signature: "HVGTERVELT 1685."

Literature:
C. Aldenhoven, *Katalog der Herzoglichen Gemäldegalerie Gotha* (Gotha, 1890), p. 61, nr. 290.

42. The Tric-trac Players (Fig. 48)

Panel, 58.5 × 46.5 cm., c. 1667–69.
The E. G. Bührle Collection, Zurich.

Provenance: Collection Jan Gildemeester Jansz., Amsterdam, 1794–95; Jurriaans Sale, Amsterdam (v.d. Schley, Roos, De Vries), August 28, 1817, nr. 64 (to De Vries); J. Ancher Sale, Amsterdam (De Vries . . . Roos), April 6, 1847, nr. 83 (to Schuller); Van Doelen Collection, Groethe; Ten Cate Collection, Almelo; D. Katz, Dieren, 1935–36.

Exhibitions: Museum Boymans-van Beuningen, Rotterdam, "Vermeer: Oorsprong en Invloed," 1935, nr. 73.

Notes: Variants of the female figure are seen in cat. nrs. 36–40; Figs. 40, 42–46. Plietzsch has noted that the same male model was used in *The Gallant Man*, dated 1669 (cat. nr. 53; Fig. 53), in Dresden. For other versions of the theme, see cat. nrs. 43, 44, 64; Figs. 49, 50, 77. Tric-trac (backgammon) is a game for two, named for the clinking sound of the pieces. It is played, as shown here, on a hinged board with fifteen black and white draughtsmen, whose moves are determined by throws of the dice. As a game of chance, tric-trac may be likened to the vicissitudes of the game of love: probably the meaning of Ochtervelt's scene of refined flirtation. A large tapestry behind the figures depicts what appears to be a Roman scene with an enthroned emperor being crowned (?) by a winged victory, perhaps an allusion to the results of the "game" in progress.

In a broader sense, such games of chance may also relate to the uncertainties of human existence—an idea expressed in a tric-trac scene by Jan Steen, dated 1661, in the Museum Boymans-van Beuningen, Rotterdam (nr. 2527). Above a plaque on the mantle inscribed "soo gewonne, soo verteert" (easy come, easy go) is a figure of Fortuna balanced on a globe and a pair of dice. Representations of tric-trac boards and players also appear in 16th- and 17th-century emblem books as symbols of the vice of idleness, often associated with excessive drinking or loose morality. (On the symbolism of tric-trac in Dutch genre painting and emblem literature, see E. de Jongh, *Tot Lering en Vermaak* [Amsterdam; Rijksmuseum, 1976], pp. 108–11.)

The condition of the painting is unusually fine. The woman, seated on a purple silk stool, wears a brilliant red-orange velvet jacket and a pale gray satin skirt. The male figure wears a black coat bordered in purple, with pink ribbons at the elbows. The servant has a dark gray coat trimmed with mustard over a lavender shirt. The chair at the right is dark green.

This painting appears as the work immediately to the left of the sculptured overdoor in Adriaen de Lely's (1775-1820) painting *Jan Gildemeester Jansz. in His Art Gallery*, Rijksmuseum, Amsterdam, nr. 1442 A7.

Literature:
Plietzsch (1937), p. 370, fn. 1; Plietzsch (1960), p. 66, fn. 1; C. J. de Bruyn, "De Amsterdamse Verzamelaar Jan Gildemeester Jansz.," *Bulletin Rijksmuseum, Amsterdam* 13 (1965): 86, pl. 8.

43. The Tric-trac Players (Fig. 49)

Signed (on gameboard).
Canvas, 68 × 53 cm., c. 1667–69.
Private collection, West Germany.

Provenance: S. van der Stel Sale, Amsterdam (v.d. Schley. . . Yver), September 25, 1781, nr. 180; P. Opperdoes Alewijn Sale, Amsterdam (Roos), April 28, 1875, nr. 14; Snouck van Loosen Sale, Enkhuizen (Muller), April 29, 1886, nr. 51; Collection M.S. B. Bos de Harlingen; Bos Sale, Amsterdam (Muller), February 21, 1888, nr. 119; Van Pappelendam and Schouten Sale, Amsterdam (Muller, Roos), June 11, 1889, nr. 137; Private Collection, Switzerland.

Exhibitions: Wallraf-Richartz-Museum, Cologne, "Die Sammlung Henle aus dem grossen Jahrhundert der niederländischen Malerei," 1964, nr. 25.

Notes: See the notes to cat. nr. 42; Fig. 48. The female figure, dressed in a red velvet jacket and white satin

skirt, is beautifully painted in the style and costume of the late 1660s. The remainder of the composition, however (male figures, floor, walls, furniture, etc.) is later overpaint. Indeed, the two men are wearing 18th-century costume. The signature on the gameboard may repeat an earlier inscription, but it is not original itself. The words "OC:TERVELT: F" are painted in rough block letters, rather than in the artist's own script. Despite the extensive overpainting, the composition as a whole probably reflects Ochtervelt's original schema. The oblique placement of figures around a table is common in other works of the same period (cat. nrs. 42, 44, 45; Figs. 48, 50, 51).

Literature:
Katalog, Die Sammlung Henle (Cologne: Wallraf-Richartz-Museum, 1964), nr. 25.

44. Musician with Tric-trac Players (Fig. 50)

Canvas, 63.5 × 50 cm., c. 1668.
Wallraf-Richartz-Museum, Cologne, nr. 2968.

Provenance: J. F. Vinck de Wesel Sale, Antwerp (v.d. Hey, Beeckmans), August 16, 1814, nr. 105; Collection Antonio Maura Montaner, Madrid.

Notes: See notes to cat. nr. 42; Fig. 48. The painting is in good condition except for losses and retouching in the center of the foreground and on the edge of the cittern; the upper left background (a framed landscape painting) has been rubbed. The dress of the seated musician is identical to that of the woman in *The Toast,* dated 166(8?) (cat. nr. 45; Fig. 51). She wears a white satin blouse and brilliant salmon pink skirt with silvery bands of embroidery; the woman in the center is dressed in lavender-gray with a white collar; and the man at the left has a black coat with touches of red, and gold embroidery at the elbows. His stockings and trousers are dark mustard.

On the frame of the painting are two illegible coats of arms with the respective inscriptions: "POST NUBILA PHOEBUS" and ". . . LOS STEMPL."

Literature:
Bryan's Dictionary of Painters and Engravers, ed. G. C. Williamson (London, 1904), vol. 4, p. 32; Bénézit, *Dictionnaire,* vol. 6 (1953), p. 404; *Weltkunst,* vol. 27, nr. 14 (July 15, 1957), p. 6; *Führer durch die Gemälde-galerie, Wallraf-Richartz-Museum, Köln* (Cologne, 1957), p. 80, pl. 77; *Wallraf-Richartz-Museum der Stadt Köln, Verzeichnis der Gemäde* (Cologne, 1959), p. 137, pl. 80; Plietzsch (1960), p. 67; *Wallraf-Richartz-Museum der Stadt Köln, Verzeichnis der Gemälde* (Cologne, 1965), p. 137, pl. 80; G. von der Osten, *Wallraf-Richartz-Museum Köln 2* (Cologne, 1966), pp. 15, 58, pl. 235; H. Vey and A. Kesting, *Katalog der niederländischen Gemälde von 1550 bis 1800 im Wallraf-Richartz-Museum und im öffentlichen Besitz der Stadt Köln* (Cologne, 1967), p. 82;

nr. 2963, pl. 119; S. D. Kuretsky, "The Ochtervelt Documents," *Oud Holland* 87 (1973); pl. 2.

45. The Toast (Fig. 51)

Signed and dated 166(8?), lower left.
Canvas, 64.7 × 50.8 cm.
Private Collection, Capetown.

Provenance: P. Calkoen Sale, Amsterdam (v.d. Schley . . . Yver), September 10, 1781, nr. 130; Collection W. A. Hankey, 1885; Collection Sir Joseph Robinson, London; Robinson Sale, London (Christie), July 6, 1923, lot 78; Collection Princess Ida Labia (née Robinson), Capetown, South Africa.

Exhibitions: Royal Academy, London, "Winter Exhibition," 1885, nr. 84; Royal Academy, London, "The Robinson Collection," 1958, nr. 49; National Gallery of South Africa, Capetown, "The Sir Joseph Robinson Collection," 1959, nr. 52; Kunsthaus, Zurich, "Sammlung Sir Joseph Robinson 1840–1929," August 17–September 16, 1962, nr. 34; National Gallery of South Africa, Capetown, "The Natale Labia Collection," 1976, nr. 15; Wildenstein, London, "Twenty Masterpieces from the Natale Labia Collection," April 26–May 26, 1978, nr. 8.

Notes: The woman's dress is identical to the costume in cat. nr. 44; Fig. 50. The catalogue of the Robinson Sale (1923) includes the following color notes: "a young gentleman in brown costume seated before a table holding up a long glass, and before him is a young lady in white bodice and red satin skirt ornamented with silver braid; beyond her is a man in green coat, holding a bugle; in the foreground is a brown and white dog. Signed and dated 1708."

Judging from the literature, the date of the painting is difficult to read. Valentiner, Plietzsch, and Gerson also read the date as 1708—obviously incorrect since we now know that the artist died in 1682. In any case, the costume represented is that of the late 1660s. When Hofstede de Groot saw the painting at the Royal Academy exhibition in 1885 (HdG notes, RKD), he noted that it was "voluit gemerkt en 1669 gedateerd," a date also given by Wurzbach. MacLaren, having studied the picture at the Robinson Exhibition of 1958, proposed that the date be read 166(8?)—a correction of the old dating of 1708, which has been accepted in this catalogue and text.

Literature:
Bryan's Dictionary of Painters and Engravers, ed. G. C. Williamson (London, 1904), vol. 4, p. 32; Wurzbach, vol. 2 (1910), p. 249; A. Graves, *A Century of Loan Exhibitions* (London, 1913-15), vol. 2, p. 874; Valentiner (1924), pp. 273–74, 284; *Pantheon* 6 (December 1930): p. lviii; Gerson,

Thieme-Becker, vol. 25 (1931), p. 556; Plietzsch (1937), pp. 370-72; E. K. Waterhouse, *The Robinson Collection* (London, 1958), p. 25, nr. 49; Plietzsch (1960), pp. 66-67; N. MacLaren, *The Dutch School, National Gallery Catalogues* (London, 1960), p. 277; S. D. Kuretsky, "The Ochtervelt Documents," *Oud Holland* 87 (1973): 130, pl. 5.

46. Violin Practice (Fig. 52)

Signed and dated 1668, lower left.
Canvas, 52.5 × 43.5 cm.
Statens Museum for Kunst, Copenhagen, nr. 518.

Provenance: G. Morell, 1760.

Notes: When Hofstede de Groot saw the painting in Copenhagen before 1922, he made the following notation (HdG notes, RKD): "Voluit gemerkt en 1663 gedateered. Het laatste cyfer is onduidelyk en kan ook een 5 zyn." My own reading of the date concurs with the museum's current dating of 1668. The style of the costume is similar to the dress seen in cat. nrs. 44, 45, and 56; Figs. 50, 51, and 54. The central figure wears an especially elaborate satin dress with a pale yellow bodice trimmed with red and white ribbons and a salmon-pink skirt; the maid is dressed in gray with brown sleeves and white collar and cuffs; and the child, playing with a music book, has a warm brown dress with green bands at the elbows. The table carpet is painted in dull tones of brown, tan, and dark blue.

Although Ochtervelt's music scenes usually show a male figure playing the violin, female violinists appear also in cat. nrs. 43 and 63; Figs. 49 and 75. The Copenhagen interior is the earliest of the artist's boudoir scenes—a theme that he painted repeatedly in the 1670s (cat. nrs. 73-80; Figs. 84, 86-91, 93). Here the male figures are relegated to a large tapestry (in the style of Rubens) on the background wall, on which an illegible depiction of an angel (?) appears to two bearded men (possibly an Annunciation to the Shepherds). The thematic connection to the foreground scene is unclear.

Literature:
Fortegnelser over Wahls og Morells Køb (undated 18th-century manuscript inventory), Copenhagen, p. 55, nr. 74; N. A. Abildgaard, *Kritisk Fortegnelse over de Malierier, som findes paa Fredensborg* (manuscript, n.d.), nr. 210; I. C. Spengler, *Catalog over Det kgl. Billedgalleri paa Christiansborg (1827),* nr. 557; *Catalogue des Ouvrages de Peinture de la Galerie Royale de Christiansborg* (Copenhagen, 1870), p. 42, nr. 349; E. Bloch, *Catalog over Den kongelige Malerisamling paa Christiansborg Slot* (Copenhagen, 1875), p. 63, nr. 267 (as signed and dated 1663); E. Bloch, *Catalog . . . paa Christiansborg Slot* (Copenhagen, 1884), p. 59, nr. 267 (as signed and dated 1663); K. Woermann and A. Woltmann, *Geschichte der Malerei* (Leipzig), vol. 2, pt. 2 (1888), p. 840; K. Madsen, *Fortegnelse over den Kongelige Malerisamlingw Billeder af AEldre Malere* (Copenhagen, 1904), pp. 110-11, nr. 254; *Bryan's Dictionary of Painters and Engravers,* ed. G. C.

Williamson (London, 1904), vol. 4, p. 32; Wurzbach, vol. 2 (1910), p. 249; *Statens Museum for Kunst, Fortegnelse over Billeder of AEldre Malere* (Copenhagen, 1922), p. 72, nr. 455; Valentiner (1924), p. 273; Plietzsch (1937), p. 370; *Royal Museum of Fine Arts, Catalogue of Old Foreign Paintings* (Copenhagen, 1951), p. 233 (ill.), nr. 518; Plietzsch (1960), p. 65.

47. Woman Singing in a Niche (Fig. 69A)

Signed, below window, c. 1668.
Panel, 26 × 19.5 cm.
Present location unknown.

Provenance: "Monplaisir," Peterhof Park, St. Petersburg, until 1882; The Hermitage, Leningrad; Hermitage Sale, Berlin (Lepke), April 1, 1930, nr. 59b; Sale, Berlin (Flechtheim, Helbing and Puffrath), March 11, 1933, nr. 7; Hanfstaengl Collection, Munich.

Notes: Plietzsch (1937) has pointed out the similarities of this work to the late style of Godfried Schalken and has convincingly suggested (1960) that it may be the companion piece to *Man in a Niche* (cat. nr. 48; Fig. 70), which is signed and dated 1668.

Literature:
A. Somof, *Ermitage Impérial, Catalogue de la Galerie des Tableaux; Écoles Néerlandaises et École Allemande* (St. Petersburg, 1901), p. 266, nr. 1769; Wurzbach, vol. 2 (1910), p. 249; Plietzsch (1937), p. 370, fn. 1; Bénézit, *Dictionnaire,* vol. 6 (1953), p. 404; Plietzsch (1960), p. 65.

48. Man in a Niche (Fig. 70)

Signed and dated 1668, at right of tapestry.
Panel, 29 × 23 cm.
Städelsches Kunstinstitut, Frankfurt am Main, nr. 606.

Provenance: Dr. Grambs Collection; Grambs Bequest to museum, 1817.

Notes: Probably the companion piece to *Woman Singing in a Niche* (see notes to cat. nr. 47; Fig. 69A). Close in style to *The Singing Violinist* (cat. nr. 33; Fig. 61) in its fine technique and masterful differentiation of textures. The figure appears in a dark brown niche with a dark green grapevine above his head. The curtain behind him is dark blue-green. He holds an orange velvet beret and wears a dark pink neckscarf, a deep violet cape with mauve highlights, and a white muslin blouse with overlying bands of cream-colored satin. The tapestry is painted in muted tones of black, dark orange, gray, and brown.

Literature:
Wurzbach, vol. 2 (1910), p. 249; Valentiner (1924), p. 273; *Städelsches Kunstinstitut, Verzeichnis der Gemälde* (Frank-

furt am Main, 1924), p. 149, nr. 606; Plietzsch (1937), p. 370; Bénézit, *Dictionnaire*, vol. 6 (1953), p. 404; Plietzsch (1960), p. 65; *Städelsches Kunstinstitut, Verzeichnis der Gemälde* (Frankfurt am Main, 1966), p. 91, nr. 606; S. D. Kuretsky, "The Ochtervelt Documents," *Oud Holland* 87 (1973): 133, fn. 27; F. Robinson, *Gabriel Metsu: A Study of His Place in Dutch Genre Painting of the Golden Age* (New York, 1974), p. 87, fn. 122.

49. Woman in a Niche Holding Grapes (Fig. 71)

Panel, 25 × 22 cm., c. 1668.
The National Gallery of Ireland, Dublin, nr. 641.

Provenance: Purchased in 1895 from Foster, London.

Notes: Very similar in size and format to *Woman Singing in a Niche* (cat. nr. 47; Fig. 69) and *Man in a Niche* (cat. nr. 48; Fig. 70). The same subject appears in Gerard Dou's *Woman Holding Grapes at a Window*, Queen's Collection, London (ill., W. Martin, *Gerard Dou* [Stuttgart, 1913], p. 109). De Jongh has demonstrated that the motif of a bunch of grapes held by the stem, which is found in a number of 17th-century Dutch portraits and genre paintings, derives from an emblem by Jacob Cats ("Una via est"), alluding to the virtues of virginity or to the purity of marital love (E. de Jongh, "Grape Symbolism in Paintings of the 16th and 17th Centuries," *Simiolus* 7 (1974): 166–91).

Although the woman's facial type in this painting is completely characteristic of Ochtervelt's style, the head is thinly painted, lacks solidity, and has almost transparent hair. The architectural detailing of the niche is only sketchily applied at the left, suggesting that this may be an unfinished work—perhaps one of a pair that was never completed. The colors are also less intense than one would expect in a finished painting. The niche enframement is grayish brown, the grape leaves are grayish green, and the tapestry is dull brick red with gray-blue stripes. The woman wears a blue dress trimmed with white and a silvery ribbon in her hair.

Literature:
Catalogue of Pictures and Other Works of Art in the National Gallery of Ireland (Dublin, 1920), pp. 87–88, nr. 641; Gerson, *Thieme-Becker*, vol. 25 (1931), p. 556; Bénézit, *Dictionnaire*, vol. 6 (1953), p. 404; *Catalogue of the Paintings, National Gallery of Ireland* (Dublin, 1971), p. 117, nr. 435.

50. The Poultry Seller (Fig. 127)

Canvas, 77.5 × 62 cm., c. 1668–69.
Present location unknown.

Provenance: P. J. de Jariges Sale, Amsterdam (De Winter, Yver), October 14, 1772, nr. 73; P. W. Calkoen Sale, Amsterdam (v.d. Schley . . . Yver), September 10, 1781, nr. 129; Engelberts & Tersteeg Sale, Amsterdam (v.d. Schley . . . De Vries), June 13, 1808, nr. 159; Collection Sir G. Murray and E. W. Anderson, 1884; Collection S. W. Fraser, New Biggen by the Sea, North Umberland, until 1904; August Berg, San Francisco; Mont Gallery, New York; André de Coppet, New York, 1940; Private collection, Germany.

Exhibitions: Leeds, 1889, nr. 65; New York World's Fair, "European and American Painting 1500–1900," May-October, 1940, nr. 96.

Notes: Pendant to *The Cherry Seller* in Antwerp (cat. nr. 51; Fig. 128). The two works were sold as a pair in 1781 and in 1801. They have the same tiled floor and are of almost identical size. The masterful handling of chiaroscuro and the combination of a slanting figural design with an obliquely patterned floor are typical of Ochtervelt's style at the end of the 1660s (cf. cat. nrs. 45, 56, 57; Figs. 51, 54, 55).

Literature:
Plietzsch (1937), p. 370; *Art Quarterly*, vol. 22, nr. 2 (Summer, 1959), p. 193 (ill.); Plietzsch (1960), p. 65.

51. The Cherry Seller (Fig. 128)

Canvas, 78 × 62.9 cm., c. 1668–69.
Museum Mayer van den Bergh, Antwerp, nr. 895.

Provenance: Hendrik Verschuuring Sale, The Hague (Rietmulder), September 17, 1770, nr. 131; P. Calkoen Sale, Amsterdam (v.d. Schley . . . Yver), September 10, 1781, nr. 128; Engelberts & Tersteeg Sale, Amsterdam (v.d. Schley . . . De Vries), June 13, 1808, nr. 159; Maystre of Geneva Sale, Paris, April 17, 1809, nr. 34; Collection A. J. Essingh, Cologne; Essingh Sale, Cologne (Heberle), September 18, 1865, nr. 193 (as De Hooch); Collection Mayer Family, Antwerp.

Notes: Pendant to *The Poultry Seller* (see notes to cat. nr. 50; Fig. 127). The painting has scattered losses and abrasions along the left side and in the left foreground, and the colors are somewhat obscured by darkened varnish. The servant at the left wears a translucent white coif, a brown(?) blouse, and a dark yellow or orange skirt; the cherry seller has a brown-gray hat, yellow jacket, white apron, and gray skirt; the child wears a blue-green dress and red hair ribbons; and the woman at the right has a black(?) jacket trimmed with white fur, a white apron, and yellow skirt. The woman strolling in the background wears a lavender and white costume and a black headdress. The cherries are bright, deep red. One copy after this painting is known (cat. nr. 51-A; Fig. 129). Peter Sutton (correspondence) has pointed out that the size and description of the Antwerp painting are similar to nr. 283 in Hofstede de Groot's

list of works by Pieter de Hooch, which includes citations of both the Maystre and Essingh sales. Hofstede de Groot's description, however, refers to the child at the left as a "young girl" and states that the lady at the right is standing "by a fence."

Literature:

J. J. Merlo, *Organ für christliche Kunst* (Cologne, 1865), p. 202, nr. 17 (as De Hooch); C. Hofstede de Groot, *A Catalogue Raisonné of the Works of the Most Eminent Dutch Painters of the 17th Century* (Esslingen a N, 1907-28; Cambridge edition 1976) I, pp. 554-55, nr. 283 (as De Hooch). H. Mireur, *Dictionnaire des Ventes d'Art* (Paris, 1911), vol. 3, p. 482 (as De Hooch); *Catalogue du Musée Mayer van den Bergh, Anvers* (Brussels, 1933), p. 89, nr. 895; Plietzsch (1937), p. 370; J. de Coo, *Museum Mayer van den Bergh, Catalogus I* (Antwerp, 1960), p. 123, nr. 895; 2d edition, 1966, pp. 125-26, nr. 895; Plietzsch (1960), p. 65; J. de Coo, "Die Beziehungen des Antwerper Sammlers Mayer van den Bergh zu Köln," *Wallraf-Richartz Jahrbuch* 24 (1962): 412, pl. 246.

51-A. The Cherry Seller (copy) (Fig. 129)

Canvas, 76 × 61 cm.
Present location unknown.

Provenance: M. Bormal, Paris, 1926.

Notes: This crude copy after the Antwerp *Cherry Seller* (cat. nr. 51; Fig. 128), is known only through a photograph in the Rijksbureau voor Kunsthistorische Documentatie, The Hague (neg. L36513). The shape of the buildings in the background has been slightly changed in the copy.

52. The Fish Market (Fig. 145)

Signed, on barrel, c. 1668-69.
Canvas, 85 × 73.5 cm.
Kunsthistorisches Museum, Vienna, nr. 6447.

Provenance: Sale, Amsterdam (De Vries . . . Roos), July 19, 1826, nr. 56 (to Roos); Collection Baron Steengracht, The Hague; Steengracht Sale, Paris (Galerie Georges Petit), June 9, 1913, nr. 53 (to Stittiner); Galerie Dr. Otto Frölich, Vienna, 1923; Keezer and Zoon, Amsterdam, 1923.

Notes: This subject, which can be related to Ochtervelt's entrance hall paintings with fish sellers (cat. nrs. 41, 55, 103; Figs. 123, 132, 135), may have been inspired by the market scenes of his Rotterdam contemporary, Hendrik Martensz. Sorgh (Fig. 144). Similar themes were also painted by Emmanuel de Witte (Fig. 146), Metsu, and Van Brekelenkam. This painting should be dated at the end of the 1660s, for the same coloring, lighting effects, and contrast between foreground and background are seen in the Antwerp *Cherry Seller* of about 1668-69 (cat. nr. 51; Fig. 128). Furthermore, the old peasant woman with her soft cap reappears in the

Antwerp painting and, again, as a grape seller and as a fishwife in the pendants of 1669 in the Hermitage (cat. nrs. 54 and 55; Figs. 130 and 132).

The painting has been rubbed in the left foreground; the face of the maid in the center is worn and the hind legs of the dog at the lower right have been damaged and retouched. The colors are predominantly warm, earthy tones of brown, tan, and red. The fishwife wears a black dress with brown sleeves; the maid, a dark red blouse and white apron; the woman at the left background, a lavender-gray jacket, white apron, and brown skirt; the fisherboy, a brown costume with gray tunic; and the woman at the far right, a dark brown-purple dress trimmed with white. The roof at the far left is pale orange and the sky is blue. According to the Steengracht catalogue of 1913 (p. 69), the garlanded signboard at the upper left is inscribed: "'t bot schip" (the flounder boat), with an illustration of a fishing boat. These details are not legible today.

Literature:

G. Geffroy, *Les Musées d'Europe* (Paris, n.d.), p. 130; *Galerie Steengracht, Catalogue des Tableaux Anciens* (Paris, 1913), vol. 1, p. 69, nr. 53; Valentiner (1924), pp. 274, 283; *Katalog der Gemäldegalerie, Kunsthistorisches Museum, Wien* (Vienna, 1928), p. 146, nr. 1299b; Gerson, *Thieme-Becker*, vol. 25 (1931), p. 556; E. H. Buschbeck, "Verzeichnis der Erwerbungen der Direktion der Gemäldegalerie in den Jahren 1911- 1931," *Jahrbuch der Kunsthistorischen Sammlungen in Wien* (N.F.V., 1931), p. 24, pl. vii; L. Baldass and G. Glück, *Gemäldegalerie im Kunsthistorischen Museum zu Wien. Erwerbungen in den Jahren 1920-1930* (Vienna, 1934), nr. 37; Plietzsch (1937), p. 370; *Katalog der Gemäldegalerie, Kunsthistorisches Museum* (Vienna, 1938), p. 120, nr. 1299b; Bénézit, *Dictionnaire*, vol. 6 (1953), p. 404; *Katalog der Gemäldegalerie II: Vlamen, Holländer, Deutsche, Franzosen* (Vienna, 1958), p. 93, nr. 268, pl. 92; Plietzsch (1960), p. 65; *Katalog der Gemäldegalerie, Kunsthistorisches Museum* (Vienna, 1963), vol. 2, p. 93, nr. 268; *Katalog der Gemäldegalerie, Holländische Meister des 15., 16. und 17. Jahrhunderts* (Vienna, 1972), p. 69, pl. 77.

53. The Gallant Man (Fig. 53)

Signed and dated 1669, over door at right.
Canvas, 81.5 × 60.5 cm.
Staatliche Kunstsammlungen, Dresden, nr. 1811.

Provenance: Kunstkamer, Elector August of Saxony; Royal Picture Gallery, Dresden (by 1722 inventory).

Notes: As Plietzsch has pointed out, the same male figure appears in *Tric-trac Players* (cat. nr. 42; Fig. 48). On the combination of lemons and wine, see notes to *The Lemon Slice* (cat. nr. 37; Fig. 42). The standing man wears a violet-gray coat and light brown pants; the woman has a red velvet jacket and white satin skirt trimmed with silver; and the child wears a pale yellow satin dress with white collar and cuffs. The dog is white,

and the table carpet is painted in tones of brownish red, white, dark blue, and black.

Literature:

K. Woermann and A. Woltmann, *Geschichte der Malerei* (Leipzig), vol. 3, pt. 2 (1888), p. 841, fig. 628; *Bryan's Dictionary of Painters and Engravers*, ed. G. C. Williamson (London, 1904), vol. 4, p. 32; Wurzbach, vol. 2 (1910), p. 249; H. W. Singer, *Die Meisterwerke der Königl. Gemälde-Galerie zu Dresden* (Munich, 1913), p. 266, nr. 1811; *Katalog der Staatlichen Gemälde-Galerie zu Dresden* (Dresden, 1920), p. 187, nr. 1811; Valentiner (1924), pp. 270, 273, fig. 10; *Katalog der Staatlichen Gemälde-Galerie zu Dresden* (Dresden, 1927), p. 184, nr. 1811; *Katalog der Staatlichen Gemälde-Galerie zu Dresden, Die Alten Meister* (Dresden, 1930), p. 148, nr. 1811; Gerson, *Thieme-Becker*, vol. 25 (1931), p. 556; Plietzsch (1937), p. 370, fn. 1; Bénézit, *Dictionnaire*, vol. 6 (1953), p. 404; Plietzsch (1960), p. 66, fn. 1; W. Bernt, *The Netherlandish Painters of the Seventeenth Century* (London and New York, 1970), vol. 2, nr. 873; A. Blankert, *Johannes Vermeer* (Utrecht, 1975), pl. 38.

54. The Grape Seller (Fig. 130)

Signed and dated 1669, below map at right.
Canvas, 81 × 66.5 cm.
The Hermitage, Leningrad, nr. 951.

Provenance: M. D. van Eversdyck Sale, The Hague (Franken), May 28, 1766, nr. 67; Hanfstaengl Collection, Munich.

Notes: According to Plietzsch (1960, p. 65), this is the companion piece to *The Fish Seller*, also in the Hermitage (cat. nr. 55; Fig. 132). The map on the background wall is C. J. Visscher's "Germania Inferior," which Ochtervelt also included in cat. nrs. 40, 63, and 75; Figs. 46, 75, and 87 (see notes to cat. nr. 40; Fig. 46). The painting is in fine condition except for the face of the peasant woman, which seems to have been retouched. The grape seller is painted in shades of brown and gray. The child wears a salmon pink dress; the standing woman is dressed in white apron and yellow velvet dress trimmed with pale green ribbons; and the maid has a black blouse and violet-brown skirt. There is a gray-blue chair against the pale gray background wall. One copy after the painting is known (cat. nr. 54-A; Fig. 131).

Literature:

P. Terwesten, *Catalogus of Naamlyst van Schilderyen* (The Hague, 1770), p. 532, nr. 67; *Ermitage Impérial, Catalogue de la Galerie des Tableaux;* vol. 2, *Les Écoles Germaniques* (St. Petersburg, 1885), p. 162, nr. 890; A. Somof, *Ermitage Impérial, Catalogue de la Galerie des Tableaux, Écoles néerlandaises et École Allemande* (St. Petersburg, 1901), p. 264, nr. 890; *Bryan's Dictionary of Painters and Engravers* ed. G. C. Williamson (London, 1904), vol. 4, p. 32; Wurzbach, vol. 2

(1910), p. 249; Valentiner (1924), p. 273; Gerson, *Thieme-Becker*, vol. 25 (1931), p. 556; Plietzsch (1937), p. 370; Bénézit, *Dictionnaire*, vol. 6 (1953), p. 404; *Catalogue of Paintings, The Hermitage;* Russian text (Leningrad, 1958), vol. 2, pp. 235-36, nr. 951; Plietzsch (1960), p. 65; W. Bernt *The Netherlandish Painters of the Seventeenth Century* (London and New York, 1970), vol. 2, nr. 875; J. A. Welu, "Vermeer: His Cartographic Sources," *Art Bulletin* 57 (December 1975): 539, fn. 49.

54-A. The Grape Seller (copy) (Fig. 131)

Canvas, 75.5 × 60 cm.
Present location unknown.

Provenance: Collection Viscount Rothermere, London, 1932; Rothermere Sale, London(Christie), December 19, 1941, nr. 89; Collection Gösta Stenman, Stockholm, 1947.

Notes: A copy after Ochtervelt's *Grape Seller* of 1669 in the Hermitage (cat. nr. 54; Fig. 130). Judging from a photograph, the surface of the painting has been badly abraded.

Literature:

Gamla Tiders Mästare, Stockholm, 1947, p. 22, nr. 48, pl. 26.

55. The Fish Seller (Fig. 132)

Signed, lower right, c. 1669.
Canvas, 81.5 × 63.5 cm.
The Hermitage, Leningrad, nr. 952.

Provenance: Unknown.

Notes: Pendant to *The Grape Seller*, also in the Hermitage (cat. nr. 54; Fig. 130). The maid at the left wears a pinkish orange dress, a violet-gray apron, and a white head scarf; the old woman is dressed in gray and brown; and the man at the right has a wine red hat, a black coat with violet-gray panels, and gray trousers. On the wall at the far right is an Italianate landscape painting in a gold frame. One copy after this work is known (cat. nr. 55-A; Fig. 133).

Literature:

Ermitage Impérial, Catalogue de la Galerie des Tableaux; vol. 2, *Les Écoles Germaniques* (St. Petersburg, 1885), p. 162, nr. 889; A. Somof, *Ermitage Impérial, Catalogue de la Galerie des Tableaux, Écoles Néerlandaises et École Allemande* (St. Petersburg, 1901), pp. 268-69, nr. 889; *Bryan's Dictionary of Painters and Engravers*, ed. G. C. Williamson (London, 1904), vol. 4, p. 32; Wurzbach, vol. 2 (1910), p. 249; Plietzsch (1937), p. 370; Bénézit, *Dictionnaire*, vol. 6 (1953), p. 404; *Catalogue of Paintings, The Hermitage;* in Russian (Leningrad, 1958), vol. 2, p. 235, nr. 952; Plietzsch (1960), p. 65.

55-A. The Fish Seller (Fig. 133)

Canvas, 71 × 60 cm.
Kunsthandel H. Schlichte Bergen, Amsterdam.

Provenance: Ch. de Burlet, Basel, 1937; H. Steinmeyer, Berlin, 1938; Munich Collecting Point, nr. 2171; Sale, London (Sotheby), December 6, 1972, nr. 76 (to M. N. Johnstone).

Notes: A variant of Ochtervelt's *Fish Seller* in the Hermitage (cat. nr. 55; Fig. 132) in which the composition has been cropped by several centimeters at top and bottom, the shape of the man's hat has been simplified, and the cleaning rag on the floor in the right foreground has been removed.

56. The Dancing Dog (Fig. 54)

Canvas, 65.5 × 52.1 cm., c. 1669.
Private Collection, England.

Provenance: Collection Mr. and Mrs. Stanley C. Wulc; Violetta Sale, London (Christie), June 29, 1973, nr. 54; Leger Galleries, London.

Notes: The male figure is very similar to the man in cat. nr. 53; Fig. 53. The dress of the seated woman is close in style to costumes in cat. nrs. 44 and 45; Figs. 50 and 51. Ochtervelt returned to the same subject in cat. nrs. 57 and 70; Figs. 55 and 81. De Jongh has shown that the motif of the dancing dog (also painted by Frans van Mieris, the elder; the Hermitage, Leningrad) can be related to an emblem in Jacob Cats's *Spiegel Vanden Ouden ende Nieuwen Tijdt,* published in Amsterdam in 1658 (E. de Jongh, *Zinne -en Minnebeelden in de Schilderkunst van de 17de Eeuw* [Amsterdam, 1967] pp. 38–42, pl. 27). The implication of careless erotic behavior conveyed by the emblem is not evident in Ochtervelt's treatment of the theme, in which the mood is a more generalized one of charming, but foolish, irresponsibility.

57. The Dancing Dog (Fig. 55)

Signed and dated 1669, over door at right.
Canvas, 72.5 × 58.5 cm.
The Wadsworth Atheneum, Hartford, Connecticut, nr. 1934.35.

Provenance: The Hapsburg Family Collection; Pommersfelden Gallery, by 1719; Sumner Collection, 1934.

Exhibitions: State University of Iowa, "Figure Paintings," November 5-30, 1936, nr. 45; John Herron Art Museum, Indianapolis, Indiana, "Dutch Painting of the 17th Century," February 27-April 11, 1937, nr. 51; The Wadsworth Atheneum, "Life in 17th-Century Holland," November 21, 1950–January 14, 1951, nr. 45.

Notes: Cat. nrs. 56 and 70; Figs. 54 and 81 depict other versions of the same subject. For an emblematic source for the dancing dog, see notes to cat. nr. 56; Fig. 54. In this painting the amorous implications of the theme are clear, for the map on the back wall has a painted frieze with three scenes from the story of Adam and Eve (from left to right: The Creation of Eve (?); The Temptation; The Expulsion). De Jongh ("Vermommingen van Vrouw Wereld," p. 203) has noted that the juxtaposition of the playful woman and the map relates to a tradition of "Lady World" allegories: a seductive woman with a globe on her head symbolizing lust. The map may be interpreted here as *"pars pro toto"* for the world: a symbol of worldliness and a moralizing comment on the behavior of the couple in the interior. A similar use of a map occurs in one of Ochtervelt's boudoir scenes of the 1670 s (cat. nr. 78; Fig. 90).

According to J. A. Welu (correspondence), the map in this painting is derived from a world map, published by Hugo Allaert, of which the only known example is in the Bodel Nijenhuis Collection, University Library, Leiden, Pl43 N27 (52.5 × 82.4 cm.). The same map appears in *Merry Company,* attributed to Anthonie Palamedesz. in the Wallraf-Richartz-Museum, Cologne (nr. 1058); in *Music Party,* also attributed to Palamedesz., formerly in the collection of M. Jules Porgès (nr. 108 in the exhibition "Maîtres Hollandais du XVIIᵉ Siècle," Jeu de Paume, Paris, April 28–July 10, 1911; and in *Family Portrait,* reproduced as Thomas de Keyser in *Die Weltkunst,* vol. 13, nr. 9 (March 5, 1939), p. 6. Interestingly enough, Welu has also pointed out that world maps of the 17th century sometimes included representations of Adam and Eve, as in Nicolaas van Geelkerck's folio map published in 1618 (41.5 × 56.5 cm.) and illustrated in Marijke de Vrij, *The World on Paper* (Amsterdam, 1967), cat. nr. 64.

In this painting the figures appear against a pale gray wall, deeply shadowed at the left. Similar Vermeer-like lighting effects are also seen in cat. nr. 63; Fig. 75, dated 1671, and in two music scenes of the late 1670s (cat. nrs. 93 and 94; Figs. 104 and 105). The man wears a black coat with a silver and gold belt, dark yellow trousers, and tan stockings; the girl wears a white headdress, ivory satin blouse, and pale lavender-gray skirt with a blue-green apron. The chair at the left is red, and the table carpet is orange with touches of dark blue and red.

Literature:
Gerson, *Thieme-Becker,* vol. 25 (1931), p. 556; *American Magazine of Art* 27 (April 4, 1934): 209 (ill.); *Catalogue of the Collection in Avery Memorial, Wadsworth Atheneum* (Hartford, 1934), p. 36; *Indiana Teacher,* vol. 81, nr. 7 (March 1937),

p. 10 (ill.); S. Donahue, "Two Paintings by Ochtervelt in the Wadsworth Atheneum," *Bulletin of the Wadsworth Atheneum* 5 (Fall, 1969): 45-54; E. de Jongh, "Vermommingen van Vrouw Wereld in de 17de Eeuw," in *Album Amicorum J. G. van Gelder* (The Hague, 1973), p. 203, fig. 11.

58. Singing Practice (Fig. 57)

Canvas, 57.3 × 46 cm., c. 1669-70.
Staatliche Kunstsammlungen, Kassel, West Germany, nr. 864.

Provenance: Collection S. Joseph, London, 1897.

Exhibitions: The Royal Academy, London, "Winter Exhibition," 1894, nr. 50; New Gallery, London, "Pictures Ancient and Modern by Artists of the British and Continental Schools," 1897-98, nr. 124; F. Muller, Amsterdam, "Importants Tableaux Anciens," July-September, 1912, nr. 25; Galerie Schäffer, Berlin, "Die Meister des holländischen Interieurs," April–May, 1929, nr. 69; Museum zu Allerheiligen, Schaffhausen, "Rembrandt und seine Zeit," April 10–October 2, 1949, nr. 96.

Notes: The rather Ter-Borchian figure at the virginals is very similar in costume and type to the woman in *The Serenade* (cat. nr. 59; Fig. 58). She wears blue ribbons in her hair and a white satin dress shadowed with blue-gray; the seated singer wears a red and white headdress, blue satin jacket, and bright red satin skirt; the man in the background is dressed in a black suit trimmed with tan ribbons; and the woman beside him wears a dark purple and green dress. In the deep shadow behind the flirtatious couple is a gold-framed painting depicting a full-length nude mythological figure (possibly a Birth of Venus). On the open lid of the virginals is the inscription: "MVSIKA MA -SOLAMEA DVLCET."

Literature:
C. Hofstede de Groot, "Die 25. Winteraustellung der Londoner Royal Academy," *Repertorium für Kunstwissenschaft* 17 (1894): 170; K. Lilienfeld, "Die Somer-Austellung bei F. Muller in Amsterdam," *Cicerone* 4 (1912): 726, fig. 2; A. Graves, *A Century of Loan Exhibitions* (London, 1913-15), vol. 2, p. 894; vol. 4, p. 2098; G. Gronau, "Erwerbungen der Casseler Galerie," *Berliner Museen* 44 (1923): 62, pl. 102; *Staatliche Gemäldegalerie zu Cassel, Kurzes Verzeichnis der Gemälde* (Kassel, 1924), p. 34, nr. 864; *Apollo* 10 (August 1929): 107 (ill.); *Katalog der Staatlichen Gemäldegalerie zu Kassel* (Berlin, 1929), p. 55, nr. 864; Gerson, *Thieme-Becker*, vol. 25 (1931), p. 556; Plietzsch (1937), p. 364; J. H. der Kinderen-Besier, *Spelevaart der Mode* (Amsterdam, 1950), p. 196, fig. 168; Bénézit, *Dictionnaire*, vol. 6 (1953), p. 404; *Katalog der Staatlichen Gemäldegalerie zu Kassel* (Kassel, 1958), pp. 104-5, nr. 864; Plietzsch (1960), p. 67.

59. The Serenade (Fig. 58)

Signed, lower left, c. 1669-70.
Canvas, 52 × 41 cm.
Present location unknown.

Provenance: Supertini and Platina Sale, Amsterdam (v.d. Schley . . . Roos), September 19, 1798, nr. 118; Collection Count Michael Andrijevich Miloradovitch (1770-1825, Military Governor of St. Petersburg); The Hermitage, Leningrad, 1826-1930; Van Diemen and Benedict, Berlin, 1930; Private Collection, London, 1937; Collection Mr. and Mrs. David Bingham, New York; Nussbaumer Collection, Switzerland.

Notes: The young woman is similar in costume and figure type to the standing musician in *Singing Practice* (cat. nr. 58; Fig. 57), but here the influence of Ter Borch seems even stronger (cf. Fig. 59; G. Ter Borch, *Procuress Scene*, in the Staatliche Museen, Berlin-Dahlem.) According to Somof (1901), the curtain at the window is blue, the chair at the left is green, the cavalier is dressed in brown, and the woman's dress is pale blue. Judging from a photograph, the large tapestry on the background wall may represent a Holy Family or a Rest on the Flight into Egypt. For a reverse variant of the composition, see *Lady at the Virginals with Lutenist* (cat. nr. 68; Fig. 79).

Literature:
Baron B. de Koehne, *Ermitage Impérial, Catalogue de la Galerie des Tableaux* (St. Petersburg, 1863), pp. xvii, 187, nr. 891; *Ermitage Impérial, Catalogue de la Galerie des Tableaux* vol. 2, *Les Écoles Germaniques* (St. Petersburg, 1885), pp. 162-63, nr. 891; A. Somof, *Ermitage Impérial, Catalogue . . . des Tableaux, Écoles Néerlandaises et École Allemande* (St. Petersburg, 1901), pp. 264-65, nr. 891; Gerson, *Thieme-Becker*, vol. 25 (1931), p. 556; Plietzsch (1937), p. 364 (ill. p. 373); Plietzsch (1960), p. 67, pl. 105.

60. Family Portrait (Fig. 154)

Canvas, 98 × 80.5 cm., c. 1670.
Dienst Verspreide Rijkscollecties, The Hague, nr. NK 1551.

Provenance: Sale, Brussels (Ste. Gudule), December 15-17, 1921, nr. 57; N. G. Sale, Brussels (Fievez), June 16, 1931, nr. 134; Dr. H. Schaeffer, Berlin, 1932; Collection Professor Hoffmann, 1940; Munich Collecting Point, nr. 1029.

Exhibitions: Paleis-Raadhuis, Tilburg, "De Gouden Eeuw," May 2–June 12, 1953, nr. 62; Bergen-op-Zoom, "Schilders uit de 17de Eeuw," July 24–August 8, 1954; IJzendijke, "Hollands Leven in de Gouden Eeuw," June 15–September 15, 1955; Kasteel Vosbergen,

Heerde, July–August, 1958; Bolsward Stadhuis, "Musiek en Dans in vroeger Eeuwen," June 15–September 15, 1962; Apeldorn-Sittard-Venlo, July 10–November 15, 1965, nr. 26.

Notes: The painting may be dated about 1670, since the costume worn by the young ladies at the left is repeated in Ochtervelt's *Family Portrait* signed and dated 1670 (cat. nr. 61; Fig. 156), in Budapest. The same emphasis on cultural refinement (books, musical instruments, etc.) is found in conversation pieces by Jan Verkolje of the same period (cf. Fig. 155; *Portrait of a Family Making Music*, signed and dated 1671, Ruzicka Bequest, Kunsthaus, Zurich).

The surface of the painting is rubbed and has small abrasions throughout. The girl at the lower left wears a pale blue satin dress trimmed with gold; her sister is dressed in pink. The husband and wife have black-and-white costumes, and the young son wears a white blouse and a gray suit trimmed with lavender and yellow ribbons. Variants of the large painting of a woman with putti on the background wall appear in cat. nrs. 19 and 61; Figs. 152 and 156. (For possible interpretations of this scene, see notes to cat. nr. 19.)

Literature;
Plietzsch (1937), p. 372; S. Donahue, "Two Paintings by Ochtervelt in the Wadsworth Atheneum," *Bulletin of the Wadsworth Atheneum* 5 (Fall 1969): 46, fig. 3.

61. Family Portrait (Fig. 156)

Signed and dated 1670, over door at left.
Canvas, 96.5 × 91 cm.
Országos Szépmüveszéti, Budapest, nr. 4286.

Provenance: Collection Marquis de Blaisel; Baron E. Beurnonville Sale, Paris (Feral, George, Petit), May 9, 1881, nr. 530; Pressburger Palace; H. O. Miethke, Vienna, 1894; Collection Johann Palffy, Budapest; Palffy Bequest to museum, 1912.

Notes: Similar in style and costume to *Family Portrait* (cat. nr. 60; Fig. 154). According to Pigler's catalogue of 1967 (vol. 1, p. 509), there was once a small footstool in the lower left corner—a later addition that was removed during restoration. The condition of the painting is good except for traces of damage and overpainting at the lower left corner and small areas of loss along the bottom edge. The girl at the left wears a white satin dress with pink ruffles above the elbows and carries a silver tray with a peach and bunches of green, blue, and purple grapes. The male figure wears brown; the child wears a lemon-yellow dress with white cuffs and yellow plumes in her hair; and the woman at the right wears a black over-dress with a white satin skirt and white

puffed sleeves. An elaborate brown marble fireplace at the right has a painted overmantle depicting a seated woman with putti. Variants of this scene appear in cat. nrs. 19 and 60; Figs. 152 and 154. (See notes to cat. nr. 19.) De Hooch-like vistas such as the one at the left background are found also in cat. nrs. 18 and 81; Figs. 150 and 158.

Literature:
G. Terey, "Budapest Museum der bildenden Künste," *Kunstchronik* 24 (1912–13): 57; G. Terey, *Vasarnapi Ujsag* (1913), p. 129; *Katalog der Gemäldegalerie des Grafen Johann Palffy* (Budapest, 1913), p. 33, nr. 84; Gerson, *Thieme-Becker*, vol. 25 (1931), p. 556; G. Terey, *Catalogue of the Paintings by Old Masters* (Budapest, 1931), p. 83, nr. P. 84; *Országos Szépmüveszéti Muzeum, A Régi Képtár Katalógusa* (Budapest, 1937), vol. 1, p. 188, nr. 4286; vol. 2, p. 189 (ill.); Plietzsch (1937), p. 370; Bénézit, *Dictionnaire*, vol. 6 (1953), p. 404; A. Pigler, *Országos Szépmüveszéti Muzeum, A Régi Képtár Katalógusa* (Budapest, 1954), vol. 1, p. 406, nr. 4286; vol. 2, p. 210 (ill.); Plietzsch (1960), p. 66; A. Pigler, *Katalog der Galerie Alter Meister* (Budapest, 1967), vol. 1, p. 509, nr. 4286; M. Mojzer, *Dutch Genre Paintings in Hungarian Museums*, trans., E. Racz (Budapest, 1974), nr. 38 (color ill.).

62. Entrance Hall with Street Musicians (Fig. 134)

Signed, lower left, c. 1670–75.
Canvas, 75 × 60 cm.
Rijksmuseum, Amsterdam, nr. A 2114.

Provenance: Sale, Amsterdam (De Winter . . . Yver), November 30, 1772, nr. 51; Van Loon-Van Winter Sale, Amsterdam (Roos), February 26, 1878, nr. 62; bequest to museum of Mevr. H. A. Insinger-van Loon, Amsterdam, 1903.

Exhibitions: John Herron Art Museum, Indianapolis, Indiana, "Dutch Painting of the 17th Century," February 27–April 11, 1937, nr. 50; Dordrecht Museum, "Mens en Muziek," July 13–September 1, 1957, nr. 60.

Notes: Two earlier depictions of entrance halls with street musicians are seen in cat. nrs. 16 and 24; Figs. 121 and 122. (See notes to cat. nr. 16.) This painting should probably be dated in the early 1670s on the basis of the figure types, the costumes, and the rather crowded composition. The surface of the painting is rubbed and obscured by murky varnish; there is a large (repaired) tear in the lower left corner. The peasant musicians wear the usual brown and gray costumes; the kneeling maid has a brown blouse, red skirt, and violet apron; the child wears a white dress with pale yellow sleeves; and the woman at the right has a pink kerchief and a gray skirt and jacket with white fur trim. On the background wall appears a large (illegible) landscape painting and

two bas reliefs. At the upper right is a tondo with a seated mythological figure holding a garland and a lyre(?) (Euterpe?); at the lower right is a narrow rectangular relief of a standing female figure with drapery billowing around her.

Literature:
Catalogus der Schilderijen . . . in het Rijksmuseum te Amsterdam (Amsterdam, 1903), p. 198, nr. 1782 (identical references in catalogue editions of 1907, 1909, and 1918); Wurzbach, vol. 2 (1910), p. 249; Valentiner (1924), p. 270, fig. 4; *Catalogus der Schilderijen . . . in het Rijksmuseum te Amsterdam* (Amsterdam, 1934), p. 213, nr. 1782; Plietzsch (1937), p. 370; A. Tompkins, "Dutch Art in Indianapolis," *Bulletin of the Art Association of Indianapolis* 23 (May 1937): 3 (ill.); Bénézit, *Dictionnaire*, vol. 6 (1953), p. 404; Plietzsch (1960), p. 65; *All the Paintings in the Rijksmuseum, Amsterdam* (Maarssen, 1974), p. 423, nr. A 2114.

63. The Music Lesson (Fig. 75)

Signed and dated 1671, lower right corner of map border.
Panel, 79 × 64.5 cm.
Chicago Art Institute, Chicago, Illinois, nr. 345.11.

Provenance: Collection Prince Demidoff, Pratolino, Italy; Collection Martin A. Reyerson, Chicago.

Exhibitions: Toledo Museum of Art, Toledo, Ohio, "Inaugural Exhibition," January-February, 1912, nr. 197; Detroit Institute of Arts, "Dutch Genre and Landscape Painting of the 17th Century," 1929, nr. 46; Chicago Art Institute, "A Century of Progress," June 1-November 1, 1933, nr. 70; M. Knoedler & Co., New York, "Holland Indoors and Outdoors," January 1938, nr. 22; Duveen Galleries, New York, Great Dutch Masters," October 8-November 7, 1942, nr. 37; Museum of Fine Arts, Boston, "The Age of Rembrandt," 1966, nr. 86.

Notes: The composition reveals strong influences of Vermeer in the oblique placement of figures, the shadowed foreground with repoussoir elements, and the use of a large map (cf. Fig. 76; Vermeer's *Soldier and Laughing Girl*, The Frick Collection, New York). Similar lighting effects are found in the Hartford *Dancing Dog* of 1669 (cat. nr. 57; Fig. 55). The map in this painting (C. J. Visscher's "Germania Inferior") appears also in cat. nrs. 40, 54, and 75; Figs. 46, 130, 87. See notes to cat. nr. 40. Part of the title band is legible at the top of this example: "NOVA XVII PROVINCIARUM GERMANIAE INFERIORIS DESCRIPTIO. . ."

The painting seems to have darkened slightly and has deep crackle throughout, but the colors remain extremely delicate. The background wall and map are pale gray. The male figure wears a black cap, a brown velvet cape, and a lavender-brown jacket. Tne woman has a white headdress and a pale yellow silk dress trimmed with white. The chair in the foreground is bright lime green.

Literature:
W. Bode, "Alte Kunstwerke in den Sammlungen in der Vereinigten Staten," *Zeitschrift für bildenden Künste*, NF, vol. 6 (1895), p. 76; Valentiner (1924), pp. 269-70, 274, 277, fig. 5; F. E. W. Freund, "Die Ausstellung altholländischer Malerei in Detroit," *Cicerone*, vol. 21, pt. 2 (1929), p. 705 (ill.); *American Magazine of Art* 20 (December 1929): 695 (ill.); W. Heil, "Holländische Ausstellung im Detroiter Museum," *Pantheon* 5 (January 1930): 35 (ill.), 36; Gerson, *Thieme-Becker*, vol. 25 (1931), p. 556; Plietzsch (1937), pp. 364, 371 (ill.); Bénézit, *Dictionnaire*, vol. 6 (1953), p. 404; Plietzsch (1960), p. 67; *Paintings in the Art Institute of Chicago, A Catalogue of the Picture Collection* (Chicago, 1961), pp. 345, 196 (ill.); S. Donahue, "Two Paintings by Ochtervelt in the Wadsworth Atheneum," *Bulletin of the Wadsworth Atheneum* 5 (Fall 1969): 51, fig. 5; J. A. Welu, "Vermeer: His Cartographic Sources," *Art Bulletin* 57 (1975): 539, fn. 49.

64. The Tric-trac Players (Fig. 77)

Signed and dated 1671, on footstool at right.
Canvas, 84 × 93 cm.
Museum der bildenden Künste, Leipzig, East Germany, nr. 1560.

Provenance: J. van den Berg Sale, Amsterdam (v.d. Schley . . . Pex), July 29, 1776, nr. 2; H. Rottermondt Sale, Amsterdam (v.d. Schley . . . Yver), July 18, 1786, nr. 321; Winkler Collection, Leipzig; Galerie Speck von Sternberg, Lützschena.

Notes: Other depictions of tric-trac appear in cat. nrs. 42-44; Figs. 48-50. (See notes to cat. nr. 42.) The composition of this painting is, in fact, a variant of *Musician with Tric-trac Players* of about 1668 in Cologne (cat. nr. 44; Fig. 50). The painting is in excellent condition except for small areas of damage: under the chin of the standing lutenist and around the left hand of the seated soldier. The soldier, seated on a yellow-green chair, has a tan jacket with violet-brown sleeves embroidered in silver and gray-tan stockings; the standing woman wears a white satin dress with pale violet trimmings; the seated woman wears a black headdress and a dark purple-brown dress; and the standing man has a brown hat and dark violet-brown cape. On the background wall is a landscape in a gold frame. A seascape hangs over the open door at the right.

Literature:
F. Becker, *Gemälde-Galerie Speck von Sternberg in Lützschena* (Leipzig, 1904), nr. 24; *Kunsthistorische Gesellschaft für Photographische Publikationen Leipzig*, vol. 11 (1905),

nr. 24; *Verzeichnis der von Speck'schen Gemälde-Sammlung* (Leipzig, 1926), p. 11, nr. 36; Plietzsch (1937), p. 372; Plietzsch (1960), p. 66.

65. The Music Lesson (Fig. 78)

Canvas, 95 × 76 cm., c. 1671.
City Museum and Art Gallery, Birmingham, England, nr. P. 113'55.

Provenance: Hinchliffe-Townshend Sale, London (Christie), May 6, 1836, nr. 108; Collection Edward Marsland, Reading, 1897; Collection Sir W. Cuthbert Quilter; Quilter Sale, London (Christie), July 9, 1909, nr. 115 (to Quilter); Quilter Sale, London (Christie), June 26, 1936, nr. 39 (to Gooden and Fox); Collection Ernest E. Cook, Bath; to museum with Cook Bequest, 1955.

Exhibitions: Whitechapel Art Gallery, "Dutch Art," 1904, nr. 374; Thos. Agnew and Sons, London, "Pictures from Birmingham," March 27–May 4, 1957, nr. 29; Ferens Art Gallery, Kingston-on-Hull, "Dutch Painting of the 17th Century," June 6–July 2, 1961, nr. 75; The Royal Academy, London, "Primitives to Picasso," 1962, nr. 128.

Notes: Similar in style and costume to *The Tric-trac Players*, dated 1671 (cat. nr. 64; Fig. 77). The theme of the woman at the virginals, which Ochtervelt treated only once during the 1660s (cat. nr. 58; Fig. 57), was used in a number of works of the 1670s (cat. nrs. 68, 94–97; Figs. 79, 105–109). There are traces of an effaced head between the standing man and maid, indicating that Ochtervelt had originally experimented with a composition of four figures. The musician, seated on an orange-red stool, wears a white satin dress with a pale blue band at the elbow; the maid wears a white headdress, dark purple dress, and brown apron; and the man has a dark brown costume with a faint purple cast. The carpet in the foreground is painted in warm tones of orange, red, yellow, blue, and black. The virginals is gray-brown, but the side facing the viewer is lime green. On the open lid is the inscription: "MUSICA LABORUM DULCE LEVAMEN." A mirror in a heavy gold frame hangs on the wall at the upper right.

Literature:
A. Graves, *A Century of Loan Exhibitions* (London, 1913–15), vol. 4, pp. 2098–99; *Connoisseur*, "The Quilter Pictures," 98 (August 1936): 120; *Art Digest* 10 (August 1936): 12 (ill.); Plietzsch (1937), p. 372, fn. 1; *Birmingham City Museum, 52nd Annual Report*, vol. 52 (1955), p. 22; *Connoisseur* (American edition), "The Cook Bequest" 136 (September 1955): 20, fig. 2; *Burlington Magazine* 99 (April 1957): 133, fig. 28; *Catalogue of Paintings, City Art Museum and Art Gallery* (Birmingham, 1960), pl. 24a, nr. P 113'55.

66. Family Portrait (Fig. 157)

Signed, over door at right, c. 1671.
Canvas, 91 × 79.5 cm.
Norton Simon Museum, Pasadena, California.

Provenance: Pereire Collection, Paris; Pereire Sale, Paris (Sedelmeyer), March 6, 1872, nr. 167; Sedelmeyer Sale, Vienna (Sedelmeyer), December 20-21, 1872, nr. 128; Ehrich Gallery, New York, 1913; Collection Mrs. Whitelaw Reid, Ophir Hall, Purchase, New York; Reid Sale, New York (American Art Association), May 14-18, 1935, nr. 1175; Julius H. Weitzner, Inc., New York, 1936; Philadelphia Museum of Art Sale, New York (Parke Bernet), February 29, 1956, nr. 11; P. de Boer, Amsterdam, 1958-59; H. Schickman Gallery, New York, 1967-69.

Notes: The same white satin dress trimmed with pale blue bands above the elbows appears in Ochtervelt's *Music Lesson* of about 1671 (cat. nr. 65; Fig. 78), in Birmingham. The little girl at the right, dressed in bright orange brocade, is a variant of the child in the Budapest family portrait, dated 1670 (cat. nr. 61; Fig. 156). The table carpet at the left is orange, yellow, and black, and the man in the center wears a brown satin coat lined with blue-green and dark gray-brown trousers and stockings.

The catalogues of both the Pereire and Sedelmeyer sales (1872) and Moes (1905) identify this couple as Prince William II of Orange and Mary Stuart, on the basis of the orange held by the woman at the left. This title was probably invented to make the picture more imposing, for Mary of Orange died in 1660, more than a decade before Ochtervelt's portrait was painted. In any case, an orange is also displayed by the woman in his *Family Portrait* of 166(4?) (cat. nr. 19; Fig. 152), in Hartford. In both works it may have been intended as a reference to the fruitfulness of marriage. In royal portraits, however, this motif can indicate connections to the House of Orange, as in Bartholomeus van der Helst's *Portrait of Mary Stuart* (signed and dated 1652, Rijksmuseum, Amsterdam, nr. A 142), in which the widowed princess is enthroned in a silver chair decorated with lions' heads and holds an orange in her right hand.

An engraving was made after the Pasadena portrait by P.-E. Le Rat (1849–92) when the painting was in Sedelmeyer's possession in 1872. (Photo. RKD, The Hague, neg. nr. L35304.)

Literature:
E. W. Moes, *Iconographia Batava* (Amsterdam), vol. 2 (1905), p. 60, nr. 4803; p. 605, nr. 9095; p. 608, fn. to nr. 51; *International Studio* 39 (November 1909): xvii (ill.); Valentiner (1924), p. 274; Plietzsch (1937), p. 370; Plietzsch (1960), p. 66; *Connoisseur* 166 (October 1967): lxxxv (ill.).

67. Lady and Maid Choosing Fish (Fig. 137)

Canvas, 67.5 × 57.5 cm., c. 1671-73.
Private Collection, England.

Provenance: Erich Gallery, New York, 1908; Collection Sir William van Horne, Montreal; Edward Speelman Ltd., London.

Exhibitions: Montreal Art Association Galleries, "A Selection from the Collection of Paintings of the late Sir William van Horne," October 16-November 5, 1933, nr. 57.

Notes: Related in subject to several of Ochtervelt's entrance hall scenes that depict the buying or selecting of fish (cat. nrs. 41, 55, and 103; Figs. 123, 132, and 135). A close parallel, and possibly the source for Ochtervelt's conception, is Van Brekelenkam's *Lady and Maid Choosing Fish*, signed and dated 1664, in the Assheton Bennett Collection, Manchester (Fig. 141). Ochtervelt's painting can be dated about 1671-73 on the basis of both the figure types and costume: the same short-sleeved, fur-trimmed velvet jacket is seen in other interiors assigned to this period (cat. nrs. 72-74; Figs. 83, 84, 86). Hofstede de Groot recorded the colors of the costume when he saw the painting at the Ehrich Gallery in 1908 (HdG notes, RKD): "Vrouwtje in een rood met pels bezet jakje en een gelen rok, bezig visch te koopen van een meid." On the background wall is a nocturnal forest still life in the style of Otto Marseus van Schrieck. Three copies or variants after the painting are known (cat. nrs. 67-A, 67-B, 67-C; Figs. 138-140).

Peter Sutton has pointed out (correspondence) that a painting whose description matches *Lady and Maid Choosing Fish* was listed by Hofstede de Groot as a De Hooch (nr. 37, 24″ × 18½″) sold in Paris in December of 1893. (*A Catalogue Raisonné of the Works of the Most Eminent Dutch Painters of the 17th Century* [Esslingen a N, 1907-28; Cambridge edition, 1976], I, 489.)

Literature:
Valentiner (1924), pp. 269-70, 274, fig. 6; Gerson, *Thieme-Becker*, vol. 25 (1931), p. 556; Plietzsch (1937), p. 364; Plietzsch (1960), p. 67.

67-A. Lady and Maid Choosing Fish (copy) (Fig. 138)

Canvas, 78.7 × 66 cm.
City of York Art Gallery, York, England, nr. 40.

Provenance: Collection John Burton; Burton Bequest, 1882.

Exhibitions: F.A.I.I., 1883, nr. 20; Arts Council of Great Britain (Wales), "Dutch Genre Painting," 1958, nr. 40.

Notes: An excellent copy after cat. nr. 67; Fig. 137. The two works are almost identical except for differences in scale, slight changes in the face of the seated lady, and the fact that the painting technique is a bit harder and less luminous in the copy.

Literature:
Preview, City of York Art Gallery, vol. 2 (April, 1949), p. 66; *Catalogue of Paintings, City of York Art Gallery;* vol. 1, *Foreign Schools* (York, 1961), pp. 59-60, nr. 40, pl. 54.

67-B. Lady and Maid Choosing Fish (copy) (Fig. 139)

Canvas, 62 × 50 cm.
Present location unknown.

Provenance: A. Schönlank Sale, Cologne (Lempertz), April 28-29, 1896, nr. 139; Werner Dahl Sale, Amsterdam (Muller), October 17, 1905, nr. 107.

Notes: This copy after cat. nr. 67; Fig. 137 is somewhat cruder in technique than the copy in York (cat. nr. 67-A; Fig. 138) and shows the legs of the standing maid in a slightly different position.

67-C. Lady and Maid Choosing Fish (copy) (Fig. 140)

Canvas, 76 × 61 cm.
Present location unknown.

Provenance: Collection Charles Sedelmeyer, Paris; Collection John Wanamaker, Philadelphia; Mortimer Brandt Gallery, New York, 1941; Hammer Collection, 1957.

Exhibitions: Mortimer Brandt Gallery, New York, "Less Known Painters of the 17th Century," March 10-April 5, 1941, nr. 18; Bob Jones University, Greenville, South Carolina, "The Hammer Collection," March 15-April 15, 1957, nr. 35.

Notes: Unlike the other copies of cat. nr. 67; Fig. 137 (cat. nrs. 67-A and 67-B; Figs. 138 and 139), this painting diverges from the original in several obvious respects: the painting on the back wall has been changed to a still life of flowers in a glass vase, figures have been added to the wall tiles behind the seated woman, and foliage and architectural details have been added to the view through the window at the right. According to the Brandt catalogue of 1941, the painting is signed; no signature is mentioned in the 1957 catalogue of the Hammer Collection.

68. Lady at the Virginals and Lutenist (Fig. 79)

Canvas, 89.5 × 69 cm., c. 1671–73.
Present location unknown.

Provenance: Wilna, Poland; F. Kleinberger, Paris, c. 1930.

Notes: This scene, whose composition is a reverse variant of *The Serenade* (cat. nr. 59; Fig. 58), reveals the continuing influence of Ter Borch and should be dated in the early 1670s on the basis of costume. Its pendant is *The Soldier's Offer* (cat. nr. 69; Fig. 80), which has similar dimensions and the same provenance. Ochtervelt painted a close variant of the standing woman (wearing the more elaborate dress and hairstyle of the late 1670s) in his *Violinist and Lady at the Virginals* (cat. nr. 97; Fig. 109), in Worms.

Literature:
Plietzsch (1937), p. 372; Plietzsch (1960), p. 67.

69. The Soldier's Offer (Fig. 80)

Canvas, 89 × 73 cm., c. 1671–73.
Present location unknown.

Provenance: Wilna, Poland; F. Kleinberger, Paris, c. 1930.

Notes: Pendant to *Lady at the Virginals and Lutenist* (cat. nr. 68; Fig. 79). The dress of the young woman appears to be identical to the costume seen in *Concert at the Virginals* (cat. nr. 65; Fig. 78). The subject of a man offering money to a woman was also used in one of Ochtervelt's tavern scenes of the 1660s (cat. nr. 22; Fig. 28).

Literature:
Plietzsch (1937), p. 372; Plietzsch (1960), p. 67.

70. The Dancing Dog (Fig. 81)

Canvas, 92 × 75 cm., c. 1671–73.
Nationalmuseum, Stockholm, nr. 658.

Provenance: Collection Viscomte de Fonspertuis; Angran, Viscomte de Fonspertuis Sale, Paris (Gersaint), March 4, 1748, nr. 392 (as Ter Borch); Collection Lovisa Ulrika.

Notes: Other versions of the same subject can be seen in cat. nrs. 56 and 57; Figs. 54 and 55. On the emblematic meaning of the dancing dog, see notes to cat. nr. 56. In this painting the woman in the foreground is a reverse variant of the figure in *The Soldier's Offer* (cat. nr. 69; Fig. 80). The surface of the painting has been rubbed,

and the table carpet to the right of the standing woman appears to be overpainted in dull green. (At the left, the carpet is painted in clearer tones of dark red, blue, and black.) There is a large right-angular (inpainted) tear around the head of the lutenist. The lady in the foreground wears white satin; the hurdy-gurdy player wears a tan blouse, metal cuirass, red cape, and dark brown boots; and the woman behind him wears a brown dress with white at the elbows.

Literature:
Drottning Lovisa Ulrikas malningssaml. (1760), p. 85, nr. 116 (as Ter Borch); included in Fredrik Sander, *Nationalmuseum, Bidrag till Taflegalleriets Historia* (1872–75), vol. 1, unpaged; *Kungl. Musei nederländska och tyska malningssaml.*, enl. C. F. Fredenheims bevarde ritningar fran 1795, nr. 26 (included in C. Nordenfalk, *Tavelgallerier pa Stockholms slott under Senare delen av 1700-talet, i. Nationalmusei handtecknings-samling* 6, 1952); O. Sundel, *Kungl. Musei malningssaml. enl. inventarium upprättat* (Stockholm, 1816), nr. 671; Wurzbach, vol. 2 (1910), p. 249; *Nationalmusei Malningssamling Katalog, Stockholm* (1927), p. 84, nr. 658; *Catalogue descriptif des Collections de Peintures du Musée National, Maîtres étrangers* (Stockholm, 1928), p. 113, nr. 658; Gerson, *Thieme-Becker*, vol. 25 (1931), p. 556; Bénézit, *Dictionnaire*, vol. 6 (1953), p. 404; *Nationalmuseum Aldre Utländska Malningar och Skulpturer* (Stockholm, 1958), p. 145, nr. 658.

71. The Oyster Meal (Fig. 82)

Canvas, 87 × 72.5 cm., c. 1671–73.
Present location unknown.

Provenance: Private Collection, Basel, Switzerland, 1945.

Exhibitions: Kunstmuseum, Basel, "Meisterwerke Holländischer Malerei," June 23–August 19, 1945, nr. 64.

Notes: For other depictions of oyster eaters, see cat. nrs. 7, 21, 23, and 36; Figs. 16, 29, 33, and 40. The symbolism of the theme is discussed in the notes to cat. nr. 21. The style of the costumes in this work is similar to cat. nrs. 68 and 69; Figs. 79 and 80. Judging from a photograph, the upper half of the painting has been badly abraded.

72. The Betrothal (Fig. 83)

Canvas, 95 × 78 cm., c. 1671–73.
Private collection, Germany.

Provenance: George Bruyn Sale, Amsterdam, March 16, 1724, nr. 33: James Stuart Sale, London (Christie), May 23, 1839, nr. 42; Collection Chaix d'Est Ange, Paris, 1907; Sale, Paris, (Galerie Charpentier), December 11, 1934, nr. 36; D. Katz, Dieren, 1935–51; N. Katz Sale, Paris (Galerie Charpentier), April 25, 1951, nr. 55;

Edward Speelman, London, 1961; Sale, Lucerne (Galerie Fischer), June 16–20, 1964, nr. 1630; Thomas Brod Gallery, London, 1968–69; Sale, Cologne (Lempertz), November 26–28, 1970, nr. 183; P. de Boer, Amsterdam, 1971.

Exhibitions: Museum Boymans-van Beuningen, Rotterdam, "Vermeer: Oorsprong en Invloed," 1935, nr. 72a; Schaeffer Gallery, New York, "Great Dutch Masters," 1936, nr. 12; D. Katz, Amsterdam, "Arti et Amicitiae," 1938, nr. 54; Rhode Island Museum, Providence, "Dutch Painting in the 17th Century," 1938, nr. 34; San Francisco, "Golden Gate International Exhibition," 1939, nr. 85; Singer Museum, Laren, "Twee Nederlandse Collecties Schilderijen," June 14–August 16, 1959, nr. 64; Galerie Sanct Lucas, Vienna, "Austellung Gemälde Alte Meister," December 1959–January 1960, nr. 21.

Notes: The costume of the seated woman (with the short-sleeved, fur-trimmed jacket characteristic of the early 1670s) appears again in cat. nrs. 73 and 74; Figs. 84 and 86. The painting on the back wall of the interior is not clearly visible, but it appears to be a depiction of ships on a stormy sea. Such scenes, as De Jongh has shown, may be related to Krul's emblem (*Minnebeelden*, Amsterdam, 1634) of a man on a sailing ship with the motto "Al zijt ghy vert, noyt uyt het Hert" ("wherever he travels, never far from the heart") and are often found in combination with a woman receiving or reading a love letter (E. de Jongh, *Zinne -en Minnebeelden in de Schilderkunst van de 17de Eeuw* [Amsterdam, 1967], pp. 50–55). If Ochtervelt has indeed depicted a seascape, he may have intended it as a similar comment on this scene of a young officer placing a ring on the finger of his betrothed.

The dog in the foreground has been damaged and clumsily repainted. The right leg of the male figure also seems to have been reworked, and an area of damage above the green chair at the left shows traces of an effaced signature. The officer is dressed entirely in brown, the seated woman wears a lemon yellow jacket and white satin skirt, and the old woman in the center is dressed in black. The table carpet is deep orange, blue, and yellow; on it are placed a silver tray with oranges and a tan wicker-covered wine flask.

Literature: G. Hoet, *Catalogus of Naamlyst van Schilderyen* (The Hague, 1752), vol. 1, p. 301; Baron Joseph du Teil, "La Collection Chaix d'Est Ange," *Les Arts*, nr. 67 (July 1907), pp. 11 (ill.), 12 (as Ter Borch); Wurzbach, vol. 2 (1910), p. 701 (as Ter Borch); Gerson, *Thieme-Becker*, vol. 25 (1931), p. 556; W. Martin, *De Hollandsche Schilderkunst in de 17de Eeuw* (Amsterdam, 1942), vol. 2, p. 211, pl. 110; *Burlington Magazine* 103 (December 1961, suppl.), p. 5, pl. xix; *Weltkunst*, vol. 36, nr. 18 (September 15, 1966), p. 822 (ill.); *Burlington Magazine* 113 (September 1971): 558 (ill.).

73. The Nursery (Fig. 84)

Signed, lower right.
Canvas, 92.6 × 74.2 cm., c. 1671–73.
Private collection, Capetown.

Exhibitions: Royal Academy, London, "The Robinson Collection," 1958, nr. 48; National Gallery of South Africa, Capetown, "The Sir Joseph Robinson Collection," 1959, nr. 51; Kunsthaus, Zurich, "Sammlung Sir Joseph Robinson 1840-1929," August 17–September 16, 1962, nr. 33; National Gallery of South Africa, Capetown, "The Natale Labia Collection," 1976, nr. 16; Wildenstein, London, "Twenty Masterpieces from the Natale Labia Collection," April 25–May 26, 1978, nr. 7.

Notes: This painting is related in style and costume to cat. nrs. 72 and 74; Figs. 83 and 86. The interest in perspectival spatial definition combined with an emphasis on rich material textures recalls the late styles of Vermeer and De Hooch (cf. De Hooch, *Woman Nursing Child*, c. 1675, Kunsthistorisches Museum, Vienna, nr. 5976). The catalogue of the Robinson Sale (1923) includes the following color notes: "a lady wearing a buff jacket lined with white fur, and pink skirt trimmed with silver braid, seated and turning toward a nurse who wears a gray jacket and blue skirt and holds in her arms a young baby."

Literature: Valentiner (1924), p. 274; *Pantheon* 6 (December 1930): lviii; Gerson, *Thieme-Becker*, vol. 25 (1931), p. 556; *Illustrated London News*, July 5, 1958, p. 30; E. K. Waterhouse, *The Robinson Collection* (London, 1958), p. 24, nr. 48; Plietzsch (1960), p. 67, pl. 104; John Hadfield, *A Book of Joy* (1962), nr. 145 (color ill.); F. W. Robinson, *Gabriel Metsu: A Study of His Place in Dutch Genre Painting of the Golden Age* (New York, 1974), pp. 83, 214, pl. 198.

74. Lady and Maid Feeding a Parrot (Fig. 86)

Canvas, 77.5 × 94 cm., c. 1671–73.
Present location unknown.

Provenance: N. Doekscheer Sale, Amsterdam (v.d. Schley . . . Haverkorn), September 9, 1789, nr. 50; Collection Ali Loebl, 1933; J. Seligmann, 1956.

Notes: Similar in style and costume to cat. nrs. 72 and 73; Figs. 83 and 84. In the left background is a large tapestry showing a group of bearded men in long robes; the subject is unidentifiable, at least in a photograph. The theme of a lady feeding a parrot is also seen in the works of Metsu and Van Mieris (cf. Robinson, *Gabriel Metsu* [New York, 1974], p. 171, pls. 121 and 121a) and in a number of paintings attributed to De Hooch, all of

which date after 1670 (ills., W. R. Valentiner, *Pieter de Hooch*, Klassiker der Kunst [Stuttgart, 1929], pp. 108, 111, 166). A partial color description of the painting is included in the sale catalogue of 1789: "een jonge juffer, gekleed in een rood fluweelen jakje met bont, en wit satynen rok aan, in een gracelyke houding aan een tafel zit, waarop een papegaaiskooi staat, en aan welke vogel, die boven op de kooi zit, zy met een zilveren vorkje een stukje brood aanbied."

75. Lady with Servant and Dog (Fig. 87)

Canvas, 93.8 × 76 cm., c. 1671–73.
The New York Historical Society, Bryan Collection, nr. B-143.

Provenance: Sale, Amsterdam (v.d. Schley . . . Yver), November 14, 1791, nr. 112; Sale, Amsterdam (v.d. Schley . . . Yver), April 7, 1794, nr. 2; H. ten Cate Sale, Amsterdam (v.d. Schley . . . Pruysenaar), June 10, 1801, nr. 165; A. van der Werff van Zuidland Sale, Dordrecht (Versteegh . . . Schouman), July 31, 1811, nr. 77; Collection Thomas J. Bryan, until 1867.

Notes: Similar in costume to cat. nrs. 74 and 77; Figs. 86 and 89. The same tiled floor appears in cat. nr. 74; Fig. 86. The map on the background wall, Visscher's "Germania Inferior," is seen also in cat. nrs. 40, 54, and 63; Figs. 46, 130, and 75. (See notes to cat. nr. 40.) The seated woman wears a yellow satin jacket and white satin skirt with a transparent white apron; the maid has a brown blouse with white collar and cuffs and a dark blue skirt. The background wall and map are pale gray, the floor tiles are dark brown and gray; and the table carpet is pale orange, red, dark blue, and yellow.

Literature:
W. Bode, "Alte Kunstwerke in den Sammlungen in der Vereinigten Staaten," *Zeitschrift für bildenden Kunste*, NF, 6 (1895): 15; *Catalogue of the Museum and Gallery of Art of the New-York Historical Society* (New York, 1903), p. 36, nr. 319; *Catalogue of the Gallery of Art of the New York Historical Society* (New York, 1915), p. 74, nr. B-143; Gerson, *Thieme-Becker*, vol. 25 (1931), p. 556; J. A. Welu, "Vermeer: His Cartographic Sources," *Art Bulletin* 57 (December 1975): 539, fn. 49.

76. Lady Trimming Her Fingernails with Maid (Fig. 88)

Canvas, 74.6 × 59 cm., c. 1671–73 (?)
National Gallery, London, nr. 2553.

Provenance: Dr. Robert Bragge Sale, London (?), 1756, 2nd day, lot 46 (to Sir John Chapman); Collection George Salting, London (to National Gallery with Salting Bequest, 1910).

Notes: According to MacLaren (1960), this is probably the "Young Lady just up and paring her nails Octervelt," which was in the Dr. Robert Bragge Sale, London (?), 1756, 2d day, lot 46, bought by Sir John Chapman. The sale is unrecorded in Lugt and known only through a manuscript copy in one of two volumes of extracts in the Victoria and Albert Museum (vol. 1, pp. 276 ff; pressmark: RC.S. I); the day and month of the sale are not given. The date of the London interior is problematic, although MacLaren (1960, p. 278) has stated that the costume is of the later 1660s. And yet the painting seems to relate to a series of boudoir scenes (cat. nrs. 75, 77–79; Figs. 87, 89–91), datable by costume to the early 1670s, all of which display the same silver pitcher and basin. (On the emblematic meaning of this motif, see notes to cat. nr. 77.) Furthermore, the style of the picture, with its incoherent spatial intervals and rather frozen gestures, seems more characteristic of the 1670s, a period in which a number of Ochtervelt's works begin to show a noticeable decline in quality.

Recent cleaning of the painting (1977) has revealed a tapestry hanging on the back wall, which, according to Christopher Brown (correspondence), may represent Hagar in the Wilderness. The maid wears a brown skirt, light brown blouse, and red stockings; the seated lady has a pale blue bodice and white satin skirt. The bed curtains at the right are dark red and the table carpet is red, orange, white, and gray. On the table is a mirror, a jewel casket, and a string of pearls. According to Plietzsch (1960, p. 66), there is an autograph repetition of this painting (to which a chandelier has been added) in a German private collection.

Literature:
Valentiner (1924), p. 274; *National Gallery Trafalgar Square London* (London, 1929), p. 258, nr. 2553; Gerson, *Thieme-Becker*, vol. 25 (1931), p. 556; J. Rijckevorsel, *Rembrandt en de Traditie* (Rotterdam, 1932), p. 89, fig. 92; p. 139, nr. 168; Plietzsch (1937), p. 372, fn. 1; *Illustrations: Continental Schools, London National Gallery* (London, 1937), p. 253; Bénézit, *Dictionnaire*, vol. 6 (1953), p. 404; F. Simpson, "Dutch Paintings in England before 1760," *Burlington Magazine* 95 (February 1953): 41; *London National Gallery, Plates: The Dutch School* (London, 1958), p. 236; N. MacLaren, *London National Gallery: The Dutch School* (London, 1960), p. 278, nr. 2553; Plietzsch (1960), p. 66; *Illustrated General Catalogue, The National Gallery* (London, 1973), p. 526, nr. 2553.

77. The Letter Reader (Fig. 89)

Canvas, 91 × 78 cm., c. 1671–73.
Private collection, Cologne.

Provenance: Sale, Amsterdam (v.d. Schley . . . Yver), June 10, 1789, nr. 6; Price Sale, London (Christie), May 6, 1893, nr. 106; Collection Baron Königswarter; Königs-

warter Sale, Berlin (Schwarz and Schulte), November 20, 1906, nr. 66; Collection Paul von Schwabach, Berlin, 1925.

Exhibitions: Hertogin de Berry, London, 1834, nr. 28; Galerie Paul Cassirer, Berlin, "Ausstellung von Werken Alter Kunst aus Berliner Privatbesitz," May–June, 1915, nr. 90.

Notes: The costume of the letter reader is identical to that seen in cat. nrs. 65 and 69; Figs. 78 and 80. The silver pitcher and basin held by the maid also appear in cat. nrs. 75, 76, 78, and 79; Figs. 87, 88, 90, and 91. E. Snoep-Reitsma has demonstrated that this motif was used in 17th-century emblems as a symbol of both physical and spiritual purity. In toilette scenes or paintings of women with love letters, the pitcher and basin may function as symbols of the purity of the woman and as a reminder of her moral duty (E. Snoep-Reitsma, "De Waterzuchtige Vrouw van Gerard Dou en de betekenis van de lampetkan," in *Album Amicorum J. G. van Gelder* [The Hague, 1973], pp. 285–92). Ochtervelt's scene probably relates to this tradition, for the young woman is indeed reading a love letter, as indicated by the painting of a reclining Venus above the mantlepiece in the right background.

Discolored varnish partially obscures the fine quality of this painting. In addition, the faces of both women have been retouched, the head of the dog and the right arm and hand of the maid have been overpainted, and there is an area of damage on the right shoulder of the seated woman. The letter reader wears a white headdress and a white satin dress with pale blue bands above the elbows; the maid has a dark blue blouse and dark brown skirt; the table carpet is red, dark blue, yellow, and white; and the chair in the foreground is dark green silk. On the reverse of the canvas is a sticker inscribed "Coll. Mrs. Young."

Literature:
Katalog der Sammlung Baron Königswarter in Wien, II, Gemälde Alter Meister (for Königswarter Sale) (Berlin, 1906), p. 49, nr. 66; Wurzbach, vol. 2 (1910), p. 249; E. Plietzsch, "Ausstellung von Werken Alter Kunst aus Berliner Privatbesitz," *Cicerone* 7 (1915): 202–4, pl. 2; *Zeitbilder*, nr. 41, May 23, 1915, p. 3; Valentiner (1924), p. 274; *Cicerone* 17 (1925): 863, nr. 288; Gerson, *Thieme-Becker*, vol 25 (1931), p. 556; Plietzsch (1937), pp. 364, 372, fn. 1; Plietzsch (1960), p. 66.

78. Lady with Servant and Dog (Fig. 90)

Canvas, 70 × 57 cm., c. 1671–73.
The Carnegie Institute Museum of Art, Pittsburgh, Henry Lee Mason Memorial Fund, nr. PC-134.

Provenance: Kleinberger, Paris, 1912; Collection Max Freiherr von Goldschmidt-Rothschild, Frankfurt am Main, 1925; Rosenberg and Stiebel, New York, n.d.

Exhibitions: Städelsches Kunstinstitut, Frankfurt am Main, "Ausstellung von Meisterwerken alter Malerei aus Privatbesitz," 1926, nr. 161; Carnegie Institute Museum of Art, Pittsburgh, "Genre Painting in Europe 1500–1900," October–December 1954, nr. 43.

Notes: According to J. A. Welu (correspondence), the large world map at the right background, entitled at the top ORBIS TERRARUM NOVA ET ACCURATISSIMA TABULA, appears to be a combination of two world maps published by the Visscher family. The two spheres are taken from a wall map, published by Claes Jansz. Visscher (190 × 250 cm.) known in two editions of 1660 and two of 1669 (examples of both in the Bibliothèque Nationale, Paris). The title band, the North and South Poles, and the corner illustrations of the Four Elements are drawn from a smaller atlas map (47 × 55 cm.) by Nicolaus J. Visscher, an example of which is in the Bodel Nijenhuis Collection, University Library, Leiden.

The compositional placement of a world map above the head of a frivolous young lady may be seen as a variation on the traditional allegorical image of "Lady World": a woman with a globe on her head symbolizing lust and vice. (See also cat. nr. 57; Fig. 55.) As De Jongh has pointed out ("Realisme en Schijnrealisme . . . ," p. 180), Ochtervelt's "Vrouw Wereld" is reinterpreted here in a more naturalistic sense as a "wereldse vrouw" (worldly woman). A more obviously symbolic treatment of the theme is J. M. Molenaer's *Vrouw Wereld*, dated 1633, and now in the Toledo Museum of Art (ill., "Realisme en Schijnrealisme . . . ," p. 182, fig. 19), in which a similar wall map appears and the woman is surrounded by overt vanitas imagery (soap bubbles, a skull, etc.). For an interpretation of the pitcher and basin as symbols of physical and moral purity, see notes to cat. nr. 77. The same implements reappear in cat. nrs. 75, 76, 78, and 79; Figs. 87, 88, 90, and 91.

Although the De Hooch-like vista into a lighted inner room was used in one of Ochtervelt's earlier genre paintings, *The Sleeping Soldier* (cat. nr. 15; Fig. 26), it is a device employed more frequently in his portraits (cat. nrs. 18, 61, and 81; Figs. 150, 156, and 158). Indeed, in its even lighting and detailed depiction of the interior, this painting seems the closest in style to portraiture of all of the artist's group genre scenes.

There are small areas of damage and retouching on the forehead and at the neckline of the young lady. Her left hand has been partially repainted, making her gesture difficult to read. Originally she must have been holding a cake or biscuit for the dog. This figure wears a brilliantly colored costume: a yellow satin bodice and salmon pink skirt trimmed with silver. The maid has a blue-white headdress, gray blouse, and blue-black skirt. The chair is lime green, the bed curtains dark green, and the table cloth dark blue with a figured border of tan, white, blue, and black. The wall and map are gray, and

the Caravaggesque soldier in the painting over the door (similar in type to cat. nrs. 25 and 33; Figs. 60 and 61) has a red beret, gray sleeves, and a metal cuirass. A woman dressed in gray and a man in black and white appear in the inner room at the left, which has blue curtains and a red and gray tiled floor.

Literature:
Plietzsch (1937), p. 372, fn. 1; *The Carnegie Magazine* 28 (December 1954): 325, cover (ill.); Plietzsch (1960), p. 66; E. de Jongh, "Realisme en Schijnrealisme in de hollandse Schilderkunst van de 17de Eeuw," in *Rembrandt en zijn Tijd* (Brussels, 1971), p. 180, fig. 18; E. de Jongh, "Vermommingen van Vrouw Wereld in de 17de Eeuw," in *Album Amicorum J. G. van Gelder* (The Hague, 1973), p. 202, fig. 8; E. de Jongh, *Tot Lering en Vermaak* (Amsterdam: Rijksmuseum, 1976), p. 178, fig. 43b.

79. The Footwashing (Fig. 91)

Signed, lower right, c. 1671-73.
Canvas, 73.5 × 60.5 cm.
Present location unknown.

Provenance: Roemjantsow Collection, Moscow; Museum of Fine Arts, Moscow; D. Katz, Dieren, 1934-39.

Exhibitions: Frans Hals Museum, Haarlem, "Oud-Hollandsche Meesters uit de Collectie Katz te Dieren," November 17-December 15, 1934, nr. 30; Huize "Belvoir," Nijmegen, "Hollandsche, Vlaamsche en Italiaansche Schilderijen uit de Collectie D. Katz," July 15-September 1, 1936, nr. 41; Van Abbe-museum, Eindhoven, "Hollandsche, Vlaamsche en Italiaansche Schilderijen uit de Collectie D. Katz," December 22-January 31, 1937, nr. 51; D. Katz, Dieren, "Tentoonstelling van Belangrijke 17de eeuwsche Hollandsche Schilderijen in de Zalen van de Firma D. Katz," August 7-September 15, 1939, nr. 64.

Notes: The standing woman is very similar in facial and figure type to the young woman in *Lady with Servant and Dog* (cat. nr. 78; Fig. 90). The same pitcher and basin are repeated in cat. nrs. 75-78; Figs. 87-90. On the emblematic meaning of this motif, see notes to cat. nr. 77. Hofstede de Groot's notes (RKD), made when he saw the painting in Moscow in 1901, include a partial color description: "Interieur met een dame in het rose, staande, die zich door een voor haar knielende meid de voeten met een spons laat reinigen. Zy draagt een doorschynend gewaad . . . Rechts ligt een hondje op een groene stoel."

Although handwashing is not an uncommon subject in Dutch genre painting (cf. Ter Borch, Gemäldegalerie, Dresden; E. H. van der Neer, Mauritshuis, The Hague, etc.), footwashing is rarely depicted. Indeed, the subject is known to this writer in only one other example: Jan Voorhout's elaborate *Maid Washing the Feet of Her Mistress* (Fig. 92: undated, 132×112 cm.),

present location unknown; exhibited at the Dublin Municipal Gallery of Modern Art, "Paintings from Irish Collections," May-August, 1957, nr. 112.

Literature:
Catalogue, Roemjantsow Museum, Moscow; in Russian (Moscow, 1901), p. 51, nr. 627; *Catalogue, Roemjantsow Museum, Moscow;* in Russian (Moscow, 1915), p. 272, nr. 704; Plietzsch (1937), p. 372; Bénézit, *Dictionnaire*, vol. 6 (1953), p. 404; Plietzsch (1960), p. 67.

80. Lady and Maid (Fig. 93)

Material of support unknown, 44.4 × 33.6 cm., c. 1671-73.
Henry E. Huntington Art Gallery, San Marino, California.

Provenance: F. Mont, New York, 1951.

Notes: Related in style and subject to other boudoir scenes by Ochtervelt that can be dated in the early 1670s (cat. nrs. 74-79; Figs. 86-91). Here, however, the composition is three-quarter length and only about half the size of the other works in the group. Since the design seems rather awkwardly truncated, it is possible that this is a fragment of an originally larger composition. Judging from a photograph, the face of the seated woman has been extensively retouched. Yet the treatment of the maid, the table carpet, and the satin costume (which reveals the contours of the legs beneath the skirt) are all completely characteristic of Ochtervelt's style.

81. Portrait of a Couple (Fig. 158)
Making Music

Canvas, 87 × 75 cm., c. 1671-75.
Städtische Kunstsammlungen, Augsburg, West Germany, Haberstock Bequest.

Provenance: Galerie van Diemen and Co., Berlin, before 1937; Galerie Haberstock, Berlin; Collection Karl and Magdalene Haberstock.

Notes: Similar in setting to the Budapest *Family Portrait* of 1670 (cat. nr. 61; Fig. 156), which also includes an elaborate marble fireplace at the right and an open door with a view to the outdoors at the left background. The figure types, however, are closer to those in Ochtervelt's portrait in Pasadena (cat. nr. 66; Fig. 157); the costume depicted is that of the early to mid-1670s. The woman, who holds a yellow music book, wears a red velvet jacket (somewhat rubbed at the shoulders and elbows) and a white satin skirt. The chair behind her is green silk. The male figure has a greenish-brown coat with a gold and white cravat and a dull pink sash. The table carpet is painted in muted tones of red, yellow, white, and dark green. The fireplace at the right is

brown marble with an illegible painted overmantle. (For a slightly later variant of the composition, see cat. nr. 90; Fig. 159.)

Literature:
H. G. B., "Ausstellungen-Berlin, Galerie Haberstock," *Kunstchronik* 38 (June 1924): 104 (ill.); Plietzsch (1937), p. 372; *Westermanns Monatshefte*, vol. 82, nr. 163 (1938), ill. following p. 356; *Weltkunst*, vol. 27, nr. 20 (October 15, 1957), p. 17; *Katalog Gemälde der Stiftung Karl und Magdalene Haberstock* (Augsburg, 1960), p. 19.

82. The Regents of the Amsterdam Leper House (Fig. 163)

Signed and dated 1674, lower left corner.
Canvas, 156 × 204 cm.
Rijksmuseum, Amsterdam, nr. C 390.

Provenance: Governors' Room, Amsterdam Leper Asylum; loaned by the City of Amsterdam to the Rijksmuseum in 1885.

Notes: Ochtervelt's largest painting, *The Regents* was probably one of the artist's first commissions after his move to Amsterdam. Moes has identified the governors as Anthony de Haes, Gillis Hens, Dr. Bonaventura van Dortmunt, and Isaac Hudde. The most recent catalogue of the Rijksmuseum replaces the name of Gillis Hens with that of Dirck van Outshoorn and identifies the man in the background as the housemaster of the asylum. Although less than life-size, this composition may have been derived from Karel Dujardin's *Regents of the Amsterdam Correction House* (Fig. 164), signed and dated 1669, Rijksmuseum, Amsterdam, nr. C 4.

The surface of the painting has been rubbed and abraded, and there are pentimenti at the left side of the hat worn by the man at the far right. The black and white costumes of the regents and the pale gray coat of the housemaster establish the cool, restrained coloring of the scene. The curtain at the left is dark green, the woman and children at the far right are also dressed in black and white, and the floor and wall are pale gray. The reliefs on the background wall relate directly to the institution the sitters serve. The panel at the far left (a female nude) is obscured by the curtain, but the central scene depicts Apollo (god of healing) with his lyre, while the panel over the door at the right shows a recumbent Lazarus with the dogs licking his sores (Luke 16: 20-21). A similar Lazarus relief appears in the right background of Werner van den Valckert's *Regents of the Amsterdam Leper House*, signed and dated 1624, Rijksmuseum, Amsterdam, nr. C 417 (ill., Haak, *Regenten en Regentessen* [1927], p. 22, fig. 30).

Literature:
A. Bredius, *Die Meisterwerke des Rijksmuseum zu Amsterdam* (Munich, n.d.), pp. 44, 166, 168 (ill.); F. A. van Schelte-ma, *Historische Beschrijvinge* (Amsterdam, 1879), p. 31, nr. 84; F. D. O. Obreen, *Archief voor Kunstgescheidenis* (Rotterdam), vol. 5 (1883), p. 317, fn. 1; A. Bredius, *Catalogus van het Rijksmuseum* (Amsterdam, 1887), p. 124, nr. 1046; E. W. Moes, *Iconographia Batava* (Amsterdam), vol. 1 (1897), p. 240, nr. 2094; p. 371, nr. 3091; p. 457, nr. 3811; vol. 2 (1905), p. 542, nr. 8597; *Catalogus der Schilderijen ... in het Rijksmuseum te Amsterdam* (Amsterdam, 1903), p. 198, nr. 1781 (same reference in catalogue editions of 1907, 1909, and 1918); *Bryan's Dictionary of Painters and Engravers*, ed. G. C. Williamson (London, 1904), vol. 4, p. 32; Wurzbach, vol. 2 (1910), p. 249; Valentiner (1924), p. 273; Gerson, *Thieme-Becker*, vol. 25 (1931), p. 556; *Catalogus der Schilderijen ... in het Rijksmuseum* (Amsterdam, 1934), p. 213, nr. 1781; W. Martin, *De Hollandsche Schilderkunst in de 17de Eeuw* (Amsterdam, 1936), vol. 2, p. 211; Plietzsch (1937), p. 372; Bénézit, *Dictionnaire*, vol. 6 (1953), p. 404; Plietzsch (1960), p. 66; *Catalogue of Paintings, Rijksmuseum* (Amsterdam, 1960), p. 231, nr. 1781; B. Haak, *Regenten en Regentessen Overleiden en Chirurgijns: Amsterdamse Groepportretten van 1600 tot 1835* (Amsterdams Historisch Museum, 1972), p. 51; S. D. Kuretsky, "The Ochtervelt Documents," *Oud Holland* 87 (1973): 128, fig. 3; *All the Paintings in the Rijksmuseum, Amsterdam* (Maarssen, 1976), p. 423, nr. C 390.

83. Concert in a Garden (Fig. 94)

Signed and dated 1674, lower left.
Canvas, 76 × 74 cm.
The Hermitage, Leningrad, nr. 3326.

Provenance: Galerie Brühl; Collection Catherine the Great; Semenov Collection, St. Petersburg.

Notes: Probably one of the first works Ochtervelt painted after his move to Amsterdam, this painting is of particular importance for understanding the artist's chronology: it is dated in the 1670s, but it illustrates a return to a type of subject matter that Ochtervelt had developed and used during the mid-1650s (cf. cat. nrs. 5 and 6; Figs. 11 and 14). But in the later work, which is close in style to cat. nr. 84; Fig. 96, the artist's touch has become looser and more fluid, and the contrasts of light and shadow are softer than the sharp Caravaggesque lighting used in the 1650s.

The standing lutenist at the left wears a dark green jacket and mustard skirt; the man in the center, a dark brown shirt, tan trousers, and dark yellow stockings; the seated singer, a white satin dress; and the flutist at the right, mustard sleeves, a metal cuirass, tan trousers, a bright red cape, and dark blue stockings. The architecture is brown, and the sky is dark gray-blue.

Literature:
Études sur les Peintures des Écoles hollandaise, flamande, et néerlandaise qu'on trouve dans la Collection Semenov et les autres Collections publiques et privées de St. Petersbourg (St. Petersburg, 1906), pp. 155-56, nr. 402; Wurzbach, vol. 2 (1910), p. 249; Plietzsch (1937), pp. 368, 372; *Hermitage*

Catalogue of Paintings, vol. 2, in Russian (Leningrad, 1958), p. 236, nr. 3326; Plietzsch (1960), p. 64.

84. Musical Company in a Rotunda (Fig. 96)

Canvas, 96 × 75 cm., c. 1674.
Collection Bentinck-Thyssen. On loan to Kunstmuseum, Düsseldorf.

Provenance: Dr. Benedict, Berlin, 1924; Collection J. Porges, Paris, 1925; Sale, Lucerne (Galerie Fischer), August 24, 1926, nr. 616; Galerie van Diemen, Berlin, c. 1929; Thyssen Collection, Schloss Rohoncz, 1930; Collection Baroness Bentinck (née Thyssen).

Exhibitions: Forbes and Patterson, London, 1902, nr. 8; Neue Pinakothek, Munich, "Sammlung Schloss Rohoncz," 1930, nr. 244; Institut Néerlandais, Paris, "Choix de la Collection Bentinck," May 20-June 28, 1970, nr. 31.

Notes: Similar in style and subject to the Hermitage *Concert in a Garden*, dated 1674 (cat. nr. 83; Fig. 94). Two copies after this painting (from which the rotunda was omitted) are known: cat. nrs. 84-A and 84-B; Figs. 97 and 98. This music scene has darkened, discolored varnish and scattered losses, most obviously on the face and neck of the woman in the center who wears a white dress with blue at the elbows. The woman at the left wears a pale yellow blouse with white sleeves and a pale pink satin skirt trimmed with silver; the standing soldier has a metal helmet and breastplate and dark white sleeves; and the violinist has mustard sleeves and trousers, a metal cuirass, a pale brown cape, and dark blue stockings. The rotunda is gray and draped with a dark gray cloth. Above it can be seen a blue sky and white clouds.

Literature:
Cicerone 19 (November 1, 1927): cover; *Art News* 26 (April 14, 1928): 14; Plietzsch (1937), p. 368, fn. 2; R. Heinemann, *Stiftung Sammlung Schloss Rohoncz* (Lugano-Castagnola, 1937), vol. 1, p. 114, nr. 311; Plietzsch (1960), p. 65, fn. 1.

84-A. Musical Company (copy) (Fig. 97)

Canvas, 52 × 49 cm.
Present location unknown.

Provenance: Private collection, Cologne; Sale, Cologne (Carola van Ham), June, 10-13, 1970, nr. 1117.

Notes: A copy after Ochtervelt's *Musical Company in a Rotunda* (cat. nr. 84; Fig. 96). Although the poses of the figures are close to those in the original, the rotunda has been omitted and a chest added at the left background, upon which are glass or ceramic vessels. The same motifs appear in a second copy in Schwerin (cat. nr.

84-B; Fig. 98). Photographs of the painting indicate that it is in poor condition and has been badly abraded in the upper left quadrant.

84-B. Musical Company (copy) (Fig. 98)

Canvas, 78 × 75 cm.
Staatliches Museum, Schwerin, East Germany, nr. 75.

Notes: A copy after Ochtervelt's *Musical Company in a Rotunda* (cat. nr. 84; Fig. 96). As in the copy sold in Cologne in 1970 (cat. nr. 84-A; Fig. 97), the rotunda has been omitted and a chest with ceramic or glass vessels added at the left background. The poses of the figures are more upright than those in either the original or in the Cologne copy, and the cape of the violinist has been changed. It is possible that this work was copied from the Cologne painting, rather than from the original itself.

85. The Visit (Fig. 99)

Canvas, 71 × 58 cm., c. 1675.
Private collection, England.

Provenance: C. J. Nieuwenhuys Sale, London (Christie), May 10, 1833, nr. 24; Collection Albert Levy; Collection Captain Dennisborn (or Dennistoun); Princess Royal Sale, London (Christie), July 18, 1924, nr. 68; W. E. Duits, London 1945-46; Collection R. A. Constantine.

Exhibitions: Arcade Gallery, London, "Baroque Painting of Flanders and Holland," June 15-July 14, 1945, nr. 22; Nottingham YMCA, "Dutch and Flemish Art," September 10-29, 1945, nr. 38; Red Lodge, Bristol, "Dutch Old Masters," March, 1946, nr. 20.

Notes: Plietzsch (1960, p. 66) dates this work around 1671, the period of the dated *Tric-trac Players* in Leipzig (cat. nr. 64; Fig. 77), and notes that it shows influences of Ter Borch. The shorter, more broadly modeled figure types and rounder faces seem, however, to relate more closely to Ochtervelt's *Concert* in the Hermitage, dated 1674 (cat. nr. 83; Fig. 94). The looser painting technique is also more characteristic of the mid-1670s. The same figure types and style of painting are seen in cat. nrs. 86 and 87; Figs. 100 and 101, which must date from the same period. Plietzsch is correct in pointing out the influence of Ter Borch, for Ochtervelt's painting is strongly reminiscent of Ter Borch's *The Greeting* of about 1658 (Mellon Collection, National Gallery of Art, Washington, D.C.; ill., S. J. Gudlaugsson, *Gerard Ter Borch* [The Hague, 1959], vol. 1, p. 296, pl. 139). Ochtervelt may also have known Netscher's copy after the Ter Borch (present location unknown; ill., Gudlaugsson, vol. 2, pl. XIV, fig. 2). The

catalogue of the Princess Royal Sale, 1924, gives the following color description: "a young cavalier, in dark coat with buff breeches, greeting hat in hand, a young lady, in white satin dress with red blouse."

Literature:
Plietzsch (1937), p. 372, fn. 1; *Burlington Magazine* 87 (December 1945): v; Plietzsch (1960), p. 66.

86. The Tease (Fig. 100)

Canvas, 81 × 65 cm., c. 1675.
Private collection, Switzerland.

Provenance: Schaeffer Gallery, New York; Collection Belport Towers, England; N. Katz Sale, Paris (Galerie Charpentier), April 25, 1951, nr. 56; Galleria Giorgio Caretto, Milan, 1967; P. de Boer, Amsterdam, 1970.

Exhibitions: P. de Boer, Amsterdam, "Tableaux Anciens," October 26–December 15, 1970, nr. 15.

Notes: Close in style to cat. nrs. 85 and 87; Figs. 99 and 101. (See notes to cat. nr. 85.) An old photograph given to the Rijksbureau voor Kunsthistorische Documentatie, The Hague (neg. L50675), by Dr. Schaeffer reveals that the hair of the standing woman once included curls at the neck (either overpaint that has since been removed or an area that has since been overpainted). In any case, this part of the painting has definitely been damaged and retouched. The woman at the left wears a pink jacket and white satin skirt; the soldier has mustard and white sleeves, a metal cuirass, dark brown stockings, and a bright red cape; and the woman at the right wears a brown jacket trimmed with white fur and a brown hat with a yellow feather. The chair at the left and the bed behind the figures are green. On the combination of lemons and wine, see notes to cat. nr. 37; Fig. 42. The same motif appears in cat. nrs. 53 and 88; Figs. 53 and 72.

87. Musical Trio (Fig. 101)

Signed, on footstool, c. 1675.
Canvas, 83 × 67.5 cm.
Present location unknown.

Provenance: Dowdeswell, London, 1899; Van Nemes Collection, Budapest; Ehrich Gallery, New York, 1920; E. Bolton, London, 1927; Collection A. F. Mondschein, Vienna, 1935.

Exhibitions: Schaeffer Gallery, Berlin, "Die Meister des holländischen Interieurs," April–May, 1929, nr. 68; Museum Boymans-van Beuningen, Rotterdam, "Vermeer: Oorsprong en Invloed," 1935, nr. 72.

Notes: Similar in style to cat. nrs. 85 and 86; Figs. 99 and 100. (See notes to cat. nr. 85.) When Hofstede de Groot saw the painting at Dowdeswell in London in March of 1899, he made the following color observations (HdG notes, RKD): "een interieur met een zingend en een op de fluit spelend meisje, in licht-geel en oranje, en een heer in het rood, op de luit spelende, aan den wand een landschap, in den trant van J. Both, in een vergulden lyst."

Literature:
Plietzsch (1937), p. 368, fn. 1; Plietzsch (1960), p. 65, fn. 1.

88. Cavalier and Maid in a Niche (Fig. 72)

Signed, lower left, c. 1675.
Canvas, 62 × 53 cm.
Present location unknown.

Provenance: Collection Catherine II of Russia; The Hermitage, Leningrad; Van Diemen and Co. Sale, Berlin (Graupe), January 25–26, 1935, nr. 43.

Notes: Larger in scale and more elaborate in composition than Ochtervelt's other niche scenes (cat. nrs. 34, 47–49; Figs. 63, 69–71). Judging from a photograph, the costume and facial type of the young woman seem to relate to Ochtervelt's style of the mid-1670s (cf. cat. nrs. 85–87; Figs. 99–101). Although the Hermitage catalogues list the dimensions as 62 × 53 cm., the Van Diemen sale catalogue gives dimensions of 56 × 46 cm. When Hofstede de Groot saw the work in St. Petersburg in 1902, he made the following color notations (HdG notes, RKD): "benevens een roode mantel en een aangesneden meloen op een zilveren bord, een jong soldaat met een lightgeel costuum zit naat links gewend, met een pyp in de linkerhand en met de rechter een snee meloen anbiedende aan een jonge dame in het blauw met een zwart jakje."

Literature:
Ermitage Impérial, Catalogue de la Galerie des Tableaux; vol. 2, *Les Écoles Germaniques* (St. Petersburg, 1885), p. 163, nr. 892; A. Somof, *Ermitage Impérial, Catalogue de la Galerie des Tableaux, Écoles Néerlandaises et École Allemande* (St. Petersburg, 1901), p. 265, nr. 972; Wurzbach, vol. 2 (1910), p. 249; Gerson, *Thieme-Becker*, vol. 25 (1931), p. 556.

89. Cavalier and Maid on a Balcony (Fig. 73)

Signed, lower left, c. 1675.
Canvas, 33 × 27.5 cm.
Galerie Kurt Meissner, Zollikon/Zurich.

Provenance: G. van der Pot Sale, Rotterdam (v. Nymegen . . . v. Rijp frères), June 6, 1808, nr. 94; Collection

Viscount Harcourt, London; Hawk Sale, American Art Association, New York (Anderson Gallery), February 4-5, 1931, nr. 19; J. Weitzner, New York, 1933; L. Koetser, London, 1959; D. Katz, Dieren, 1962-63; Sale, Paris (Galliéra), June 10, 1964, nr. 20; I. Bier, Haarlem, 1967; Duyvendijk Collection, Scheveningen, 1968; P. de Boer, Amsterdam.

Exhibitions: L. Koetser, London, "Autumn Exhibition," November 2-30, 1959, nr. 7; D. Katz, Dieren, "Oude Hollandse en Vlaamse Meesters," November 22, 1962-January 15, 1963, nr. 41; Kunsthandel P. de Boer, Amsterdam, "Fine Old Master Paintings," March 16-June 1, 1970, nr. 45.

Notes: Because of extensive restoration and retouching, the painting is difficult to date. The facial type of the female figure seems similar to those of the mid-1670s (cf. cat. nrs. 85-87; Figs. 99-101). Hollstein (vol. 14, p. 187) lists two mezzotints after this painting: one by Jan Verkolje (nr. 5) inscribed "Ochter Velt pinx. A 1685"; the other, an undated print by Pieter Schenk (1660-1718/19) inscribed "Ochtervelt pinx ... P. Schenk fec. et exc." (nr. 3). Schenk's print (Fig. 74) is of particular interest because it shows the figures within a stone archway. Either Ochtervelt painted another variant (since lost), or the niche was added by the copyist. Recent cleaning and X-ray did not reveal a niche. In 1959, when the painting was photographed for the exhibition at Koetser's, the hair of the maid had been repainted in a darker color and the copper basin replaced with a letter, probably to give the scene greater refinement. This overpaint must have been added after 1931, for it is not visible in the catalogue reproduction for the American Art Association Sale (February, 1931).

The maid has blond hair, a rose-colored blouse, and a dark brown skirt; the cavalier wears a tan jacket and hat with blue and white plumes. The balcony is gray and the sky is painted in tones of blue, orange, and brown.

90. Portrait of a Couple Making Music (Fig. 159)

Canvas, 80 × 72 cm., c. 1675-80.
Private collection, Milan.

Provenance: Collection W. B. Paterson, 1904; P. Mersch Sale, Berlin (Keller and Reiner), March 1-2, 1905, nr. 75; Heberle Sale, Cologne (Lempertz), November 18, 1907, nr. 36; P. Mersch Sale, Paris (Hotel Drouot), May 8, 1908, nr. 57; J. Böhler, Munich, before 1940, K. Meissner, Zurich, 1967.

Exhibitions: Whitechapel Art Gallery, "Dutch Exhibition," March 30-May 10, 1904, nr. 308.

Notes: The composition is a variant of Ochtervelt's double portrait in Augsburg (cat. nr. 81; Fig. 158).

Although the costume of the woman is similar to that seen in the Budapest *Family Portrait* of 1670 (cat. nr. 61; Fig. 156), the tightly laced sleeves did not come into fashion until around 1675.

The catalogue of the Mersch Sale (Berlin, 1905) includes the following color notes: "In einem grau gehaltenen Interieur steht vor einem Tische, in einem schwarzen, ausgeschnittenen Sammetkleid mit langer Schleppe, kurzen weizen Armeln und weizen von reicher Goldstickerei durchzogenen Devant, eine junge Dame, in der rechten Hand ein Notenbuch, über dem linken Arm einem schwarzen Kragen haltend. Neben ihr, rechts im Bilde, sitzt, half von links gesehen, das von einer blonden Perücke eingerahmte Gesicht nach vorn gewendet, ein junger Mann in langem braunen Mantel."

Literature:
Plietzsch (1937), p. 370; Plietzsch (1960), p. 66.

91. Lucretia (Fig. 102)

Signed and dated 1676 (location of signature and date unknown).
Panel, 29.1 × 24.7 cm.
Present location unknown.

Provenance: Collection Admiral Walker; A. Walker Sale, London (Sotheby), December 3, 1952, nr. 104 (to Dent); Collection L. McCormick-Goodhart, Alexandria, Virginia, 1954.

Notes: Lucretia is Ochtervelt's only known attempt at a subject drawn from Roman history. Like the Italianate garden scene of 1674, (cat. nr. 83; Fig. 94), this work seems to demonstrate the artist's response to the fashion for academic classicism, prevalent in Amsterdam during the last quarter of the 17th century. Although the format and pose of Ochtervelt's Lucretia are somewhat similar to Rembrandt's famous depiction of the theme (National Gallery, Washington, dated 1664), the polished treatment of the flesh and ornamental drapery seem closer to Gerard de Lairesse or Van der Werff. Stechow has shown that the source for figures of this type may be traced to Italian painting of the 16th century: particularly North-Italian Lucretias (Bramantino, Johnson Collection, Philadelphia Museum of Art; Palma Vecchio, Borghese Gallery, etc.), shown in half-length with languid upward glances and a restrained display of the nude. Such figures were often used as symbols of chastity or faithfulness in love (W. Stechow, "Lucretiae Statua," in *Beiträge für Georg Swarzenski* [Berlin, 1951], pp. 114-24).

According to the catalogue of the Walker Sale, the painting is signed and dated 1676, but the location of signature and date are not specified.

92. Woman Combing Her Hair Before a Mirror (Fig. 103)

Canvas, 117 × 85 cm., c. 1676.
Kunsthandel A. H. Bies, Eindhoven, The Netherlands.

Provenance: Galerie Internationale, The Hague, 1961; Sale, Amsterdam (Mak van Waay), May 24, 1966, nr. 381; Kunsthandel A. H. Bies, Eindhoven, 1967; Sale, Amsterdam (Mak van Waay), February 23-25, 1968, nr. 367.

Notes: Similar in style and type to Ochtervelt's *Lucretia*, which is dated 1676 (cat. nr. 91; Fig. 102). The emphasis on the nude, the lack of contemporary allusions (furniture, costume, etc.), and the mirror and string of pearls at the right suggest that this may have been intended as a representation of Venus, or perhaps as a Vanitas allegory. There are areas of damage and overpaint around the mouth and on the neck and right arm of the figure. The marked disparity between the woman's face and its mirrored reflection may result from the condition of the painting. The figure wears a white satin "skirt" and is seated on a mass of pink satin drapery. An accent of yellow satin at the left completes the rather rococo coloring of the painting. The slippers in the left foreground are brown with pink highlights.

93. The Duet (Fig. 104)

Signed, lower left (?), c. 1676-80.
Canvas, 85 × 70 cm.
Private collection, London.

Provenance: Collection Dr. L. Lilienfeld, Vienna; on loan to Boston Museum of Fine Arts (nr. 297.53), 1953-74.

Notes: Similar in setting and lighting effects to *The Dancing Dog*, dated 1669 (cat. nr. 57; Fig. 55), in Hartford, but the costumes, the freer painting technique, and the more crowded, and less coherent, design point to a date in the later 1670s. The powerful contrast in scale between the shadowed foreground, defined by a tapestry-covered table, and the placement of figures against a lighted wall, suggest the influence of Vermeer (cf. Fig. 56, *Lady and Gentleman at the Virginals,* Queen's Collection, London). A signature is not visible on the painting today, but when Hofstede de Groot viewed the work in Vienna in 1915, he noted that it was "links beneden voluit gemerkt" (HdG notes, RKD).

The condition of *The Duet* is poor. Extensive overpaint has been applied throughout the composition, most obviously on the floor in the foreground, the hands and face of the maid, the door behind her, the face

and hair of the seated woman, the coat of the violinist, and the red jacket on the bench between the two musicians. The table carpet is orange-red with touches of yellow and blue; the lutenist wears a blue satin jacket and yellow satin skirt; and the male figure has a black coat and mustard colored stockings.

The gray map on the background wall has not been identified, but, according to J. A. Welu (correspondence), the decorative figures at the left (Neptune and Amphitrite riding on a shell and Triton blowing his horn) are derived from the title cartouche at the upper right of C. J. Visscher's map of the Seventeen Provinces ("Germania Inferior")—a map that Ochtervelt represented in four of his paintings: cat. nrs. 40, 54, 63, and 75; Figs. 46, 130, 75, and 87. (See notes to cat. nr. 40.)

Literature: G. Glück, *Niederländische Gemälde aus der Sammlung des Herr Dr. Leon Lilienfeld in Wien* (Vienna, 1917), nr. 47; F. Becker, review of Glück, *Kunstchronik* 29 (1918): 395; Plietzsch (1937), p. 368, fn. 3; Plietzsch (1960), p. 65, fn. 1.

94. The Music Party (Fig. 105)

Signed, over door at right, c. 1676-80.
Canvas, 84.5 × 75 cm.
National Gallery, London, nr. 3864.

Provenance: A. D. S. de Vahl Sale, London (Christie), February 20, 1920, lot 142 (to Peacock); purchased by the National Gallery from S. T. Smith and Son, 1924.

Notes: As in *The Duet* (cat. nr. 93; Fig. 104), the composition and lighting (and subject) show influences of Vermeer. Variants of the standing woman appear in cat. nrs. 95-97; Figs. 107-109. According to J. A. Welu (correspondence), the map on the background wall is taken from an atlas-size map (47 × 58.5 cm.) of North and South America ("AMERICAE/ nova discriptio") published in Amsterdam in 1661 by Dancker Danckerts. An example is in the collection of the Library of Congress, Washington, D.C.

On the left half of the open lid of the virginals is an effaced inscription: "S(?) . . . D(?) . . . E(?). Before 1920 the hair of the two women had been altered and the tail of the dog on the left painted out. Shortly after the de Vahl Sale (1920), the overpaint on the women's hair was removed, but the dog on the right was completely painted out. (For reproduction, see *Burlington Magazine* 44 [1924]: 193.) In 1924 complete restoration was done, removing all overpaint. The man on the left is seated on a jade green chair and wears a lavender-gray coat, a brown cape, and brown stockings; the seated singer wears a blue dress with a violet stripe at the neck and a mustard apron; and the woman at the virginals

has a rose colored satin dress trimmed with gold lace. A poor pastiche after this *Music Party* was at the Galerie Stern, Dusseldorf, in 1936 (cat. nr. 94-A, Fig. 106).

Literature:
Sir Charles Holmes, "Ochtervelt and 'Melozzo' at Trafalgar Square," *Burlington Magazine* 44 (April 1924): 192–95, pl. A; Valentiner (1924), p. 274; *National Gallery Trafalgar Square* (London, 1929), p. 258, nr. 3864; Gerson, *Thieme-Becker*, vol. 25 (1931), p. 556; *Illustrations: Continental Schools, London National Gallery* (London, 1937), p. 253; Plietzsch (1937), p. 368; R. Witt, "An Overpainting in the Music Party," *Apollo* 43 (January 1946): 21; Bénézit, *Dictionnaire*, 6 (1953), p. 404; *London National Gallery, Plates: The Dutch School* (London, 1958), p. 237; N. MacLaren, *London National Gallery: The Dutch School* (London, 1960), pp. 278–79, nr.3864; Plietzsch (1960), p. 64; *The National Gallery, Illustrated General Catalogue* (London, 1973), p. 526, nr. 3864.

94-A. The Music Party (pastiche) (Fig. 106)

Canvas, 85 × 72 cm.
Present location unknown.

Provenance: Van Diemen Galleries, Berlin, 1927; Galerie Stern, Dusseldorf, 1936.

Notes: A crude pastiche after the London *Music Party* (cat. nr. 94; Fig. 105) which includes the lady at the virginals, a standing variant of the seated singer, and the dog at the right (moved to the left and deprived of his tail).

Literature:
Art News, vol. 25, nr. 19 (February 12, 1927), p. 13 (ill.).

95. The Music Lesson (Fig. 107)

Canvas, 79.7 × 65.4 cm., c. 1676–80.
National Gallery, London, nr. 2143.

Provenance: Collection Fürstin Carolath-Beuthen, Berlin, 1883; Huldschinsky Sale, Berlin (Lepke), March 18-20, 1900, nr. 54; presented to the National Gallery in 1907 by Henry J. Pfungst.

Exhibitions: Königlichen Akademie der Künste, Berlin, "Ausstellung von Gemälden Älterer Meister im Berliner Privatbesitz," January–March, 1883, nr. 86; London National Gallery and Arts Council of Great Britain Touring Exhibition (Newcastle, Bolton, Lincoln, Southampton), "Dutch Genre Painting," 1978, nr. 10.

Notes: Variants of the standing woman appear in cat. nrs. 94, 96, and 97; Figs. 105, 108, and 109. The dog reappears in cat. nr. 102; Fig. 115. Recent cleaning of the painting (1977) revealed that the background is seriously abraded.

In the left foreground is a lime green chair partly covered by a gray jacket trimmed with gold braid. The man at the left wears a gray(?) coat; the lady at the virginals wears a dark pink satin dress with gold embroidery; and the servant at the right has a dark gray or green coat with a yellow sash and pink ribbons at the neck. There is a landscape in a black frame at the left background and a classical bust over the open door at the right.

Literature:
W. von Bode, "Die Ausstellung von Gemälde älterer Meister im Berliner Privatbesitz," in *Jahrbuch der Preussischen Kunstsammlungen*, vol. 4 (1883), p. 209; Valentiner (1924), p. 274; *National Gallery Trafalgar Square* (London, 1929), p. 258, nr. 2143; Gerson, *Thieme-Becker*, vol. 25 (1931), p. 556; Plietzsch (1937), p. 368, fn. 3; *Illustrations: Continental Schools, London National Gallery* (London, 1937), p. 252; Bénézit, *Dictionnarie*, vol 6 (1953), p. 404; *London National Gallery, Plates: The Dutch School* (London, 1958), p. 235; N. MacLaren, *London National Gallery: The Dutch School* (London, 1960), p. 278, nr. 2143; Plietzsch (1960), p. 65, fn. 1; *The National Gallery, Illustrated General Catalogue* (London, 1973), p. 525, nr. 2143; C. Brown, *The National Gallery Lends Dutch Genre Painting* (London, 1978), p. 18, nr. 10.

96. Lady at the Virginals (Fig. 108)

Canvas, 49 × 39 cm., c. 1676–80.
Present location unknown.

Provenance: Collection Duchesse F. Melzi d'Eril de Lodi; Melzi d'Eril de Lodi Sale, Brussels (Le Roy), April 29–30, 1920, nr. 76; Paul Hartog Sale, Berlin (Graupe), June 25–26, 1934, nr. 21; Dr. J. von Bleichröder Sale, Berlin (Lepke), May 31, 1938, nr. 162; Sale, Galerie Heuschen, Wuppertal, October 6, 1954.

Notes: The woman (whose profile appears to have been retouched) is a close variant of the figure in *The Music Lesson* (cat. nr. 95; Fig. 107). The music teacher in that painting, however, is replaced here by a young Moor—a motif that appears in none of Ochtervelt's other works. Whether this figure is original or overpaint cannot be determined from a photograph. The small scale and unusually close framing of the figure suggest that the work may be a fragment. A description in the catalogue of the Hartog Sale (1934) includes the following color observations: "junge Frau in dunkelrosa Atlasseidegewand nach rechts an einem Spinett stehend. . . . Neben dem Spinett auf einem Stuhl ein vorherrschend blauer Knüpfteppich. Im Dunkel des Hintergrundes die Figur eines Mohren."

Literature:
Plietzsch (1937), p. 368, fn. 3; Plietzsch (1960), p. 65, fn. 1.

97. Violinist and Lady at the Virginals (Fig. 109)

Canvas, 89 × 73.5 cm., ca. 1676-80.
Kunsthaus Heylshof, Worms.

Provenance: Julius Böhler, Munich, 1916.

Notes: The standing woman is a reverse repetition of the figure in the London *Music Lesson* (cat. nr. 95; Fig. 107). The same pink satin dress with gold trimmings appears in cat. nrs. 94-96; Figs. 105, 107, 108. The violinist wears a gray cape, a dark gray jacket with pale gray sleeves, and tan trousers and stockings; the woman behind him is dressed in black. On the background wall is a large landscape tapestry painted in tones of brown. The surface of the painting has been rubbed and abraded throughout; narrow strips have been added at the top, bottom, and right sides, probably to make the painting fit its present frame.

Literature:
Gerson, *Thieme-Becker*, vol. 25 (1931), p. 556; G. Swarzenski, *Die Kunstsammlung im Heylshof zu Worms* (Frankfurt am Main, n.d.), p. 14, nr. 43, pl. XXIV; Plietzsch (1937), p. 368, fn. 1; Bénézit, *Dictionnaire*, vol. 6 (1953), p. 404; Plietzsch (1960), p. 65, fn. 1.

98. The Faint (Fig. 110)

Signed and dated 1677, lower left.
Canvas, 72 × 84 cm.
Museum Ca' d'Oro, Venice, nr. 183.

Provenance: Molin Bequest.

Notes: Ochtervelt's latest known dated painting, *The Faint* represents an elaboration of a subject the artist had treated in the mid-1660s (cat. nr. 28; Fig. 38; Leipzig). Other representations of the doctor's visit appear in cat. nrs. 27, 32, and 105; Figs. 35, 37, and 116. On the emblematic use of the urine flask in scenes of lovesickness, see notes to cat. nr. 27. The painting is rather obscured by darkened varnish, and the surface has been rubbed, especially in the left background. There is an area of damage and overpaint between the standing maid in the center and the kneeling woman in the foreground, whose hair appears to have been retouched. The fainting woman lies upon a dark brown quilt and wears a white satin dress with gold embroidery and a pale orange jacket. At her feet is an orange quilt. Beside her is a woman in a pale blue-lavender satin dress trimmed with gold; the maid at the right wears a brown blouse with dark blue cuffs. The table carpet is bright red-orange with touches of dark blue and yellow.

Literature:
Wurzbach, vol. 2 (1910), p. 249; T. von Frimmel, "Der wiedergefundene Ochtervelt im Wiener Nationalmuseum," *Studien und Skizzen zur Gemäldekunde* 5 (1920-21), p. 173; T. von Frimmel, "Kunstgeschichtliche Nachrichten aus Venedig," in *Von alter und neuer Kunst* (Vienna, 1922), p. 59; Valentiner (1924), p. 274; *Catalogo, La R. Galleria Giorgio Franchetti alla Ca' d'Oro* (Venice, 1929), p. 179; Gerson, *Thieme-Becker,* vol. 25 (1931), p. 556; Plietzsch (1937), p. 372; G. Fogolari, *La Galleria Giorgio Franchetti alla Ca' d'Oro di Venezia* (Rome, 1950), p. 19; Plietzsch (1960), p. 66; N. MacLaren, *London National Gallery: The Dutch School* (London, 1960), p. 277.

99. The Sleeping Soldier (Fig. 111)

Canvas, 83 × 66 cm., c. 1678-80.
Nationalmuseum, Stockholm, nr. 688.

Provenance: Collection Gustav III.

Notes: Previously attributed to Ter Borch and to Johannes Voorhout, this painting illustrates the uneven quality typical of Ochtervelt's latest style. It is possible, however, that the extremely awkward head of the woman holding the mirror is the result of damage and overpainting. This figure wears a rose-colored satin dress with pale pink undersleeves; the standing woman (whose face is abraded on the right side) has a pale yellow satin bodice and a blue skirt or apron; the sleeping officer wears a metal cuirass, a tan coat with purple cuffs, red trousers, and black boots; and the trumpeter has a metal cuirass and brown coat. The gray map on the background wall is too sketchily rendered to permit identification.

The same subject of a sleeping soldier being awakened by a trumpeter was used in an early tavern scene of about 1660-63 (cat. nr. 15; Fig. 26) and in another late work of about 1678-80 (cat. nr. 100; Fig. 112). (For the sources and interpretation of this theme, see notes to cat. nr. 15.)

Literature:
Gustav III:s saml., enl. bouppteckningen (1792), p. 126, nr. 260, as "Dutch School" (included in F. Sander, *Nationalmuseum, Bidrag till Tafelgalleriets Historia* [Stockholm, 1872-75], vol. 2, unpaged); *Kungl. Musei nederländska och tysa malningssaml., enl. C. F. Fredenheims bevarade ritningar fran 1795,* nr. 145, as Ter Borch (included in C. Nordenfalk, *Tavelgallerier pa Stockholms slott under senare delen av 1700-talet, i. Nationalmusei handteckningssamling 6,* 1952); O. Sundel, *Kungl. Musei malningssaml. enl. inventarium upprättat* (1816), nr. 93, as J. Voorhout; Wurzbach, vol. 2 (1910), p. 249; *Nationalmusei, Malningssamling Katalog* (Stockholm, 1927), p. 84, nr. 688; *Catalogue descriptif des Collection de Peintures du Musée National, Maîtres étrangers*

(Stockholm, 1928), p. 113, nr. 688; Gerson, *Thieme-Becker*, vol. 25 (1931), p. 556; Bénézit, *Dictionnaire*, vol. 6 (1953), p. 404; *Aldre utländska Malningar och Skulpturer, National-museum* (Stockholm, 1958), p. 145, nr. 688.

100. The Sleeping Soldier (Fig. 112)

Canvas, 82.5 × 67 cm., c. 1678-80.
Ronald Cook, London.

Provenance: Collection Alfred Zweig, New York; Sale, New York (Sotheby Parke Bernet, Inc.), January 13, 1978, lot 6.

Notes: This painting, of which one copy is known (cat. nr. 100-A; Fig. 113), is similar in style and subject to Ochtervelt's *Sleeping Soldier* in Stockholm (cat. nr. 99; Fig. 111). The same theme appears in an early tavern scene of about 1660-63 (cat. nr. 15; Fig. 26). (On the sources and interpretation of the subject, see notes to cat. nr. 15.)

100-A. The Sleeping Soldier (copy) (Fig. 113)

Canvas, 84 × 67 cm.
Musée Communal, Verviers, Belgium, nr. E. 214.

Provenance: Hohenzollern Sale, Berlin (Lepke), May 13, 1890, nr. 30; Hanzeur Collection.

Notes: Listed in earlier literature as an Ochtervelt, this painting must be classified as a literal but rather crudely painted copy after a late Ochtervelt (cat. nr. 100; Fig. 112) that recently surfaced in the art trade.

Literature:
Gerson, *Thieme-Becker*, vol. 25 (1931), p. 556; *Musée Communal de Verviers, Catalogue II, Peinture* (Verviers, 1943), pp. 16-17, nr. 127; Bénézit, *Dictionnaire*, vol. 6 (1953), p. 404.

101. The Concert (Fig. 114)

Canvas, 84 × 70 cm., c. 1680.
Present location unknown.

Provenance: Comte de Bousies Sale, Paris (Charpentier), March 24, 1953, nr. 53; Sale, Paris (Charpentier), June 6, 1958, nr. 11; Sale, London (Sotheby), January 19, 1966, lot 136 (to Ansdell); Sale, Amsterdam, (P. Brandt), November 5-8, 1958, nr. 102; B. Cohen Gallery, London; Galleria Giorgio Caretto, Turin.

Exhibitions: Galleria Giorgio Caretto, Turin, October 27-November 20, 1970, nr. 55.

Notes: Aside from the fact that the three figures at the right are in poor condition and show signs of crude retouching, the quality of the painting as a whole is extremely low. The harsh lighting, weak painting technique, and incoherent rendering of space and design are typical of Ochtervelt's style of about 1680 (cf. cat. nrs. 102, 105, and 106; Figs. 115-117). The artist's proclivity to reuse motifs from earlier works is especially evident here and contributes to the pastiche-like appearance of the painting. The woman at the left is a standing variant of the seated lutenist in the Bentinck *Musical Company in a Rotunda* (cat. nr. 84; Fig. 96), from which the woman seated behind the table is also derived. The man at the right foreground is a close variant (with changes of costume and hairstyle) of the flutist in the Hermitage *Concert in a Garden* (cat. nr. 83; Fig. 94).

102. Musical Company Around a Table (Fig. 115)

Canvas, 83.5 × 66.5 cm., c. 1680.
Dayton Art Institute, Dayton, Ohio, nr. 60.9.

Provenance: Lichnowski Collection; P. Cassirer, Amsterdam, 1927-28; Galerie Fleischmann, Munich, 1929-30; B. Mont, New York, 1950; Newhouse Galleries, New York, 1955; Collection Jefferson Patterson (gift to museum, 1960).

Notes: Similar in style and costume to *The Concert* (cat. nr. 101; Fig. 114). Here again, the crowded, elaborate composition and the hard technique date the work near the end of the artist's career, as does the use of classicizing sculptural motifs (see cat. nrs. 105 and 106; Figs. 116 and 117). On the mantelpiece are two helmeted marble putti, perhaps intended as a piquant parallel to the merrymaking soldiers in the interior. The dog in the foreground is a self-quotation from Ochtervelt's *Music Lesson* in London (cat. nr. 95; Fig. 107), while the seated woman at the right is an adaptation of the singer in his Hermitage garden scene of 1674 (cat. nr. 83; Fig. 94). The lutenist wears a white satin dress, while the singer beside her is dressed in pink. The soldiers wear brown costumes with gold embroidery at the sleeves. The cape of the violinist in the foreground is bright red; the tablecloth is dark blue.

Literature:
Pantheon 6 (August, 1930): iii (ill.); Plietzsch (1937), p. 368, fn. 3; *Burlington Magazine* 97 (August 1955): v (ill.); *The Dayton Art Institute Annual Report*, 1959-60, ill. inside cover, p. 10, nr. 60.9; Plietzsch (1960), p. 65, fn. 1.

103. The Fish Seller (Fig. 135)

Canvas, 74 × 83 cm., c. 1680.
Pushkin Museum, Moscow, nr. 635.

Provenance: "Monplaisir," Peterhof, until 1882; The Hermitage, Leningrad, until 1924.

Notes: Earlier depictions of entrance halls with fish vendors appear in cat. nrs. 41 and 55; Figs. 123 and 132. Both the condition and quality of the painting are poor. The crowded figural grouping, incoherent design, and weak painting technique are characteristic of Ochtervelt's faltering style at about 1680 (cf. cat. nrs. 101 and 102; Figs. 114 and 115). In its present (uncleaned) state, the painting has a rather monochromatic effect. The man at the left wears a dark blue coat, the peasants are dressed in dark brown, and the kneeling maid wears black (?). The standing maid has a reddish-brown costume with a white collar, and the lady at the right is dressed in white satin with gold embroidery.

Literature:
G. F. Waagen, *Die Gemäldesammlung in der kaiserlichen Ermitage zu St. Petersburg nebst Bemerkungen über andere dortige Kunstsammlungen* (Munich, 1864), p. 367, nr. 1768; A. Somof, *Ermitage Impérial, Catalogue de la Galerie des Tableaux, Écoles néerlandaises et École Allemande* (St. Petersburg, 1901), p. 265, nr. 1768; Bénézit, *Dictionnaire*, vol. 6 (1953), p. 404; *Catalogue, Pushkin Museum*, in Russian (Moscow, 1957), p. 106, nr. 635.

104. Portrait of a Boy with Bird's Nest (Fig. 162)

Signed, lower left, c. 1680.
Canvas, 31 × 27 cm.
Present location unknown.

Provenance: Dr. Benedict, Berlin, 1928; Otto Weszner Sale, Lucerne (Fischer), December 7-11, 1949, nr. 3357.

Notes: The long lace cravat and knee-length waistcoat worn by the sitter point to a date of about 1680. In addition, this compositional format (a three-quarter-length figure leaning against a parapet with landscape in the background) became popular in Dutch portraiture after around 1675 (cf. Nicolaes Maes, *Portrait of a Man*, signed and dated 1677, Wallraf-Richartz-Museum, Cologne, nr. 1391; Willem van Mieris, *Portrait of Admiral Tromp*, signed and dated 1686, Candamo Sale, Paris, December 14, 1933, nr. 37).

The bird's nest (occupied here by four fledglings), which the boy holds in his left hand and points to with his right, is a motif that appears occasionally in other representations of children by 17th-century Dutch artists. Ochtervelt himself had included a bird's nest in his early children's portrait of 1660 (cat. nr. 12; Fig. 147).

Pieter van Slingeland's undated *Portrait of Johannes Meerman and His Family,* in the Louvre (nr. MN 2886), also shows the young daughter holding and pointing to a bird's nest, even though the scene is set in an interior (ill., R. Edwards, *Early Conversation Pieces* [London, 1954], p. 95, fig. 40). In the Accademia Carrara in Bergamo are two small, undated pendant paintings by Jacob Backer: *A Little Girl with a Flower Garland* (nr. 575) and *A Little Boy with a Bird's Nest with Eggs and Fledglings* (nr. 576) (ill., K. Bauch, *Jakob Adriaensz. Backer* [Berlin, 1926], cat. nrs. 107 and 82). In these examples, the motif may have been intended as an allusion to the youth and vulnerability of the children who have not yet left the protection of the familial "nest."

Interestingly enough, nests with young birds also appear in pastoral paintings by artists of the Utrecht School such as Paulus Moreelse's *Two Shepherdesses with Bird's Nest* (Earl of Darnley Sale, London [Christie], May 1, 1925, nr. 52) and Gerrit van Honthorst's *Shepherdess with Young Doves in a Nest,* dated 1622, Centraal Museum, Utrecht, nr. 150. In this context Judson has related the motif to Ripa's emblem of Innocence (*Iconologia*, 1603, p. 225) and has pointed out that the Honthorst shepherdess gazes flirtatiously at the viewer while protecting the young birds with her right hand (J. R. Judson, *Gerrit van Honthorst* [The Hague, 1959], cat. nr. 134, pl. 23). For further discussion of birds as erotic symbols in Dutch genre painting, see E. de Jongh, "Erotica in vogelperspectief. De dubbelzinnigheid van een reeks 17de eeuwse genrevoorstellingen," *Simiolus* 2 (1968-69): 22-74.

Literature:
Weltkunst, vol. 17, nrs. 11-12 (March 14, 1943), p. 2 (ill.).

105. The Doctor's Visit (Fig. 116)

Canvas, 84.5 × 69 cm., c. 1680-82.
Bayerischen Staatsgemäldesammlungen, Munich (on loan to Aachen Museum).

Provenance: Sale, Vienna (Posonyi), April 5, 1881, nr. 22; Collection de Beurnonville; Reulting Sale, New York (Anderson Gallery), November 4-5, 1925, nr. 61; Böhler, Lucerne, 1943; Hitler Collection, Linz, 1943-45; Munich Collecting Point, nr. 2792.

Notes: Other depictions of the doctor's visit are seen in cat. nrs. 27, 32, and 98; Figs. 35, 37, and 110. The subject of the fainting woman also appears in cat. nrs. 28 and 98; Figs. 38 and 110. The idea of lovesickness, frequently suggested in scenes involving a young female patient, is conveyed here by the placement of a classical sculpture of a nude male in a niche behind the unconscious

woman. A similar classical backdrop is found in cat. nr. 106; Fig. 117.

The left background and right foreground (under the chair) have been abraded, and there is damage around the forehead and right eye of the woman standing beside the patient. The painting is extremely colorful: the kneeling woman wears a brilliant red satin dress trimmed with gold and kneels on a purple velvet cushion; the patient has a pale gray satin dress with gold embroidery and a lavender silk jacket; and the woman at her shoulder wears a brown-violet velvet jacket and a light brown satin skirt. The woman at the far right wears dark brown or black, and the chair in the foreground is purple silk with a yellow fringe.

106. The Last Testament (Fig. 117)

Canvas, 75 × 85.7 cm., c. 1682.
Schloss Grünewald, Berlin, nr. 145.

Provenance: W.v. Grondesteyn Sale, Rotterdam (Buurt), March 30, 1758, nr. 60; Potsdamer Stadtschloss, 1810; Königliche Schlösser, Berlin, 1820; Gemäldegalerie, Berlin Museum, 1829–1906.

Notes: According to the catalogue of 1964 (p. 109): "wahrscheinlich identisch mit dem 1698 im Schloss Köpenick erwähnten Bild 'Eine sterbenden Frau unterschreibt ihr Testament.'" The painting was once attributed to Lairesse and indeed is the closest to his style of all of Ochtervelt's works—not only in the classical trappings in the background but also in the friezelike compositional arrangement. A similar background with a curtain pulled to reveal a full-length antique sculpture on a pedestal appears in E. H. van der Neer's *Woman Playing a Theorbo*, dated 1678, Alte Pinakothek, Munich (ill., *Holländische Malerei des 17. Jahrhunderts, Alte Pinakothek* [Munich, 1967], pl. 94).

The surface of the painting is rubbed and badly abraded throughout. The woman at the far left has pale gray sleeves, a white apron, and mustard skirt; beside her is a woman in a violet satin bodice, a dark blue-green apron, and a gray skirt. The standing lady in the center wears a pale pink satin dress with gold embroidery and a dark green satin apron. The dying woman lies upon a red, yellow, and green striped couch with a lavender and blue quilt over her legs; she wears a white dress embroidered with gold flowers and a yellow veil. The man at the far right is dressed in a lavender coat and stockings. The pulled curtain above the figures is dark mustard yellow. The unusual subject of this work obviously relates to the artist's depictions of fainting women and doctors' visits (cat. nrs. 27, 28, 32, 98, and 105; Figs. 35, 38, 37, 110, and 116).

Literature:
G. F. Waagen, *Verzeichnis der Gemälde-Sammlungen des Königlichen Museums zu Berlin* (Berlin, 1832), p. 122, nr. 490; J. Meyer, *Königliche Museen, Gemälde-Galerie*, Berlin, 1878), p. 189, nr. 509 (as G. de Lairesse); J. Meyer, *Königliche Museen, Gemälde-Galerie* (Berlin, 1883), p. 321, nr. 509 (as Ochtervelt); F. D. O. Obreen, *Archief voor Kunstgeschiedenis* (Rotterdam), vol. 5 (1883–84), p. 317, fn. 1; W. von Bode, *Beschreibendes Verzeichnis der Gemälde* (Berlin, 1898), p. 424, nr. 509; *Bryan's Dictionary of Painters and Engravers*, ed. G. C. Williamson (London, 1904), vol. 4, p. 32; *Katalog Schloss Grünewald* (Berlin, 1933), p. 17; Plietzsch (1937), p. 372; Plietzsch (1960), p. 66; *Die Gemälde im Schloss Grünewald* (Berlin, 1964), p. 109, nr. 145.

Part II: Paintings of Disputed Attribution

Part II of the catalogue includes copies after lost originals, as well as paintings whose attribution to Ochtervelt should be questioned. As in the catalogue of authentic works, copies or variants have also been included (and illustrated) and are listed by letter after the catalogue number to which they relate.

In preparing any catalogue, one faces the problem of determining sensible limits for the amount of marginal material worth including. When the subject is an artist like Ochtervelt, whose *oeuvre* has not previously been catalogued, the writer's dilemma becomes more acute. Nearly always, it is the less familiar figure whose name is conveniently tagged to pictures of uncertain authorship. Thus, in the case of problematic attributions, only paintings that have entered the literature under Ochtervelt's name have been included in this study. Exceptions have been made, however, for three previously published works that can be classified as copies after lost originals (cat. nrs. D-1, D-1A, and D-2).

D-1. Merry Company with Soldiers in a Garden (Fig. 165)

Canvas, 124 × 103 cm.
Present location unknown.

Provenance: J. Goudstikker, Amsterdam; Stichting Nederlands Kunstbezit, 1950, inv. nr. 1285.

Notes: Known only through a photograph in the Rijksbureau voor Kunsthistorische Documentatie, The Hague (neg. 14618). An accompanying notation states that the painting was in the Dutch State Art Collection in 1950; it is not, however, presently listed (at least under Ochtervelt) in the files of the Dienst Verspreide Rijkscollecties, The Hague.

The painting is similar in subject, costume, and setting to Ochtervelt's Italianate garden scenes of the mid-1650s (cat. nrs. 5 and 6; Figs. 11 and 14), in which exactly the same figure types are used. In fact, the flutist at the left is a close variant of standing male figures seen from the back in cat. nrs. 4, 5, and 7; Figs. 10, 11, and 16. The painting technique, however, is much too harsh and dry for Ochtervelt, indicating that this must be a copy after a lost garden scene of about 1655. A second copy after the same lost original is listed as cat. nr. D-1A; Fig. 166.

D-1A. Merry Company with Soldiers in a Garden (Fig. 166)

Canvas, 124 × 103 cm.
Present location unknown.

Provenance: Gebr. Douwes, Amsterdam, December 1929; Sporia Collection, Vienna.

Notes: Known only through a photograph in the Rijksbureau voor Kunsthistorische Documentatie, The Hague (neg. 115937). This work is a cruder copy of the same lost original from which cat. nr. D-1; Fig. 165 is also derived.

D-2. Two Soldiers, Woman and Maid (Fig. 167)

Canvas, 75.6 × 74.4 cm.
Private collection, Cologne, West Germany.

Provenance: Duits Gallery, London; Galleria Giorgio Caretto, Turin, Italy.

Notes: Either a copy after a lost Ochtervelt or a pastiche. The same costumes worn by the soldier and the seated woman in the foreground are repeated in *The Tease* of about 1675 (cat. nr. 86; Fig. 100). And yet the extremely

simplified setting is reminiscent of early interiors painted around 1655-60 (cat. nrs. 7-11; Figs. 16, 18, 19, 22, 23). The figure at the left is a close variant of the standing maid in Ochtervelt's *Musical Company in a Garden* of about 1655 (cat. nr. 6; Fig. 14).

D-3. Four Musicians (Fig. 168)

Canvas, 73.7 × 71.9 cm.
Alexander Gebhardt Galerie, Munich.

Provenance: Collection Victor de Steurs; De Steurs Sale, London (Christie), November 26, 1965, lot 38.

Notes: According to the 1965 catalogue of the De Steurs Sale, the painting was once in the Bos de Harlingen Collection and was included in the Bos de Harlingen Sale (Amsterdam, Muller, February 21, 1888. However the Harlingen catalogue (Lugt nr. 47093) only lists one Ochtervelt (nr. 119) that can be identified as *Tric-trac Players*, Private collection, West Germany (cat. nr. 43, Fig. 49).

The attribution of this painting is highly problematic, for the work has been extensively damaged and overpainted, especially the background and the two figures in the center. The composition lacks coherence, and the quality of painting is poor except for the sleeve and hand of the seated soldier and the violin and hands of the musician at the right, which are executed with great delicacy. The figures are definitely close to Ochtervelt's style of the mid-1670s. Indeed, the lutenist and violinist are close variants of corresponding figures in his *Musical Company in a Rotunda* of about 1674 (cat. nr. 84; Fig. 96). The colors are also characteristic of Ochtervelt. The lutenist wears a dark yellow-tan dress with a white apron; the woman in the center wears a white satin dress trimmed with pale pink ribbons; the soldier has a gray metal cuirass, dark yellow sleeves with gold highlights, and lavender-gray trousers; and the violinist has a metal cuirass, dark yellow sleeves, a bright red cape, and dark brown boots. Although the painting in its present state has the look of a pastiche or a copy, it is probably an original (but badly damaged) Ochtervelt of the mid-1670s.

Literature:
Manuscript catalogue, De Steurs Collection, 1915, nr. 194.

D-4. Girl with Dog (Fig. 169)

Canvas, 18 × 17 cm.
National Gallery of Ireland, Dublin, nr. 641.

Provenance: Presented to museum by Sir Walter Armstrong, 1912.

Notes: The painting has been much damaged and retouched, especially the faces of the girl and the spaniel, as well as the background. The gesture of the figure is meaningless, and her pose is rather awkward, but her facial type is characteristic of Ochtervelt's style (of the late 1660s), as is the vivid pink satin dress and the artist's manner of defining the figure's legs beneath the drapery. Because of its tiny size and rather clumsy composition, the painting may be an extensively reworked fragment of an originally larger work, either by Ochtervelt or by a later imitator.

Literature:
Catalogue of Pictures and Other Works of Art in the National Gallery of Ireland (Dublin, 1914), p. 115, nr. 641; *Catalogue . . . National Gallery of Ireland* (Dublin, 1920), p. 88, nr. 641; Bénézit, *Dictionnaire*, vol. 6 (1953), p. 404; *Catalogue of the Paintings, National Gallery of Ireland* (Dublin, 1971), p. 117, nr. 641.

D-5. Musicians in a Niche (Fig. 170)

Canvas, 59 × 49.5 cm.
California Palace of the Legion of Honor, San Francisco, nr. 1933.8.

Provenance: Gift to museum of Archer M. Huntington.

Exhibitions: John Herron Art Museum, Indianapolis, Indiana, "Dutch Paintings of the 17th Century," February 27–April 11, 1937, nr. 49; Schaeffer Galleries, San Francisco, "Paintings by Dutch Masters," May 1939, nr. 8.

Notes: There is a curious technical (and possibly stylistic) disparity between the foreground figures and the woman at the left in this composition. The two women (crudely painted and rather awkwardly fitted into the composition) are strongly reminiscent of Ochtervelt's faltering style at the beginning of the 1680s (cf. cat. nrs. 101, 102, 105, and 106; Figs. 114-117), but the foreground man and woman (painted in a far more delicate and refined style) are less characteristic of Ochtervelt's style in both costume and facial types. Either the painting should be attributed to a Leiden artist working about 1680 (with overpainted additions at the left in the style of Ochtervelt), or perhaps this is a genuine (albeit unusual) late Ochtervelt that has been crudely retouched at the left. The left side of the work is in fact damaged. A similar niche enframement with pulled curtain appears in Ochtervelt's signed *Cavalier and Maid in a Niche* of about 1675 (cat. nr. 88; Fig. 72).

Literature:
California Palace of the Legion of Honor: Illustrated Handbook of the Collections (San Francisco, 1944), pp. 32 (ill.), 111, nr. 1933.8; *Bulletin of the California Palace of the Legion of Honor*, vol. 3 (August, 1945), p. 46.

D-6. Merry Company at a Table (Fig. 171)

Canvas, 46.5 × 46.5 cm.
North Carolina Museum of Art, Raleigh, nr. 62.

Provenance: E. Bolton, London; Bottenwieser Gallery, London; Collection Martin A. Reyerson, Chicago; Chicago Art Institute.

Exhibitions: Chicago Art Institute, "A Century of Progress," 1933, nr. 69; High Museum of Art, Atlanta, Georgia, "Painting and Sculpture: Gothic to Surrealism," January 8–February 5, 1950, nr. 22; Wadsworth Atheneum, Hartford, Connecticut, "Life in 17th-Century Holland," November 21, 1950–January 14, 1951, nr. 37; Wilmington Society of Fine Arts, Wilmington, Delaware, "17th-Century Dutch Masters," May 6–June 17, 1951, nr. 26; Musée de Bordeaux, "L'Europe et la Découverte du Monde," May 20–July 31, 1960, nr. 26; Museum of Fine Arts, St. Petersburg, Florida, "Inaugural Exhibition," February 7–March 7, 1965, nr. 58; Museum of Fine Arts, Boston, "The Age of Rembrandt," 1966, nr. 87; William Rockhill Nelson Gallery, Kansas City, Missouri, "Paintings of 17th-Century Dutch Interiors," December 1, 1967–January 7, 1968, nr. 16.

Notes: Although this painting has invariably been attributed to Ochtervelt in the literature, its subject matter has more in common with him than its style. The composition lacks Ochtervelt's characteristic angular rhythm, the even lighting differs from his usual chiaroscuro, and the figure types are unlike those in his genuine works. The ambiguous spatial intervals and marked discrepancies in scale among the figures suggest that the work may be a pastiche, probably derived from Vermeer. The left portion of the scene with the seated man is strikingly reminiscent of Vermeer's *Coquette*, in Braunschweig, while the seated woman in the foreground can be related to a similar figure in Vermeer's *Lady and Gentleman Drinking*, in Berlin. Despite its decorous mood, this is probably a brothel subject rather than a domestic interior. The attitude of the standing man implies that he is arranging, with the "procuress" at the left, an assignation with the young woman at the right. The man's hand, prominently placed between the two female figures, is somewhat damaged, suggesting that he once held a coin.

Literature:
Bulletin of the Art Institute of Chicago, vol. 17 (1923), pp. 25–28; Valentiner (1924), p. 269; Gerson, *Thieme-Becker*, vol. 25 (1931), p. 556; *A Guide to Paintings in the Permanent Collection, Chicago Art Institute* (Chicago, 1932), inv. nr. 23.10, p. 24 (ill.); Plietzsch (1937), p. 369; A. B. de Vries, *Jan Vermeer van Delft* (London, 1948), p. 52, pl. XXVI; W. R. Valentiner, *Catalogue of Paintings, North Carolina Museum of Art* (Raleigh, 1956), p. 51, nr. 62, pl. 62; Plietzsch (1960), p. 67; B. F. Williams, "À Raleigh, Carolina du Nord," *L'Oeil*, nr. 155 (November, 1967), p. 6.

D-7. The Proposal (Fig. 172)

Canvas, 46.8 × 38.4 cm.
Staatliche Kunsthalle, Karlsruhe, West Germany, nr. 262.

Provenance: Comte de Vence Sale, Paris (Remy), February 9, 1761, nr. 52; Collection Vidame d'Amiens, 1962; Collection Margravine Karoline Luise.

Notes: A painting of impressive quality, the Karlsruhe *Proposal* was attributed to Ter Borch until the late 19th century and was engraved, as a Ter Borch, by Pierre-François Basan (Le Blanc, *Manuel de l'Amateur d'Estampes*, vol. 1 [1854], p. 198, nr. 374). The sensitive psychological interpretation of the couple—particularly the face of the man at the right—does recall Ter Borch, but Gudlaugsson could not include the work within Ter Borch's *oeuvre*. An attribution to Ochtervelt is, however, equally unsatisfactory, for neither these costumes nor these figure types are found in any of his other works. The simplified treatment of surfaces is very different from Ochtervelt's insistence on rich material textures, and the rather geometric definition of forms (for example, the sphere-like head, tubular bodice, and block-like knees of the young lady) is uncharacteristic of his style. A. B. de Vries has suggested (in conversation) that the painting may even be 18th century: possibly an 18th-century imitator of Ter Borch. Three copies or variants after this painting are known (cat. nrs. D-7A, D-7B, and D-7C; Figs. 173– 175.

Literature:
J. D. Descamps, *La Vie des Peintres flamands* (Paris), vol. 2 (1754), p. 128 (as Ter Borch); *Description du Cabinet de M. le Comte de Vence* (Paris, 1760), p. 24 (as Ter Borch); J. Smith, *A Catalogue Raisonné of the Works of the Most Eminent Dutch, Flemish and French Painters* (London), vol. 4 (1833), p. 118, nr. 5 (as Ter Borch); L. Viardot, "Le Musée de Carlsruhe," *Gazette des Beaux Arts* 17 (1864/II): 147 (as Ter Borch); K. Woermann and A. Woltmann, *Geschichte der Malerei* (Leipzig), vol. 3 (1888), pt. 2, p. 840 (as Ochtervelt); Wurzbach, vol. 2 (1910), pp. 249, 702, nr. 12 (as Ochtervelt); H. Mireur, *Dictionnaire des Ventes d'Art* (Paris), 7 (1912), p. 161 (as Ochtervelt); C. Hofstede de Groot, *Beschreibendes und kritisches Verzeichnis der Werke der hervorragendsten holländischen Maler des XVII. Jahrhunderts* (Esslingen a N), vol. 5 (1912), p. 149, fn. 2 (as Ochtervelt); H. W. Singer, "Der Vierfarbendruck in der Gefolgschaft Jacob Christoffel Le Blons," *Monatschefte für Kunstwissenschaft* 10 (1917): 284, nr. 59, pl. 44; Valentiner (1924), p. 274 (as Ochtervelt); *Katalog der badischen Kunsthalle Karlsruhe* (Berlin, 1929), p. 93, nr. 262 (as Ochtervelt); G. Kircher, *Karoline Luise von Baden als Kunstsammlerin, Schilderungen und Dokumente zur Geschichte der Badischen Kunsthalle in Karlsruhe* (Karlsruhe, 1933), p. 133, nr. 60; p. 212, nr. 15 (as Ochtervelt); Plietzsch (1937), p. 364 (as Ochtervelt); K. Martin, *Jacob Burckhardt und die Karlsruher Galerie* (Karlsruhe, 1941), p. 157 (as Ochtervelt); W. Bernt, *Die Niederlänischen Maler des 17. Jahrhunderts* (Munich, 1948), vol. 2, nr. 611 (as Ochtervelt); K. E. Simon, review of Bernt, *Zeitschrift für Kunstgeschichte*

16 (1953): 79 (as C. de Bisschop); J. Lauts, *Meisterwerke der Staatlichen Kunsthalle Karlsruhe* (Karlsruhe, 1957), p. 45, nr. 262, pl. 68 (as Ochtervelt); *Holländischen Meister Karlsruhe* (Karlsruhe, 1960), nr. 29 (as Ochtervelt); Plietzsch (1960), p. 67, fn. 2 (as Ochtervelt); J. Lauts, *Katalog Alte Meister Staatliche Kunsthalle Karlsruhe*, 2 vols. (Karlsruhe, 1966), 1: 231, nr. 262 (as Ochtervelt); 2 (Plates): 390, nr. 262.

D-7A. The Proposal (Fig. 173)

Canvas, 55 × 43 cm.
Present location unknown.

Provenance: Marquise d'Aoust Sale, Paris (Petit), June 5, 1924, nr. 57; Sale, London (Christie), July 26, 1968, nr. 90.

Notes: Falsely signed and dated "Metsu 1658." According to Gudlaugsson, it was sold in Amsterdam, July 17, 1775, nr. 3 (as Ter Borch). In this excellent copy after the painting attributed to Ochtervelt in the Staatliche Kunsthalle, Karlsruhe (cat. nr. D-7; Fig. 172), the woman's bodice is lower, the position of her head is slightly changed, and the scene has been extended by several centimeters at the right.

Literature:
S. J. Gudlaugsson, *Gerard Ter Borch* (The Hague, 1959), vol. 2, p. 279, nr. D 26 (as a copy after the "Ochtervelt" in Karlsruhe).

D-7B. The Proposal (Fig. 174)

Dimensions and material of support unknown.
Present location unknown.

Provenance: Collection Louise Stupka von Eisenlohr, Freienwaldau, 1942.

Notes: Known only through a photograph in the Rijksbureau voor Kunsthistorische Documentatie, The Hague (neg. L 35216). In this copy after the painting attributed to Ochtervelt in Karlsruhe (cat. nr. D-7; Fig. 172), the technique is quite hard, contrasts of light and shadow are sharpened, and the scene has been cropped by several centimeters at the left.

D-7C. Woman Reading and Servant (Fig. 175)

Canvas, 45.7 × 37.3 cm.
National Museum, Warsaw, nr. 915.

Provenance: Sapieha Collection, Paris; State Art Collection, the Royal Castle, Warsaw, until 1945.

Exhibitions: Szépművészeti Múzeum, Budapest, "Holland mestermüvek a XVII. századbol," 1967, nr. 43.

Notes: A variant after *The Proposal*, attributed to Ochtervelt, in the Staatliche Kunsthalle, Karlsruhe (cat. nr. D-7; Fig. 172). The bed canopy has been shifted to the right background and changed from a circular to a rectangular shape, and the seated man at the table has been replaced with the standing figure of a young male servant, who carries a pitcher and basin. Instead of the writing implements placed on the table in the Karlsruhe painting, this artist has included a different grouping of objects, several of which (the extinguished candle, the mirror, and the watch) have *Vanitas* associations. Similar objects appear in a number of Ter Borch's boudoir scenes (cf. Gudlaugsson, *Ter Borch*, vol. 1, figs. 110, 111, 112, and 124).

Literature:
J. Michalkowa, *Holanderskie i flamandzkie malarstwo rodzajowe XVII w.*, Muzeum Narodowe w Warszawie (Warsaw, 1955), nr. 38; *Malarstwo Europejskie Katalog, Muzeum Narodowe Warszawie* (Warsaw, 1967), vol. 2, p. 21, nr. 915; *Catalogue of Paintings, Foreign Schools, National Museum of Warsaw* (Warsaw, 1970), vol. 2, nr. 915.

D-8. The Faint (Fig. 176)

Canvas, 61 × 49 cm.
Rheinisches Landesmuseum, Bonn, nr. 201.

Provenance: Kaiser-Friedrich Museum, Berlin, 1904–09; Wesendonk Collection, Bonn.

Notes: Falsely signed Jan Steen, lower left. The Bonn *Faint* has usually been given to Ochtervelt in the literature, but its attribution to him has also been rightly questioned. Plietzsch originally rejected it in 1914, although he later placed it within Ochtervelt's *oeuvre* (1937, 1960). Hofstede de Groot suggested an attribution to Metsu or Samuel van Hoogstraten (HdG notes, RKD), and Gerson (1931) listed the work as a disputed attribution. Comparison of the painting to Ochtervelt's three versions of the same theme (cat. nrs. 28, 98, and 105; Figs. 38, 110, and 116) reveals marked differences in the choice of figure types, handling of drapery, and painting technique. The rather crude application of paint and the lack of spatial clarity suggest that the Bonn painting may be a copy, perhaps after Metsu, to whom it seems closer in style.

Literature:
W. Cohen, "Die Sammlung Wesendonk," *Zeitschrift für bildenden Kunst* 21 (1910): 64 (as Ochtervelt); W. Cohen, *Katalog der Gemäldegalerie des Provinzialmuseums in Bonn* (Bonn, 1914), nr. 201 (as Ochtervelt); E. Plietzsch, review of Cohen catalogue, *Cicerone* 6 (1914): 668 (rejects Ochtervelt attribution); W. Cohen, *Provinzialmuseum in Bonn, Katalog der Gemäldegalerie* (Bonn, 1927), p. 99 (as Ochtervelt); Gerson, *Thieme-Becker*, vol. 25 (1931), p. 556 (as Ochtervelt?); M. Goering, "Neuerwerbungen niederländischen Gemälde des 17. Jahrhunderts im Bonner Landesmuseum," *Pantheon* 22 (August 1938): 242 (as Ochtervelt); Plietzsch (1960), p. 66 (as Ochtervelt).

D-9. Artist with a Woman Student (Fig. 177)

Canvas, 72.5 × 59 cm.
Rheinisches Landesmuseum, Bonn, nr. 37.50.

Provenance: Berlin art trade, c. 1929.

Notes: Goering (1938) accepts this work as an early Ochtervelt, while Plietzsch (1960) places it with the artist's late paintings. It has, however, little in common with Ochtervelt's works of any period in subject or in style. The loose painting technique, the treatment of faces, and the choice of subject recall Johannes Voorhout (see also cat. nr. D-10; Fig. 178).

Literature:
M. Goering, "Neuerwerbungen niederländischen Gemälde des 17. Jahrhunderts im Bonner Landesmuseum," *Pantheon* 22 (August 1938): 242 (color ill.); F. Rademacher, *Rheinisches Landesmuseum im Bonn, Verzeichnis der Gemälde* (Bonn, 1959), p. 34 (ill.); Plietzsch (1960), p. 66.

D-10. Still Life with a Woman at an Easel (Fig. 178)

Signed, lower right, "J. voorh . . ."
Canvas, 48.5 × 40.3 cm.
Worcester Art Museum, Worcester, Massachusetts, nr. 1923.209.

Provenance: Sale, Amsterdam (A. Mak), April 12, 1921, nr. 84; J. Walsham Sale, London (Christie), March 16, 1923, nr. 47; E. Bolton, London, 1923; purchased by the museum in 1923 from Paul Bottenwieser, Berlin.

Exhibitions: Kleinberger Galleries, New York, and Detroit Institute of Art, "Dutch Masters Sponsored by the College Art Association," 1931-32.

Notes: Attribution of the Worcester painting to Ochtervelt was based on a misreading of the partially illegible signature on the table edge at the lower right as "J. Ochtervelt." The corrected attribution to Johannes Voorhout was published for the first time in the Worcester catalogue of 1974.

Literature:
Valentiner (1924), pp. 269, 274; *Worcester Art Museum Annual Report* (1924), pp. 16, 33, nr. 16; *Worcester Art Museum Bulletin*, vol. 16, nr. 1 (April 1925), p. 6; Gerson, *Thieme-Becker*, vol. 25 (1931), p. 556; W. R. Valentiner, "Dutch Painting in Fine Exhibit at Kleinberger's," *Art News*, vol. 30, nr. 5 (October 31, 1931), p. 7; *Worcester Art Museum, Guide to the Collections* (Worcester, 1933), p. 86; Plietzsch (1937), p. 372; Bénézit, *Dictionnaire*, vol. 6 (1953), p. 404; *European Paintings in the Collection of the Worcester Art Museum* (Worcester, 1974), vol. 1, pp. 148-49 (as Johannes Voorhout).

D-11. The Peach (Fig. 179)

Canvas, 42.5 × 39 cm.
Private collection, London.

Provenance: Buckley Sale, Paris (Kleinberger), May 4, 1901, nr. 108; Collection Adolph Schloss, Paris; Schloss Sale, Paris (Charpentier), May 25, 1949, nr. 44; Eugene Slatter, London.

Exhibitions: Eugene Slatter, London, "Dutch and Flemish Masters," May 10-June 8, 1950, nr. 7.

Notes: When Hofstede de Groot viewed the Schloss Collection in Paris in 1922, he noted that this painting was "voluit gemerkt. 1675 gedateerd" (HdG notes, RKD). The Slatter catalogue of 1950 also mentions that the painting is "signed in full." Neither a signature nor a date is visible today.

Although this work has been ignored in almost all of the Ochtervelt literature, Plietzsch (1960) has specifically related it to two Ochtervelt paintings of the early 1670s: *The Nursery* (cat. nr. 73; Fig. 84) and *Lady and Maid Choosing Fish* (cat. nr. 67; Fig. 137). Despite certain similarities in the choice of compositional motifs, there are also strong differences in style. In the London interior the application of paint is broader and less precise than Ochtervelt's technique; the figures seem squatter and more shortened than even Ochtervelt's late figure types; and the drapery does not strongly define the underlying forms of the body. Furthermore, the even continuous lighting is quite different from Ochtervelt's selective chiaroscuro. The composition and theme of the painting are reminiscent of Pieter de Hooch's *Woman Offering Fruit to a Child*, Museum der bildenden Künste, Leipzig (ill., W. R. Valentiner, *Pieter de Hooch*, (Klassiker der Kunst [Stuttgart, 1929], p. 90).

Literature:
Illustrated London News, May 13, 1950, p. 755; Plietzsch (1960), p. 67.

D-12. Woman at Her Toilet (Fig. 180)

Canvas, 35 × 33 cm.
Nationalmuseum, Stockholm, nr. 657.

Provenance: Unknown.

Notes: According to the 1928 catalogue of the museum, the painting has a false (illegible) signature and an authentic date of 1640 at the lower left. The 1958 catalogue states that the painting is dated 1660. Evaluation of this work is complicated because the face and hair of the seated woman appear to have been overpainted. In composition, subject, and lighting, this painting can be related to Ochtervelt's boudoir scenes of

the early 1670s (cf. *Lady and Maid*, cat. nr. 80; Fig. 93). However, the rather bland surfaces, the flattened face of the standing maid, and the handling of drapery (in short broken folds, rather than in long continuous curves following the body contours) suggest that this may be a copy or a later variant of a lost Ochtervelt.

Literature:
O. Sundel, *Kungl. Musei malningssaml., enl. invenatrium upprättat* (Stockholm, 1816), p. 93, nr. 443 (as Ter Borch), included in Fredrik Sander's *Nationalmuseum, Bidrag till Tafelgalleriets Historia* (Stockholm, 1872-75), vol. 4 (unpaged); Wurzbach, vol. 2 (1910), p. 249 (as Ochtervelt); *Catalogue descriptif des Collection de Peintures du Musée National, Maîtres étrangers* (Stockholm, 1928), pp. 112-13, nr. 657 (as Ochtervelt); Gerson, *Thieme-Becker*, vol. 25 (1931), p. 556 (as Ochtervelt); Bénézit, *Dictionnaire*, vol. 6 (1953), p. 404 (as Ochtervelt); *Äldre Utländska Malningar och Skulpturer, Nationalmuseum* (Stockholm, 1958), p. 145, nr. 657 (as Ochtervelt).

D-13. Musical Interior (Fig. 181)

Canvas, 50 × 41 cm.
Nationalmuseum, Stockholm, nr. 659.

Provenance: Collection Lovisa Ulrika.

Notes: Only the musical subject matter and the lighting recall Ochtervelt. The thin figure types with their sloping shoulders and large eyes are completely different from his style.

Literature:
O. Sundel, *Kungl. Musei malningssaml., enl. inventarium upprättat Stockholm* (Stockholm, 1816), p. 94, nr. 451 (as Uyterveld), included in Fredrik Sander, *Nationalmuseum, Bidrag till Tafelgalleriets Historia* (Stockholm, 1872-75), vol. 4 (unpaged); *Catalogue descriptif des Collection de Peintures du Musée National, maîtres étrangers* (Stockholm, 1928), p. 113, nr. 659 (as Ochtervelt); Gerson, *Thieme-Becker*, vol. 25 (1931), p. 556 (as Ochtervelt); *Äldre Utländska Malningar och Skulpturer, Nationalmuseum* (Stockholm, 1958), p. 145, nr. 659 (as Ochtervelt).

D-14. Offering the Glass of Wine (Fig. 182)

Canvas, 37 × 31 cm.
Present location unknown.

Provenance: Kellner Collection, Vienna; Kellner Sale, Berlin (Lepke), December 3, 1929, nr. 13.

Notes: Plietzsch mentions the exaggerated poses and almost caricatured mood of this scene, but he attributes it to Ochtervelt on the basis that the artist used "unnatural" poses in other works, such as *The Embracing Cavalier* of about 1660-63 (cat. nr. 14; Fig. 25). Comparison of the two works reveals few similarities, however,

for the Kellner painting lacks Ochtervelt's characteristic chiaroscuro, and the composition is much simpler and more stable than the oblique designs favored in his interiors of the early 1660s. Although the pose of the male figure is somewhat similar to that of the gentleman in Ochtervelt's *The Visit* of about 1675, (cat. nr. 85; Fig. 99), the lighting, the facial types, and the furnishings of the interior are quite different and do not support an attribution of this problematic work to Ochtervelt.

Literature:
"Vorschau auf die Herbstversteigerungen," *Kunst und Kunstler* vol. 28, pt. 2 (1930), p. 86 (ill.); Plietzsch (1937), p. 368; Plietzsch (1960), p. 68.

D-15. Woman at the Mirror (Fig. 183)

Panel, 33 × 26.5 cm.
Musée d'Art et d'Histoire, Geneva, nr. CR 295.

Provenance: Musée Ariana, Geneva; G. Revilliod Bequest.

Notes: Gudlaugsson has correctly identified this work as a copy after Ter Borch's *Woman at the Mirror*, formerly in the De Bruyn Collection (ill., *Ter Borch*, vol. 1, p. 243, nr. 83).

Literature:
G. Sidler, *Catalogue officiel du Musée Ariana* (Geneva, 1900), p. 155, nr. 24 (as Ter Borch); Gerson, *Thieme-Becker*, vol. 25 (1931), p. 556 (as Ochtervelt); Bénézit, *Dictionnaire*, vol. 6 (1953), p. 404 (as Ochtervelt); L. Hautecoeur, *Catalogue de la Galerie des Beaux Arts Geneva* (Geneva, 1948), p. 13 (as "after Ter Borch"); S. J. Gudlaugsson, *Gerard Ter Borch* (The Hague, 1959), vol. 2, p. 101, nr. 83-a (as a copy after Ter Borch).

D-16. The Drinkers (Fig. 184)

Panel, 29 × 25.5 cm.
Bayerischen Staatsgemäldesammlungen, Munich.

Provenance: Zweibrücker Galerie; Gemäldegalerie, Schloss Schleissheim.

Notes: Neither the subject nor the style of this work bear any relationship to Ochtervelt's paintings. Seymour Slive (in conversation) has pointed out its connections to late 17th-century genre painting in Leiden and its strong similarities to the style of Bartholomaus Maton (cf. W. Bernt, *The Netherlandish Painters of the Seventeenth Century* [London and New York, 1970], vol. 2, nr. 742).

Literature:
Katalog der Gemälde-Galerie im K. Schlosse zu Schleissheim (Munich, 1905), pp. 174-75, nr. 816 (as Ochtervelt); Wurz-

bach, vol. 2 (1910), p. 249 (as Ochtervelt); *Katalog der königlichen Gemäldegalerie zu Schleissheim* (Schleissheim, 1914), pp. 178–79, nr. 3816 (as Ochtervelt); Bénézit, *Dictionnaire*, vol. 6 (1953), p. 404 (as Ochtervelt).

D-17. Lutenist and Woman Drinking Wine (Fig. 185)

Panel, 37 × 32 cm.
Staatliche Kunstsammlungen, Dessau, nr. 120.

Provenance: Unknown.

Notes: The subject of this painting is reminiscent of Ochtervelt's scenes of feasting or drinking couples shown in three-quarter length, painted during the late 1660s (cf. cat. nrs. 36 and 37; Figs. 40 and 42). The style of the work, however, seems closer to Jan Verkolje, in the elaborate detailing of the woman's costume, the tight application of paint, and the rather hard edges of the drapery folds.

Literature:
Führer durch die Anhaltische Gemälde-Galerie (Dessau, 1929), p. 48, nr. 120; Gerson, *Thieme-Becker*, vol. 25 (1931), p. 556; Bénézit, *Dictionnaire*, vol. 6 (1953), p. 404.

D-18. Mother and Children Before a Fireplace (Fig. 186)

Canvas, 39.5 × 36 cm.
Offentliche Kunstsammlungen, Basel, nr. 928.

Provenance: Hans VonderMühll Bequest, 1914.

Notes: The bland treatment of surfaces, the static lighting, and the facial types seen in this work are not characteristic of Ochtervelt, nor is the horizontal emphasis of the design. The painting may instead be related to the circle of Samuel van Hoogstraten, who painted similar domestic scenes of mothers and children during his later years (cf. *Lady and Maid with Cradle*, signed and dated 1670. Springfield Museum of Art, Springfield, Massachusetts; *Mother with Cradle*, Sale, London (Christie), February 7, 1950, nr. 31).

Literature:
Katalog Öffentliche Kunstsammlungen Basel (Basel, 1926), p. 94, nr. 928; Gerson, *Thieme-Becker*, vol. 25 (1931), p. 556; Bénézit, *Dictionnaire*, vol. 6 (1953), p. 404.

D-19. Woman in an Interior (Fig. 187)

Canvas, 52 × 46 cm.
Present location unknown.

Provenance: Goldschmidt Collection, Vienna; S. B. Goldschmidt Sale, Vienna (Schwarz), March 11, 1907, nr. 35; Liechtenstein Collection, Vienna, nr. 905.

Notes: Neither the pasty application of paint nor the type of room furnishings depicted here supports an attribution to Ochtervelt. Gudlaugsson (in conversation) kindly pointed out that similar wall decorations appear in late interior scenes by Samuel van Hoogstraten. The lack of focus and unity in this crowded composition suggest that the work may be a pastiche.

Literature:
A. Kronfeld, *Führer durch die Fürstlich Liechtensteinsche Gemäldegalerie in Wien* (Vienna, 1927), p. 183, nr. 905; Gerson, *Thieme-Becker*, vol. 25 (1931), p. 556.

D-20. Lutenist and Boy with a Dog (Fig. 188)

Canvas mounted on panel, 52 × 46 cm.
Cincinnati Art Museum, Cincinnati, Ohio, nr. 1946.97.

Provenance: Scott and Fowles, New York; Mary Hanna Collection, Cincinnati (gift to museum, 1946).

Notes: The delicate and highly detailed execution of this fine work point to late 17th-century genre painting in Leiden. The soft lighting (which does not model the forms in depth as in Ochtervelt's works) and the sweet facial expressions are similar to the style of Pieter van Slingeland. (On the emblematic meaning of the dancing dog motif, see notes to cat. nr. 56; Fig. 54.)

Literature:
News of the City Art Museum, Cincinnati, nr. 2, February 1946, p. iii.

D-21. Letter Writer and Maid (Fig. 189)

Canvas, 95 × 79.5 cm.
Present location unknown.

Provenance: Collection Norman Forbes Robertson, London, Robertson Sale, London (Christie), May 19, 1911, nr. 116; B. Thaw Sale, London (Christie), June 24, 1932, nr. 76; F. T. Sabin, London, 1934; P. de Boer, Amsterdam, 1945; Polak Collection, Amersfoort; Munich Collecting Point, nr. 2183.

Exhibitions: F. T. Sabin, London, "Dutch and Flemish 17th-Century Paintings," October 1934, nr. 12; P. de Boer, Amsterdam, "Tableaux Anciens," Summer 1937, nr. 25.

Notes: Although Ochtervelt did paint a number of full-length interiors depicting women with their maidservants (cat. nrs. 73–79; Figs. 84, 86–91), he used different

facial types, worked with more diagonally ordered compositions, and painted with a lighter touch. After viewing the Sabin exhibition in 1934, Hofstede de Groot expressed the opinion that the painting was not by Ochtervelt and seemed closer in style to Jan van Noordt or Cornelis de Man (HdG notes, RKD). A photograph of 1911 in the Rijksbureau voor Kunsthistorische Documentatie, The Hague (neg. L36510), reveals that the jacket of the seated woman was once darker than her skirt: possibly overpaint that has since been removed.

Literature:
L'Art Flamand et Hollandais 15 (November 1911): 149.

D-22. Woman Preparing Vegetables (Fig. 190)

Panel, 37.5 × 28 cm.
The Wawel State Collections of Art, Cracow, Poland, inv. nr. 1121.

Provenance: Collection L. Pininski, Cracow.

Notes: Bialostocki attributed this painting only tentatively to Ochtervelt in his catalogue and included an alternative suggestion of Bega. The most recent attribution of the picture (correspondence, museum, 1978) is to Pieter van den Bosch.

Literature:
J. Bialostocki, *Europäische Malerei in Polnischen Sammlungen* (Warsaw, 1956), nr. 307.

D-23. Letter Reader and Maid (Fig. 191)

Panel, 43 × 34 cm.
Present location unknown.

Provenance: Collection Franco-Chauvegne, Paris; Norbert Fischmann, Munich, 1928.

Exhibitions: Galerie Schaeffer, Berlin, "Die Meister des holländischen Interieurs," April–May, 1929, nr. 66.

Notes: Although the painting is signed "J. Ochtervelt" at the lower left, the script is not in Ochtervelt's hand. Indeed, the costume depicted is not of the 17th century. The crude modeling and chalky highlights suggest that the painting may be a copy, but not after Ochtervelt, since neither the figure types nor the composition reflect his style.

Literature:
A. Scharf, "Die Meister des holländischen Interieurs," *Cicerone* 1 (1929): 223.

D-24. The Love Letter (Bathsheba?) (Fig. 192)

Canvas, 71.5 × 59.5 cm.
Present location unknown.

Provenance: Collection A. H., Vienna; N. Katz Sale, Paris (Drouot), June 15, 1951, nr. 37.

Notes: The elaborate costumes and Roman setting of this scene can be related to Ochtervelt's late, Lairesse-influenced style of about 1680 (cat. nrs. 105 and 106; Figs. 116 and 117), although none of the artist's works includes such a vast and ornate architectural structure. The rough application of paint and chopping drapery folds are, however, completely unlike Ochtervelt's style. Possibly this is a copy after a lost Ochtervelt or should be attributed to another artist working in the circle of Lairesse.

Literature:
"Ein unbekannter Ochtervelt," *Weltkunst* 12 (March 13, 1938): 3.

D-25. Herring Seller in a Niche (Fig. 193)

Panel, 49.5 × 41.5 cm.
Present location unknown.

Provenance: Galerie van Diemen, Berlin, 1923; Sale, Cologne (Lempertz), May 2, 1929, nr. 198; Sale, Munich (Helbing), December 17, 1929, nr. 407; Sale, London (Christie), April 11, 1930, nr. 13; Sale, Munich (Helbing), March 29–30, 1933, nr. 492.

Notes: Signed and dated "J. Ochtervelt 1671" at the lower left. Plietzsch commented on the poor quality of this painting but did not reject it from Ochtervelt's *oeuvre*. The exceptionally weak rendering of the figures and the flat technique clearly preclude an attribution to Ochtervelt. Since neither the costumes nor figure types relate to his style, the painting should probably be considered a falsely signed copy after another artist. (For a close variant of the scene, see cat. nr. D-25A; Fig. 194.)

Literature:
Plietzsch (1937), p. 372; Plietzsch (1960), p. 66.

D-25A. Herring Seller in a Niche (Fig. 194)

Material of support and dimensions unknown.
Present location unknown.

Provenance: Goldschmidt and Wallerstein, Munich, ca. 1933.

Notes: Known only through an old photograph in the Rijksbureau voor Kunsthistorische Documentatie, The Hague (neg. L34663). The painting is signed and dated "J. Ochtervelt 1674" at the bottom center and is a close variant of cat nr. D-25, Fig. 193, except for changes in the costume of the woman at the right. Although equally crude in quality, the two works do not appear to be by the same hand. Neither is close to the style of Ochtervelt.

D-26. Man and Woman at a Table (Fig. 195)

Canvas, 59.4×46.5 cm.
Private collection, London.

Provenance: F. Kleinberger, 1924; W. Cornwallis Sale, Brussels (Fievez), December 19-20, 1924, nr. 122; G. Neumans, Paris, 1927; K. Haberstock, Berlin, 1929; Van Diemen Sale, Berlin (P. Graupe), April 26-27, 1935, nr. 43; C. H. B. Caldwell Sale, London (Sotheby), April 26, 1939, nr. 101; G. Arnst, London, 1939.

Notes: Plietzsch's 1960 discussion of Ochtervelt includes three paintings (cat. nrs. D26-28, Figs. 195-197) that appear to be by the same hand and that the author correctly classifies as being of uncertain authorship. The figure types and costumes and the rather soft, cottony paint texture found in these works are not characteristic of Ochtervelt, but they are very close to the style of Hendrik Verschuuring (cf. Verschuuring, *Woman Playing a Cittern*, signed, Württembergische Staatsgalerie, Stuttgart, nr. 426).

Literature:
Plietzsch (1960), p. 67, fn. 1.

D-27. Violinist and Singer (Fig. 196)

Panel, 49.5 × 36.5 cm.
Present location unknown.

Provenance: Galerie, Duc Pfalz-Zweibrücken, Schloss Karlsberg; Galerie, Schloss Schleissheim; Leo van den Bergh Sale, Amsterdam (Mak van Waay), November 5, 1935, nr. 14 (as Metsu).

Notes: See notes to *Man and Woman at a Table* (cat. nr. D-26; Fig. 195). The painting is falsely signed and dated at the upper right: "Metzue f. 1655."

Literature:
Katalog der Gemälde-Galerie im K. Schlosse zu Schleissheim (Munich, 1905), p. 174, nr. 813 (as Metsu); C. Hofstede de

Groot, *Beschreibendes und kritisches Verzeichnis der Werke der hervorragendsten Holländischen Maler des XVII. Jahrhunderts* (Esslingen a N), vol. 1 (1907), p. 296, nr. 157 (as Metsu); *Katalog der Königlichen Gemäldegalerie zu Schleissheim* (1914), p. 160, nr. 3813 (as Metsu); Plietzsch (1960), p. 67, fn. 1 (as uncertain authorship).

D-28. Woman with Dog (Fig. 197)

Panel, 26 × 20.2 cm.
Present location unknown.

Provenance: Van Ittersum Sale, Amsterdam (Muller), May 14, 1912, nr. 155; Private collection, Heidelberg; Private collection, Stuttgart.

Exhibitions: Staatsgalerie, Stuttgart, "Meisterwerke aus Baden-württembergischem Privatbesitz," October 9, 1958–January 10, 1959, nr. 195 (as Jan Steen).

Notes: See notes to *Man and Woman at a Table* (cat. nr. D-26; Fig. 195).

Literature:
Plietzsch (1960), p. 67, fn. 1 (as uncertain authorship).

D-29. Portrait of an Artist (Fig. 198)

Canvas, 81.5 × 66.5 cm.
Koninklijke Musea voor Schone Kunsten, Brussels, nr. 4659.

Provenance: Galerie Fievez, Brussels, 1927.

Notes: The type of face depicted here, the broad application of paint, and the continuous foreground illumination (which permits only minimal shadow on the face and costume) are quite different from Ochtervelt's style as seen, for example, in his *Self-Portrait* (cat. nr. 30; Fig. 160). Both the facial type and painting technique suggest a relationship to Michiel Sweerts or a member of his circle.

Literature:
Catalogus der oude Schilderkunst, Koninklijke Musea voor Schone Kunsten van Belgie (Brussels, 1959), p. 81, nr. 973 (as Ochtervelt).

D-30. Portrait of a Family (Fig. 199)

Canvas, 85 × 96.7 cm.
Musée des Beaux Arts, Lille, nr. 567.

Provenance: Collection Alex Leleux, 1873; Ryssel Museum, 1893.

Exhibitions: Valenciennes, 1918, nr. 342; Musée des Beaux Arts, Lille, "La Collection d'Alexandre Leleux," May 18–September 30, 1974, nr. 64.

Notes: This friezelike composition with its even lighting bears little resemblance to Ochtervelt's family groups (cat. nrs. 18, 19, 60, 61, and 66; Figs. 150, 152, 154, 156, and 157), in which a more dynamic interaction is created among the figures, their space, and changing intensities of light. Legrand has convincingly attributed this work to the Flemish portraitist and genre painter Egidius van Tilborch, whose works include similar figure types.

Literature:
Jules Lenglart, *Catalogue des Tableaux du Musée de Lille* (Lille, 1893), pp. 201-2, nr. 567 (as Ochtervelt); F. Benoit, *Musée de Lille* (Lille, 1909), vol. 2, nr. 216 (as Ochtervelt); Bénézit, *Dictionnaire*, vol. 6 (1953), p. 404 (as Ochtervelt); Fr. Cl. Legrand, *Les Peintres flamands de genre au XVII^e siècle* (Brussels, 1963), p. 166 (as Tilborch).

PLATES

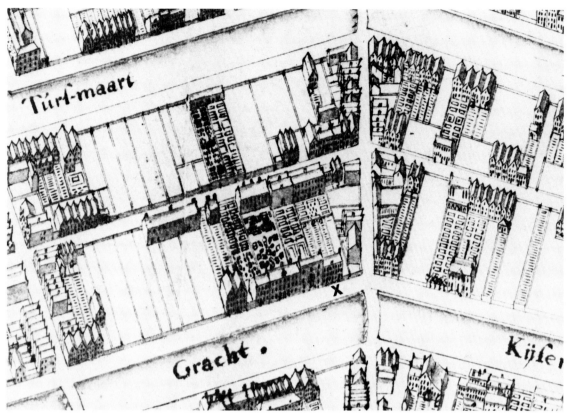

Figure 1. *Detail:* Bird's-eye-view map of Amsterdam, 1679. Collection IJsbrand Kok, Amsterdam. The location of Ochtervelt's house on the Keizersgracht is marked with an X.

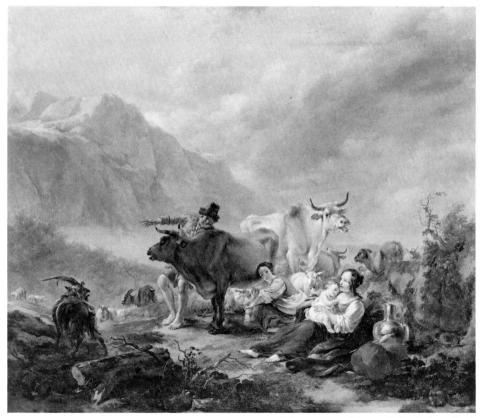

Figure 2. Nicolaes Berchem, *Pastoral Landscape*, 1649. Toledo Museum of Art, Toledo, Ohio. Gift of Edward Drummond Libbey.

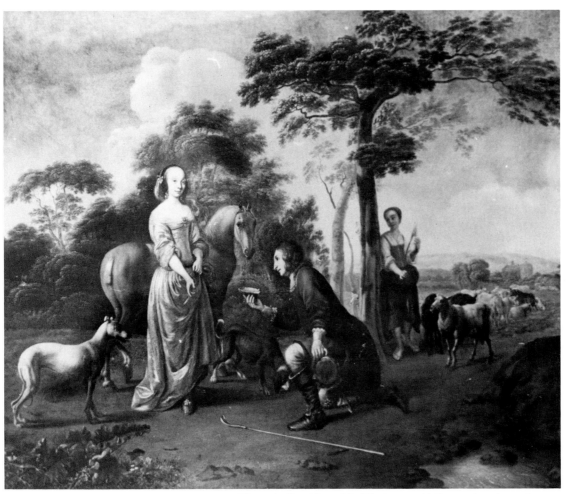

Figure 3. *Granida and Daifilo* (cat. nr. 1). Present location unknown.

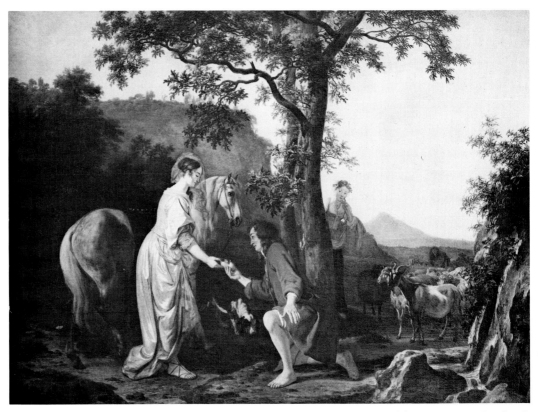

Figure 4. Ludolf de Jongh, *Granida and Daifilo*, 1654. Städtisches Museum, Osnabrück.

112

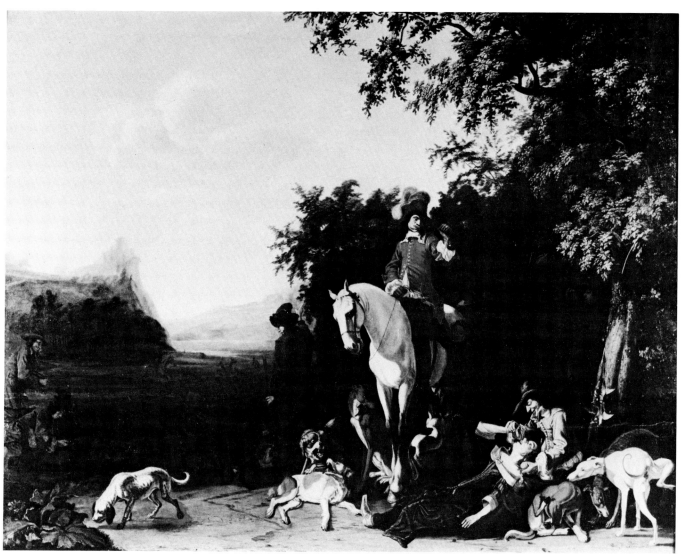

Figure 5. *Hunting Party at Rest* (cat. nr. 2). Present location unknown.

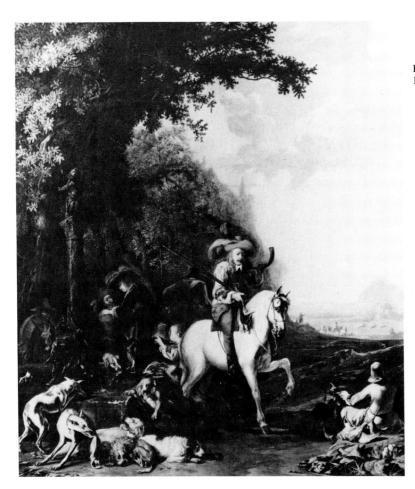

Figure 6. Jan Baptiste Weenix, *Hunting Party at Rest*, 1652. Present location unknown.

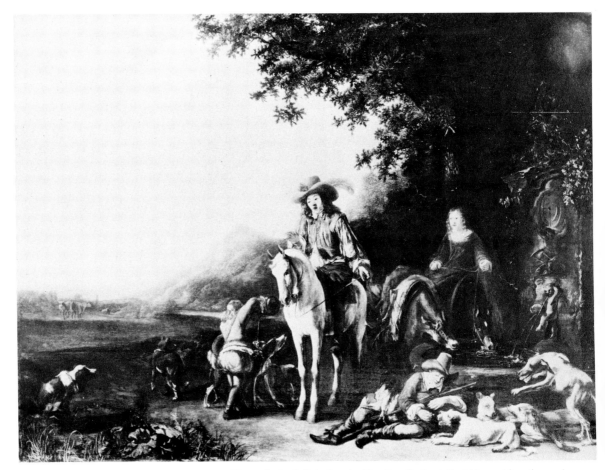

Figure 7. Ludolf de Jongh, *Hunting Party at Rest*. Present location unknown.

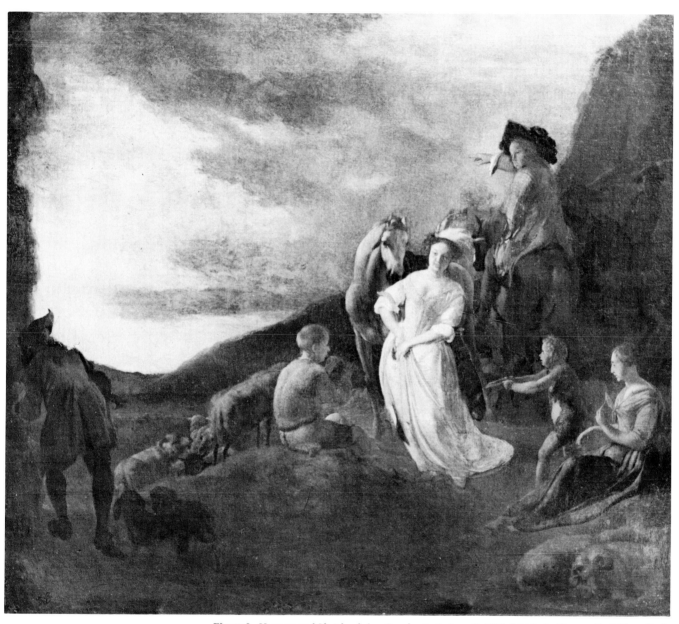

Figure 8. *Hunters and Shepherds in a Landscape* (cat. nr. 3), 1652. Städtische Museen, Karl-Marx-Stadt, East Germany.

Figure 9. Jan Baptiste Weenix, *Erminia and the Shepherds*. Schloss Grünewald, Berlin.

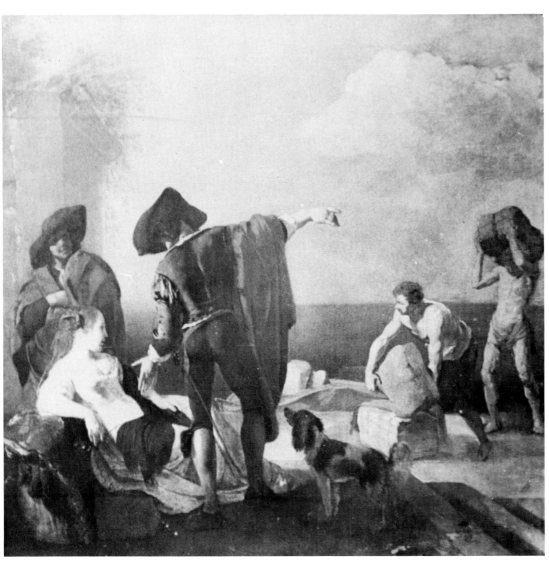

Figure 10. *The Embarkation* (cat. nr. 4). Present location unknown.

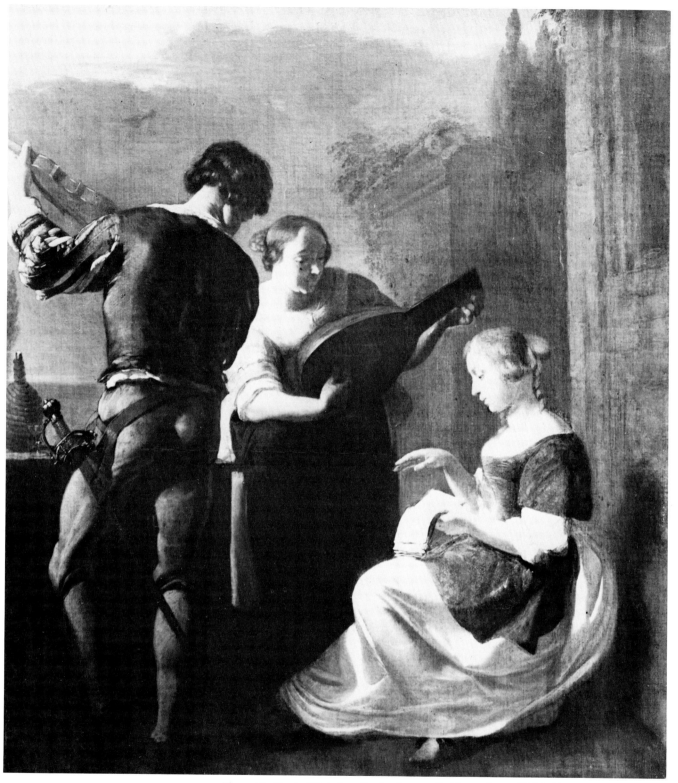

Figure 11. *Musical Trio in a Garden* (cat. nr. 5). Herzog-Anton-Ulrich Museum, Braunschweig.

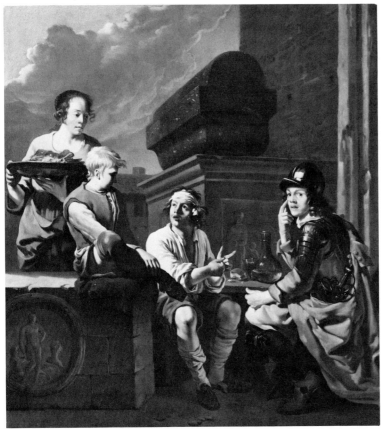

Figure 12. Karel Dujardin, *The Story of the Soldier*. Yale University Art Gallery, New Haven. Leonard C. Hanna, Jr. Fund.

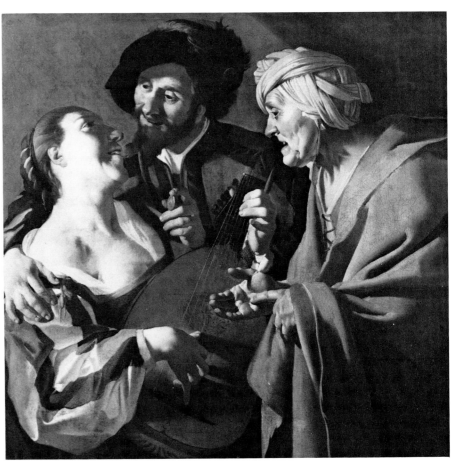

Figure 13. Dirck van Baburen, *The Procuress*, 1622. Courtesy, Museum of Fine Arts, Boston.

118

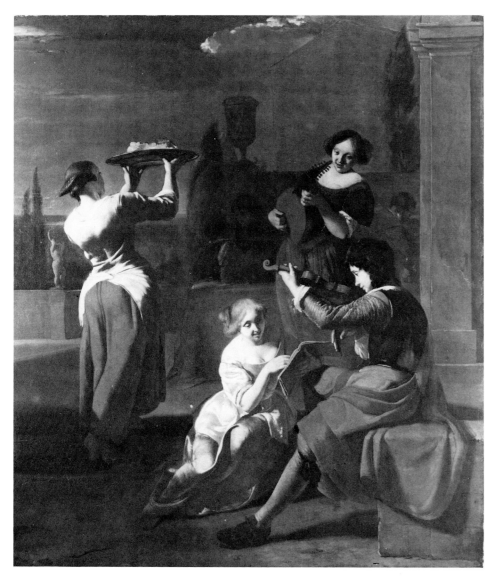

Figure 14. *Musical Company in a Garden* (cat. nr. 6). Douwes Bros., Amsterdam.

Figure 15. *Musical Company in a Garden* (cat. nr. 6-A, copy). Present location unknown.

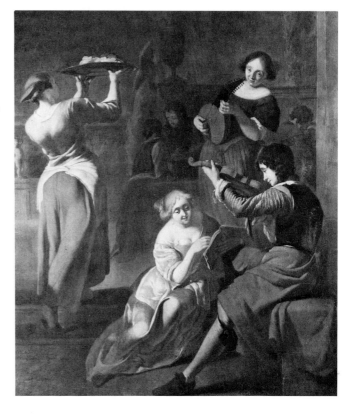

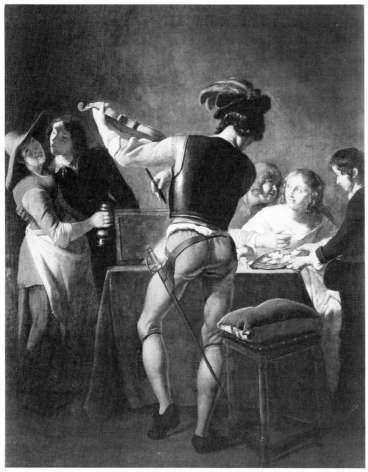

Figure 16. *Merry Company with Violinist* (cat. nr. 7). Collection Walter P. Chrysler, Jr., on loan to Chrysler Museum, Norfolk, Virginia.

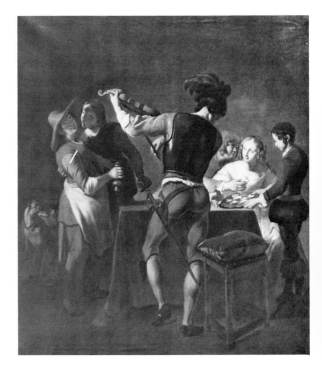

Figure 17. *Merry Company with Violinist* (cat. nr. 7-A, copy). Present location unknown.

120

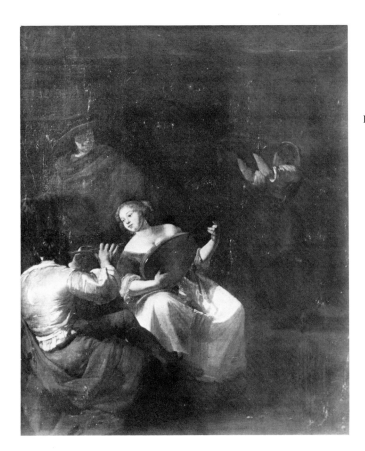

Figure 18. *The Concert* (cat. nr. 8). Present location unknown.

Figure 19. *The Card Players* (cat. nr. 9). Private collection, Amsterdam.

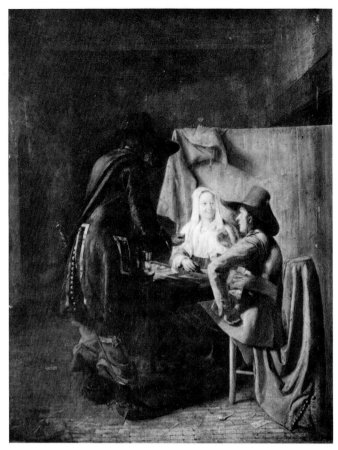

Figure 20. Pieter de Hooch, *Tric-trac Players*. Courtesy of the National Gallery of Ireland, Dublin.

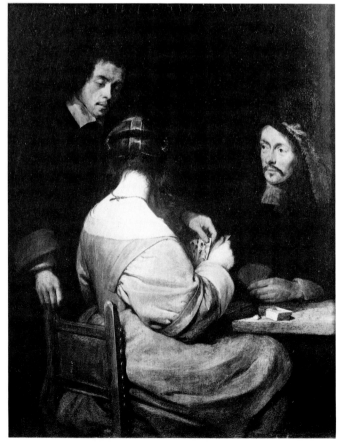

Figure 21. Gerard Ter Borch, *The Card Players*. Oskar Reinhart Collection "Am Römerholz," Winterthur.

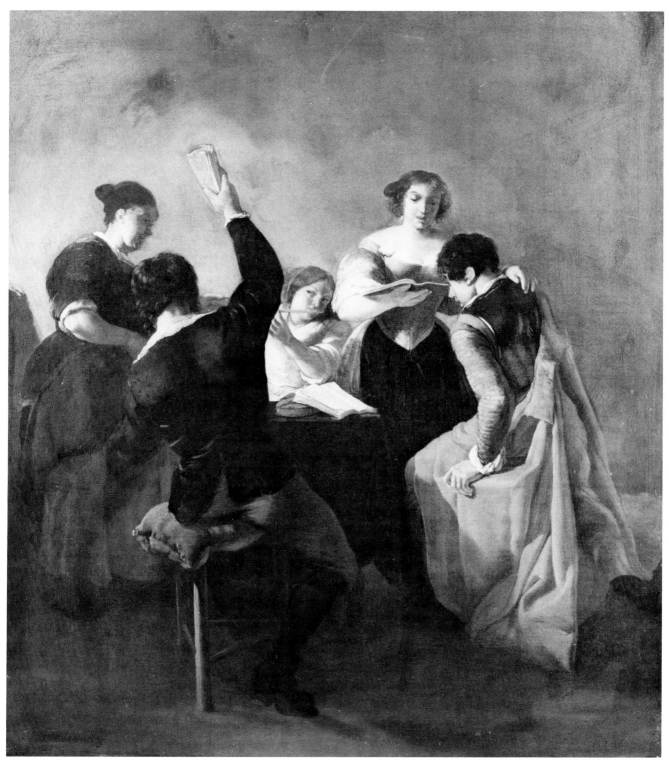

Figure 22. *Musical Company at a Table* (cat. nr. 10). Courtesy of Marie Andrén , Sollebrunn, Sweden.

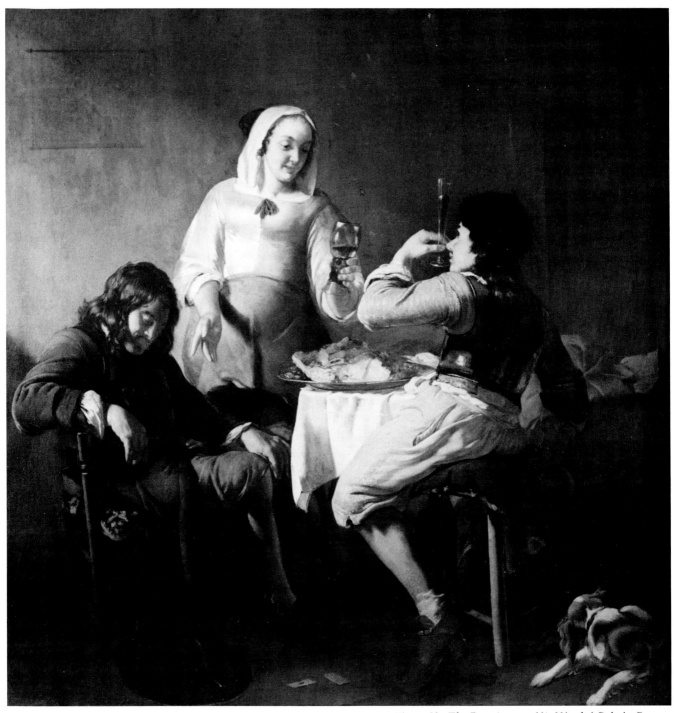

Figure 23. *The Feast* (cat. nr. 11). Národní Galerie, Prague.

Figure 24. Frans van Mieris, the elder, *Soldier and Maid*, 1658. Mauritshuis, The Hague.

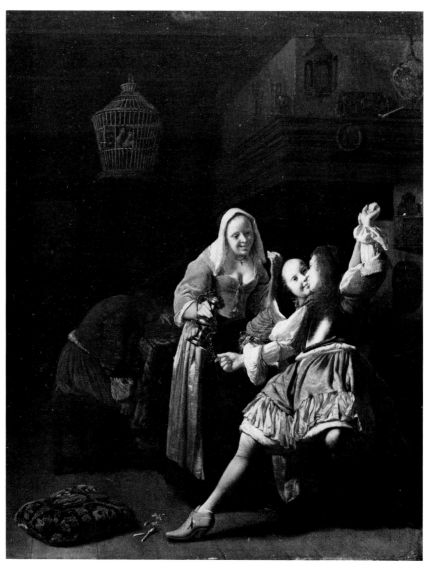

Figure 25. *The Embracing Cavalier* (cat. nr. 14). Courtesy of the Trustees of the Assheton Bennett Collection, Manchester, England. On loan to Manchester City Art Gallery.

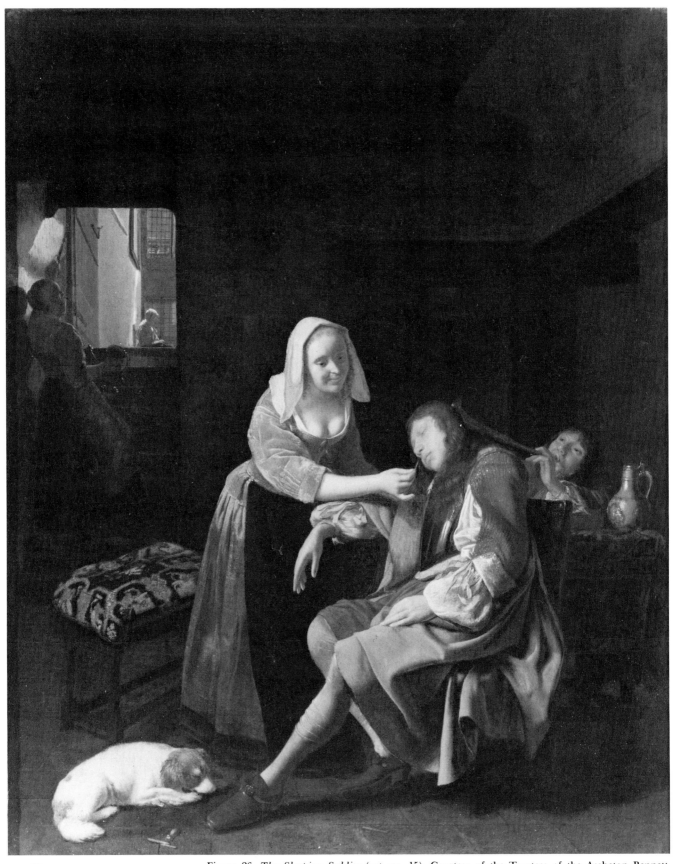

Figure 26. *The Sleeping Soldier* (cat. nr. 15). Courtesy of the Trustees of the Assheton Bennett Collection, Manchester, England. On loan to Manchester City Art Gallery.

126

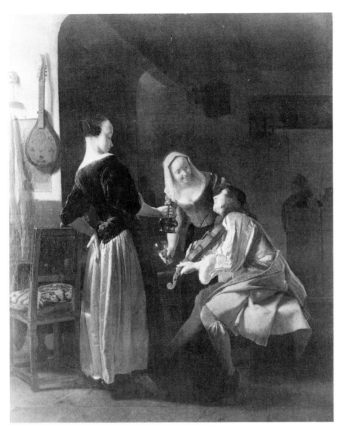

Figure 27. *Violinist and Two Maids* (cat. nr. 20). By permission of Manchester City Art Gallery, Manchester, England.

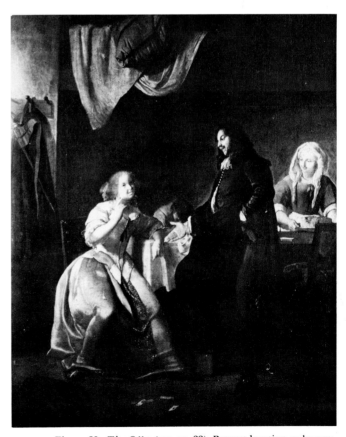

Figure 28. *The Offer* (cat. nr. 22). Present location unknown.

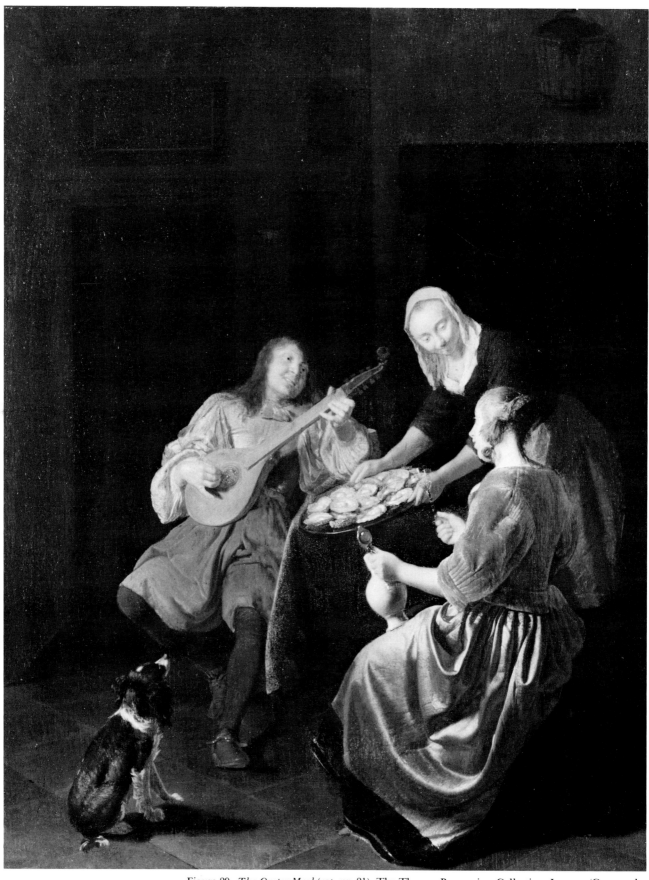

Figure 29. *The Oyster Meal* (cat. nr. 21). The Thyssen-Bornemisza Collection, Lugano/Castagnola.

Figure 30. *The Oyster Meal* (cat. nr. 21-A, copy). Present location unknown.

Figure 31. *The Oyster Meal* (cat. nr. 21-B, copy). Present location unknown.

Figure 32. *The Oyster Meal* (cat. nr. 21-C, copy). Present location unknown.

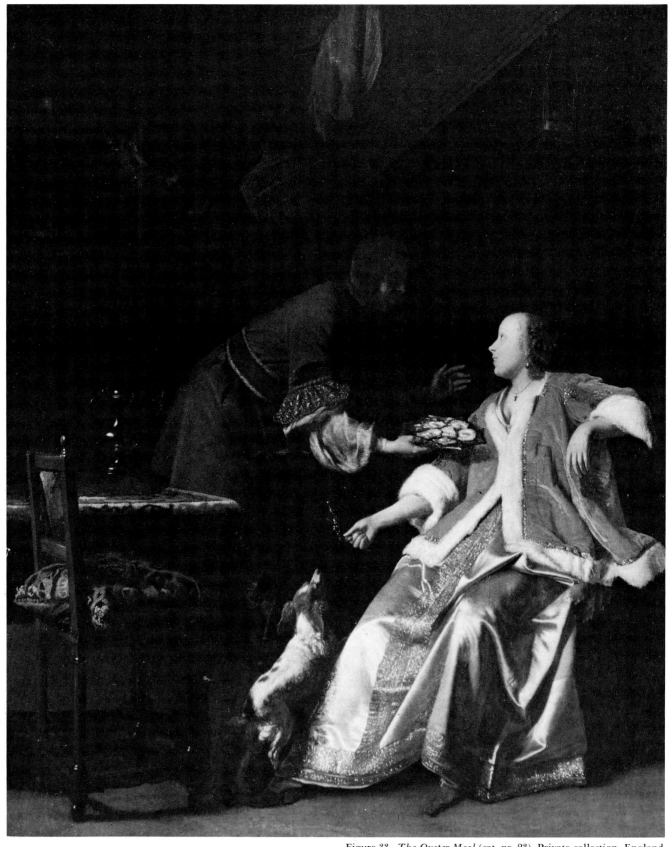

Figure 33. *The Oyster Meal* (cat. nr. 23). Private collection, England.

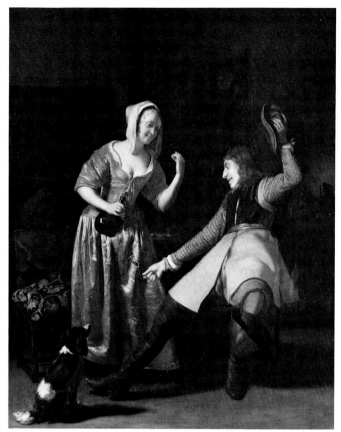

Figure 34. *The Gallant Drinker* (cat. nr. 26). Present location unknown.

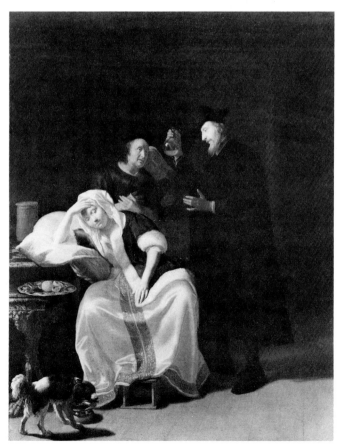

Figure 35. *The Doctor's Visit* (cat. nr. 27). Courtesy of the Trustees of the Assheton Bennett Collection, Manchester, England. On loan to Manchester City Art Gallery

131

AMORVM. 121

Figure 36. Lovesickness emblem. Otto van Veen (Vaenius).
Amorum Emblemata, Antwerp, 1608, nr. 121. By permission
of the Houghton Library, Harvard University, Cambridge.

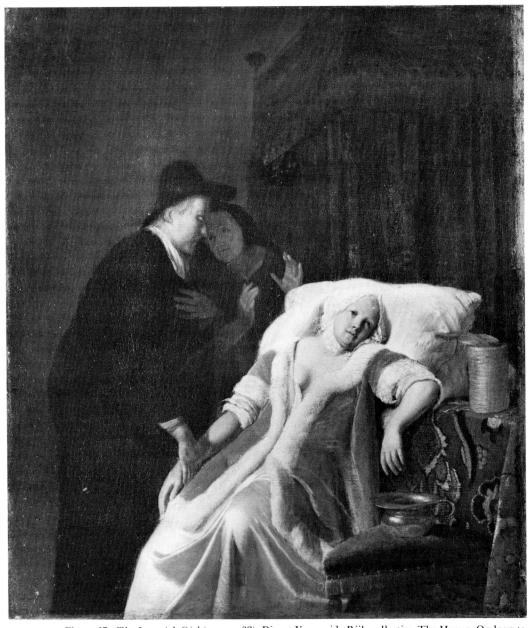

Figure 37. *The Lovesick Girl* (cat. nr. 32). Dienst Verspreide Rijkscollecties, The Hague. On loan to
Embassy Stockholm, P.W.v. Gallery, The Hague.

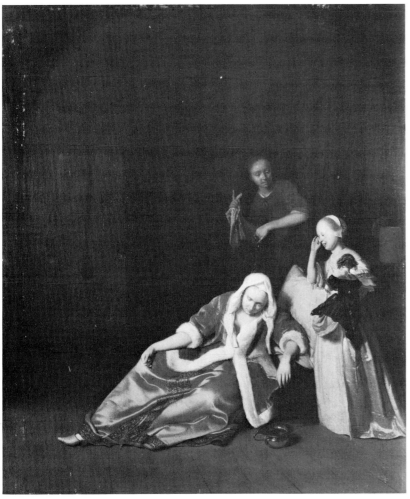

Figure 38. *The Faint* (cat. nr. 28). Museum der bildenden Künste, Leipzig.

Figure 39. Frans van Mieris, the elder, *The Faint*, 1667. Private collection, Paris.

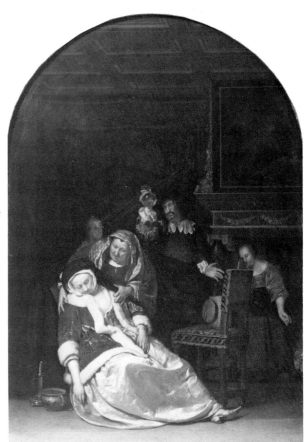

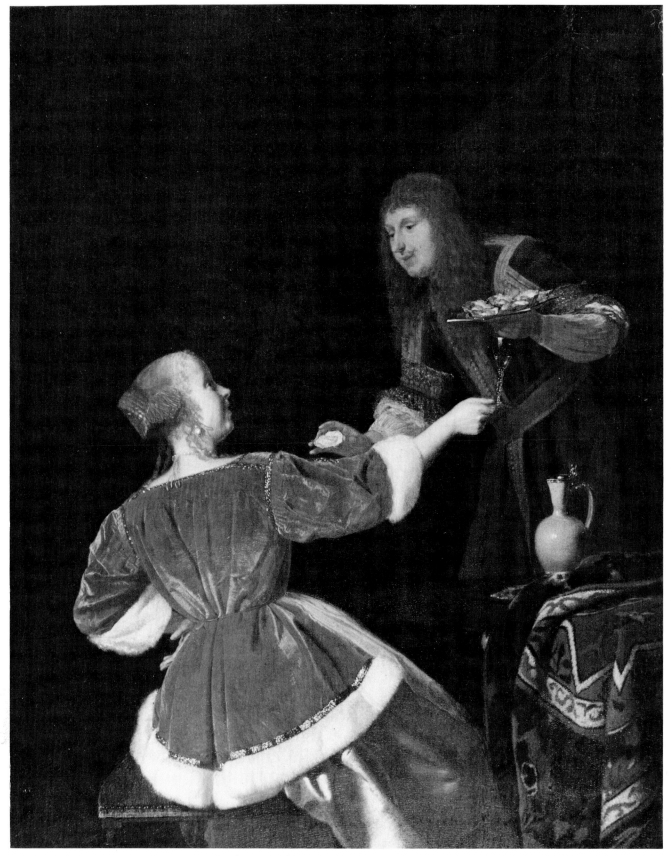

Figure 40. *The Oyster Meal* (cat. nr. 36), 1667. Museum Boymans-van Beuningen, Rotterdam.

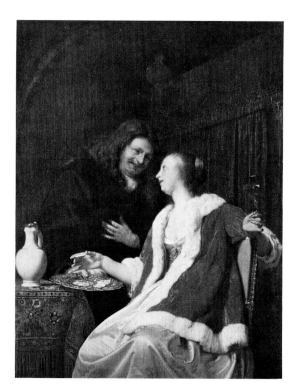

Figure 41. Frans van Mieris, the elder, *The Oyster Meal*,
1661. Present location unknown.

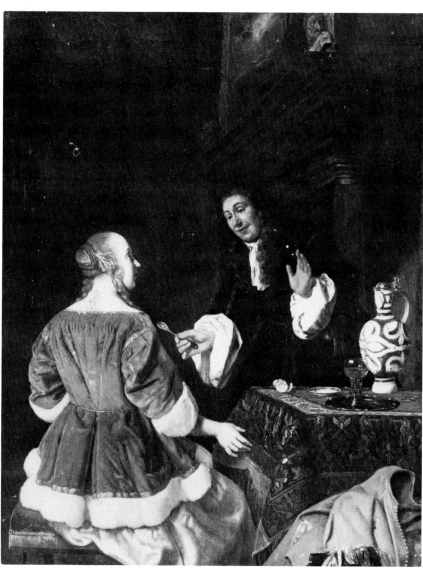

Figure 42. *The Lemon Slice* (cat. nr. 37). Present location unknown.

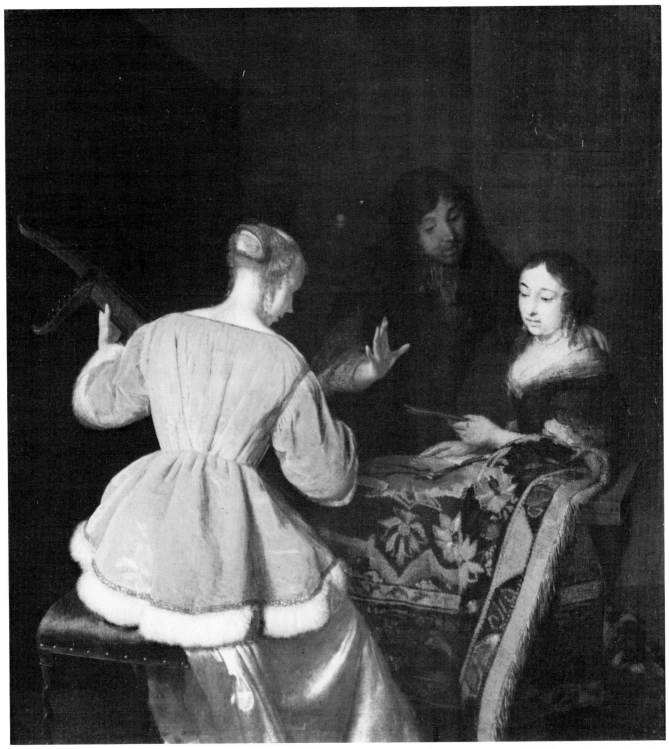

Figure 43. *The Concert* (cat. nr. 38). Private collection, London.

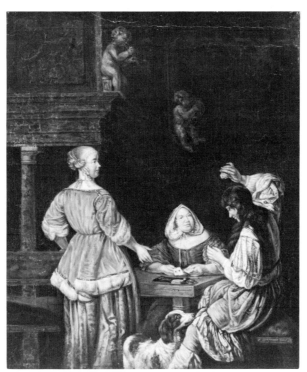

Figure 44. *The Card Players* (cat. nr. 39–A, copy). Museum Boymans-van Beuningen, Rotterdam.

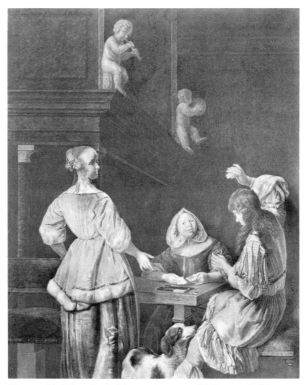

Figure 45. *The Card Players* (cat. nr. 39-B, copy). Museum Boymans-van Beuningen, Rotterdam.

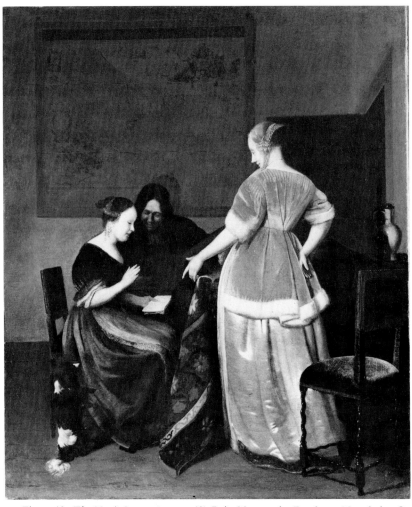

Figure 46. *The Music Lesson* (cat. nr. 40). Reiss Museum im Zeughaus, Mannheim. On permanent loan to Landes Baden-Württemberg.

Figure 47. *The Music Lesson* (cat. nr. 40-A, copy). Present location unknown.

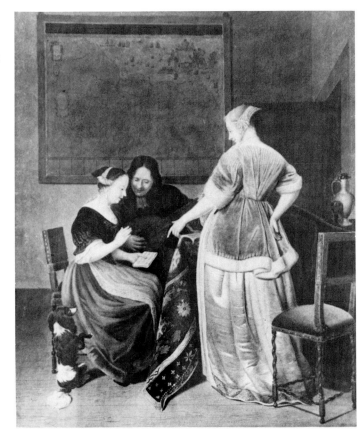

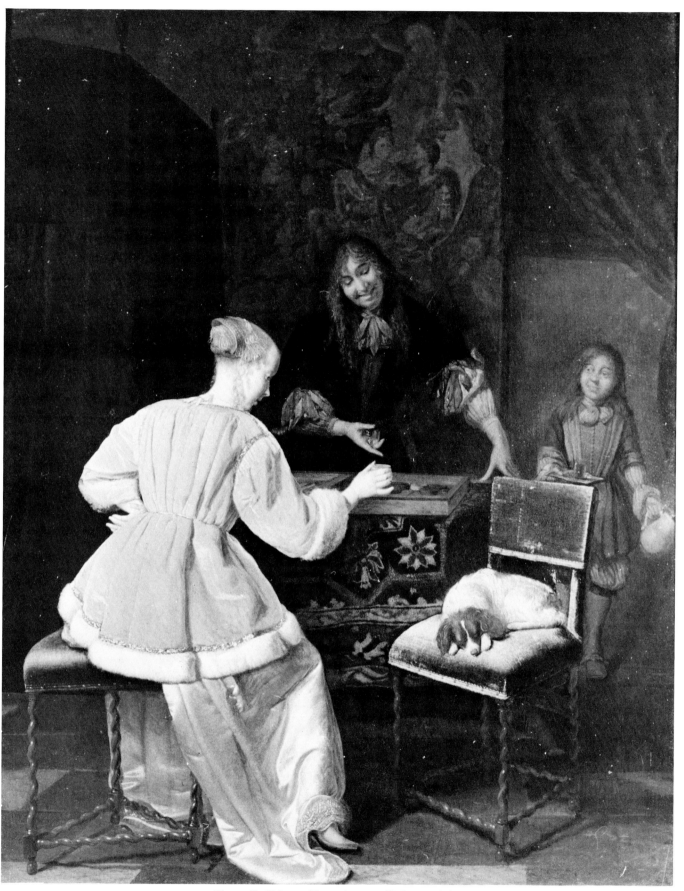

Figure 48. *Tric-trac Players* (cat. nr. 42). By permission of The Foundation "E. G. Bührle Collection," Zurich.

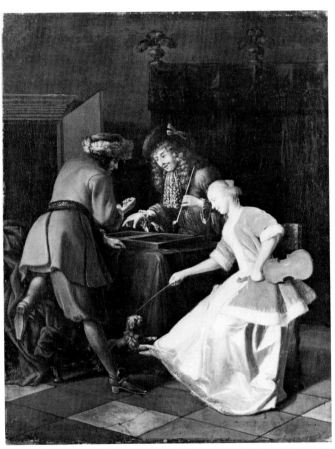

Figure 49. *Tric-trac Players* (cat. nr. 43). Private collection, West Germany.

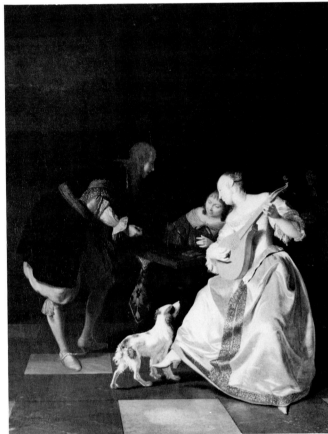

Figure 50. *Musician with Tric-trac Players* (cat. nr. 44). Wallraf-Richartz-Museum, Cologne.

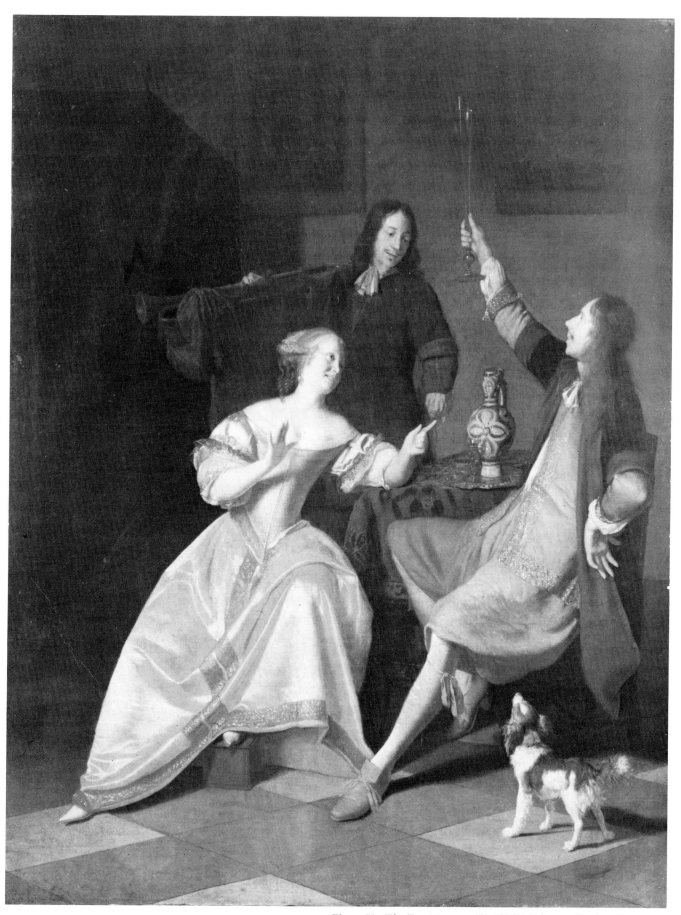

Figure 51. *The Toast* (cat. nr. 45), 166(8?). Private collection, Capetown.

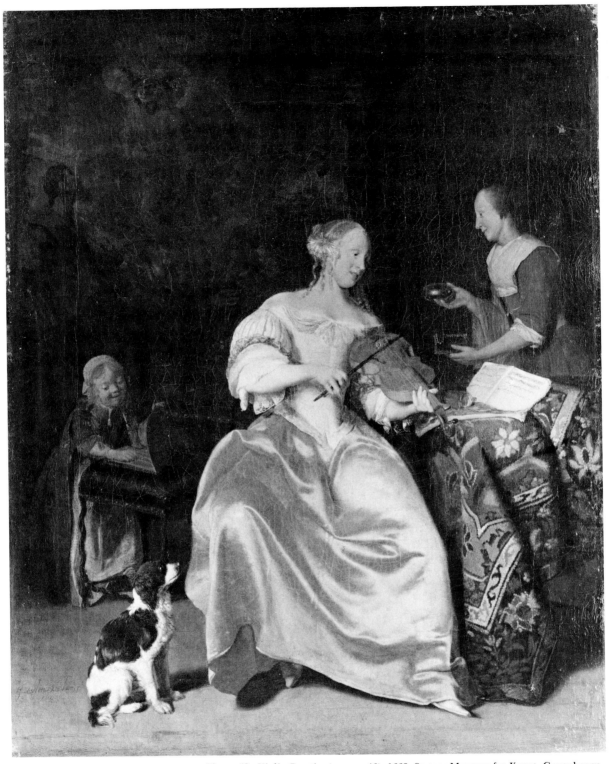

Figure 52. *Violin Practice* (cat. nr. 46), 1668. Statens Museum for Kunst, Copenhagen.

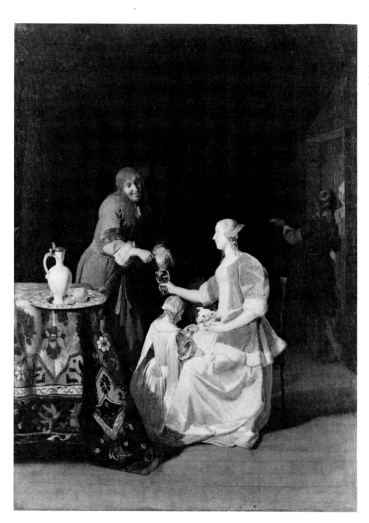

Figure 53. *The Gallant Man* (cat. nr. 53), 1669. Staatliche
Kunstsammlungen, Dresden.

Figure 54. *The Dancing Dog* (cat. nr. 56). Private collection, England.

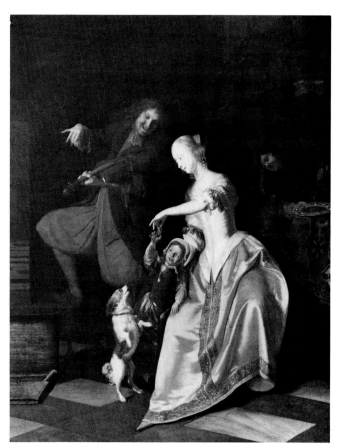

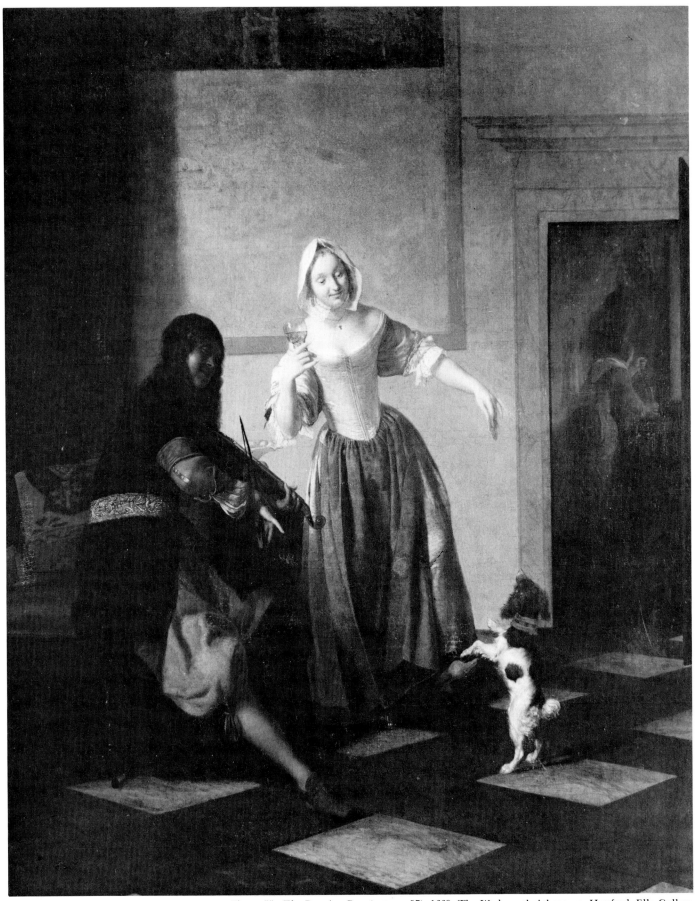

Figure 55. *The Dancing Dog* (cat. nr. 57), 1669. The Wadsworth Atheneum, Hartford. Ella Gallup Sumner and Mary Catlin Sumner Collection.

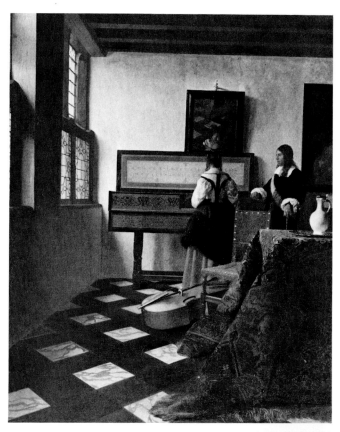

Figure 56. Jan Vermeer, *Lady and Gentleman at the Virginals.* St. James's Palace, London. Copyright reserved.

Figure 57. *Singing Practice* (cat. nr. 58). Staatliche Kunstsammlungen, Kassel.

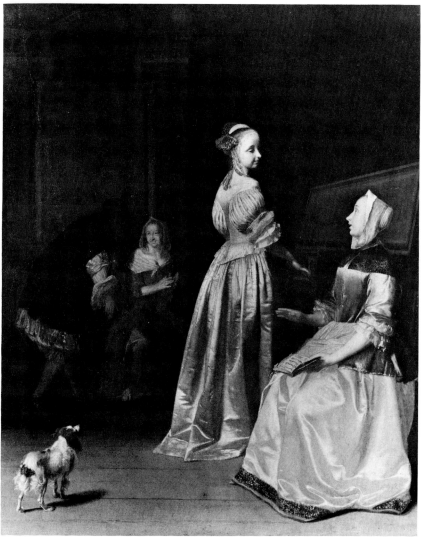

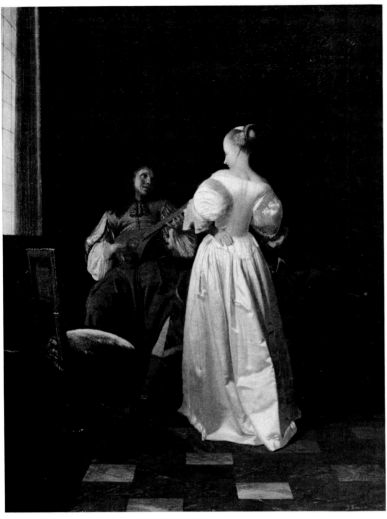

Figure 58. *The Serenade* (cat. nr. 59). Present location unknown.

Figure 59. Gerard Ter Borch, *Procuress Scene,* Berlin-Dahlem. Museum.

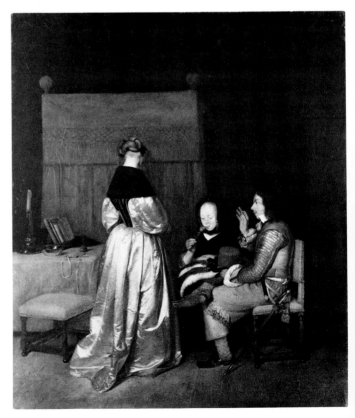

146

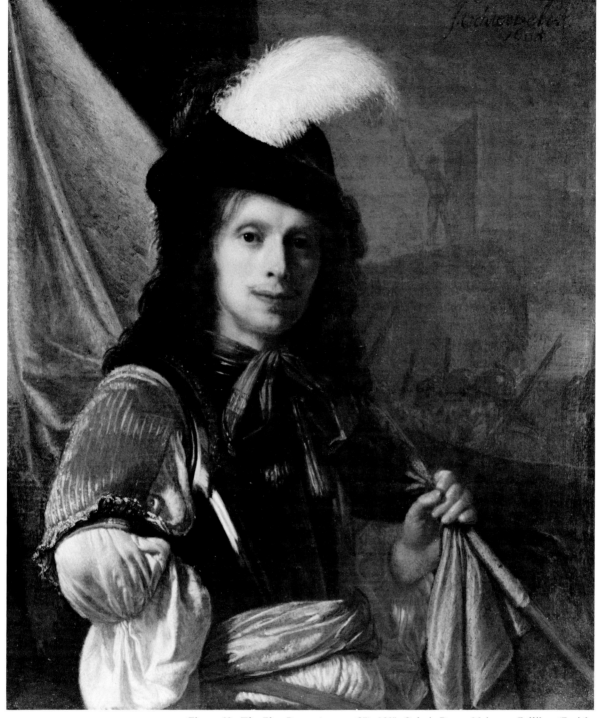

Figure 60. *The Flag Bearer* (cat. nr. 25), 1665. Galerie Bruno Meissner, Zollikon/Zurich.

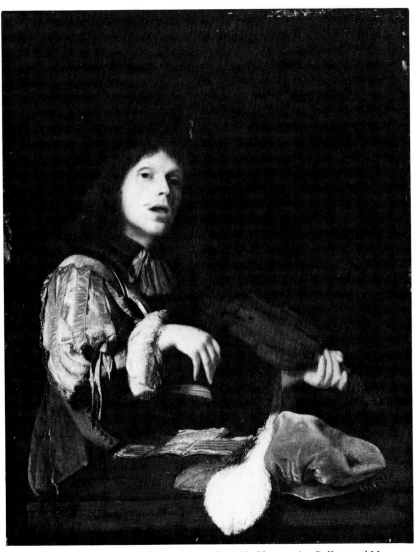

Figure 61. *The Singing Violinist* (cat. nr. 33), 1666. Glasgow Art Gallery and Museum.

Figure 62. Pieter van Noort, *Singing Violinist*, Landesmuseum, Münster.

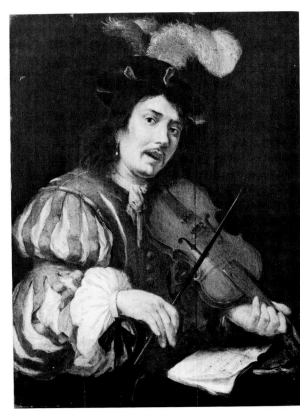

148

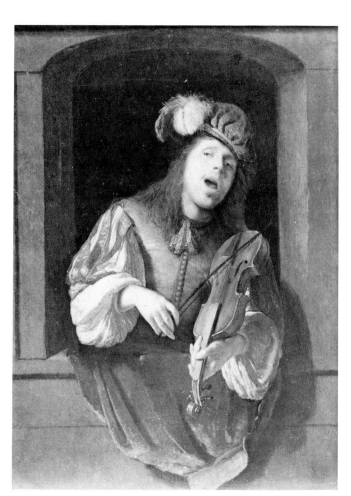

Figure 63. *Singing Violinist in a Niche* (cat. nr. 34). Present location unknown.

Figure 64. *Singing Violinist* (cat. nr. 35). Present location unknown.

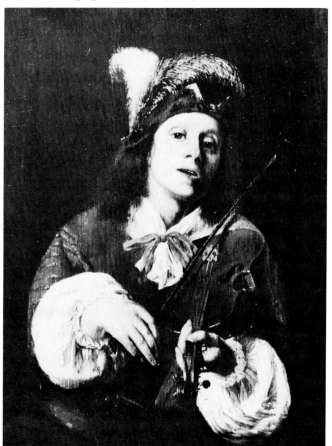

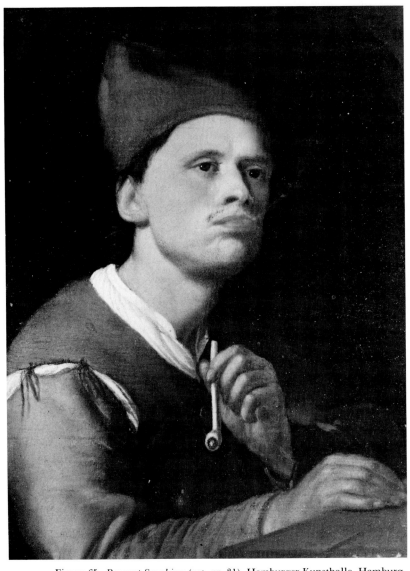

Figure 65. *Peasant Smoking* (cat. nr. 31). Hamburger Kunsthalle, Hamburg.

Figure 66. Adriaen van Ostade, *Peasant Smoking*, 1640. Hamburger Kunsthalle, Hamburg.

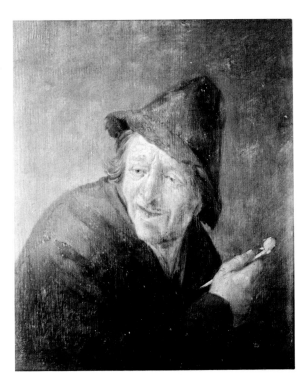

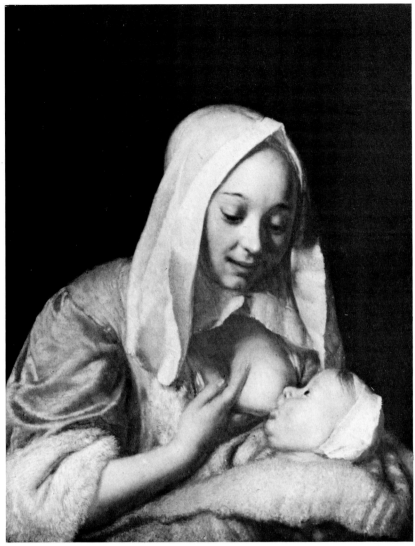

Figure 67. *Woman Nursing a Child* (cat. nr. 29). Foundation Prof. Dr. L. Ruzicka, Kunsthaus, Zurich.

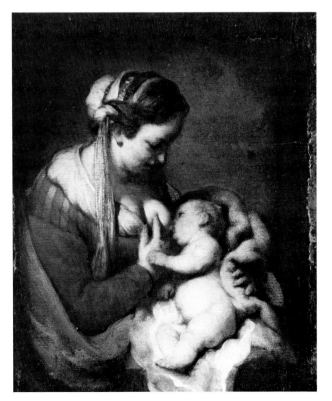

Figure 68. Gerbrand van den Eeckhout, *Virgin and Nursing Child*, 1659. Herzog-Anton-Ulrich Museum, Braunschweig, West Germany.

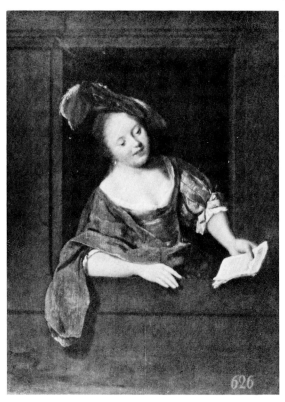

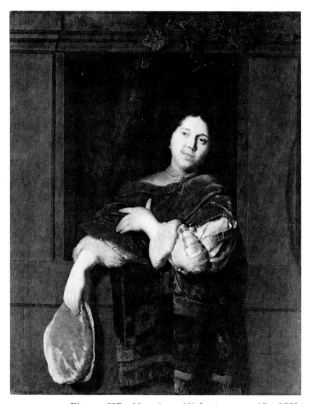

Figure 69A. *Woman Singing in a Niche* (cat. nr. 47). Present location unknown.

Figure 69B. *Man in a Niche* (cat. nr. 48), 1668. Städelsches Kunstinstitut and Städtische Galerie, Frankfurt am Main.

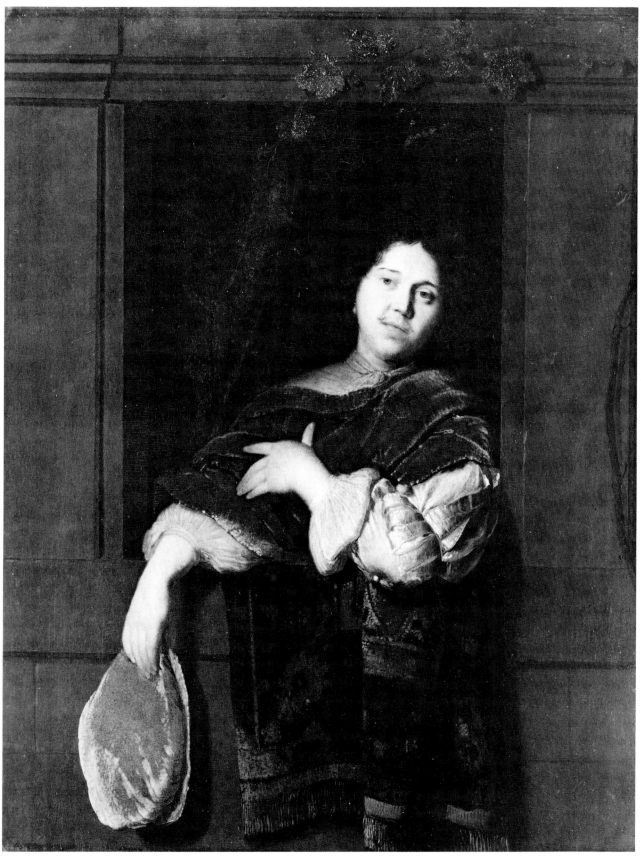

Figure 70. *Man in a Niche* (cat. nr. 48), 1668. Städelsches Kunstinstitut, Frankfurt am Main.

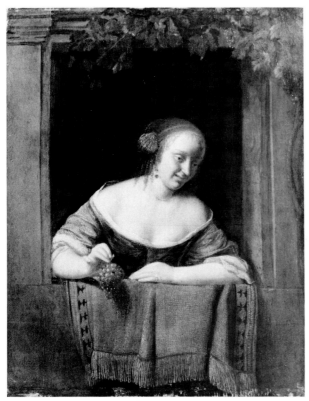

Figure 71. *Woman in a Niche Holding Grapes* (cat. nr. 49). Courtesy of the National Gallery of Ireland, Dublin.

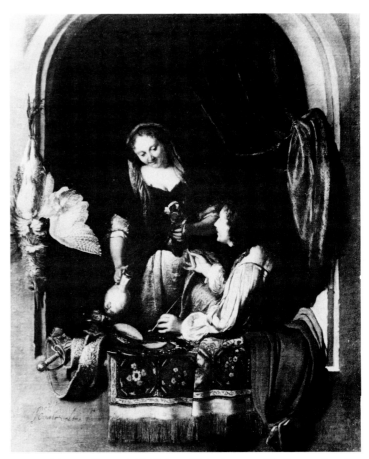

Figure 72. *Cavalier and Maid in a Niche* (cat. nr. 88). Present location unknown.

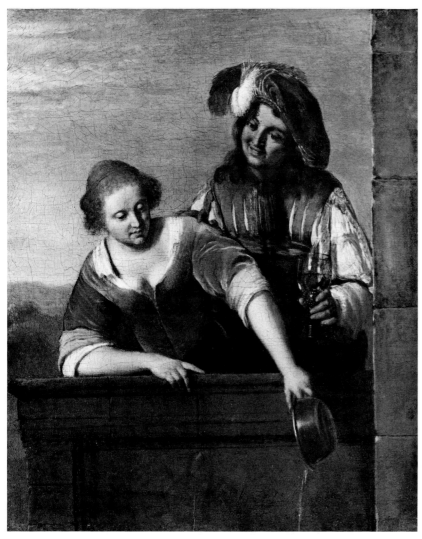

Figure 73. *Cavalier and Maid on a Balcony* (cat. nr. 89). Kurt Meissner, Zollikon/Zurich.

Figure 74. Pieter Schenk, *Cavalier and Maid in a Niche*, mezzotint after Ochtervelt.

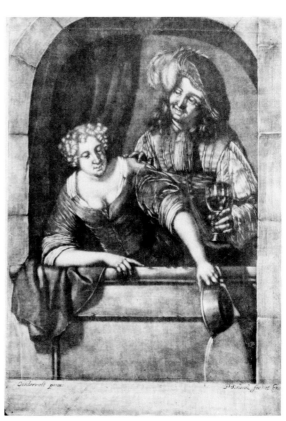

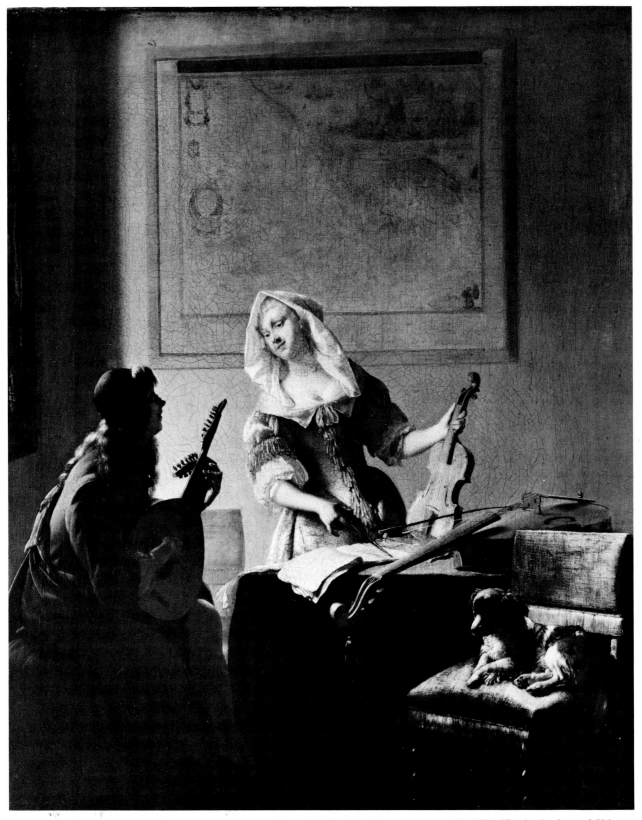

Figure 75. *The Music Lesson* (cat. nr. 63), 1671. The Art Institute of Chicago.

Figure 76. Jan Vermeer, *Soldier and a Laughing Girl.* The Frick Collection, New York.

Figure 77. *The Tric-trac Players* (cat. nr. 64), 1671. Museum der Bildenden Künste, Leipzig.

Figure 78. *The Music Lesson* (cat. nr. 65). By courtesy of City Museum and Art Gallery, Birmingham, England.

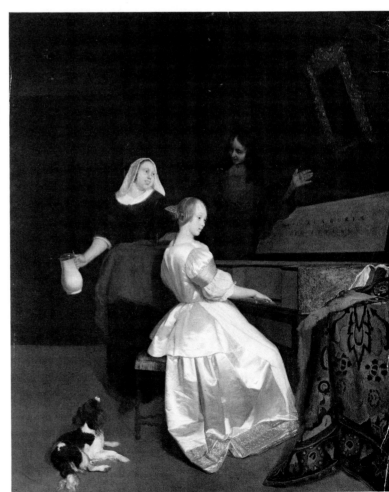

158

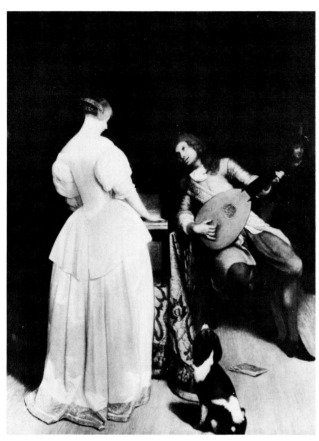

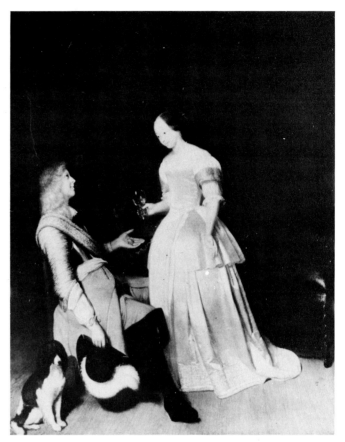

Figure 79. *Lady at the Virginals and Lutenist* (cat. nr. 68). Present location unknown.

Figure 80. *The Soldier's Offer* (cat. nr. 69). Present location unknown.

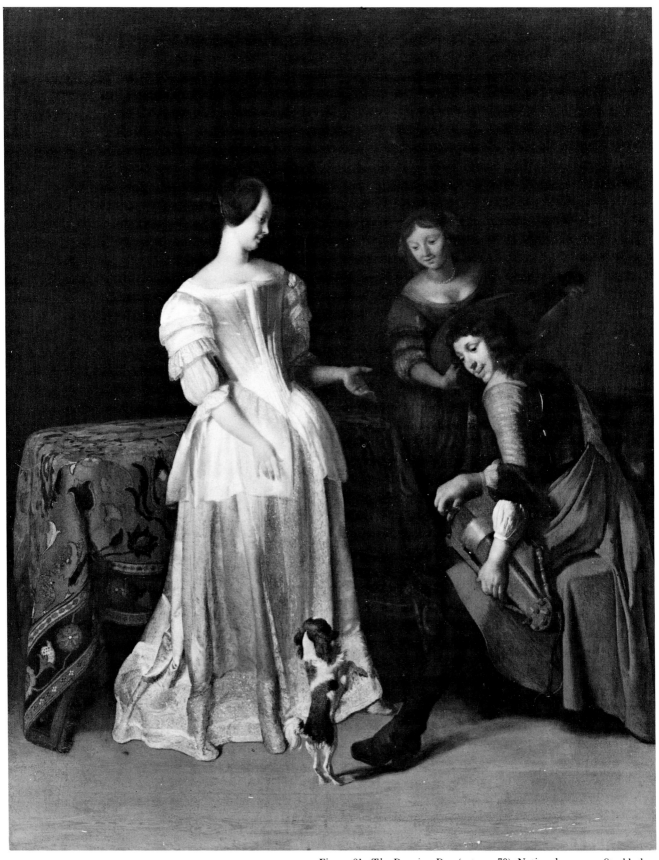

Figure 81. *The Dancing Dog* (cat. nr. 70). Nationalmuseum, Stockholm.

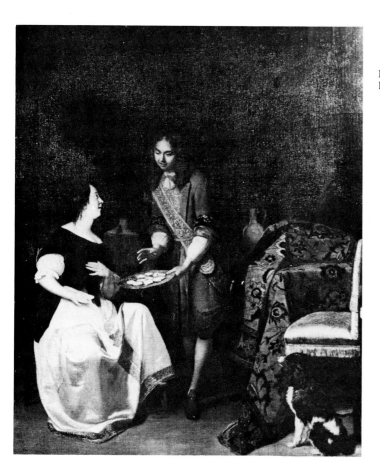

Figure 82. *The Oyster Meal* (cat. nr. 71). Present location unknown.

Figure 83. *The Betrothal* (cat. nr. 72). Private Collection, Germany.

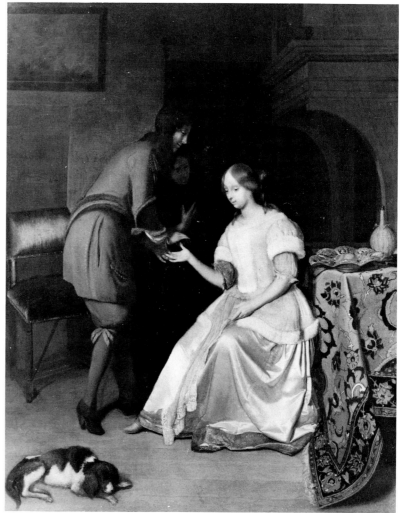

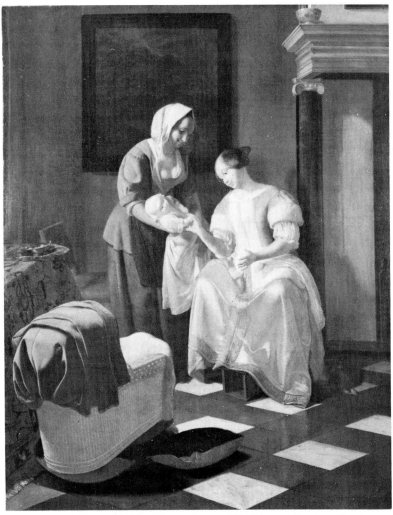

Figure 84. *The Nursery* (cat. nr. 73). Private collection, Capetown.

Figure 85. Jan Verkolje, *Nursery Scene,* 1675. The Louvre, Paris. By permission of Cliché des Musées Nationaux, Paris.

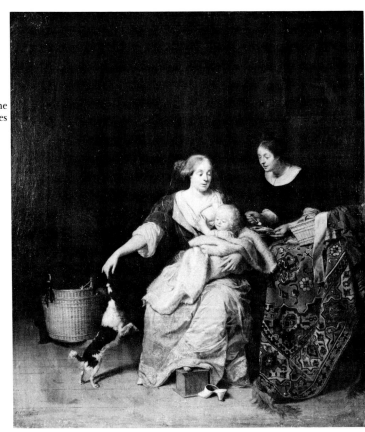

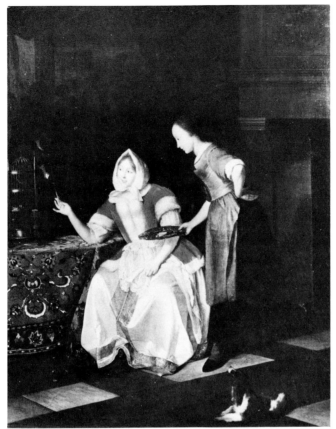

Figure 86. *Lady and Maid Feeding a Parrot* (cat. nr. 74). Present location unknown.

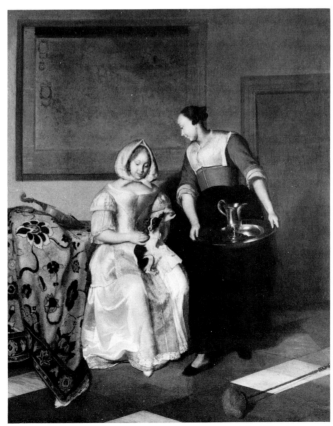

Figure 87. *Lady with Servant and Dog* (cat. nr. 75). The New York Historical Society, Bryan Collection.

163

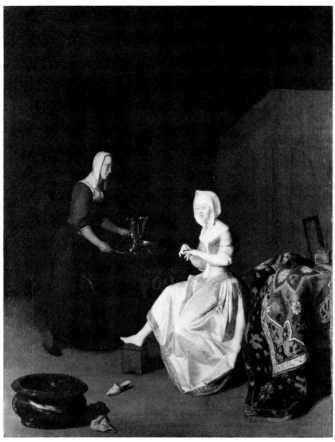

Figure 88. *Lady Trimming Her Fingernails with Maid* (cat. nr. 76).
Reproduced by Courtesy of the Trustees, National Gallery, London.

Figure 89. *The Letter Reader* (cat. nr. 77). Private collection, Cologne.

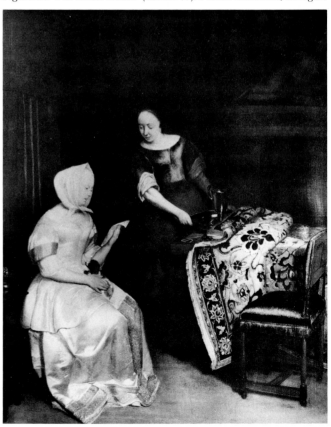

164

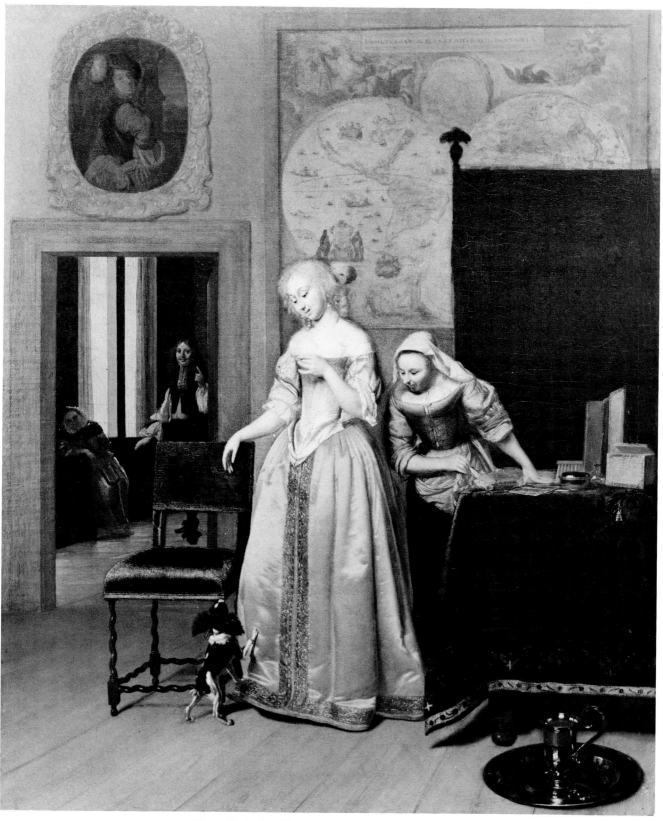

Figure 90. *Lady with Servant and Dog* (cat. nr. 78). The Carnegie Institute Museum of Art, Pittsburgh, Pennsylvania.

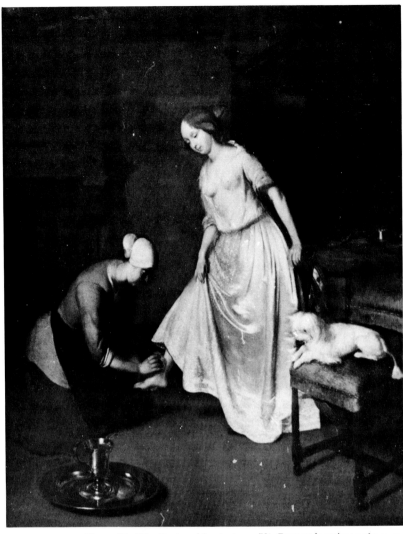

Figure 91. *The Footwashing* (cat. nr. 79). Present location unknown.

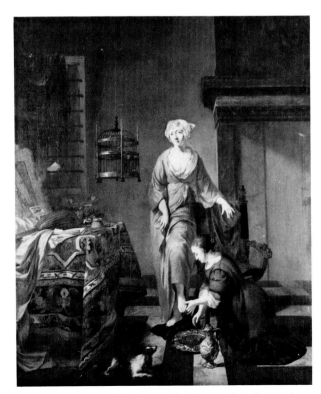

Figure 92. Johannes Voorhout, *The Footwashing*. Present location unknown.

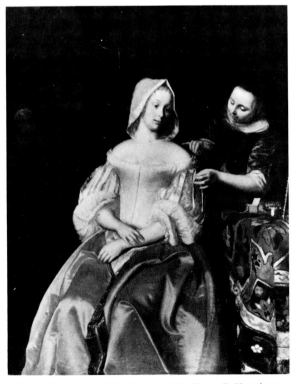

Figure 93. *Lady and Maid* (cat. nr. 80). Henry E. Huntington Art Gallery, San Marino, California.

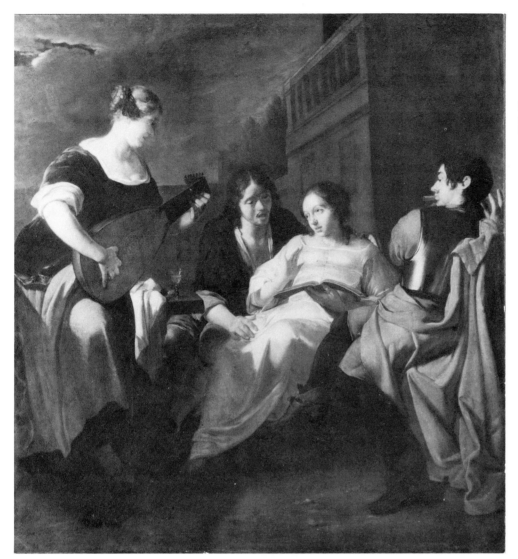

Figure 94. *Concert in a Garden* (cat. nr. 83), 1674. By permission of The Hermitage Museum, Leningrad.

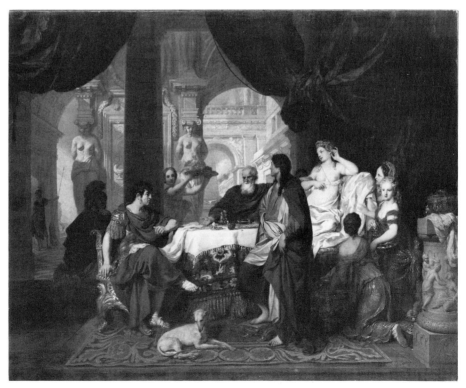

Figure 95. Gerard de Lairesse, *Antony and Cleopatra*. Rijksmuseum, Amsterdam.

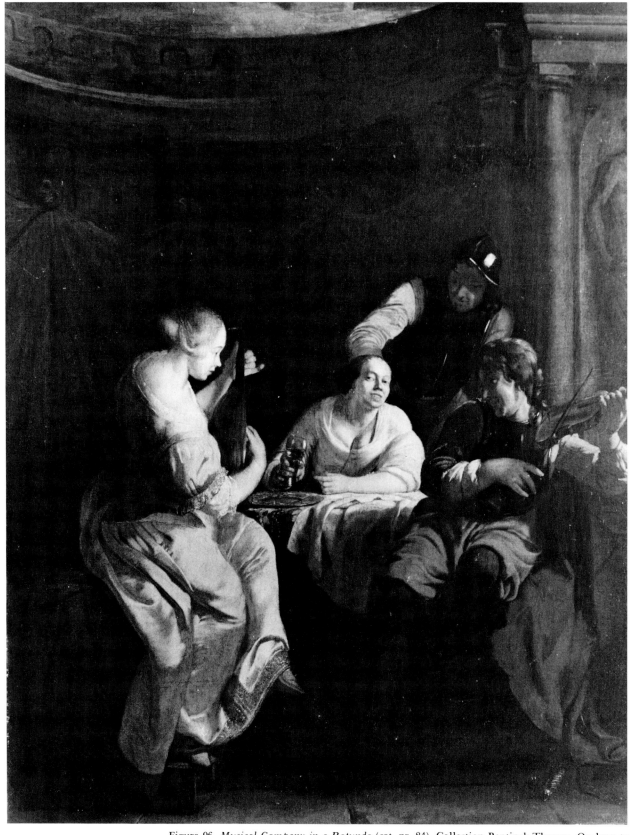

Figure 96. *Musical Company in a Rotunda* (cat. nr. 84). Collection Bentinck-Thyssen. On loan to Kunstmuseum, Düsseldorf.

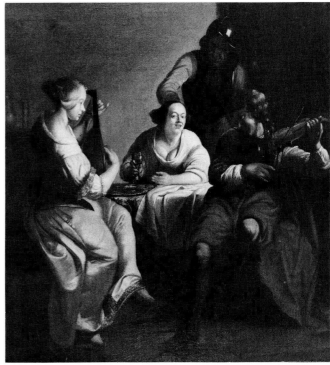

Figure 97. *Musical Company* (cat. nr. 84-A, copy). Present location unknown.

Figure 98. *Musical Company* (cat. nr. 84-B, copy). Staatliches Museum, Schwerin.

169

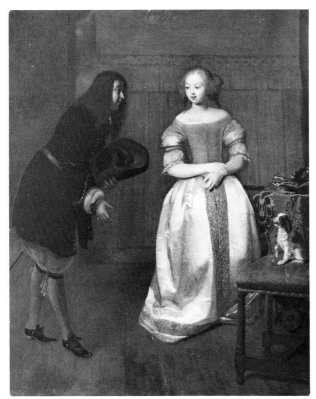

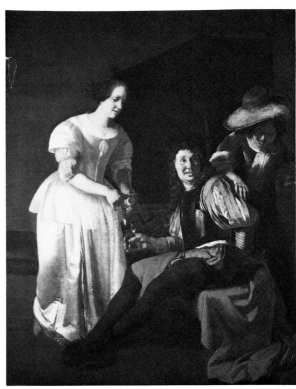

Figure 99. *The Visit* (cat. nr. 85). Private collection, England.

Figure 100. *The Tease* (cat. nr. 86). Private collection, Switzerland.

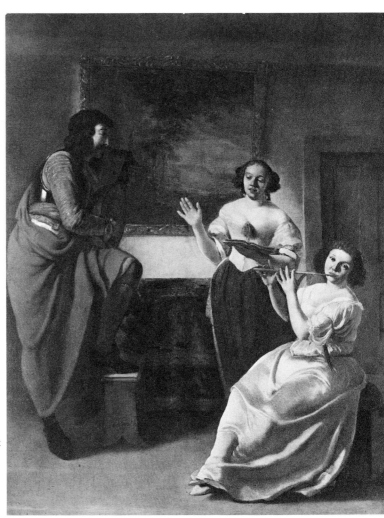

Figure 101. *Musical Trio* (cat. nr. 87). Present location unknown.

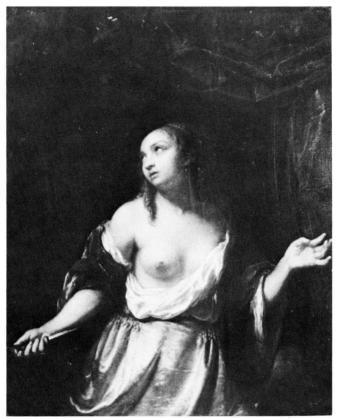

Figure 102. *Lucretia* (cat. nr. 91), 1676. Present location unknown.

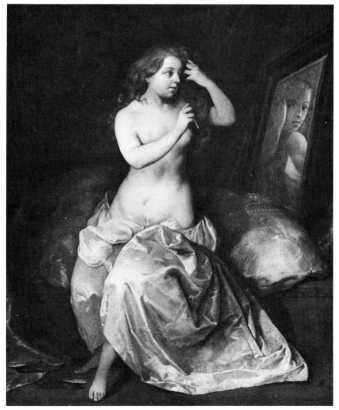

Figure 103. *Woman Combing Her Hair Before a Mirror* (cat. nr. 92). A.
H. Bies Kunsthandel, Eindhoven, The Netherlands.

171

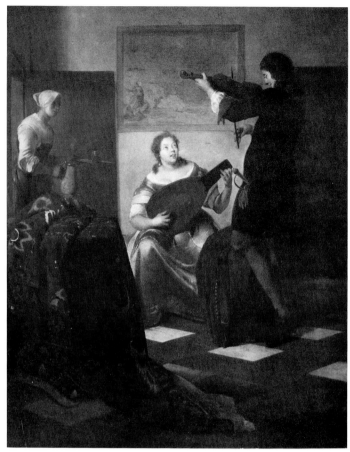

Figure 104. *The Duet* (cat. nr. 93). Private collection, London.

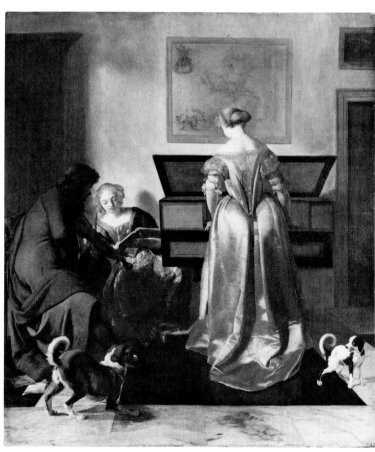

Figure 105. *The Music Party* (cat. nr. 94). Reproduced by courtesy of the Trustees, National Gallery, London.

172

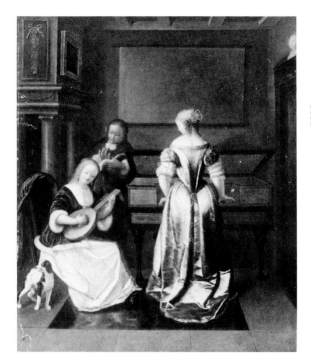

Figure 106. *The Music Party* (cat. nr. 94-A, pastiche). Present location unknown.

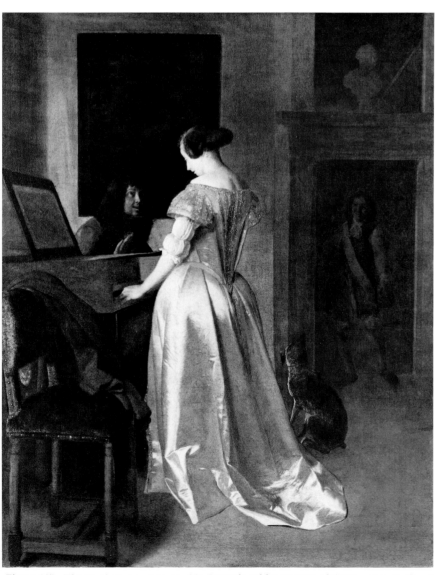

Figure 107. *The Music Lesson* (cat. nr. 95). Reproduced by courtesy of the Trustees, National Gallery, London.

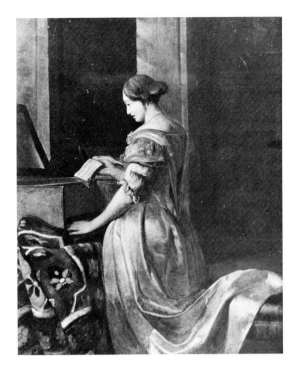

Figure 108. *Lady at the Virginals* (cat. nr. 96). Present location unknown.

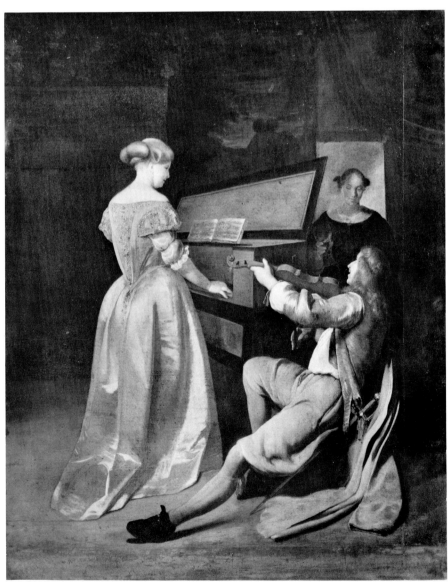

174 Figure 109. *Violinist and Lady at the Virginals* (cat. nr. 97). Stiftung Kunsthaus Heylshof, Worms.

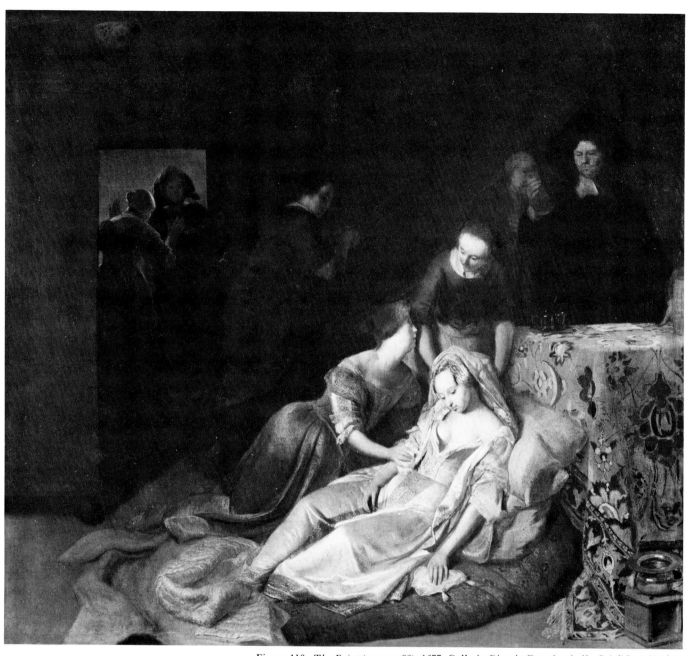

Figure 110. *The Faint* (cat. nr. 98), 1677. Galleria Giorgio Franchetti alla Ca' d'Oro, Venice.

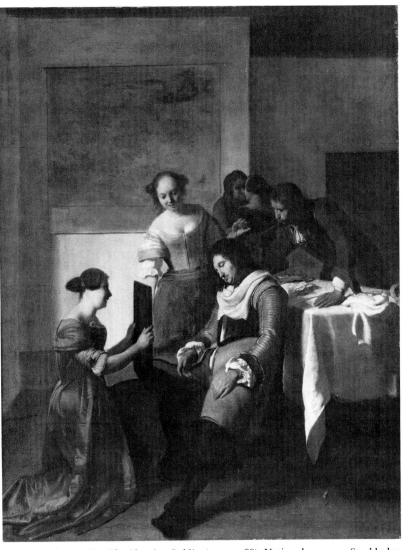

Figure 111. *The Sleeping Soldier* (cat. nr. 99). Nationalmuseum, Stockholm.

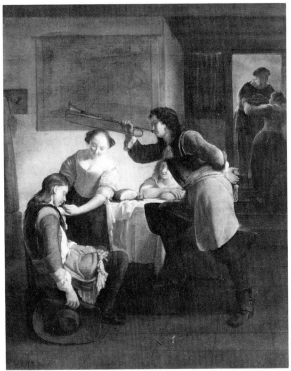

Figure 112. *The Sleeping Soldier* (cat. nr. 100). Ronald Cook, London.

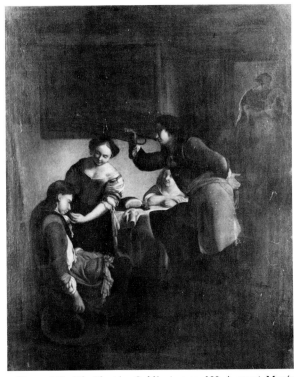

Figure 113. *The Sleeping Soldier* (cat. nr. 100–A, copy). Musée Communal, Verviers, Belgium.

176

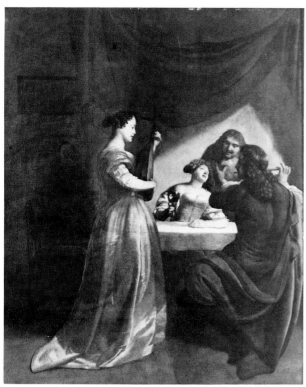

Figure 114. *The Concert* (cat. nr. 101). Present location unknown.

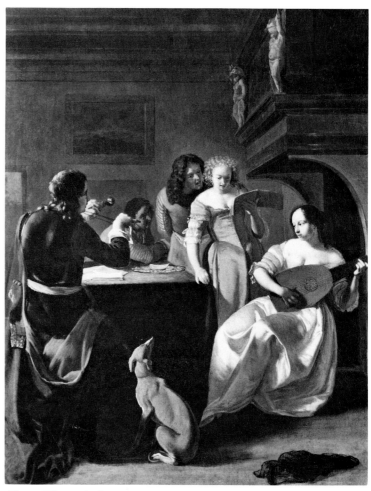

Figure 115. *Musical Company Around a Table* (cat. nr. 102). Dayton Art Institute, Dayton, Ohio. Gift of the Honorable and Mrs. Jefferson Patterson.

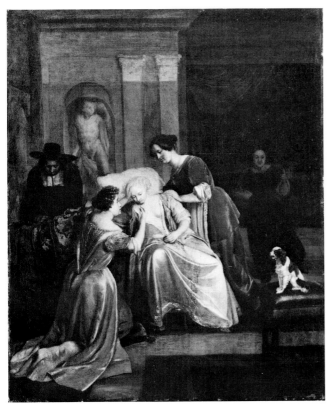

Figure 116. *The Doctor's Visit* (cat. nr. 105). Bayerischen Staatsge-
mäldesammlungen, Munich. On loan to Aachen Museum.

Figure 117. *The Last Testament* (cat. nr. 106). Schloss Grünewald, Berlin.

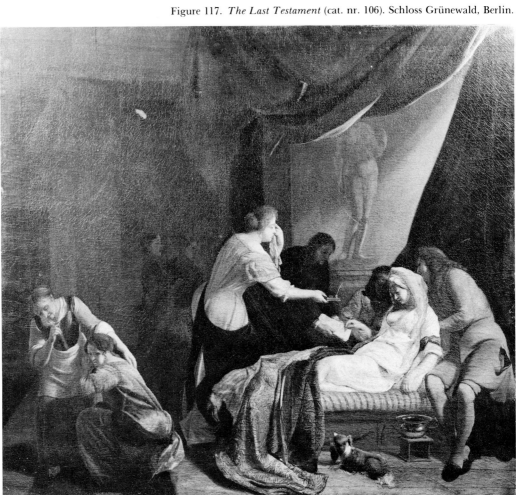

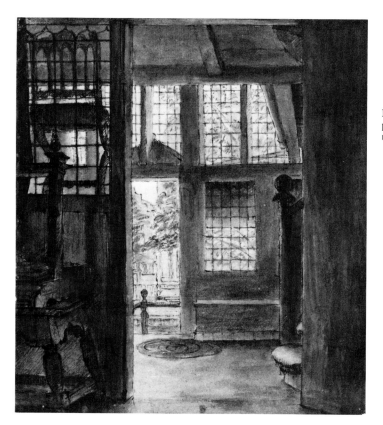

Figure 118. Rembrandt School, *The Entrance Hall*, pen and wash drawing. Reproduced by courtesy of the Trustees of the British Museum, London.

Figure 119. Ludolf de Jongh, *Entrance Hall Scene*. Present location unknown.

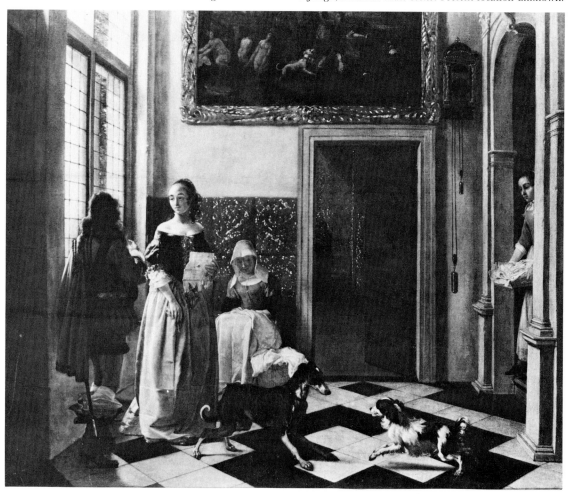

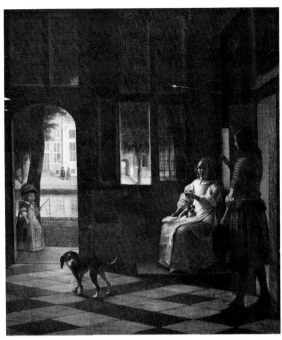

Figure 120. Pieter de Hooch, *The Letter*, 1670.
Rijksmuseum, Amsterdam.

Figure 121. *Street Musicians at the Door* (cat. nr. 16). Berlin-Dahlem Museum.

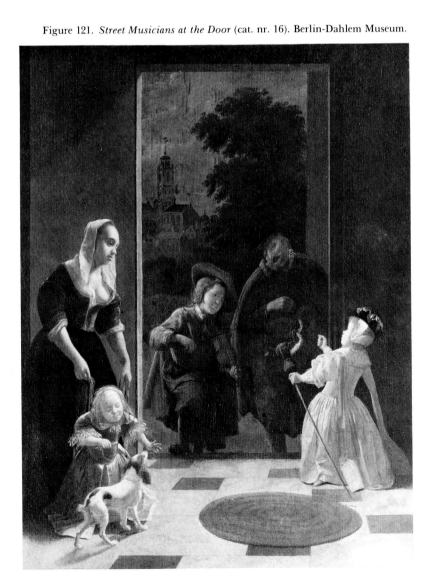

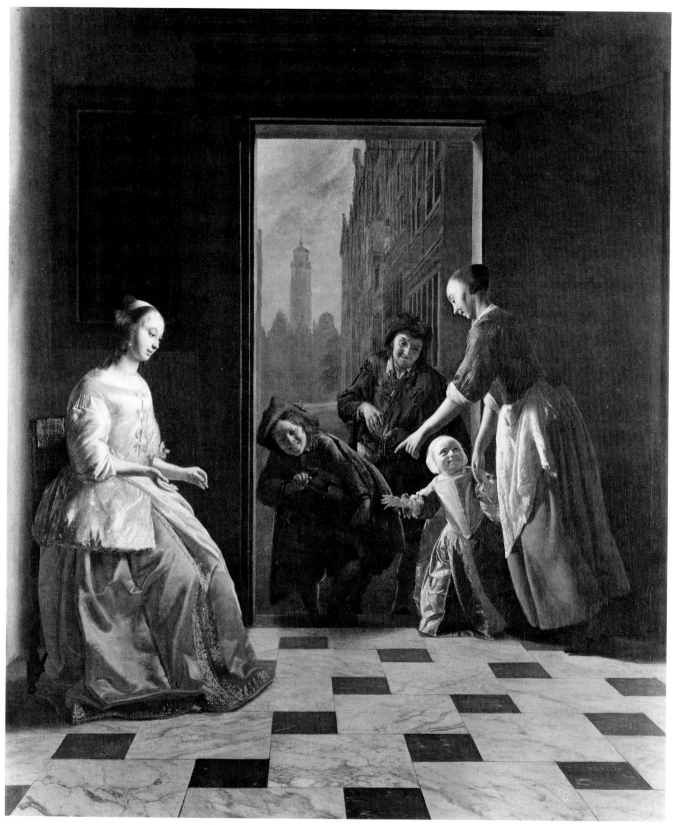

Figure 122. *Street Musicians at the Door* (cat. nr. 24), 1665. The St. Louis Art Museum. Gift of Mrs. Eugene A. Perry.

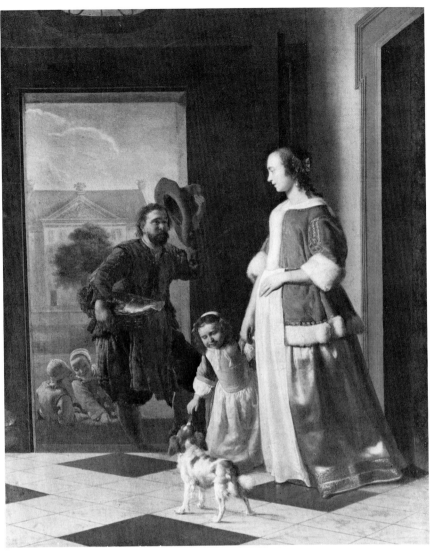

Figure 123. *Fish Seller at the Door* (cat. nr. 41). Mauritshuis, The Hague.

Figure 124. *Fish Seller at the Door* (cat. nr. 41-A, copy). Present location unknown.

Figure 125. *Fish Seller at the Door* (cat. nr. 41-B, copy). Present location unknown.

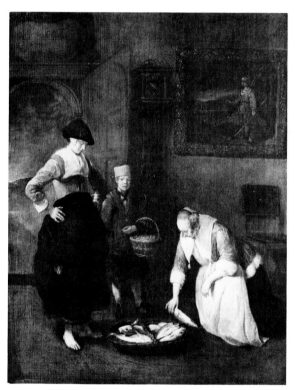

Figure 126. Quiringh van Brekelenkam, *Fish Sellers*, 1666. Museum der Bildenden Künste, Leipzig, East Germany.

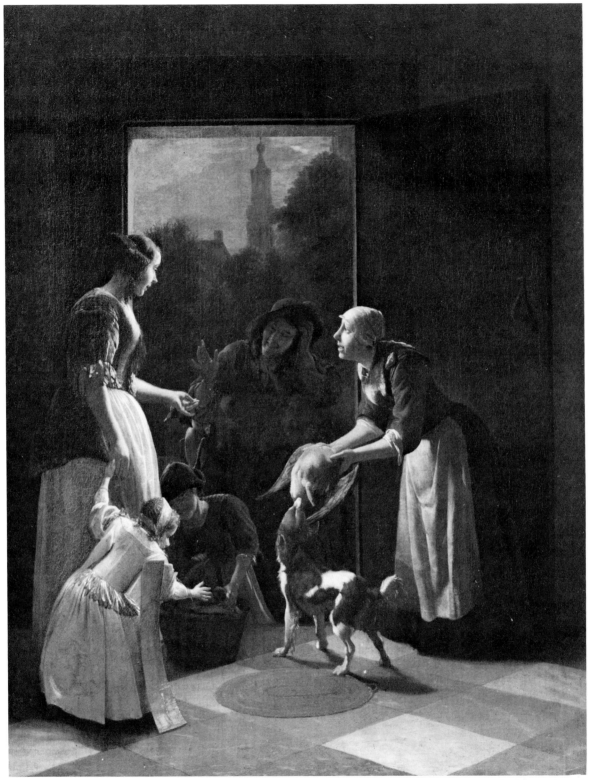

Figure 127. *The Poultry Seller* (cat. nr. 50). Present location unknown.

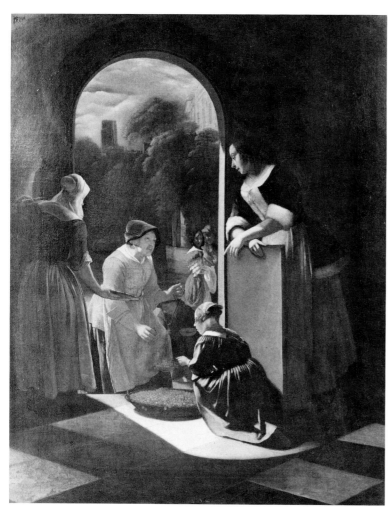

Figure 128. *The Cherry Seller* (cat. nr. 51). Museum Mayer van den Bergh, Antwerp.

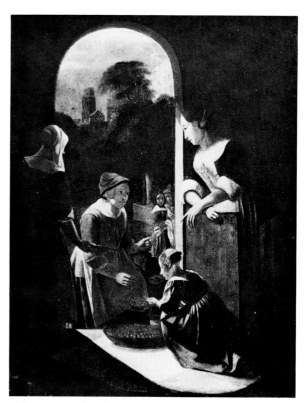

Figure 129. *The Cherry Seller* (cat. nr. 51-A, copy). Present location unknown.

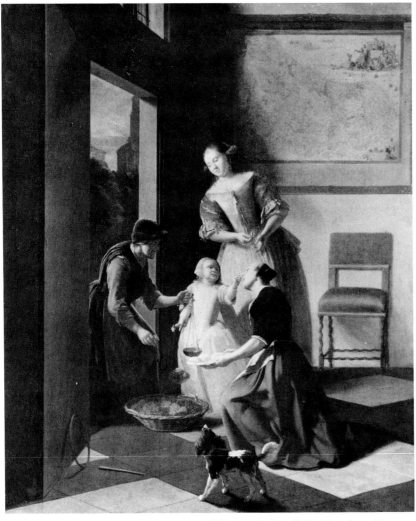

Figure 130. *The Grape Seller* (cat. nr. 54), 1669. By permission of The Hermitage Museum, Leningrad.

Figure 131. *The Grape Seller* (cat. nr. 54-A, copy). Present location unknown.

186

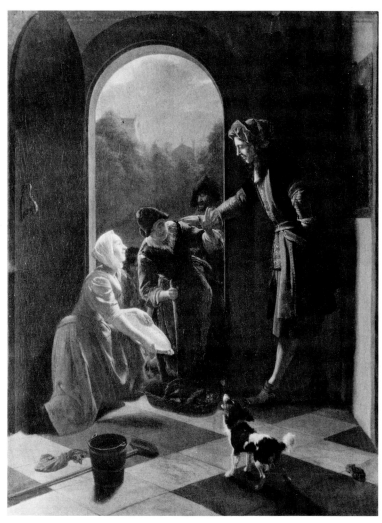

Figure 132. *The Fish Seller* (cat. nr. 55). By permission of The Hermitage Museum, Leningrad.

Figure 133. *The Fish Seller* (cat. nr. 55-A). Kunsthandel H. Schlichte Bergen B.V., Amsterdam.

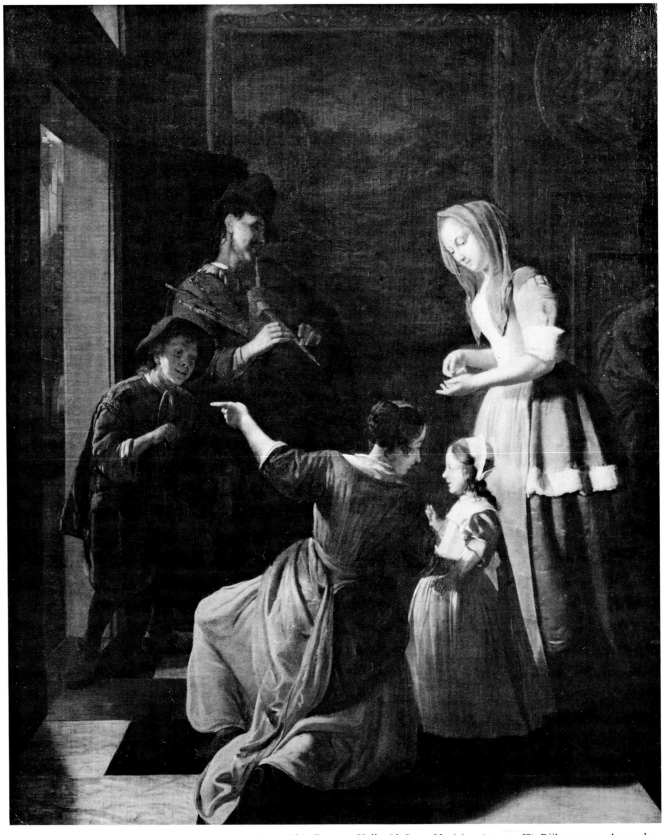

Figure 134. *Entrance Hall with Street Musicians* (cat. nr. 62). Rijksmuseum, Amsterdam.

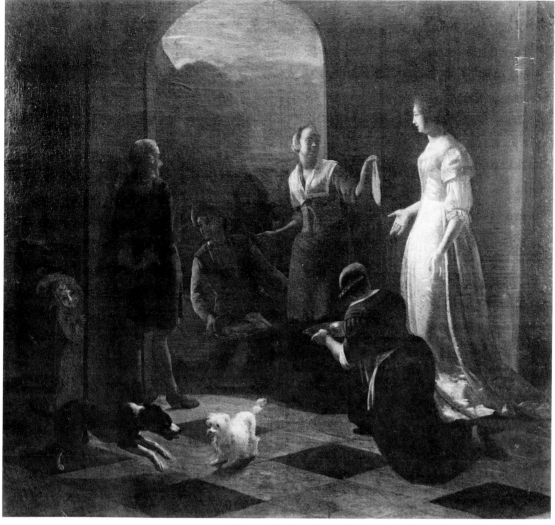

Figure 135. *The Fish Seller* (cat. nr. 103). Pushkin Museum, Moscow.

Figure 136. Hendrik Bergen, *The Welcome*. Present location unknown.

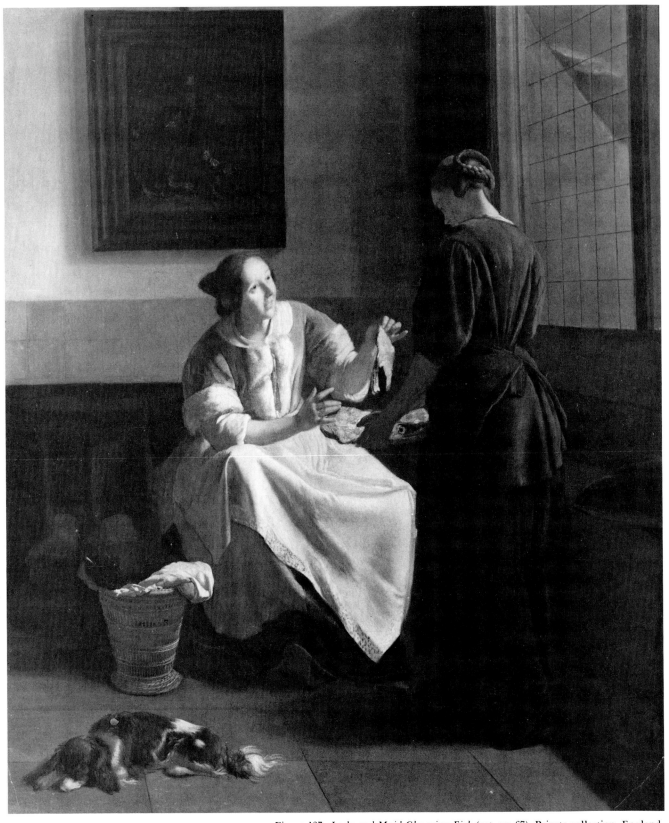

Figure 137. *Lady and Maid Choosing Fish* (cat. nr. 67). Private collection, England.

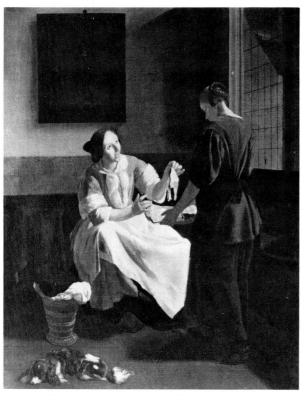

Figure 138. *Lady and Maid Choosing Fish* (cat. nr. 67-A, copy). York City Art Gallery, York, England. By permission of the owner.

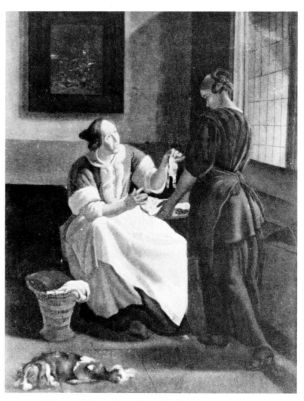

Figure 139. *Lady and Maid Choosing Fish* (cat. nr. 67-B, copy). Present location unknown.

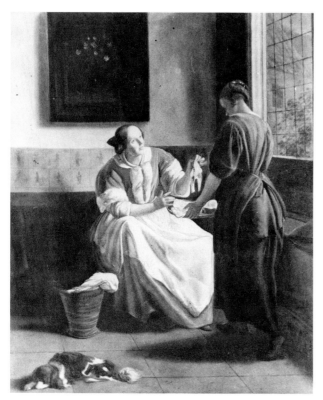

Figure 140. *Lady and Maid Choosing Fish* (cat. nr. 67-C, copy). Present location unknown.

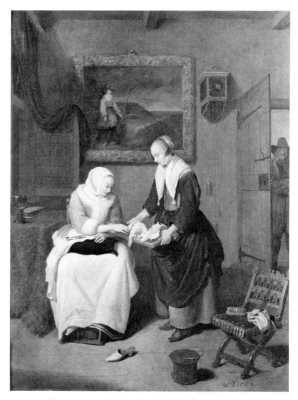

Figure 141. Quiringh van Brekelenkam, *Lady Choosing Fish.* Courtesy of the Trustees of the Assheton Bennett Collection. On loan to Manchester City Art Gallery, Manchester, England.

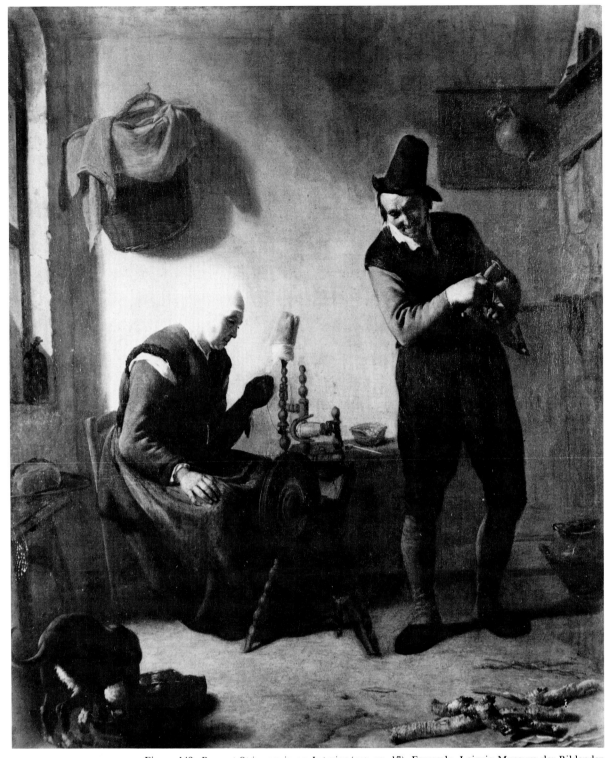

Figure 142. *Peasant Spinners in an Interior* (cat. nr. 17). Formerly, Leipzig Museum der Bildenden Künste (destroyed, World War II).

Wat ruſt en ghewin gheeft luttel onderwin.

Figure 143. Emblem on the virtues of domestic labor. Johan de Brune, *Emblemata of zinne-werck . . .*, Amsterdam, 1624, nr. 318, The Royal Library, The Hague.

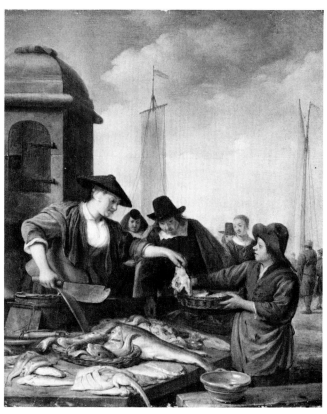

Figure 144. H. M. Sorgh, *Fish Market*, 1655. Courtesy of the Trustees of the Assheton Bennett Collection. On loan to Manchester City Art Gallery, Manchester, England.

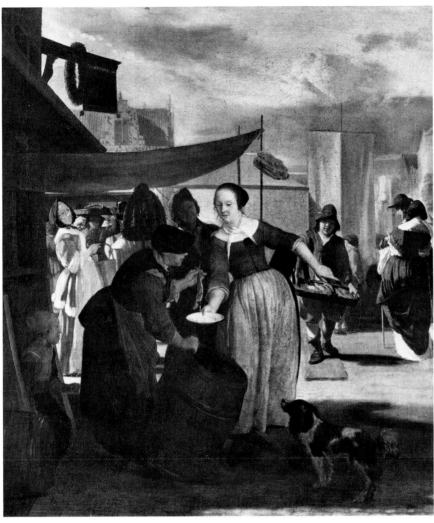

Figure 145. *The Fish Market* (cat. nr. 52). Kunsthistorisches Museum, Vienna.

Figure 146. Emmanuel de Witte, *Fish Market*. Reproduced by courtesy of the Trustees, The National Gallery, London.

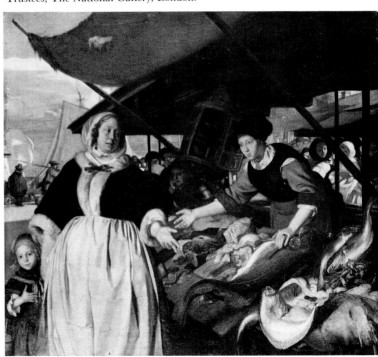

194

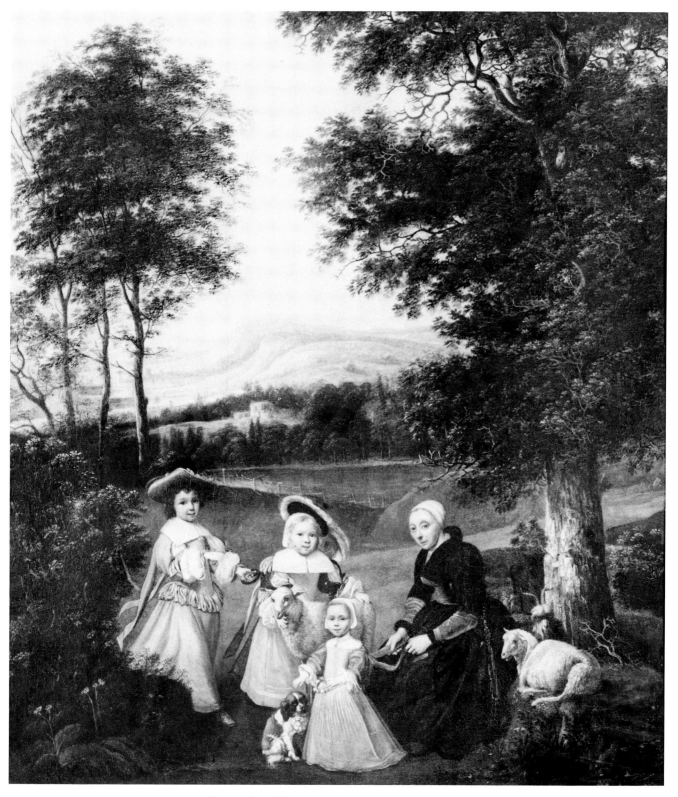

Figure 147. *Children and Frisian Nursemaid in a Landscape* (cat. nr. 12), 1660. Private collection, England.

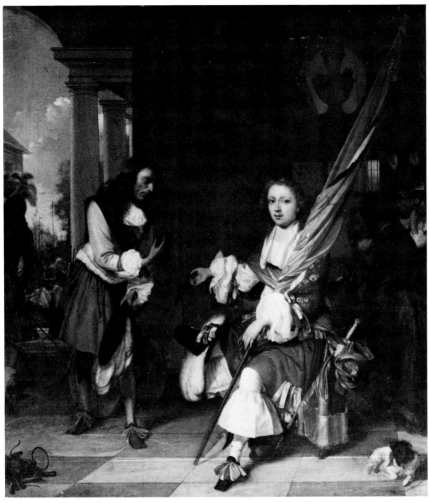

Figure 148. *The Ensign* (cat. nr. 13), 166(0?). Dienst Verspreide Rijkscollecties, The Hague. On loan to Embassy Stockholm, P.S.v. Gallery, The Hague.

Figure 149. Thomas de Keyser, *Portrait of Constantijn Huygens and His Clerk,* 1627. Reproduced by courtesy of the Trustees, The London National Gallery.

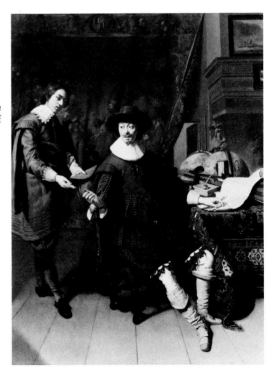

196

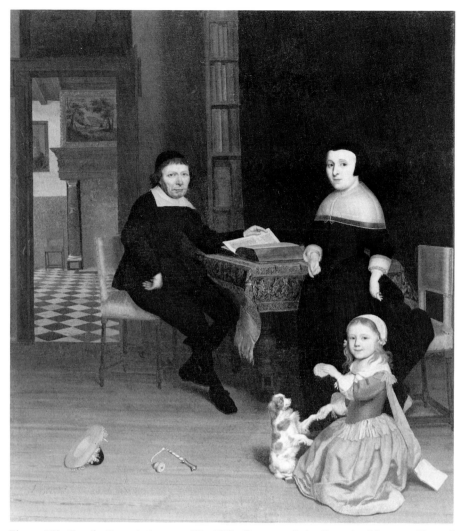

Figure 150. *Family Portrait* (cat. nr. 18), 1663. Courtesy of the Fogg Art Museum, Harvard University, Cambridge, Massachusetts. Gift of Frederic F. Sherman in memory of his brother, Frank D. Sherman.

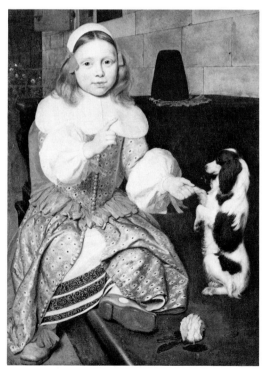

Figure 151. Ludolf de Jongh, *Portrait of a Child Instructing a Dog*, 1661. Virginia Museum of Fine Arts, Richmond, Virginia.

197

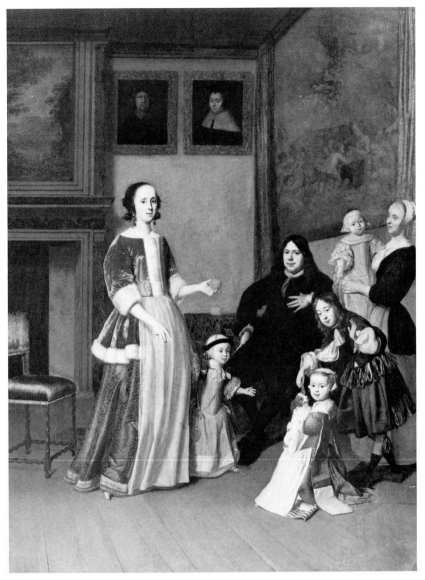

Figure 152. *Family Portrait* (cat. nr. 19), 166(4?). The Wadsworth Atheneum, Hartford, Connecticut. Gift of Robert Lehman.

Figure 153. Gabriel Metsu, *Family Portrait*. Berlin-Dahlem Museum.

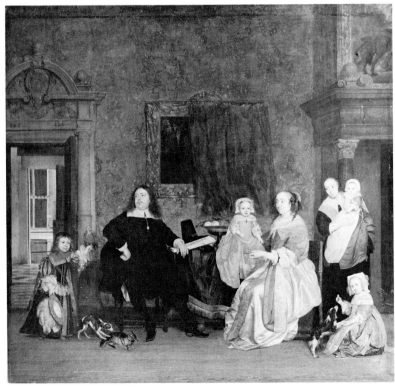

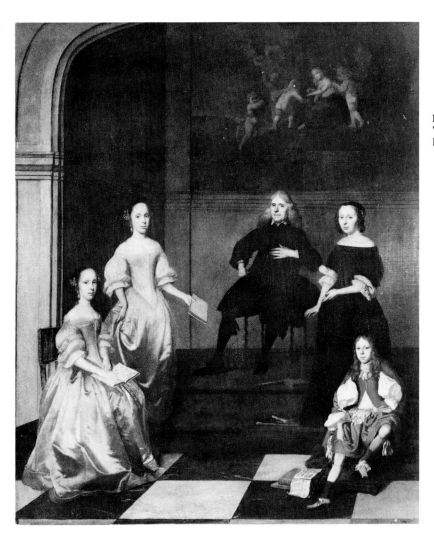

Figure 154. *Family Portrait* (cat. nr. 60). Dienst Verspreide Rijkscollecties, The Hague. On loan to Embassy Stockholm, P.S.v. Gallery, The Hague.

Figure 155. Jan Verkolje, *Family Portrait*, 1671. Foundation, Prof. Dr. L. Ruzicka, Kunsthaus, Zurich.

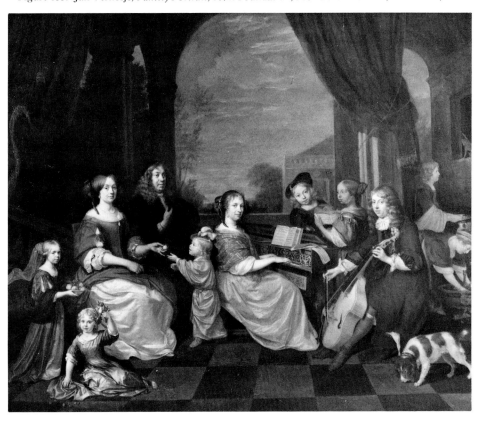

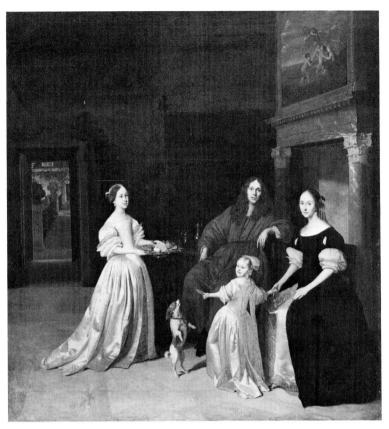

Figure 156. *Family Portrait* (cat. nr. 61), 1670. Országos Szépmüveszéti, Budapest.

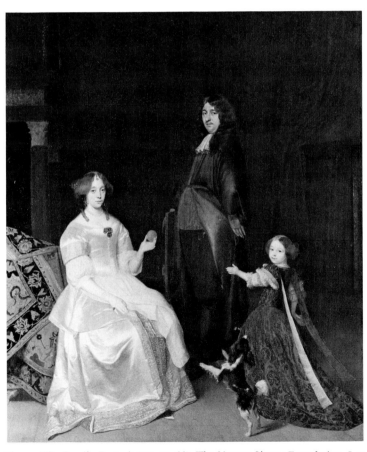

Figure 157. *Family Portrait* (cat. nr. 66). The Norton Simon Foundation, Los Angeles.

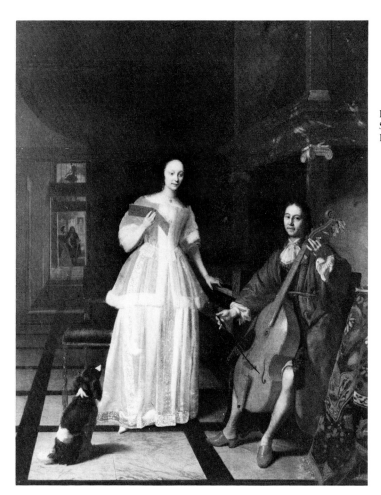

Figure 158. *Portrait of a Couple Making Music* (cat. nr. 81). Städtische Kunstsammlungen, Augsburg. Karl and Magdalene Haberstock Bequest.

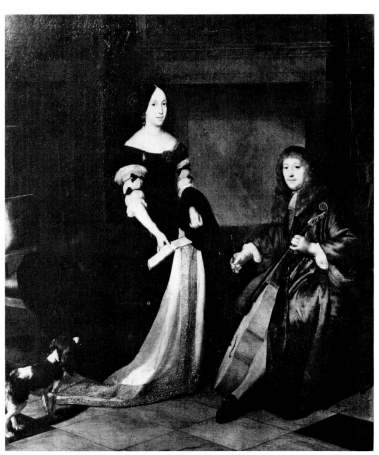

Figure 159. *Portrait of a Couple Making Music* (cat. nr. 90). Private collection, Milan.

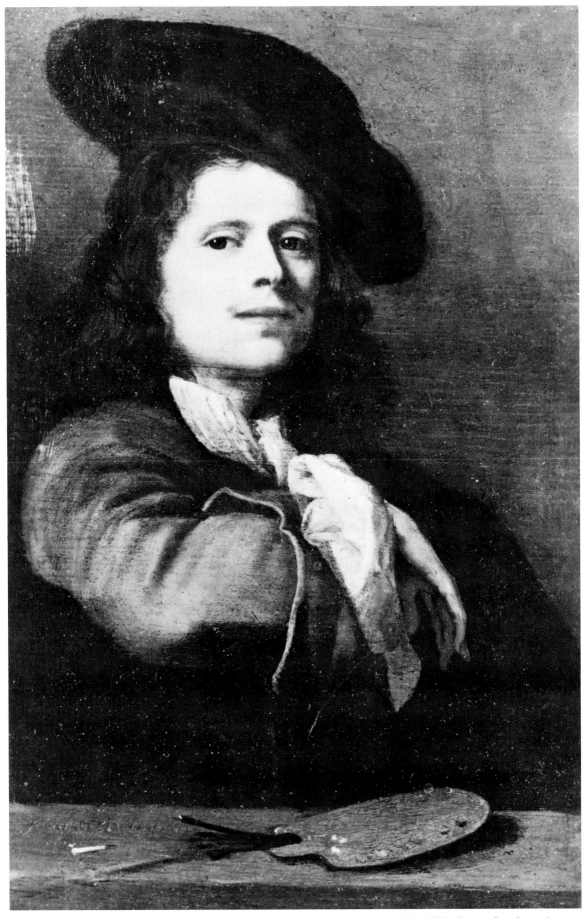

Figure 160. *Self-portrait* (cat. nr. 30), 166(?). Present location unknown.

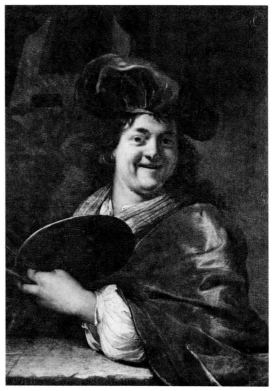

Figure 161. Frans van Mieris, the Elder, *Self-Portrait*. Stedelijk Museum "de Lakenhal," Leiden.

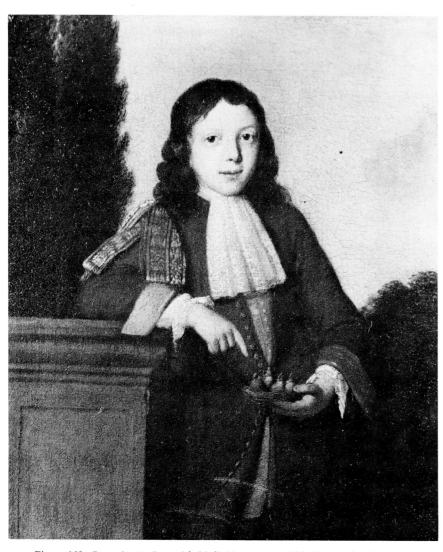

Figure 162. *Portrait of a Boy with Bird's Nest* (cat. nr. 104). Present location unknown.

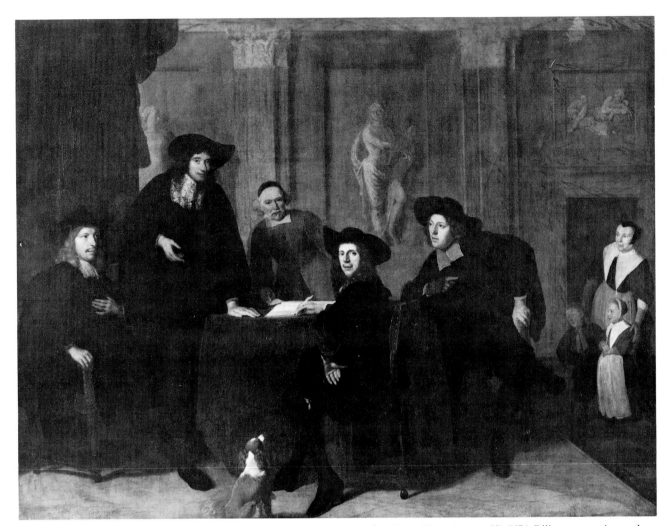

Figure 163. *The Regents of the Amsterdam Leper House* (cat. nr. 82), 1674. Rijksmuseum, Amsterdam.

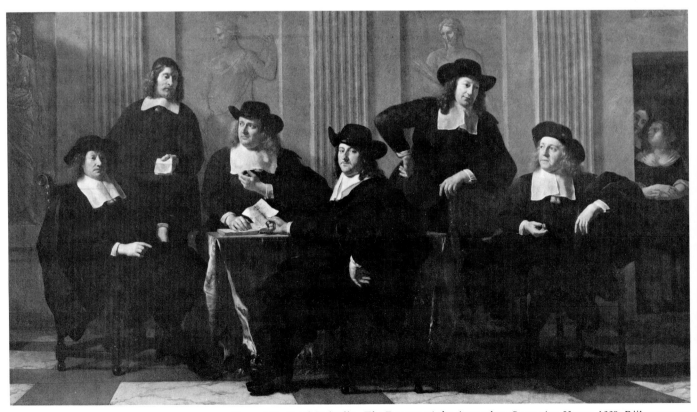

Figure 164. Karel Dujardin, *The Regents of the Amsterdam Correction House*, 1669. Rijksmuseum, Amsterdam.

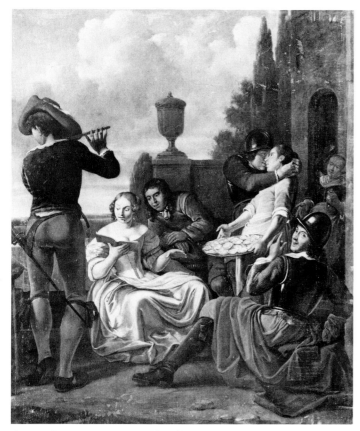

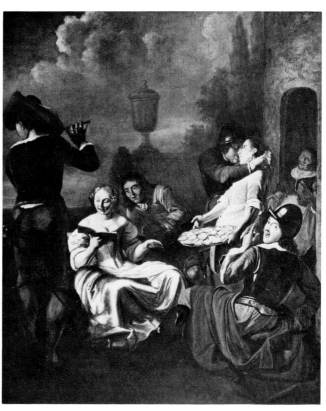

Figure 165. *Merry Company with Soldiers in a Garden* (cat. nr. D-1). Present location unknown.

Figure 166. *Merry Company with Soldiers in a Garden* (cat. nr. D-1A). Present location unknown.

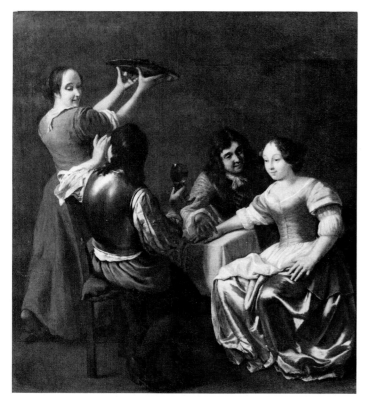

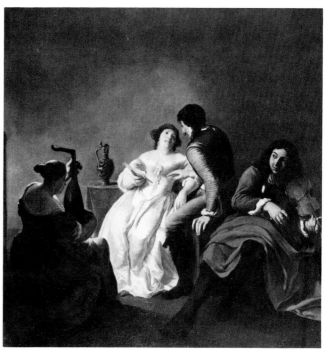

Figure 168. *Four Musicians* (cat. nr. D-3). Alexander Gebhardt Galerie, Munich.

Figure 167. *Two Soldiers, Woman and Maid* (cat. nr. D-2). Private collection, Cologne.

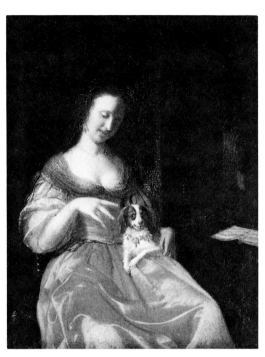

Figure 169. *Girl with Dog* (cat. nr. D-4). Courtesy of the National Gallery of Ireland, Dublin.

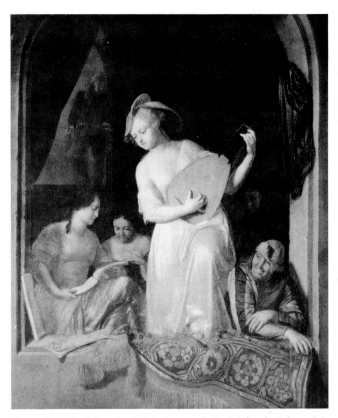

Figure 170. *Musicians in a Niche* (cat. nr. D-5). California Palace of the Legion of Honor, San Francisco. By permission of The Fine Arts Museums of San Francisco.

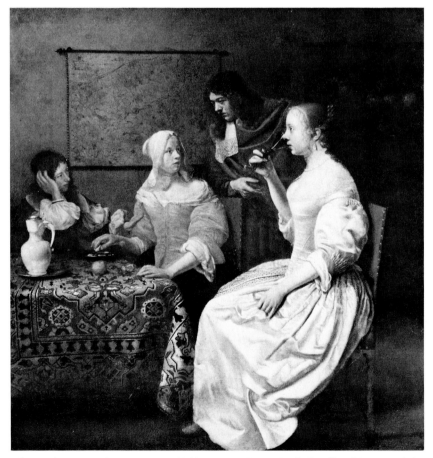

Figure 171. *Merry Company at a Table* (cat. nr. D-6). North Carolina Museum of Art, Raleigh.

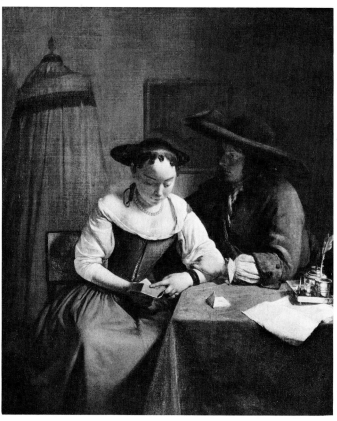

Figure 172. *The Proposal* (cat. nr. D-7). Staatliche Kunsthalle, Karlsruhe.

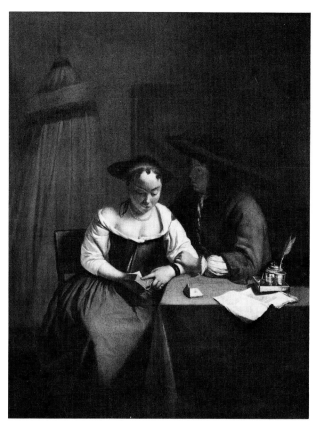

Figure 173. *The Proposal* (cat. nr. D-7A). Present location unknown.

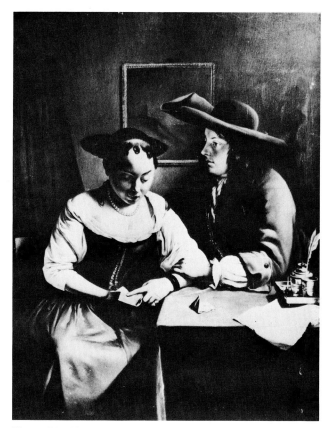

Figure 174. *The Proposal* (cat. nr. D-7B). Present location unknown.

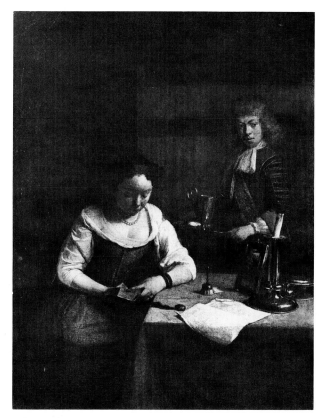

Figure 175. *Woman Reading and Servant* (cat. nr. D-7C). Courtesy of Narodowe Museum, Warsaw.

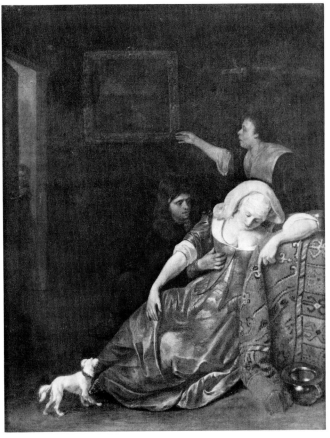

Figure 176. *The Faint* (cat. nr. D-8). Rheinisches Landesmuseum, Bonn.

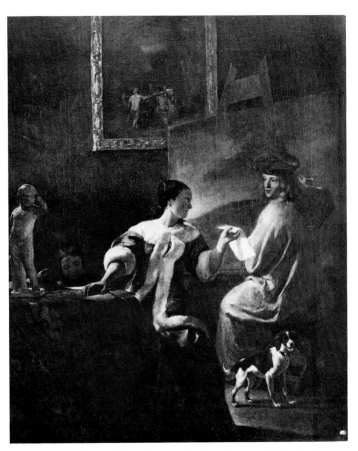

Figure 177. *Artist with a Woman Student* (cat. nr. D-9). Rheinisches Landesmuseum, Bonn.

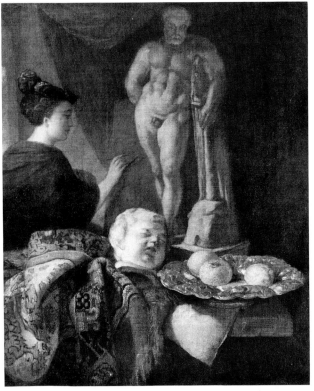

Figure 178. Johannes Voorhout, *Still Life with a Woman at an Easel* (cat. nr. D-10). Worcester Art Museum, Worcester, Massachusetts.

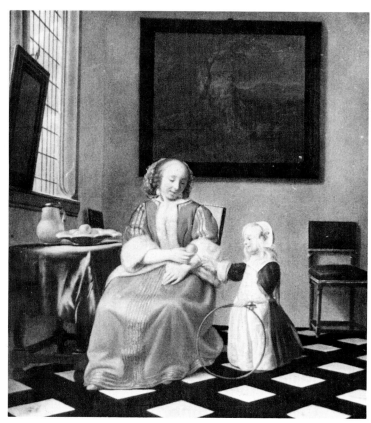

Figure 179. *The Peach* (cat. nr. D-11). Private collection, London.

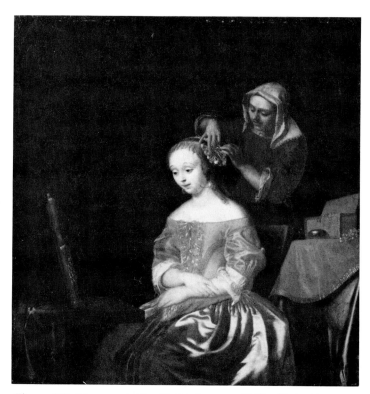

Figure 180. *Woman at Her Toilet* (cat. nr. D-12). Nationalmuseum, Stockholm.

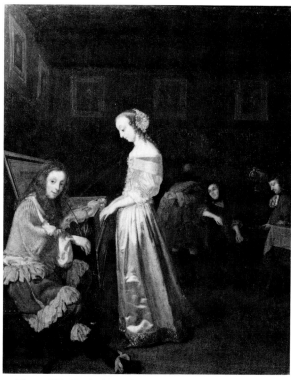

Figure 181. *Musical Interior* (cat. nr. D-13). Nationalmuseum, Stockholm.

209

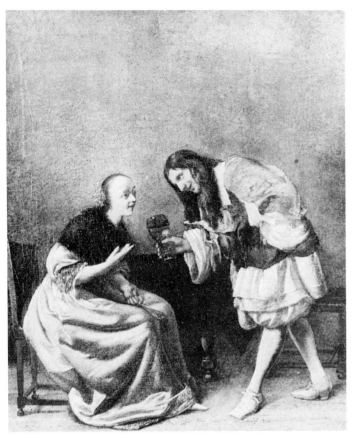

Figure 182. *Offering the Glass of Wine* (cat. nr. D–14). Present location unknown.

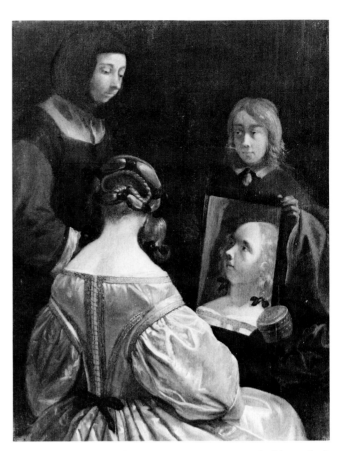

Figure 183. *Woman at the Mirror* (cat. nr. D-15). Musée d'Art et d'Histoire, Geneva.

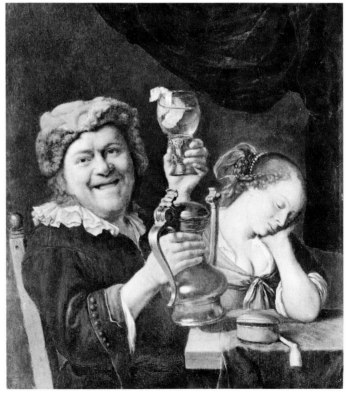

Figure 184. *The Drinkers* (cat. nr. D-16). Bayerischen Staatsgemälde sammlungen, Munich.

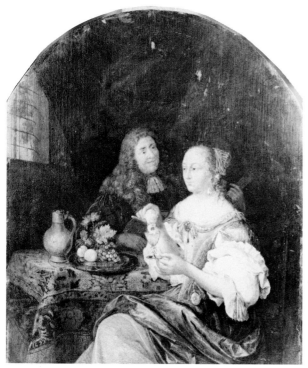

Figure 185. *Lutenist and Woman Drinking Wine* (cat. nr. D-17). Staatliche Kunstsammlungen, Dessau.

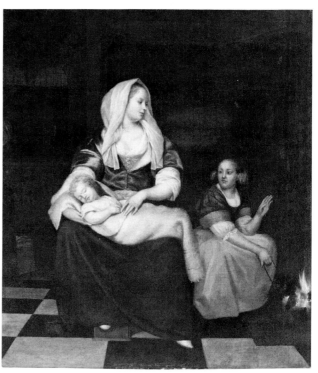

Figure 186. *Mother and Children Before a Fireplace* (cat. nr. D-18). Öffentliche Kunstsammlungen, Basel.

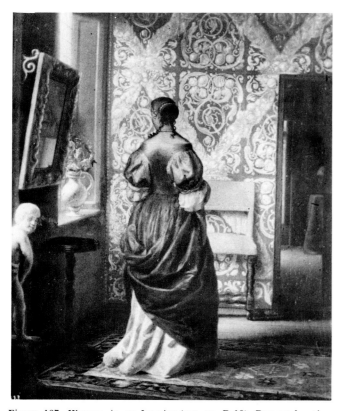

Figure 187. *Woman in an Interior* (cat. nr. D-19). Present location unknown.

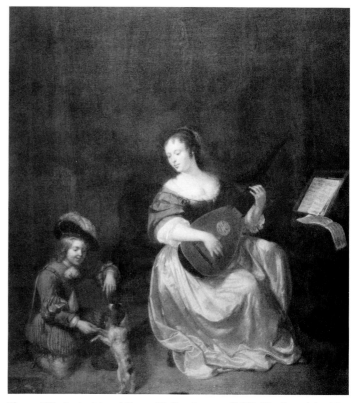

Figure 188. *Lutenist and Boy with Dog* (cat. nr. D-20). Cincinnati Art Museum, Cincinnati. Gift of Mary Hanna.

211

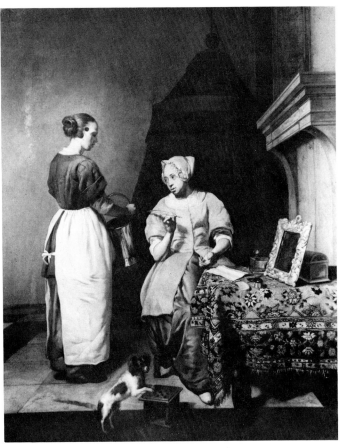

Figure 189. *Letter Writer and Maid* (cat. nr. D-21). Present location unknown.

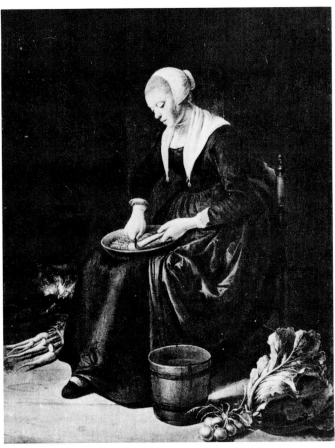

Figure 190. *Woman Preparing Vegetables* (cat. nr. D-22). The Wawel State Collections of Art, Cracow.

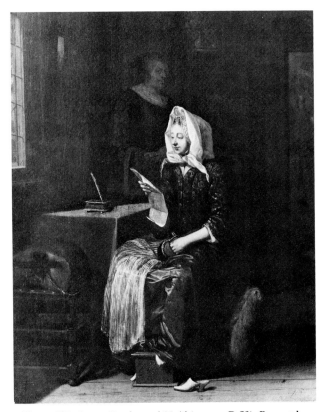

Figure 191. *Letter Reader and Maid* (cat. nr. D-23). Present location unknown.

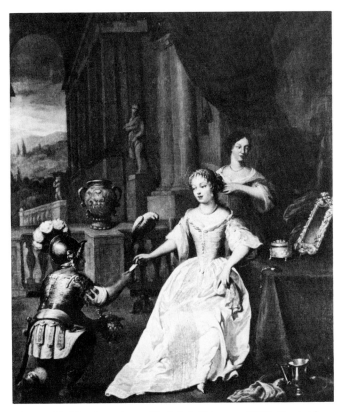

Figure 192. *The Love Letter (Bathsheba?)* (cat. nr. D-24). Present location unknown.

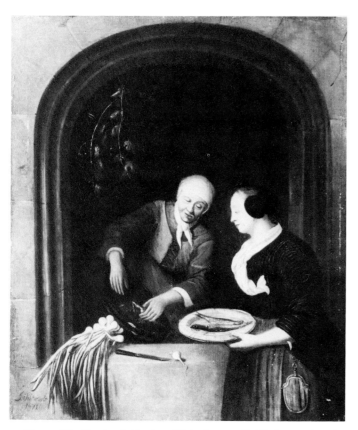

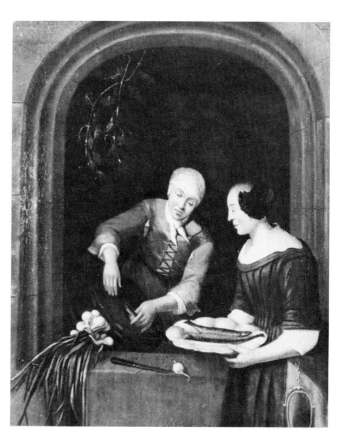

Figure 193. *Herring Seller in a Niche* (cat. nr. D-25). Present location unknown.

Figure 194. *Herring Seller in a Niche* (cat. nr. D-25A). Present location unknown.

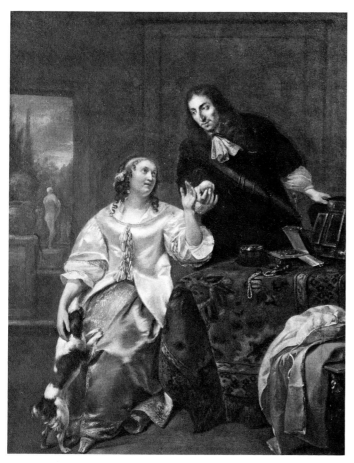

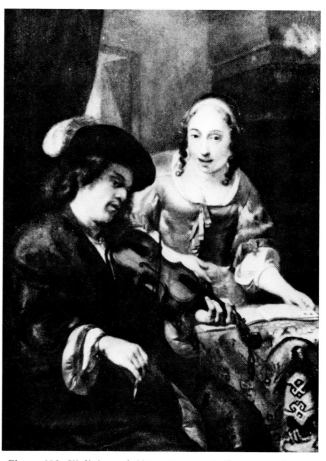

Figure 195. *Man and Woman at a Table* (cat. nr. D-26). Private collection, London.

Figure 196. *Violinist and Singer* (cat. nr. D-27). Present location unknown.

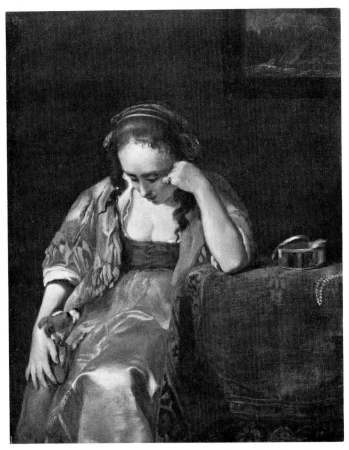

Figure 197. *Woman with Dog* (cat. nr. D-28). Present location unknown.

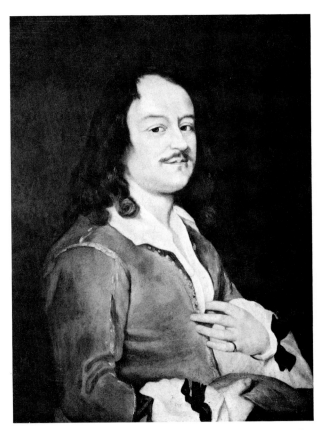

Figure 198. *Portrait of an Artist* (cat. nr. D-29). Koninklijke Musea voor Schone Kunsten van België, Brussels.

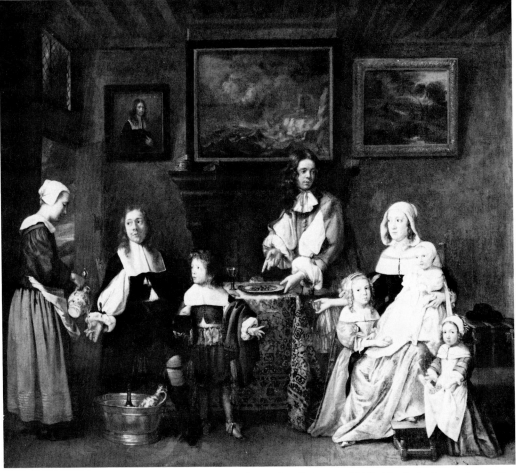

Figure 199. *Portrait of a Family* (cat. nr. D-30). Musée des Beaux Arts, Lille.

Photographic Credits

AMSTERDAM: Collection IJsbrand Kok (Gemeentelijke Archiefdienst), Fig. 1; Kunsthandel Gebr. Douwes, Fig. 14; Kunsthandel Mr. H. Schlichte Bergen B. V. (A. Dingjan, The Hague), Fig. 133; Rijksmuseum (Fotocommissie Rijksmuseum), Figs. 95, 120, 134, 163, 164. ANTWERP: Museum Mayer van den Bergh (A.C.L., Brussels), Fig. 128. AUGSBURG: Städtische Kunstsammlungen, Fig. 158. BASEL: The Kunstmuseum (Öffentliche Kunstsammlungen), Fig. 186. BERLIN: Schloss Grünewald (Verwaltung der Staatlichen), Figs. 9, 117; Berlin-Dahlem Museum (Walter Steinkopf, Berlin), Figs. 59, 121, 153. BIRMINGHAM, ENGLAND: City Museum and Art Gallery, Fig. 78. BONN: Rheinisches Landesmuseum, Figs. 176, 177. BOSTON: Museum of Fine Arts, Fig. 13. BRAUNSCHWEIG: Herzog Anton Ulrich-Museum (Museumfotos B.P. Keiser), Figs. 11, 68. BRUSSELS: Koninklijke Musea voor Schone Kunsten van België (A.C.L.), Fig. 198. BUDAPEST: Szépmüvészeti Museum, Fig. 156. CAMBRIDGE: Fogg Art Museum, Harvard University, Fig. 150; Houghton Library, Harvard University, Fig. 36. CHICAGO: The Art Institute of Chicago, Fig. 75. CINCINNATI: Cincinnati Art Museum, Fig. 188. COLOGNE: Wallraf-Richartz-Museum (Rheinisches Bildarchiv), Fig. 50. COPENHAGEN: Statens Museum for Kunst, Fig. 52. CRACOW: The Wawel State Collections of Art, Fig. 190. DAYTON: The Dayton Art Institute, Fig. 115. DESSAU: Staatliche Kunstsammlungen, Fig. 185. DRESDEN: Staatliche Kunstsammlungen (Deutsche Fotothek), Fig. 53. DUBLIN: National Gallery of Ireland, Figs 20, 71, 169. DÜSSELDORF: Kunstmuseum Düsseldorf, Collection Bentinck-Thyssen, Fig. 96. EINDHOVEN: A. H. Bies Kunsthandel, Fig. 103. FRANKFURT AM MAIN: Städelsches Kunstinstitut (Bildarchiv Foto Marburg), Fig. 69-B, 70. GENEVA: Musée d'Art et d'Histoire, Fig. 183. GLASGOW: Glasgow Art Gallery and Museum, Fig. 61. THE HAGUE: Dienst Verspreide Rijkskollekties, Figs. 37, 148, 154; Mauritshuis (A. Dingjan), Figs. 24, 123; Royal Library, Fig. 143. HAMBURG: Hamburger Kunsthalle (Kleinhempel Fotowerkstätten), Figs. 65, 66. HARTFORD: Wadsworth Atheneum, Figs. 55, 152. KARL-MARX-STADT: Städtische Museum (Foto Nordmann), Fig. 8. KARLSRUHE: Staatliche Kunsthalle, Fig. 172. KASSEL: Staatliche Kunstsammlungen, Fig. 57. LEIDEN: Stedelijk Museum "de Lakenhal" (A. Dingjan), Fig. 161. LEIPZIG: Museum der Bildenden Künste, Figs. 38, 77, 126, 142. LENINGRAD: The Hermitage Museum, Figs. 94, 130, 132. LILLE: Musée des Beaux-Arts, Fig. 199. LONDON: The British Museum, Fig. 118; Ronald Cook (Sotheby Parke Bernet), Fig. 112; St. James's Palace (Photo Studios Ltd.), Fig. 56; The National Gallery, Figs. 88, 105, 107, 146, 149. LOS ANGELES: The Norton Simon Foundation (H. Shickman, New York), Fig. 157. LUGANO/CASTAGNOLA:

Thyssen-Bornemisza Collection (Foto Brunel), Fig. 29. MANCHESTER, ENGLAND: City Art Gallery (Assheton-Bennett Collection), Figs. 25, 26 (Sydney Newbery, London), Figs. 35, 141, 144; City Art Gallery, Fig. 27. MANNHEIM: Reiss-Museum, Fig. 46. MOSCOW: Pushkin Museum, Fig. 135. MUNICH: Bayerischen Staatsgemäldesammlungen, Figs. 116, 184; Alexander Gebhardt Galerie, Fig. 168. MÜNSTER: Westfälisches Landesmuseum, Fig. 62. NEW HAVEN, CONN.: Yale University Art Gallery, Fig. 12. NEW YORK: The Frick Collection, Fig. 76; The New-York Historical Society, Fig. 87. NORFOLK, VA.: Walter P. Chrysler, Jr. Collection (Chrysler Museum), Fig. 16. OSNABRÜCK: Stadtisches Museum (Maria-Th. Seelig-Bothe), Fig. 4. PARIS: The Louvre (Service de documentation photographique), Fig. 85. PITTSBURGH: The Carnegie Institute of Art, Fig. 90. PRAGUE: Národní Galerie, Fig. 23. RALEIGH: North Carolina Museum of Art, Fig. 171. RICHMOND, VA.: Virginia Museum of Fine Arts (Cooper), Fig. 151. ROTTERDAM: Museum Boymans-van Beuningen, Fig. 40; (Dick Wolter, Ovezande) Fig. 44; (A. Frequin, Voorburg) Fig. 45. ST. LOUIS, MO.: The St. Louis Art Museum, Fig. 122. SAN FRANCISCO: California Palace of the Legion of Honor, Fig. 170. SCHWERIN: Staatliches Museum, Fig. 98. SOLLEBRUN, SWEDEN: Marie Andrén Collection (H. Bukowski, Stockholm), Fig. 22. STOCKHOLM: Nationalmuseum, Figs. 81, 111, 180, 181. TOLEDO, OHIO: Toledo Museum of Art, Fig. 2. VENICE: Ca' d'Oro (Cameraphoto), Fig. 110. VERVIERS, BELGIUM: Musées Communaux, Fig. 113. VIENNA: Kunsthistorisches Museum, Fig. 145. WARSAW: Narodowe Museum, Fig. 175. WINTERTHUR: Oskar Reinhart Collection "Am Römerholz," Fig. 21. WORCESTER, MASS.: Worcester Art Museum, Fig. 178. WORMS: Stiftung Kunsthaus Heylshof, Fig. 109. YORK, ENGLAND: York City Art Gallery (K. Pettinger), Fig. 138. ZOLLIKON/ZURICH: Galerie Bruno Meissner, Fig. 60; E. G. Bührle Collection, Fig. 48; Galerie Kurt Meissner, Fig. 73; Kunsthaus (Ruzicka Foundation), Figs. 67, 155. PRIVATE COLLECTIONS: AMSTERDAM (Kunsthandel P. de Boer), Fig. 19; COLOGNE (Galleria G. Caretto, Turin), Fig. 167; GERMANY (T. Brod Gallery, London), Fig. 83; ENGLAND (E. Speelman Ltd., London), Figs. 33, 137; (Christie's, London) Fig. 54; (Duits, London) Fig. 99; (Sotheby's, London) Fig. 147; LONDON (City of Birmingham Art Gallery) Fig. 43; Figs. 179; 104; MILAN (K. Meissner, Zurich) Fig. 159; PARIS (National-museum, Stockholm) Fig. 39; SWITZERLAND (Galleria G. Caretto, Turin) Fig. 100; WEST GERMANY (Rheinisches Bildarchiv, Cologne) Fig. 49. PRESENT LOCATION UNKNOWN: (Bayerische Staategemälde-sammlungen, Munich) Figs. 5, 41; (J. Böhler, Munich) Figs. 15, 191; (Christie's, London) Fig. 173; (City of Birmingham Museum and Art Gallery) Fig. 34; (Galerie Sanot Lucas, Vienna) Fig. 101; (Kunsthandel P. de Boer, Amsterdam) Figs. 127, 189; (B. Mason, Dublin) Fig. 92; Rücker, Frankfurt am Main) Fig. 17; (Staatsgalerie, Stuttgart) Fig. 197; (C. van Ham, Cologne) Fig. 97.

APPENDIX

Appendix: Documents

Documents in the Appendix are listed in chronological order. The archival reference is followed in each case by an English summary of the contents of the document. Transcriptions of the original Dutch texts have also been included, except for brief archival entries (records of baptisms, marriages, etc.) and documents witnessed by Ochtervelt that do not relate directly to the artist or his family.

September 6, 1626.

> *Doopboek Nederduits-Gereformeerde Gemeente Rotterdam, 1626-28, Retroacta burgerlijke stand Zuid-Holland, inventaris Brouwer, afdeling Rotterdam, nr. 2.*

Baptized: Heinderickge; parents: Lukas Heinderix and Trindtge Jans; witnesses: Brechtge Pieters and Aereyaentgen.

April 19, 1631.

> *Doopboek Nederduits-Gereformeerde Gemeente Rotterdam, 1629-34, inventaris Brouwer, nr. 3.*

Baptized: Pieter; parents: Luckas Heinderickse and Trindtge Jans; witness: Grietge Jans.

1632–35.

> "Blaffert van de wedden ofte pensioenen die de stadt Ṙotterdam jaerlicx uutkeert 1632-35." This salary list is contained in a volume entitled: *Blaffaard van de vaste stedelijke inkomsten en uitgaven, 1626-1645.*

Lucas Hendricksz. and Adriaen Bastiens are appointed bridgemen of the Roode Brugge as replacements for Lucas Willems and Evert Tonis, at an annual salary of twelve pounds, payable each year by the first of April. The exact date the appointments were made is not specified. (The names underlined in the salary list indicate the men who were replaced.)

Adriaen Bastiaens
<u>Lucas Willems</u> ende Lucas Henricxs
<u>Evert Tonis,</u> van den roode brugge opt hooft waer te nemen elcx 12 ƒ XXIIII ƒ
den lesten april

219

February (1?), 1634.

Doopboek Nederduits-Gereformeerd Gemeente Rotterdam, 1629–34, inventaris Brouwer, nr. 3.

Baptized: Jacobus; parents: Lucas Heinderickse and Trindtge Jans. (The day of the month of this entry is not clearly legible, but it appears to be a "1.")

April 4, 1636.

Doopboek Nederduits-Gereformeerde Gemeente Rotterdam, 1634–36, inventaris Brouwer, nr. 4.

Baptized: Achtgen; parents: Lukas Heinderickse and Trindtge Jans.

November 1, 1639.

Trouwboek Nederduits-Gereformeerde Gemeente Rotterdam, 1638–41, inventaris Brouwer, nr. 58.

Jan Lucasz. Ochtervelt, young man, living in the Capiteyn Iemantssteech and Triyntgien Eduwaerts, living in the Vranckestraet, both born in Rotterdam, married on November 1st, having published the banns on October 9, 1639. (Note: no record of Jan Ochtervelt's baptism has been found in the Rotterdam archives.)

December 14, 1655.

Trouwboek Nederduits-Gereformeerde Gemeente Rotterdam, 1655–60, inventaris Brouwer, nr. 62.

Jacobus Ochtervelt, young man of Rotterdam living in the Wagenstraet and Dirckjen Meesters, young woman of Rotterdam "op de Beurs" (living near the Exchange?), married on December 14th, having published the banns on November 28, 1655.

December 16, 1657.

Memoriaal der overledenen van Weesmeesteren van Rotterdam, 1657–76, Archief Weeskamer Rotterdam, inventaris Moquette, nr. 272.

Deceased: Lukas Hendricksz. Ochtervelt, widower, who lived in the Krattensteech.

December 28, 1657.

Resolutien van het College van Burgemeesteren van Rotterdam, 1646–60, f. 147 vo (28 December 1657).

Dirc Willemsen is appointed bridgeman of the Roode Brugge to replace Lucas Henrixsen, deceased. Present: G (erardt) van Berghen, burgermeester.

Is Dirc Willemsen geadmiitteert als bruggewachter van de helffte van de roode brugge in plaetse van Lucas Henrixsen saliger gedachtenis, present G. van Berghen, burgermeester.

December 23, 1661.

Archief Weeskamer Rotterdam, inventaris Moquette, nr. 327.

Maria Goverts, widow of Pieter de Bloot, makes her will before the Rotterdam notary Pieter Winckelmans. Witnesses: Jacob Ochtervelt "meester schilder" and Johannis Jorisz. Goethals, both of Rotterdam. (The will entered the Weeskamer Archives on February 23, 1668.)

September 8, 1664.

Notariële archieven Rotterdam, 1585-1811, inventaris Wiersum, nr. 859, akte nr. 74.

Jannetje Sijmens makes her will before the notary Dirck Meesters. Witnesses: Jacobus Ochtervelt and Roelant Henricsz. Wecke.

July 30, 1665.

Resolutiën van het College van Burgemeesteren van Rotterdam, 1660-78, f. 59 en vo.

Jacob Ochtervelt and five members or relatives of the Meesters family (Jan Meesters, Dirck Meesters, Jan Meesters the younger, Magdaleena Post, and Jacob Scheffens) draw up an agreement concerning the upbringing and education of Andries Meesters, the orphan son of Joris Meesters and Eva de Swaen. It is decided that Andries will be sent to school in Sprangh for two years to learn reading, writing, and ciphering. Afterward he will be trained in some craft or profession at which he can make his living. Jacob Scheffens (relative of the late Eva de Swaen) agrees to contribute 40 percent of the costs and to share the guardianship of the boy with Dirck Meesters. Dirck Meesters and the other contracting parties agree to contribute 60 percent of the costs among themselves. Any dispute will be submitted to the College of Burgermeesters of Rotterdam, including the question of how much each paternal relation of the child will contribute to the said 60 percent of the costs. Witness: A. Sonmans.

Wij, ondergeseyde vrunden ende bloetverwanten van 's vaders zijde, ende Jacob Scheffens, bloed-verwant van 's moeders zijde van Andries Meesters naergelaten outste soontje van Joris Meesters ende Eva de Swaen zaliger, alle woonende tot Rotterdam, bekennen metten anderen door inter-cessie ende tusschenspreecken van d'Heer Johan de Reus, burgermeester deser stad, nopende het onderhout ende opvoedinge van de voorseyde Andries Meesters te zijn geaccordeert ende verdragen in deser maniere.

Dat denselven Andries Meesters voor den tijt van twee jaren tot Sprangh sal werden schoole gelecht ofte besteet omme aldaer wel te leeren lesen, schrijven ende cijveren. Ende daernaer denselven alsdan te doen leeren een goet ambacht ofte ander eerlijck exercitie, daertoe hij, Andries Meesters, best bequaem ende sijn cost in tijt ende wijle mede sal cunnen verdienen.

In alle hetwelcke ik, ondergeseyde Jacob Scheffens, aengenomen hebbe ende mijnselven bij desen verbinde te betalen de summe van veertich guldens ten hondert, ende wij, ondergeseyde vrunden van 's vaders zijde, gesamentlijck de summe van tsestigh guldens ten hondert.

Doch alles onder dese conditie, dat alleen ik, Scheffe, ende Dirck Meesters, sullen moeten hebben het toesicht, gesach ende voogdije van de voorseyde Andries Meesters. Ende dat dienvolgende alle hetgundt bij ons, ondergeseyden, ten voordele van 't voorseyde kint soude mogen werden gedaen ende verricht, bij de verdere vrunden sal moeten werden geapprobeert.

Ende in cas over 'tgene voorseyt staet t'eeniger tijt eenige questie ofte oneenicheden soude mogen comen te resulteren, verclaren wij, ondergeseyden, gesamentlijck deselve questie ende verschillen— hoedanich die soude mogen wesen—absolutelijcken te hebben gesubmitteert ende verbleven in de finale uytspraecke van de Edele Achtbare Heeren Burgermeesteren deser stad, in der tijt zijnde. Gelijck wij, ondergeseyde vrunden van 's vaders zijde aen Haer Edele Achtbaren bij desen mede submitteren ende absolutelijcken verblijven het geschil tusschen ons, ondergeseyden, nament-

lijcken hoeveel bij yder van ons in de voorseyde sestich ten hondert sal moeten werden gecontribueert, voldaen ende betaelt.

Beloovende wij, ondergeseyde, den voorseyde contracte ende te doene uytspraecke in allen deelen punctuelijcken te sullen achtervolgen ende naercoomen, sonder daerjegen oyt te comen in relieff off reductie, als daervan bij desen wel specialijck renunciërende ende afstandt doende. Daeronder verbindende onse respective persoonen ende goederen, geen uutgesevt, ten bedwangh van alle rechten ende rechteren.

Actum in Rotterdam, den 30sten july 1665.

(Was getekend:) Jan Meesters; Jacob Scheffens; D. Meesters; 1665; Jan Meesters de jonge; Jacob Ochtervelt; Magdaleena Post, als last hebbende van min man, Mathijs Meesters; mij praesent als getuyge, A. Sonmans.

January 7, 1666.

Chronologische lijst van voogden, die na het afleggen van de voorgeschreven eed door Weesmeesters tot de voogdij zijn toegelaten, 1650-70, Archief Weeskamer Rotterdam, inv. Moquette, nr. 550, f. 432.

Jacob Ochtervelt, painter, and Willem Jansz., cabinet maker, are appointed guardians of the orphaned children of Trijntgen Eduwaerts and Jan Lucasz. Ochtervelt, who died on a return voyage from the East Indies.

Jacob Ochterveldt, schilder, is genordonneert als medevoogt (nevens Willem Jansz., schrienwerker) over de naergelatene weeskinderen van Jan Lucasz. Ochterveldt, in Oostindiën in de wederomreyse overleden, daer moeder af was Trijntgen Eeduwaertsdochter, onder etc. Actum ut supra.

January 28, 1666.

Doopboek Nederduits-Gereformeerde Gemeente Rotterdam, 1664-70, inventaris Brouwer, afdeling Rotterdam, nr. 12.

Baptized: Maria; parents: Dirck Meesters and Berbra Elsievier. Witnesses: Jacob Ogtervelt, Symon Elsievier, and Marya de Gelder.

February 2, 1666.

Notariële archieven Rotterdam 1585-1811, inventaris Wiersum, nr. 858, akte nr. 26.

Seigneur Hendrick Mechels declares, before the notary Dirck Meesters, that he will lease a house on the south side of the Hoogstraet in Rotterdam to Seigneur Louys Elsievier, who agrees to rent the house. Witnesses: Mattijs Meesters, Jacob Ochtervelt, and Pieter de Jongh.

March 24, 1666.

Notariële archieven Rotterdam 1585-1811, inventaris Wiersum, nr. 397, akte nr. 292.

Jacob Jansz. Peur, bridgeman of the Roode Brugge of Rotterdam, about 53 years of age, and Jan Gerritsz. Bock, sword cuttler, and citizen of Rotterdam, about 43 years of age, testify at the request of Jacob Lucasz. Ochtervelt, the widow and children of Jan Lucasz. Ochtervelt, Willem Jansz. Verwissel (the husband of Heindrickje Lucas Ochtervelt), Aechje Lucas Ochtervelt (unmarried, of age, living in Amsterdam), and the orphan child of Stijntge Lucas Ochtervelt. They testify that they

were fully acquainted with Lucas Hendricksz. Ochtervelt and his wife Trijntge Jans of Rotterdam and also with their son Pieter Lucasz. Ochtervelt of Rotterdam. Pieter had gone to the East Indies as a gunner on board the "Schiedam" of the Department of Delft of the *Verenigde Oostindische Compagnie* in 1648 and died there in 1657. They declare that they also know the requisitionists very well as full brothers and sisters or the children of full brothers and sisters of Pieter Ochtervelt, and therefore heirs to his estate. As proof of their testimony, they declare that they have been neighbors and friends of the Ochtervelts for many years and that Jacob Peur had been the companion bridgeman of Lucas Ochtervelt for thirteen years. Notary: Jacob Delphius. (This document contains the only known reference to Ochtervelt's sister, Stijntge.)

Op huyden, den 24sten martii anno 1666, compareerden voor mijn, Jacob Delphius, notaris publycq, bij den Hove van Hollant geadmitteert, residerende tot Rotterdam, ende voor den naergenoemden getuygen, Jacob Jansz. Peur, brughwachter van den Roodebrugge alhier, out 53, ende Jan Gerritsz. Bock, swaertveger ende burger alhier, out 43 jaren, of elcx daerontrent.

Dewelcke bij haerlieden mannen waerheyt, in plaetse van eede, ter requisitie ende versoucke van Jacob Lucasz. Ochtervelt, de wedue ende kinderen van Jan Lucasz. Ochtervelt, ende Willem Jansz. Verwissel, getrout hebbende Heindricje Lucas (doorgenaald: getuycht ende verclaert hebben) Ochtervelt, item Aechje Lucas Ochtervelt, ongehoude meerderjarige dogter, woonende tot Amsterdam, ende 't weeskint van Stijntge Lucas Ogtervelt zaliger, alhier overleden, getuycht ende verclaert hebben, zooals zijn doen bij desen, waer te zijn, dat zij, deposanten, wel hebben gekent Lucas Heindericxsz. Ochtervelt ende Trijn Jans, in haer leven echteluyden, alhier gewoont hebbende, mitsgaders Pieter Lucasz. van Rotterdam, desselfs soone, die anno 1648 voor bosschieter is gevaren naer Oostindiën, wegen de Camer tot Delft, met het schip genaemt "Schiedam," ende in den jaere 1657, zoo men verstaet, in Oostindiën is overleden, volgens bijgaende bescheyden. Ende dat zijluyden oock alsnoch wel zijn kennende de voorsz. requiranten. Ende mitsdien oock wel weten dat de voorn. requiranten zijn volle broeders ende susters, ofte volle broeders—ende susterskinderen, ende zulcx eenige erffgenaemen ab intestato van den voorsz. Pieter Lucasz. van Rotterdam, in Oostindiën overleden, zonder, datter oock eenige erffgenaemen van denselven meer zijn.

Gevende voor redenen van welwetenschap zij, deposanten, dat zij van over veele ende lange jaren zijn oude gebuyren ende bekenden geweest van den voorn. Lucas Heinderixsz. van Ochtervelt ende Trijn Jans ende haer voorsz. kinderen, van dat de voorsz. Jacob Jansz. den tijt van dertien jaren de voorsz. brugge neffen de vader heeft bedient. Ende dat zij mitsdien van 'tgene voorsz. is sekere ende vaste kennisse zijn hebbende. Presenterende etc.

Aldus gedaen ende gepasseert binnen der voorsz. stadt Rotterdam, ter presentie van Cornelis de Rij ende Andries Sempel, mijnen clercquen, als getuygen hiertoe gerequireert.

(Was getekend:) Jacob Janse Poer; Jan Gerritse Bock; Andries Sempel, 1666; Cornelis de Rij; Jacobus Delphius, notaris publycq, anno 1666 24 3.

April 4, 1666.

Notariële archieven Amsterdam, nr. 2076, fol. 177-178v.

Achtgen Lucas Ochtervelt appears before the Amsterdam notary J. Hellerus in order to draw up her will. She is the wife of Olivier Meyersz., a sailor on the ship "De Spiegel" with the vice-admiral Van der Hulst, and living in the Egelantiersstraet "over 't Wapen van Engeland" (probably a pub). As witnesses, two of her neighbors appear: Jan Barensz., a lace worker, and Hendrick Sickesz., a ribbon worker. They declare that they are fully acquainted with Achtgen and testify that she is of sound health, mind, and memory. Having "willed" her soul to God and her body to the earth, she states that all her personal property, assets and credits, etc., is to be left to her husband Olivier Meyersz.,

with the provision that after her death, he settle the sum of six Carolus guilders upon her nearest heirs. This arrangement is to stand as her last will and testament, as long as she remains without children by her husband.

(Note: Since the Rotterdam document of March 24, 1666, describes Achtgen as an unmarried resident of Amsterdam, the term "huysvrou" used in this declaration should probably be interpreted as common-law wife.)

In den name des Heeren, Amen. Kennelijck zij eenen ijgelijck bij dit jegenwoordich publycq instrument, dat in den jare onses Heeren ende Salichmakers Jesu Christi 1666 op den 4en dagh des maent aprilis, des nademiddaghs de clocke ontrent vier uyren, voor mij Joannes Hellerus notaris etc. ende de nabeschreven getuygen personelijck gecomen ende verschenen is Aeghje Lucas Ochtervelt, huysvrou van Olivier Meyersz., aengenomen om te varen voor bootsgesel op 't schip De Spiegel met den vice-admirael Van der Hulst, wonende in den Egelantiersstraet over 't Wapen van Engeland, den nabeschreven getuygen bekend, cloeck ende gesond, haer verstand, memorie ende sprake ten vollen gebruyckende soo 't opentlijck scheen ende bleeck, dewelcke door overdenckinge des doots verclaerde gemaeckt te hebben haer testament ende uytterste wille in manieren navolgenden. In den eersten haer siele Gode almachtich ende haer doode lichaem d'aerde bevelend heeft voorts tot haer eenig ende universele erfgenaem in alle haer na te laten goederen, roerende, onroerende, actiën, creditie ende gerechticheden, gene uytgesondert, geïnstittueert ende genomineert gelijck zij institueert ende nomineert mits desen de voorsz. Olivier Meyersz., haer man, behoudelijck dat denselve daeruyt sal moeten uytkeeren ende voldoen aen haer naeste erfgenamen ab intestato als den indertijt zijnde de somme van ses Carolus guldens eens, die zij testatrice aen selve is legaterende, en dit alles in cas zij testatrice sonder kind off kinderen bij haer voorsz. man geprocreëert na te laten aflijvich wert. Alle 't welcke zij testatrice verclaerde te wesen haer testament ende uytterste wille, willende dat alle 't selve volcomen cracht sal hebben ende effect sorteren, 't sij als testament, codicille off eenig andere uytterste wille, soo ende sulx alle 't selve best nae rechten ende goedertieren gewoonten subsisteren ende bestaen can, niettegenstaende eenig nodig solemniteyten ende rechten in desen niet geobserveert bevonden mochten werden, begerende 't uytterste voorsz. beneficium aen desen te genieten, versoekende aen mij notaris hiervan een off meer instrumenten in forma. Aldus gedaen ende gepasseert ten woonstede mijns notaris, gestaen op de Egelantiersgraft alhier, in 't bijsijn van Jan Barensz., passamentwercker, ende Hendrick Sickesz., lintwercker, buyren van testatrice, als getuygen hiertoe versocht ende gebeden, die verclaerden de testatrice wel te kennen ende te zijn soodanich als zij haer in desen noemt ende baptiseert.

Letteren gestelt bij Aeghje Lucas voornt. (NN)

Merck gestelt bij Jan Barensz. voornt. (NN)

Merck gestelt bij Hendrick Sickersz. voornt. (NN)

Quod attestor J. Hellerus, nots. publ., anno 1666.

May 28, 1666.

"Gifteboeken." Akten van transport van onroerend goed ten overstaan van schepenen van Rotterdam, 1664-67; Archief schout end schepenen van Rotterdam, inv. nr. 519, f. 185.

A house and property that had belonged to Jan Lucasz. Ochtervelt is sold by Annetgen Ariëns (widow of Adam Jansz. van Cleeff and Jan Lucasz. Ochtervelt) and by Adriaen Adamsz. van Cleeff, Jacob Ochtervelt, painter, and Willem Jansz., cabinetmaker. The latter two are the guardians of the children from the marriage of Jan Lucasz. Ochtervelt and Trijntge Eduwaerts. The house, which stands on the east side of the Langelijnstraet in Rotterdam, is sold for 1,113 guilders and 15 stuivers to Bartel Bartelsz., a carpenter.

Den 28sten mey 1666.

Annetgen Ariëns, eerst weduwe van Adam Jansz. van Cleeff ende laest van Jan Lucasz. Ochtervelt, Adriaen Adamsz. van Cleeff, Jacob Ochtervelt, schilder, ende Willem Jansz., schrijnwercker, als geordonneerde vooghden over de naergelate weeskinderen van den voorn. Jan Lucasz. Ochtervelt, daer moeder aff was Trijntge Eduwaerts, hebben de voorn. vooghden hiertoe van de Edele Achtbare Heeren van de Weth deser stadt speciaele acte van authorisatie, gestelt in margine van seker requeste tot dien eynde aen Haer Edelen gepresenteert, van date den 16den january 1666, ons schepenen geëxhibeert.

Ende geven aen Bartel Bartelsz., timmerman, gifte ende eygendom van een huys ende erve, staende ende gelegen aen de oostsijde van de Langelijnstraet alhier, belent ten noorden Trijntge Pauls ende ten zuyden Lambert Gerritsz., streckende voor van de straet tot achter aen de sloot toe, geregistreert op no 2962, wijders met soodanige vrijdommen, conditiën, servituyten, recht ende gerechtigheyt als het voorsz. huys ende erve hebbende ende lijdende, mitsgaders tot desen dage toe gebruyct ende gepossideert is volgens de oude giften ende andere bescheyden daervan sijde, die aen den cooper sullen werden overgelevert omme hem daernaer te reguleren, vrij ende niet belast.

Stellende zij, comparanten, in desen tot waerborge de voorsz. oude giften ende de waerborge daerinne gemelt ende voor den tijt van haer ende den overledens possessie haer, comparante, ende de voorsz. weeskinderen persoon ende goederen.

Ende bekend van de coop, cessie ende everdrachte deses voldaen ende betaelt te wesen met de somme van elff hondert dertien gulden ende vijftien stuyvers, bij haer, comparenten, in gereden gelde ontfangen.

Alles sonder fraude.

(Was getekend:) R. Visch; H. van Zoelen.

December 1, 1666.

Notariële archieven Rotterdam 1585–1811, inventaris Wiersum, nr. 860, akte nr. 77.

Seigneur Adriaen Hogendijck settles a debt owed to Isbrant Siere, before the notary Dirck Meesters. Witnesses: Jan Meesters the younger, drill sergeant ("drilmeester") and Jacobus Ochtervelt.

December 14, 1666.

Notariële archieven Rotterdam 1585–1811, inventaris Wiersum, nr. 860, akte nr. 93.

Jacob Ochtervelt agrees, before the notary Dirck Meesters, to rent a house from Hendrickge Dirckx, the widow of Jan Jansz. van Bockhoult. The house, which is on the north side of the Hoogstraet and at the west side of the house called "Brabantse Anna," is to be rented for two years beginning May 1, 1667, with an option to rent for four years altogether. The rent is 190 guilders per year.

Op huyden den 14de december 1666 compareerde voor mij Dirck Meesters, notaris publycq etc., de eerbare Henrickge Dirckx, weduwe Jan Jansz. van Bockhoult.

Dewelcke bekende ter eenre verhuyrt ende Jacobus Ochtervelt ter andere zijde in huyr aengenomen te hebben haar verhuyrsters huysinge ende erve, staende ende gelegen aen de noortsijde van de Hoogstraet, belent ten oosten in de wandelinge genaamt "Brabants Anna," ende ten westen Arien Jorissen, streckende voor van de straet het voorsz. huys tegen het packhuys van de verhuyrster ende met een gange tot achter op de sloot toe, voor den tijt van vier jaren vast ten reguarde van de verhuyrster, ende ten reguarde van den huyrder twee jaren vast ende het derde ende vierde jaer in sijn obtie. Des dat hij, huyrder, den verhuyrster in cas van verhuysen nopende het voorsz. derde ende

vierde jaar vier maanden tevooren sal moeten waarschouwen. Voor welcke huyr den huyrder bij desen belooft jaarlijcx te voldoen ende betalen de somme van hondert ende tnegentich guldens, alle half jaren de gerechte helfte, innegaande de voorsz. huyr den 1sten mey 1667, waarvan het eerste half jaar huyshuyr ommegecoomen ende verschenen wesen sal den 1sten november 1667, geduyrende alsoo van half jaar tot half jaar ter expiratie van de voorsz. huyr toe. Onder dese verder conditie dat den verhuyrster de tusschenmuyr staande op den achtercamer sal moeten omveersmijten tot ruyminge van deselve kamer ende deselve kamer weder bequaem repareren, alsmede de rechtbank in de benedenkeucke staande doen afbreecken ende de plaets behoorlijcken repareren, gelicjck de verhuyrster mede alleen moet dragen de schattinge die van de voorsz. huysinge moet werden betaalt.

Tot naarcoominge van 'tgeen voorsz. staat verbinden partijen hierinne hare respective persoonen ende goederen, geen uutgesondert, ten bedwang specialijcken van den Hove van Hollandt ende alle andere gerechten ende rechteren.

Aldus gepasseert binnen Rotterdam, ter presentie van Willem le Chasteleyn ende Abraham Borremans, mijne clercquen, als getuygen van gelove hierover gerequireert.

(Was getekend:) Jacob Ochtervelt.

February 16, 1667.

Register van acten betreffende de ontheffing uit de voogdij of de curateele, 1648-80, Archief Weeskamer Rotterdam, inventaris Moquette, nr. 740.

The "Weesmeesteren" (orphans' trustees) of Rotterdam release Grietgen Jans, daughter of Jan Lucasz. Ochtervelt, from the guardianship of Jacob Ochtervelt and William Jansz. Verwissel, after being informed by the guardians that their charge is of sufficient ability and age (twenty-five years) to handle her own affairs. The guardians are ordered to give Grietgen her property as soon as possible.

Den 16den february 1667.

Weesmeesteren der stadt Rotterdam, gelet op het te kennen geven van Grietgen Jans, dochter van Jan Lucasz. Ochtevelt ende Trijntgen Eduwaerts, beyde zaliger gedenckenisse, hierop gehoort Jacob Lucasz. Ochtevelt, schilder, ende Willem Jansz. Verwissel, schrienwercker, als geordonneerde voochden over de requirante, geïnformeert de requirante over de vijffentwintich jaeren out, van goeden beleyde ende comportemente, mitsgaders tot de regieringe haerder eygene goederen wel gequalificeert te sijn.

Hebben de requirante uyt de voochdije van hare voorsz. voochden ontslagen ende vrijgestelt, ende de requirante tot de regieringe haerder eygene goederen geadmitteert ende geauctoriseert, sulx Haer Edelen doen midsdese.

Ordonnerende de voorsz. voochden aen de requirante alle hare eygene goederen met den eersten te laten volgen.

Actum bij W. Visch ende M. J. Pesser, Weesmeesteren.

February 16, 1667.

Register van kwitantiën van weeskinderen bij de opheffing van de voogdij, 1645-68, Archief Weeskamer Rotterdam, inventaris Moquette, nr. 821.

Grietgen Jans Ochtervelt, released from the guardianship of Jacob Ochtervelt and Willem Jansz. Verwissel, receives her inheritance from Pieter Lucasz. Ochtervelt (relative on her father's side): 31 guilders and 8 pennies.

Den 16den february 1667.

Compareerde op huyden ter Weeskamer deser stede Rotterdam, Grietgen Jans, dochter van Jan Lucasz. Ochtevelt ende Trijntgen Eduwaerts, beyde zaliger gedenckenisse, op huyden de voochdije van hare voochden ontslagen ende vrijgestelt.

Ende verclaerde uyt handen van Jacob Lucasz. Ochtevelt, schilder, ende Willem Jansz. Verwissel, schrienwercker, haer comparantes gewesene voochden, ontfangen te hebben de somme van een-endertich guldens en acht penningen, in voldoeninge van haer comparantes portie in de erffenisse gecomen van Pieter Lucasz. Ochtevelt, oom van 's vaeders zijde. Bekennende sij, comparante, hiermede diesaengaende volcomentlijck voldaen ende betaelt te sijn.

Actum W. Visch ende Mr J. Pesser, Weesmeesteren.

Dit hantmerck X is gestelt bij Grietgen Jans Ochtevelt.

October 18, 1667.

Register van voordrachten en benoemingen van hoofdlieden der gilden van Rotterdam, 1667–69.

The document transcribed below is the list of nominees for leadership of the St. Luke Guild of Rotterdam. Separate nominations were proposed from four categories of guild members: painters, glassblowers, booksellers, and tile-makers. The names marked with a dash are the ones who were elected.

Nominatie van de hooftluyden van 't Lucasgilden.
 Schilders
—Cornelis Sachtleven (Cornelis Saftleven)
 Abraham Westervelt
 Jacob Ochtervelt
 Glaesmakers
 Aert Pieters Kortleeve
—Sander Thomasse
 Bouckverkoopers
 Aermout Laers
—Isaac de Haen
 Tegelbackers
 Symon Boudewijns van der Voort
—Jan Jans Lufneur

Bij de Heern Burgermeesteren deser stede geëligeert de persoonen met een streep aengehaelt. Actum den 18de oktober 1667. Present alle de burgermeestern, sonder A. Prins.

July 10, 1672.

Doopboek Nederduits-Gereformeerde Gemeente Rotterdam, 1671–75, inventaris Brouwer, nr. 13.

Baptized: Trijntge; parents: Jan Meesters and Marya de Jon(g); witnesses: Jacob Ochtervelt and Dirckje Meesters.

1674.

Quohier van de 200ste penning 1674, Amsterdam, fol. 451.

The entry in the taxation register reads: "Jacob Vechteveld fijnschilder 5." In other words, Ochtervelt was taxed five guilders. At a taxation rate of one penny to every two hundred, his property would have been worth about one thousand guilders.

June 28, 1677.

Notariële archieven Amsterdam, nr. 3752, 28-6-1677.

Jacob Ochtervelt, artist, appears before the notary Jan Coemans to authorize Nicolaes Swanenerff, an Amsterdam bookkeeper (accountant), to act as his agent in collecting a sum of money that is owed to Ochtervelt by two other artists: Isack Croonend and Lodewijck van Ludick. Swanenerff is authorized to use whatever means are necessary to settle the debt.

Compareerde voor mij Jan Coemans, notaris publycq, bij den Hove van Hollandt geadmitteert, resideerende binnen Amstelredamme, ende den getuygen naegenoemt Sr. Jacob van Ochtervelt, kunstschilder, woonachtig binnen deser stede, ende heeft in der bester forma geconstitueert ende volmachtich gemaeckt sulx doende bij desen Nicolaes Swanenerff, boeckhouder alhier, omme uyt zijn constituants naem ende sijnentwegen zoowel binnen als buyten rechten te eysschen, vorderen, innen ende ontfangen zoodanige somme van penningen als hem constituant van Srs. Isack Croonend ende Lodewijck van Ludick, beyde mede cunstschilder alhier, deuchdelijck is competerende, breder blijckende bij de bescheyde de geconstitueerde neffens dese alreede ter handt gestelt ende nae desen noch meerder ter handt te stellen, van zijn ontfangh quitantie te passeeren ende voor naemaninge te caveeren, is 't noodt daeromme te mogen doen ende doen doen alderhande requisitie, protestatien, arresten, detensie ende uytwinninge van persoon, penningen ende goederen. Ende voorts recht te mogen plegen voor alle heeren rechteren ende gerechtsbancken, soowel eysschende als verweerende alle termijnen van recht te observeren, ende de saecke bij alle behoorelijcke ende mogelijcke wegen ende middelen van recht, zoo in de eerste als alle volgende instantien, te prosequeeren totte diffinitive sententie ende 't uyteynde van de executie van dien toe. Ende voorts generalijck in 't gunt voorsz. is met dies aencleff alles te mogen doen ende verrichten, wes hij constituant selffs present sijnde soude connen mogen ende behoort te doen, al waer 't dat de saecke nader, breder off speciaelder bevel dan voors. staet requireerden, alles ter goeder trouwen ende onder verbant ende belofte van ratificatie als nae rechten, consenteerende hij comparant hiervan acten. Aldus gedaen ende gepasseert binnen Amstelredamme ter presentie van Sr. Gerald Rambergh ende Hendrick Elbertse Snoek, inwoonders deser stede, als getuygen hierover gestaen, den 28 junii 1677.

October 23, 1677.

Rechterlijck archieven Amsterdam, nr. 740, schepenminuutregister, fol. 90.

Melis van Paddenburg, deputy for Dammas Guldewaagen (secretary of the City of Haarlem), and Nicolaes Swanenwerff, deputy for Jacob Ochtervelt, appear at the Amsterdam City Court to try to collect money that is owed to their clients by Bartholomeus Abba. The deputy for Guldewaagen demands 94 guilders and 10 pennies, and the deputy for Ochtervelt demands 70 guilders. Apparently Abba has some assets, since his furniture, sold by foreclosure, fetched something over 53 guilders. The two deputies ask the court to credit their clients with the entire sum owed to each of them. On another page of the same document, the magistrates, after examining the requests, agree to credit the deputies with the sums they demand.

Aen de Edelaghtb. Heeren van de Gerechte der Stad Amsterdam. Geven reverentelijck te kennen Melis van Paddenburg, gemachtigde van Dammas Guldewaagen, secretaris der stad Haerlem, en

Nicolaes Swanenwerff, gemachtigde var Jacob van Ogtervelt, dat sij supplianten ider in de voors. qualité ten laste van mr. Bartholomeus Abba hebben geobt. de annexe vonnissen, het eene ter beloop van f94-10 ende 't ander f70, en vermits de meubilen van de voors. Abba bij executie sijn verkocht ende daervan volgens de onderteeckening van de conchergie is geprocedeert f53-11-13, waeruyt de annexe vonnissen konnen werden voldaen, maer alsoo 't selve niet kan geschieden als met Uedelachtb. authorisatie ende consent. soo keert hij suppliant sig tot Uedelachtb. reverentelijck versoeckende dat Uedelachtb. de heeren secretarissen gelieven te aucthoriseeren aen hen supplianten ter voors. somme van f94-10 ende f70 respective te verleenen sonder cautie. 't Welck doende etc. Getekent: F. Uutenbogaert. Cornelis de Magistris. Was bij annexe acte geappostilleert.
 Idem. fol. 90v.

Schepenen nader geëxamineert hebbende de requestie bij Melis van Paddenburgh, gemachtigde van mr. Dammas Guldewaagen, secretaris der stad Haerlem, ende Nicolaes Swanenwerff, gemachtigde van Jacob van Oghtervelt, aen haer Edelachtb. overgegeven, ende mede gehoort hebbende het beright van de secretaris mr. Gerrit Hooft, aucthoriseeren denselve om aen de supplianten, namentlijck aen Melis van Paddenburgh, in qualité als boven, afschrijvinge te verleenen ter somme van vier an 't negentig guldens tien stuivers en aen Nicolaes Swanenwerff, in qualité als boven, ter somme van 't seventig guldens, mits stellende suffisante cautie. Actum den 23 octobris 1677, praesentibus d' heeren mrs. C. Cloeck, J. Boreel, C. Roch, A. Bentes en E. de Vrij, schepenen.

May 1, 1682.

D.T.B. 1069, fol. 48 (begrafenisregister Nieuwezijds Kapel) : den 1 dito.

The Burial Register of the Nieuwezijds Chapel in Amsterdam states that Ochtervelt was buried on May 1, 1682, and that he had been living at the Schapenmarkt near the Royal Mint.

1 mei 1682. Een man Jacob Ochtervelt, kompt van de Schapemarckt bij de Munt.

November 3, 1682.

Notariële archieven Amsterdam, nr. 4104, 3-11-1682.

Gillis Pelgrom of Amsterdam appears before the Amsterdam notary Dirck van der Groe and authorizes Nathan Swab, also of Amsterdam, to act as his defender in a lawsuit that has been brought against him by the widow of Jacob Ochtervelt. (The reason for the lawsuit is not specified.)

Op huyden den darden novembris anno 1682 compareerde voor mij Dirck van der Groe, notaris publ., in presentie van de nabescreven getuygen Sr. Gillis Pelgrom, woonende binnen deser steede, ende heeft geconstitueert ende machtich gemaeckt als hij constitueert ende machtich maecht bij desen Sr. Nathan Swaab, mede woonende alhier, omme uyt sijn comparants naeme ende van sijnentwegen te defenderen, vervolgen ende waer te nemen de sake ende questie, die bij de weduwe van Jacob Ochtervelt op ende jegens hem comparant wert gemoveert, ende tot dien eynde te mogen compareren voor de heeren commissarissen van de cleyne saecken binnen deser steede ende daer verder ende anders vereysschen sal ende aldaer op ende jegens de voorsz. weduwe van Ochtervelt ende allen anderen te ageren ende recht te spreecken, soowel eysschende als verwerende ende in omnibus ad lites in communiforma. Ende voorts in desen soo in rechte als daerbuyten noch alles te doen ende laten wes hij comparant selfs present sijnde soude connen ende mogen doen, belovende te approberen 't gunt in crachte deses gedaen ende verricht sal werden onder het verbant ende subjectie als nae rechte. Alles oprecht gedaen te Amsterdam ter presentie van Jac. van der Groe ende

Henricus de Bruyn als getuygen hiertoe versocht.

(w.g.) J. van der Groe, H. de Bruyn, Gillis Pelgrom.

Quod attestor rogatus D. van der Groe, nots. publ.

January 20, 1691.

Notariële archieven Rotterdam 1585-1811, inventaris Wiersum, nr. 847, akte nr. 159.

Nicolaas du Chemin, a Rotterdam merchant, appears with his two daughters, Anna and Elizabeth, before the Rotterdam notary Zeger van der Brugge. He draws up a declaration giving his two daughters, among other goods, two portraits of himself and his wife by the artist Ochtervelt. The daughters declare that they gratefully accept the gift. (Note: There are presently no known pendant portraits by Ochtervelt, although he did paint two double portraits of a husband and wife [cat. nrs. 81 and 90, Figs. 158, 159]. Unfortunately, none of the artist's known single portraits [cat. nrs. 13, 30, and 104, Figs. 148, 160, 162] can be related to this document.)

Op huyden, den 20sten january 1691, compareerde voor mij, Zeger van der Brugge, notaris publycq, bij den Hove van Holland geadmitteert, residerende tot Rotterdam etc., seigneur Nicolaas du Chemin koopman alhier.

Ende verklaarde bij desen uyt sijnen liberen ende vrijen wille, als een gifte onder de levende, onwederroepelijk te schencken ende te geven aan sijne dochteren, jufferen Anna ende Elisabeth du Chemin, meerderjarige ongehoude dochteren, twee bedden, twee peuluwen, vier hooftkussens, alle met fijne strepen ende beste bedden die hij, comparant heeft, met noch ses de beste dekens, peuluwen en kussens, ende twee portraicten van hem, comparant, ende van sijne huysvrouwe, haer beyde gedaan door den konstenaar Ochtervelt. Omme deselve bedden, peuluwen, hoftkussens, dekens ende portraicten bij sijne voornomde dochters aanstondts naar haar genomen te mogen werden, ofte andersints ten tijde wanneer deselve off de een off ander van dien kompt te huwelijken, off van hem, comparant, metterwoon off te gaan. Affgaande hij, comparant, bij desen val alle gratiën, keuren, ordonnantiën, statuten en placaten, die hem hiertegens enigsints te stade souden konnen komen.

Compareerden mede de voornomde jufferen Anna ende Elisabeth du Chemin, ende verklaarden de bovengenomde gifte in voegen voorschreven van haren voornomden vader met alle danckbaarheyt te accepteren.

Aldus gedaan ende verleden ten huyse van den comparant, in presentie van Pieter van der Snoeck ende Andries van der Snoeck, als getuygen ten desen versocht.

(Was getekend:) N. due Chemin; Anna du Chemin; Elisabeth du Chemin; P.v. Snoeck; A.v. Snoeck; S.v. Brugge, notaris publycq, 1691.

February 11, 1710.

Begrafenisregister Nederduits-Gereformeerde Gemeente Rotterdam 1708-12, inventaris Brouwer, nr. 218, Archief Kerkmeesters Nederduits-Gereformeerde Gemeente Rotterdam, inventaris Moquette nr. 635.

Buried: Dyrcktje Meesters, widow of Jakop Ogtervelt. A sum of three guilders was paid to the college of church wardens of the Dutch Reformed Church of Rotterdam.

Bibliography

Museum catalogues are listed in the bibliography according to place. Catalogues of private collections are listed after the name of the collector.

Amsterdam. *All the Paintings in the Rijksmuseum, Amsterdam.* Maarssen, 1976.

Antwerp. *Catalogus I, Museum Mayer van den Bergh.* Antwerp, 1966.

Assheton Bennett Collection. *Catalogue of Paintings and Drawings from the Assheton Bennett Collection* (by F. G. Grossmann). City of Manchester Art Gallery, 1965.

Augsburg. *Katalog der Stiftung Haberstock.* Augsburg, 1960.

Bauch, K. *Jakob Adriaensz. Backer.* Berlin, 1926.

Bedaux, J. B. "Minnekoorts-, Zwangerschaps- en Doodsverschijnselen op 17de Eeuwse Schilderijen." *Antiek*, vol. 10, nr. 1 (1975-76), pp. 17-42.

Bénézit, E. *Dictionnaire des Peintres, Sculpteurs, Dessinateurs et Graveurs.* Paris, 1953. Vol. 6. pp. 404-05.

Berlin. *Gemäldegalerie Berlin-Dahlem. Katalog der ausgestellten Gemälde des 13. bis 18. Jahrhunderts* (by H. Bock and J. Kelch). Berlin, 1975.

————. *Die Gemälde im Jagdschloss Grünewald.* Berlin, 1964.

Bernan, S., and Bernan, R. *A Guide to Myth and Religion in European Painting 1270-1700.* New York, 1973.

Bernt, W. *The Netherlandish Painters of the Seventeenth Century,* 3 vols. London, 1970.

Bialostocki, J., and Wolicki, M. *Europäische Malerei im Polnischen Sammlungen.* Warsaw, 1956.

Birmingham. *Catalogue of Paintings, City Museum and Art Gallery.* Birmingham, 1960.

Bisschop, Jan de. *Paradigmata Graphices variorum Artificum.* The Hague, 1671.

Blanc, C. *Le Trésor de la Curiosité,* 2 vols. Paris, 1857.

Blankert, A. "Rembrandt, Zeuxis and Ideal Beauty," in *Album Amicorum J. G. van Gelder.* The Hague, 1973. Pp. 32-39.

————. *Johannes Vermeer.* Utrecht, 1975.

Bode, W. von. "Die Austellung von Gemälde älterer Meister im Berliner Privatbesitz." *Jahrbuch der Preussischen Kunstsammlungen* 4 (1883): 191-217.

————. "Alte Kunstwerke in den Sammlungen in der Vereinigten Staten." *Zeitschrift für bildenden Kunst,* N. F. 6 (1895): 13-19, 70-76.

Bonn. *Rheinisches Landesmuseum, Verzeichnis der Gemälde* (by F. Rademacher). Bonn, 1959.

Borenius, T. "Treasures from the Rothermere Collection." *Apollo,* vol. 22 (December 1935): 329-34.

Braam, F. A. van. *Art Treasures from the Benelux Countries.* N.p., 1958.

————. *World Collectors' Annuary,* 11 vols. N.p., 1946-67.

Bredius, A. (revised by H. Gerson). *Complete Paintings of Rembrandt.* London, 1969.

Brière-Misme, C. "Tableaux inédits ou peu connus de Pieter de Hooch." *Gazette des Beaux Arts,* vol. 10 (1927): 364-66.

Brochhagen, E. *Karel Dujardin. Ein Beitrag zum Italianismus in Holland im 17. Jahrhunderts.* Inaug. diss., Cologne, 1957.

231

Brulliot, F. *Dictionnaire des Monogrammes, Marques figurées, Lettres initiales, Noms abregées, etc.*, 3 vols. Munich, 1834.

Brune, J. de. *Emblemata of Zinne-werck.* Amsterdam, 1624.

Brussels. *Catalogus der oude Schilderkunst, Koninklijke Musea voor Schone Kunsten van Belgie.* Brussels, 1959.

Bruyn, C. J. de. "De Amsterdamse Verzamelaar Jan Gildemeester Jansz." *Bulletin Rijksmuseum Amsterdam,* vol. 13 (1965): 79-114.

Bryan's Dictionary of Painters and Engravers (ed., G. C. Williamson), 5 vols. London, 1904.

Budapest. *Katalog der Galerie alter Meister* (by A. Pigler), 2 vols. Budapest, 1967.

Cats, J. *Silenus Alcibiades, sive Proteus,* Middelburg, 1618.

——. *Spiegel Vanden Ouden ende Nieuwen Tijdt.* Amsterdam, 1658.

Chicago. *A Guide to Paintings in the Permanent Collection, Chicago Art Institute.* Chicago, 1932.

——. *Paintings in the Art Institute of Chicago, A Catalogue of the Picture Collection.* Chicago, 1961.

Chrysler Collection. *Paintings from the Collection of Walter P. Chrysler, Jr.* Portland, Oregon, 1956.

Cologne. *Katalog der niederländischen Gemälde von 1550 bis 1800 im Wallraf-Richartz-Museum und im öffentlichen Besitz der Stadt Köln."* (by H. Vey and A. Kesting). Cologne, 1967.

Coo, J. de. "Die Beziehungen des Antwerper Sammlers Mayer van den Bergh zu Köln." *Wallraf-Richartz Jahrbuch,* vol. 24 (1962): 409-12.

Copenhagen. *Catalogue of Old Foreign Paintings, Royal Museum of Fine Arts.* Copenhagen, 1951.

Descamps, J. B. *La Vie des Peintres flamandes, allemands et hollandais,* 4 vols. Paris, 1753-63.

Donahue, S. "Two Paintings by Ochtervelt in the Wadsworth Atheneum." *Bulletin of the Wadsworth Atheneum,* vol. 5 (Fall 1969): 45-54.

Dresden. *Katalog der Staatlichen Gemäldegalerie zu Dresden, Die alten Meister.* Dresden, 1930.

Dublin. *Catalogue of the Paintings, National Gallery of Ireland.* Dublin, 1971.

Edwards, R. *Early Conversation Pieces from the Middle Ages to about 1730: A Study in Origins.* London, 1954.

Eeghen, I. H. van. "De Kerk het Vredesduife." *Maandblad Amstelodamum* (1957), pp. 145-49.

Emmens, J. *Rembrandt en de Regels van de Kunst.* Utrecht, 1968.

Fischer, F. H. (De Roever-Dozy). *Het Leven van onze Voorouders,* 6 vols. Amsterdam, 1892-1906.

Fischer, P. *Music in Paintings of the Low Countries in the 16th and 17th Centuries.* Amsterdam, 1975.

Fleischer, R. E., "Ludolf de Jongh and the Early Work of Pieter de Hooch," *Oud Holland* 92 (1978): 49-67.

Frankfurt am Main. *Verzeichnis der Gemälde, Städelsches Kunstinstitut.* Frankfurt am Main, 1966.

Frimmel, T. von. *Geschichte der Wiener Gemäldesammlungen,* vol. 1. Vienna, 1899.

——. "Neuerwerbungen der Sammlungen Matsvanszky." *Blätter für Gemäldekunde,* vol. 6 (1910): 38-39, 94-96; 7: 49-55.

——. "Zur Geschichte der Puthon'schen Gemäldesammlungen." *Blätter für Gemäldekunde,* vol. 7 (1911): 19-27.

——. "Die wiedergefundene Ochtervelt im Wiener Nationalmuseum." *Studien und Skizzen zur Gemäldekunde,* vol. 5 (1920-21): 173-76.

——. *Von alter und neuer Kunst.* Vienna, 1922.

Geffroy, G. *Les Musées d'Europe.* Paris, 19—.

Geyl, P. *The Netherlands in the 17th Century, Part Two, 1648-1715.* London, 1968.

Glasgow. *Dutch and Flemish, Netherlandish and German Paintings, Glasgow Art Gallery and Museum.* Glasgow, 1961.

Goering, M. "Neuerwerbungen niederländischen Gemälde des 17. Jahrhunderts im Bonner Landesmuseum." *Pantheon,* vol. 22 (August 1938): 237-47.

Gool, J. van. *De Nieuwe Schouburgh,* 2 vols. The Hague, 1750-51.

Graves, A. *A Century of Loan Exhibitions,* 5 vols. London, 1913-15.

Gronau, G. "Erwerbungen der Casseler Galerie." *Berliner Museen* vol. 44 (1923): 60-71.

Gudlaugsson, S. J. "Representations of Granida in Dutch 17th Century Painting III." *Burlington Magazine* vol. 91 (February 1949): 39-43.

——. *Gerard Ter Borch,* 2 vols. The Hague, 1959.

————. *The Comedians in the Work of Jan Steen and His Contemporaries* (trans. J. Brockway). Soest, 1975.

Haak, B. *Regenten en Regentessen Overleiden en Chirurgijns: Amsterdamse Groepportretten van 1600 to 1835*. Amsterdams Historisch Museum, 1972.

Haley, K. H. D. *The Dutch in the Seventeenth Century*. London, 1972.

Hall, H. van. *Portretten van Nederlandse Beeldende Kunstenaars*. Amsterdam, 1963.

Hamburg. *Katalog der älten Meister der Hamburger Kunsthalle*. Hamburg, 1966.

Hartford. *Catalogue of the Collection in Avery Memorial, Wadsworth Atheneum*. Hartford, 1934.

Haverkorn van Rijsewijk, P. "Pieter de Hooch of de Hoogh." *Oud Holland* vol. 10 (1892): 172-77.

Held, J. "Jordaens' Portraits of his Family." *Art Bulletin* vol. 22 (1940): 70-82.

Henle Collection. *Katalog, Die Sammlung Henle, Duisburg*. Cologne, 1964.

Higginson Collection. *Catalogue of the Collection of E. Higginson of Saltmarshe*. London, 1842.

Hoet, G. *Catalogus of Naamlyst van Schilderyen*, 2 vols. The Hague, 1752.

Hofstede de Groot, C. "Holländische Kunst in Schotland." *Oud Holland*, vol. 11 (1893): 141.

————. *Die Urkunden über Rembrandt*. The Hague, 1906.

————. *Beschreibendes und kritisches Verzeichnis der Werke der hervorragendsten holländischen Maler des XVII. Jahrhunderts*, 10 vols. Esslingen a N., 1907-28.

Holländer, E. *Die Medizin in der klassichen Malerei*. Stuttgart, 1950.

Hollstein, F. W. H. *Dutch and Flemish Etchings, Engraving and Woodcuts 1450-1700*, vol. I—. Amsterdam, 1949—.

Holmes, C. "Ochtervelt and the 'Melozzo' at Trafalgar Square." *Burlington Magazine* vol. 44 (1924): 192-95.

Hooft, P. C. *Granida* (ed., C. A. Zaalberg). Zutphen, 1958.

Hoogstraten, S. van. *Inleyding tot de Hooge Schoole der Schilder-Konst*. Rotterdam, 1678.

Houbraken, A. *De Groot Schouburgh der nederlantsche Konstschilders en Schilderessen*, 3 vols. Amsterdam, 1718-21.

Huizinga, J. H. *Dutch Civilization in the Seventeenth Century*. London, 1968.

Immerzeel, J. *De Levens en Werken der hollandsche en vlaamsche Kunstschilders, Beeldhouwers, Graveurs en Bouwmeesters*, 3 vols. Amsterdam, 1842.

Jongh, E. de. *Zinne -en Minnebeelden in de Schilderkunst van de Zeventiende Eeuw*. Amsterdam, 1967.

————. "Erotica in Vogelsperspectief: De Dubbelzinnigheid van een Reeks 17de eeuwse Genrevorstellingen." *Simiolus*, vol. 3 (1968-69): 43-47.

————. "Realisme en Schijnrealisme in de hollandse Schilderkunst van de 17de Eeuw," *Rembrandt en zijn Tijd*. Brussels, 1971. Pp. 143-98.

————. "Vermommingen van Vrouw Wereld in de 17de Eeuw." In *Album Amicorum J. G. van Gelder*. The Hague, 1973. Pp. 198-206.

————. "Grape Symbolism in Paintings of the 16th and 17th Centuries." *Simiolus*, vol. 7 (1974): 166-91.

————. *Tot Lering en Vermaak*. Amsterdam: Rijksmuseum, 1976.

Judson, J. R. *Gerrit van Honthorst*. The Hague, 1959.

Karlsruhe. *Katalog Alte Meister, Staatliche Kunsthalle Karlsruhe* (by J. Lauts), 2 vols. Karlsruhe, 1966.

Kassel. *Katalog der Staatlichen Gemäldegalerie zu Kassel*. Kassel, 1958.

Kelly, F. M., and Schwabe, R. *Historic Costume: A Chronicle of Fashion in Western Europe 1490-1790*. London, 1925.

Kersbergen, A. C. *Zes Eeuwen Rotterdam*. Rotterdam, n.d.

Keyszelitz, R. *Der "clavis interpretandi" in der holländischen Malerei des 17. Jahrhunderts*. Inaug. diss., Munich, 1956.

Kinderen-Besier, J. H. der. *Spelevaart der Mode*. Amsterdam, 1950.

Kirschenbaum, B. *The Religious and Historical Paintings of Jan Steen*, New York, 1977.

Kramm, C. *De Levens en Werken der Hollandsche en Vlaamsche Kunstschilders, Beeldhouwers, Graveurs en Bouwmeesters*, 7 vols. Amsterdam, 1851-64.

Krul, J. *Minnebeelden*. Amsterdam, 1634.

Kunze, I. "Depotbilder einer grossen Galerie." *Pantheon*, vol. 27 (1941): 1-12.

Kuretsky, S. D. "The Ochtervelt Documents." *Oud Holland,* vol. 87 (1973): 124-41.

Labia Collection. *Natale Labia Collection on Loan to the South African National Gallery.* Capetown, 1976.

Lairesse, G. de. *Grondlegginge der Teekenkonst.* Amsterdam, 1701.

―――. *Het Groot Schilderboek.* Amsterdam, 1707.

Lebrun, J. B. P. *Galerie des Peintres Flamands, Hollandais et Allemands,* 2 vols. Paris, 1792.

Ledermann, I. *Beiträge zur Geschichte des romantischen Landschaftsbildes im Holland und seines Einflusses auf die nationale Schule um die Mitte des 17. Jahrhunderts.* Inaug. diss., Berlin, 1920.

Legrand, Fr. Ch. *Les Peintres flamands de Genre au XVII^e Siècle.* Brussels, 1963.

Leipzig, *Katalog Museum der bildenden Künste zu Leipzig.* Leipzig, 1929.

Leningrad. *Catalogue of Paintings, The Hermitage* (in Russian), 2 vols. Leningrad, 1958.

Lilienfeld Collection. *Niederländische Gemälde aus der Sammlung des Herr Leon Lilienfeld in Wien* (by G. Glück). Vienna, 1917.

Lilienfeld, K. "Wiedergefundene Gemälde des Pieter de Hooch." *Zeitschrift für bildende Kunst,* vol. 58 (1924-25): 183-88.

London. *The Dutch School, National Gallery Catalogues* (by N. MacLaren). London, 1960.

―――. *The National Gallery, Illustrated General Catalogue.* London, 1973.

Lugt, F. *Répertoire des Catalogues des Ventes publiques,* 3 vols. The Hague, 1938.

Manchester, *Illustrated Guide to the Art Collections in the Manchester Corporation Galleries.* Manchester, 1938.

Mannheim. *Reiss-Museum Mannheim* (by A. Griefhagen). Munich, 1958.

Martin, W. *De Hollandsche Schilderkunst in de 17de Eeuw,* 2 vols. Amsterdam, 1942.

―――. *De Schilderkunst in de 2de Helft van de 17de Eeuw.* Amsterdam, 1950.

―――. *Gerard Dou.* Klassiker der Kunst, Stuttgart-Berlin, 1913.

Matsvanszky Collection. *Verzeichnis der Gemälde in der Sammlung Matsvanszky* (by T. von Frimmel). Vienna, 1922.

Mayer, A. L. "Die Ausstellung der Sammlung Schloss Rohoncz in Munich." *Pantheon,* vol. 6 (July 1930): 314.

Mees, N. A. "Aanteekeningen over oud-Rotterdamsche Kunstenaars." *Oud Holland,* vol. 30 (1913): 241-68.

Meischke, Ir. R., and Zantkuijl, H. J. *Het Nederlandse Woonhuis van 1300-1800.* Haarlem, 1969.

Mireur, H. *Dictionnaire des Ventes d'Art,* 7 vols. Paris, 1911.

Mirimonde, A. P. de. "La Musique dans les Allegories de l'Amour." *Gazette des Beaux Arts,* vol. 68 (1966): 265-90.

Moes, E. *Iconographia Batava,* 2 vols. Amsterdam, 1897-1905.

Mojzer, M. *Dutch Genre Paintings in Hungarian Museums.* Budapest 1974.

Moscow. *Catalogue, Pushkin Museum* (in Russian). Moscow, 1957.

Munich. *Katalog III, Holländische Malerei des 17. Jahrhunderts, Alte Pinakothek.* Munich, 1967.

Nagler, G. K. *Allgemeines Künstler-lexikon,* 20 vols. Leipzig, 1872-1950.

New York. *Catalogue, New York Historical Society.* New York, 1915.

Nicolson, B. *Hendrik Terbrugghen.* London, 1958.

Obreen, F. D. O. *Archief voor Kunstgeschiedenis,* 7 vols. Rotterdam, 1877-90.

Philippi, A. *Die Blüte der Malerei in Holland.* Leipzig and Berlin, 1901.

Playter, C. B. *Willem Duyster and Pieter Codde: The "Duystere Werelt" of Dutch Genre Painting, c. 1625-35.* Inaug. diss., Harvard University, 1972.

Plietzsch, E. "Ausstellung von Werken alter Kunst aus Berliner Privatbesitz." *Cicerone,* vol. 7 (1915): 201-14.

―――. "Jacob Ochtervelt." *Pantheon,* vol. 20 (1937): 364-72.

―――. "Randbemerkungen zur holländischen Malerei vom Ende des 17. Jahrhunderts." *Festschrift Friedrich Winkler.* Berlin, 1959. Pp. 313-25.

―――. *Holländische und flämische Maler des XVII. Jahrhunderts.* Leipzig, 1960.

Prague. *The National Gallery of Prague* (by R. F. Samsour; trans. by L. Kesner). Prague, 1964.

Praz, M. *Conversation Pieces: A Survey of the Informal Group Portrait in Europe and America.* Pennsylvania State University Press, 1971.

Price, J. L. *Culture and Society in the Dutch Republic during the 17th Century.* New York, 1974.

Raleigh. *Catalogue of Paintings, North Carolina Museum of Art* (by W. R. Valentiner). Raleigh, 1956.

Rijckevorsel, J. *Rembrandt en de Traditie*. Rotterdam, 1932.

Robinson Collection. E. K. Waterhouse. *The Robinson Collection*. London, 1958.

Robinson, F. W. *Gabriel Metsu (1629-1667): A Study of His Place in Dutch Genre Painting of the Golden Age*. New York, 1974.

Rosenberg, J., Slive, S., and Ter Kuile, E. H. *Dutch Art and Architecture 1600-1800*. London: Pelican, 1966.

Rotterdam. *Het Museum Boijmans te Rotterdam* (by P. Haverkorn van Rijsewijk). The Hague and Amsterdam, 1909.

————. *Catalogus Schilderijen tot 1800, Museum Boymans-van Beuningen*. Rotterdam, 1962.

————. *Old Paintings 1400-1900, Illustrations. Museum Boymans-van Beuningen*. Rotterdam, 1972.

Sandrart, J. von. *Teutsche Academie*. Nuremberg, 1675-79.

San Francisco. *Illustrated Handbook of the Collections, California Palace of the Legion of Honor*. San Francisco, 1944.

Schaar, E. *Studien zu Nicolaes Berchem*. Inaug. diss., Cologne, 1958.

Scheltema, F. A. van. *Historische Beschrijvinge*. Amsterdam, 1879.

Sick, I. von. *Nicolaes Berchem: ein Vorläufer des Rokoko*. Cologne, 1930.

Simpson, F. "Dutch Paintings in England before 1760." *Burlington Magazine*, vol. 95 (February 1953): 39-42.

Sip. J. *Mistri Hollandské*. Prague, 1949.

Sitwell, S. *Conversation Pieces: A Study of English Domestic Portraits and Their Painters*. New York, 1937.

Six Collection. *Catalogus der Verzameling Schilderijen en Familie-Portretten van de Herren . . . Six*. Amsterdam, 1900.

Slatkes, L. J. *Dirck van Baburen*. Utrecht, 1962.

Slive, S. *Rembrandt and His Critics 1630-1730*. The Hague, 1953.

————. *Frans Hals*, 3 vols. London and New York, 1970-74.

Smith, A. *A Catalogue Raisonné of the Works of the Most Eminent Dutch, Flemish and French Painters*, 9 vols. London, 1829-42.

Snoep-Reitsma, E. "De Waterzuchtige Vrouw van Gerard Dou en de Betekenis van de Lampetkan," in *Album Amicorum J. G. van Gelder*. The Hague, 1973. Pp. 285-92.

Spaan, Gerard van. *Beschrijvinge der Stad Rotterdam*. Rotterdam, 1698; Donker edition, Antwerp, 1943.

Speck von Sternberg Collection. *Gemälde Galerie Speck von Sternberg* (by F. Becker). Leipzig, 1904.

Spencer, E. G. "The Thyssen-Bornemisza Gallery at Castagnola." *Connoisseur*, vol. 127 (May 1951): 119-20.

Stampart, F., and Prenner, A. *Prodromus*. Vienna, 1728-35.

Staring, A. *De Hollanders Thuis. Gezelschapstukken uit drie Eeuwen*. The Hague, 1956.

————. "Vier Familiegroepen van Nicolaes Maes." *Oud Holland*, vol. 80 (1965): 169-79.

Stechow, W. "Lucretiae Statua," in *Beiträge für Georg Swarzenski*. Berlin, 1951. Pp. 114-24.

Stockholm. *Nationalmuseum, Äldre Utländska Malingar och Skulpturer*. Stockholm, 1958.

St. Petersburg. *Ermitage Impérial, Catalogue . . . des Tableaux, Écoles Néerlandaises et École Allemande* (by A. Somof). St. Petersburg, 1901.

Stummer Collection. *Verzeichnis der Gemälde im Besitz der Frau Baronin Auguste Stummer von Tavernok* (by T. von Frimmel). Vienna 1895.

Ter Borch Exhibition (catalogue). Münster: Landesmuseum, 1974.

Terwesten, P. *Catalogus of Naamlyst van Schilderyen*. The Hague, 1770.

Teychiné Stakenberg, A. J. *Rotterdam*. The Hague, 1958.

The Hague. *Catalogue Raisonné des Tableaux et des Sculptures, Musée Royal de Tableaux, Mauritshuis*. The Hague, 1935.

————. *Beknopte Catalogus van de Schilderijen . . . Mauritshuis*. The Hague, 1968.

Thiel, P. J. van. "Marriage Symbolism in a Musical Party by Jan Meinse Molenaer." *Simiolus*, vol. 2 (1967-68): 91-99.

Thieme, U., and Becker, F. *Allgemeines Lexikon der bildenden Künstler*, 37 vols. Leipzig, 1907-50.

Thoré, E. J. T. (writing as W. Bürger). *Les Musées de la Hollande*, 2 vols. Paris, 1858.

Thyssen Collection. *Collection Thyssen-Bornemisza*. Lugano, 1967.

Valentiner, W. R. "Jacob Ochtervelt." *Art in America*, vol. 12 (1924): 264-84.

————. *Nicolaes Maes*. Klassiker der Kunst. Stuttgart, 1924.

————. *Pieter de Hooch.* Klassiker der Kunst. Stuttgart, 1929.

Veen, Otto van. *Amorum Emblemata.* Antwerp, 1608.

Venice. *La Galleria Giorgio Franchetti alla Ca' d'Oro di Venezia* (by G. Fogolari). Rome, 1950.

Verviers. *Musée Communal de Verviers, Catalogue II, Peinture.* Verviers, 1943.

Vienna. *Katalog der Gemäldegalerie, Holländische Meister des 15., 16. und 17. Jahrhunderts.* Vienna, 1972.

Voss, H. "Vermeer von Delft und die Utrechter Schule." *Monatschefte für Kunstwissenschaft,* vol. 5 (1912): 79–83.

Vries, A. B. de. *Jan Vermeer van Delft.* London, 1948.

Warsaw. *Catalogue of Paintings, Foreign Schools, National Museum of Warsaw,* 2 vols. Warsaw, 1970.

Welu, J. A. "Vermeer: His Cartographic Sources." *Art Bulletin,* vol. 57 (1975): 529–47.

White, C. *Rembrandt and His World.* London-New York, 1964.

Wilson, C. *The Dutch Republic.* New York-Toronto, 1968.

Witt, R. "An Overpainting in The Music Party." *Apollo,* vol. 43 (January 1946): 21.

Woermann K., and Woltmann, A. *Geschichte der Malerei.* Leipzig. Vol. 3, pt. 2 (1888), p. 840.

Worcester. *European Paintings in the Collection of the Worcester Art Museum,* vol. I. Worcester, 1974.

Worms. *Die Kunstsammlung im Heylshof zu Worms* (by G. Swarzenski). Frankfurt am Main, n.d.

Wurzbach, A. von. *Niederländisches Künstler-lexikon.* Vienna and Leipzig, 1910. Vol. 2, p. 249.

Zumthor, P. *La Vie quotidienne en Hollande au Temps de Rembrandt.* Paris, 1959.

Index*

*Pages on which illustrations appear are listed in italics.